William Hogarth

The ANALYSIS of BEAUTY

William Hogarth
The ANALYSIS of BEAUTY

Edited
with an Introduction and Notes by
Ronald Paulson

Published for the
Paul Mellon Centre for British Art by
Yale University Press
New Haven & London
1997

Set in Garamond by Best-set Typesetter Ltd., Hong Kong
and printed by St Edmundsbury Press Ltd., Bury St Edmunds, Suffolk

Library of Congress Cataloging-in-Publication Data

Hogarth, William, 1697–1764.
 The analysis of beauty / William Hogarth ; edited with an
introduction and notes by Ronald Paulson.
 p. cm.
 "The present edition is based on the first (and only) edition
published during Hogarth's lifetime, incorporating his errata in the
text, and correcting obvious errors."—Pref.
 Includes bibliographical references and index.
 ISBN 0-300-07335-6 (cloth : alk. paper).—ISBN 0-300-07346-1
(pbk. : alk. paper)
 1. Aesthetics—Early works to 1800. I. Paulson, Ronald.
II. Title.
BH181.H6 1997
00—dc21 97-26266
 CIP

To the memory of
Basil Taylor and Lawrence Gowing

Contents

List of Illustrations ix

Preface xi

Works Frequently Cited xv

Introduction xvii

Columbus Breaking the Egg lxiv

Title Page lxv

Text of *The Analysis of Beauty* 1

Manuscripts of *The Analysis of Beauty*: Supplementary Passages 115

Plate 1 139

Plate 2 141

Notes to the Illustrations 143

Index 157

Supplementary Illustrations 167

List of Illustrations

1. *Columbus Breaking the Egg* (subscription ticket). Courtesy of the Trustees of the British Museum, London. lxiv
2. Title Page. lxv
3. *Analysis of Beauty*, Plate 1, 2nd state. Courtesy of the Trustees of the British Museum, London. 139
4. *Analysis of Beauty*, Plate 2, 2nd state. Yale University, Lewis-Walpole Collection. 141

Supplementary Illustrations 167

5. Plate 2, 1st state (detail). Courtesy of the Trustees of the British Museum, London.
6. Plate 2, 3rd state (detail). Courtesy of the Trustees of the British Museum, London.
7. *The Country (or Wedding) Dance*; painting (c. 1745–6); Tate Gallery, London.
8. *Moses Brought to Pharaoh's Daughter* (1752, detail). Courtesy of the Trustees of the British Museum, London.
9. *Gulielmus Hogarth* (1749). Courtesy of the Trustees of the British Museum, London.
10. *Noon* (1738, detail). Courtesy of the Trustees of the British Museum, London.
11. (a) Logo, *Analysis* title page. (b) Trinity with Tetragrammaton: L. Cecill, detail of title page, Thomas Heywood, *The Hierarchie of the Blessed Angells* (1635). (c) *Enthusiasm Delineated* (c. 1759), detail. Courtesy of the Trustees of the British Museum, London. (d) *Enthusiasm Delineated*, detail. Courtesy of the Trustees of the British Museum, London.
12. *Harlot's Progress*, Plate 6 (1732). Courtesy of the Trustees of the British Museum, London.

13. *Boys Peeping at Nature* (subscription ticket for *A Harlot's Progress*, 1731, detail). Royal Library, Windsor Castle copyright 1990, H.M. Queen Elizabeth II.

14. *Tailpiece; or The Bathos* (1764). Courtesy of the Trustees of the British Museum, London.

15. *Characters and Caricaturas* (subscription ticket for *Marriage A-la-mode*, 1743, detail). Courtesy of the Trustees of the British Museum, London.

16. *The Reward of Cruelty* (1751/2). Courtesy of the Trustees of the British Museum, London.

17. *The March to Finchley* (1750). Courtesy of the Trustees of the British Museum, London.

18. Charles-Antoine Coypel, *Don Quixote Attacks the Puppets*; etching and engraving by François Poilly (1724; 1756 ed.). Courtesy of the Trustees of the British Museum, London.

19. *The Mystery of Masonry Brought to Light by the Gormogons* (1724, detail). Courtesy of the Trustees of the British Museum, London.

20. Annibale Carracci, *The Woman of Samaria*, etched, Carracci. Courtesy of the British Museum.

21. *The Bench* (1758; fourth state, 1764). Courtesy of the Trustees of the British Museum.

22. Paul Sandby, *Puggs Graces Etched from his Original Daubing* (1753/4). Courtesy of the Trustees of the British Museum.

23. Paul Sandby, *The Author Run Mad* (1754). Courtesy of the Trustees of the British Museum.

24. Paul Sandby, *The Vile Ephesian* (1753). Courtesy of the Trustees of the British Museum.

25. Thomas Rowlandson, *A Statuary Yard* (1780s), drawing. Oxford, Ashmolean Museum.

26. Thomas Rowlandson, *Exhibition Stare-Case* (c. 1800), drawing. Yale Center for British Art, Paul Mellon Collection.

Preface

THE IMPORTANCE OF William Hogarth's *Analysis of Beauty* (1753) has been obscured largely because its argument lies outside the main tradition of writing on art, whether of painter's manuals or aesthetic treatises. Its argument is anti-academic; indeed, one of its immediate stimuli was the struggle over whether to turn Hogarth's St. Martin's Lane Academy, with its life class (notoriously with a nude female model), into a state academy centered on copying from plaster casts of the canonical sculptures revered by the Italian Renaissance.

A second reason for the relative neglect of the *Analysis* is Hogarth's vastly better-known engravings and paintings, his "modern moral subjects." An aesthetics in which sensation and pleasure replace moral judgment apparently contradicts the tenor of his major works. The *Analysis* was labeled by contemporaries of the academic party as a great graphic moralist's misguided detour into theory. Hogarth was, it was claimed, probably not even the author of his own treatise. How could a comic artist (who acknowledged that he was "one who never took up the pen before" [p. 1]) write a philosophical treatise? It was in all probability to guard against such accusations that Hogarth preserved the manuscript drafts of the *Analysis*.

Art historians have contained the subversive energies of the *Analysis* under the label of rococo (the rococo of Boucher, Chippendale chairs, and Capability Brown's gardens). Thus the *Analysis* is merely a rationalization of "the rococo values of intimacy and informality, and the beautiful . . . associated with the terms 'graceful,' 'elegant,' and 'genteel'," the preference for *dulce* over *utile*, and a rationalization of the "over-loading of ornament which was in fashion for engraved plate at this time."[1]

The *Analysis* was not, like Hogarth's prints, a best-seller. There was only one edition in his lifetime. It was eclipsed as an aesthetic treatise by Burke's *Philosophical Enquiry into the Origin of Our Ideas of the Sublime and Beautiful* of four years later and, compared with Reynolds' *Discourses*

(1769ff.), had a negligible influence on painting in England. The *Philosophical Enquiry*, which privileged the Sublime, was what connoisseurs of the "high style" wanted to hear; and the *Discourses*, a brilliantly eclectic synthesis of Renaissance ideas, were what ambitious artists wanted to hear, arguably to the detriment, certainly of the originality, of their work. Hogarth's *Analysis* was written against the interest of connoisseurs, theorists of art, and the artists themselves.

Joseph Burke, in the only scholarly edition of the *Analysis* (1955), has stated Hogarth's importance fairly: "the first work in European literature to make formal values both the starting-point *and* basis of a whole aesthetic theory. It is a cardinal post-Renaissance aesthetic treatise, a novel and original attempt to define beauty in empirical terms." But even Burke concluded that its chief influence was as a "theoretical link between the rococo and the picturesque."[2]

In the Preface Hogarth connects his serpentine line with Michelangelo, Lomazzo, and Renaissance art. But he is not being disingenuous when he claims that he had not read the basic art treatises before evolving his theory, which was grounded on observation. As an empirical theory its real source is in his native England, in Locke's *Essay Concerning Human Understanding*, Addison's *Spectator*s, philosophical empiricism, Whig anticlericalism (including critical deism), Protestant iconoclasm, and the literary tradition of satire emerging, at just this time, in the novel.

Despite the vicissitudes of its history, and its primarily literary influence, the *Analysis* occupies a significant, virtually unique, theoretical and practical position in the development of English (which is essentially pre-Kantian) aesthetics. The absolute centrality of Hogarth in English culture of the eighteenth century alone suggests that his attempt to systematize and theorize his practice needs to be defined and properly understood. What he proposes is, quite simply, an aesthetics of the middle range, which subordinates both the Beautiful and the Sublime to the everyday world of human choice and contingency. What makes the *Analysis* such a delight to read is the sheer abundance of Hogarth's sharp observations of contemporary London life.

There is no textual problem in *The Analysis of Beauty* because there was no second edition.[3] In his 1955 edition Burke modernized the text (while oddly retaining the long s), compared the printed text against the manuscripts, and printed many of the rejected manuscript passages in an appendix. But he included no annotation of the text and little of the illustrations. Since then a great deal has been published on Hogarth,

including a catalog of the engravings, a biography, and studies of the British tradition of aesthetics.[4]

The present edition is based on the first, incorporating Hogarth's errata, and correcting obvious errors. Only such eighteenth-century conventions as the long s and v/u have been regularized and marginal quotation marks eliminated. References to illustrations, which are sometimes in the margin, sometimes in the text, are bracketed in the text. Only Hogarth's spelling of *Lamozzo* has been corrected to *Lomazzo* and a few spellings adjusted for the sake of intelligibility. I have omitted Hogarth's errata sheet, his explanation of his plate/figure references, and his advertisement at the end for the prints on sale in his shop. The asterisk and dagger footnotes are his, the numbered notes mine. His list of correspondences between plates/figures and the pages on which they are discussed is replaced by full annotations of the plates (see pp. 143–56).

The illustrative plates are, as we might expect, of equal significance with the text. Hogarth emphasizes their importance on the first page of his introduction, noting that they should be "examined as attentively" as the text. However sharp and colorful Hogarth's words, the verbal discourse of his text is less sophisticated than the graphic discourse of the illustrations. His images are always more radical, more searching, than his written words.[5]

The manuscripts contain some supplementary and variant passages of interest: for example, some passages cut as too expansive, aggressive, or indiscreet; additional examples that seemed expendable (two rather lengthy jokes); but also the introduction of the whole subject of memory, which is crucial to an understanding of Hogarth's system.

I have printed what I take to be the significant passages, keying them into the printed text where I believe they would have gone. I have checked the manuscripts against Burke's readings, which are in general accurate; often when he cannot make sense of a word, neither can I. We differ in one particular: my principle of editing has been to give Hogarth, writing hastily, the benefit of the doubt for words that verge on shorthand. I was not interested in producing a literal transcription of the manuscripts (Burke did this) but in making them readable and usable as a supplement to the *Analysis* text.[6] I have indicated minimal punctuation for sense (primarily full stops) in brackets but not capitals (which he uses erratically) at the beginning of a sentence.

I am grateful to John Nicoll of the Yale University Press and Brian Allen of the Paul Mellon Centre for asking me to edit the *Analysis* as a

partial celebration of the three-hundredth anniversary of Hogarth's birth, and for their invaluable assistance in my preparation of the text. I have also benefited from the expertise of Elizabeth Cropper, Charles Dempsey, DeAnn DeLuna, Mervyn Jannetta, William Keller, Michael Kitson, Martin Clayton, Susan de Sola Rodstein, Ann Stiller, Joan Sussler, and above all, Guilland Sutherland, who copy-edited the manuscript, compiled the index, and helped in too many ways to enumerate.

NOTES

1. Wylie Sypher, *Rococo to Cubism in Art and Literature* (New York, 1960), p. 52; Ellis Waterhouse, *The Pelican History of Art: Painting in Britain 1530 to 1790* (Baltimore, 1953), p. 127.

2. Burke, pp. xlvii, liv. Wallace Jackson, in an elaborate attempt to place the *Analysis* historically, concluded that it "survives for us, if at all, only as a strangely eccentric document, a peculiar product of eighteenth-century empirical aesthetics," which he still regards as rococo ("Hogarth's *Analysis*: The Fate of a Late Rococo Document," *SEL*, 6 [1966]:550; 543–50).

3. Besides Burke's introduction to his edition of the *Analysis*, see Stanley E. Read, "Some Observations on William Hogarth's *Analysis of Beauty*. A Bibliographical Study," *Huntington Library Quarterly*, 5 (1941–42):360–73.

4. These appear in Works Frequently Cited. My introduction and annotation, besides benefiting from Burke's introduction, my own biography of Hogarth and (for the plates) *Hogarth's Graphic Works*, draw heavily on my *Beautiful, Novel, and Strange*. This, in turn, is indebted to such recent works as Howard Caygill's *Art of Judgment* (Oxford, 1989), Peter de Bolla's *The Discourse of the Sublime: History, Aesthetics & the Subject* (Oxford, 1989), and Terry Eagleton's *The Ideology of the Aesthetic* (Oxford, 1990).

5. For example, in his notes for an introduction to his prints, written a few years after the *Analysis*, he describes *Industry and Idleness* and *The Four Stages of Cruelty* as no more than attacks on idleness and cruelty to animals ("Autobiographical Notes," ed. Burke, *Analysis*, pp. 225–26).

6. Burke also published in the same volume the manuscript known as "Autobiographical Notes," probably written in the 1760s (BL). However, he overlooked a number of extra boxes of manuscripts in the British Library, and these were later edited by Michael Kitson (London: Walpole Society, vol. 41, 1968).

Works Frequently Cited

Beckett	R.B. Beckett, *Hogarth* (catalogue of the paintings) (London, 1949)
Biogr. Anecd.	John Nichols, George Steevens, Isaac Reed, et al., *Biographical Anecdotes of William Hogarth* (London, 1781, 1782, 1785)
BL / BM	British Library / British Museum
BM Sat.	F.G. Stephens, *British Museum Catalogue of . . . Political and Personal Satires* (London, 1873–83)
BNS	Ronald Paulson, *The Beautiful, Novel, and Strange: Aesthetics and Heterodoxy* (Baltimore, 1996)
Burke	Joseph Burke, ed., Hogarth, *Analysis of Beauty* (Oxford, 1955)
Dobai	Johannes Dobai, "William Hogarth and Antoine Parent," *Journal of the Warburg and Courtauld Institutes*, 31 (1968):336–82. (Condensed in Dobai, *Die Kunstliteratur des Klassizismus und der Romantik in England* [Bern, 1975], 2:639–55.)
Dobson	Austin Dobson, *William Hogarth* (London, 1907 ed.)
Gen. Works	John Nichols and George Steevens, *The Genuine Works of William Hogarth*, 3 vols. (London, 1808–17)
Haskell and Penny	Francis Haskell and Nicholas Penny, *Taste and the Antique* (New Haven and London, 1981)
HGW	Ronald Paulson, *Hogarth's Graphic Works: First Complete Edition* (New Haven, 1965; revised eds., 1970; London, 1989 [edition cited])
Hog.	Ronald Paulson, *Hogarth, Vol. 1: The "Modern Moral Subject"* (New Brunswick, 1990); *Hogarth, Vol. 2:*

High Art and Low (New Brunswick, 1991); and *Hogarth, Vol. 3: Art and Politics* (New Brunswick, 1993). (These are revised versions of *Hogarth: His Life, Art, and Times* [New Haven and London, 1971].)

J. Ireland John Ireland, *Hogarth Illustrated*, 3 vols. (London, 1791–98; 1805)

Nichols J.B. Nichols, *Anecdotes of William Hogarth*, (final ed. of the Nichols-Steevens vols., catalogue of Hogarth's prints) (London, 1833)

Oppé A.P. Oppé, *The Drawings of William Hogarth* (London, 1948)

Richardson, *Works* Jonathan Richardson, *The Works* (London, 1773)

Spectator *The Spectator*, ed. Donald F. Bond, 5 vols. (Oxford, 1965)

Vertue George Vertue, *Notebooks*, 6 vols. (Oxford, Walpole Society, 1934–55)

Introduction

O N 24 MARCH 1752 Hogarth announced the *Analysis of Beauty* in his friend Henry Fielding's *Covent-Garden Journal*. He proposed to publish by subscription "A short Tract in Quarto, called THE ANALYSIS OF BEAUTY. Wherein objects are considered in a new Light, both as to Colour and Form. / (Written with a View to fix the fluctuating Ideas of Taste) / To which will be added, / Two Explanatory Prints, serious and comical engraved on large Copper-Plates, fit to frame for Furniture."[1]

The subscription ticket, *Columbus Breaking the Egg* (ill. 1), was the receipt for the first payment. The earliest tickets I have seen are dated in March. Subscriptions were to be taken until the end of November; the price was 10 shillings, 5 shillings in advance and the rest upon delivery of the book and prints. The price went up to 15 shillings after the close of the subscription.

In the *General Advertiser* of 16 November Hogarth announced that the subjects of the two explanatory prints would be "a Country Dance, and a Statuary's Yard: that these will be accompany'd with a great Variety of Figures, tending to illustrate the new System contained therein." He adds of the *Analysis* that "he has endeavoured to render it useful and interesting to the Curious and Polite of both Sexes, by laying down the Principles of personal Beauty and Deportment, as also of Taste in general, in the plainest, most familiar, and entertaining Manner." Both statements suggest the continuum of the *Analysis* with the engraved "modern moral subjects" that led up to it.[2]

The prints were distributed to subscribers or sold separately around 5 March 1753, the date given in the publication line. They could be folded and bound into the book and, as well, were "fit to frame for Furniture." Unsurprisingly, they sold far better than the book they illustrated. When bound into the book, they appear at different places at the whim of the binder, but most often at the back. The subscription ticket, without its receipt, was sometimes bound in as a frontispiece.

The *Analysis* was in print by 25 November when Hogarth sent a copy to Thomas Birch for the Royal Society's library.[3] It was announced as ready for subscribers on 1 December in the *London Evening Post* (17–20 November); and as "This day . . . published" for the general public on 17 December (*Public Advertiser*).

When he first announced the subscription for his *Analysis* Hogarth also reminded his customers that "The Two Prints, one Moses brought to Pharoah's Daughter, the other Paul before Felix, are ready to be delivered to the Subscribers." These were engravings of sublime history paintings in which he challenged comparison with Poussin and Raphael. Writing the *Analysis* was, among other things, an attempt to live up to the Renaissance humanist ideal of a scholarly and lettered artist who paints poetry and generalizes his principles in writing.

The engraving of *Moses Brought to Pharaoh's Daughter* (ill. 8) included a prominent Line of Beauty twisted around a staff, two pyramids, and a sphinx, all of which would reappear in the first *Analysis* plate. The Line of Beauty, in a roundel directly behind Pharaoh's daughter, is a hieroglyph indicating the principle of beauty embodied in the lines of her drapery.[4]

Hogarth informs us in the Preface that he had included a Line of Beauty on the palette in the self-portrait, *Gulielmus Hogarth* (ill. 9), he utilized as the frontispiece for his folios of engravings, and that his enthusiastic talk of the Line had elicited the skepticism of his colleagues, which led him to theorize it. George Vertue noted as early as 1745 that the Line of Beauty was a frequent topic of Hogarth's conversation, and David Garrick jocularly wrote Hogarth in 1746, "I have been lately allarm'd with some Encroachments of my Belly upon the Line of Grace & Beauty, in short I am growing very fat."[5]

If Hogarth's discovery of the Line of Beauty was a topic of discussion in the mid-1740s, his turning from morality to the subject of art had been announced as early as 1737 when he published an essay signed "Britophil" in response to a French criticism of his late mentor (and father-in-law) Sir James Thornhill.[6] This is a satire that links the picture dealers who make their living selling foreign pictures to English buyers and the critics and connoisseurs (whom he calls "quacks") who validate their fraud. He singles out for comment the "Ship Loads of dead *Christs, Holy Families, Madona's*, and other dismal Dark Subjects, neither entertaining nor Ornamental; on which [dealers] scrawl the terrible cramp

Names of some *Italian* Masters, and fix on us poor *Englishmen*, the Character of *Universal Dupes*."[7]

In this mock dialogue Hogarth pits a commonsense Englishman against "Mr. Bubbleman" the dealer, who is trying to sell him a Venus: "'That Grand *Venus* (as you are pleased to call it) has not Beauty enough for the Character of an *English* Cook-Maid.' — Upon which the Quack answers with a confident Air, 'O L–d, Sir, I find you are no *Connoisseur.*'" There is little doubt that Hogarth intentionally juxtaposed this passage in the "Britophil" essay with an announcement in the same journal of his subscription for *The Four Times of the Day*. In the second plate, *Noon* (ill. 10), he presents an English Venus accompanied by an English Cupid and Mars. Twenty years later he centers the Venus de Medici in Plate 1 of *The Analysis of Beauty* (ill. 3) and within the text writes, "Who but a bigot, even to the antiques, will say that he has not seen faces and necks, hands and arms in living women, that even the Grecian Venus doth but coarsely imitate?" (p. 59).

Hogarth's attack on dealers and connoisseurs was embraced by his colleagues, the other artists in the St. Martin's Lane Academy, who in the 1730s felt as threatened as he by the competition of foreign art.[8] By the 1750s, however, the artists had divided into parties for and against the founding of a new state-supported academy on the French model. In October 1753, just before the publication of the *Analysis*, they were meeting and caballing.[9] The issue was the method of instructing artists, whether by copying casts of the canonical sculptures or drawing from the live model, and whether from the rules of the art treatises or the method Hogarth designated "experience," based on the principle of the Line of Beauty. Hogarth was the leading spokesman of the second position, and his focus of attention on the issue of copying in his first plate, which shows Henry Cheere's sculpture yard where he sold lead copies of the canonical sculptures (themselves mostly copies), would have appeared a provocation to the proto-academicians.

"Experience" was the term that enabled Hogarth to broaden his "analysis" from a poetics of art to an aesthetics. Aesthetics, though it dwelt on the beautiful, was an empiricist philosophy based on the senses rather than reason or faith.[10] The first aesthetic treatises were the third earl of Shaftesbury's *Characteristicks* (1711, collecting essays that went back as far as the late 1690s) and Joseph Addison's "Pleasures of the Imagination" essays in *The Spectator* of 1712. These were very different from the art treatises of Alberti, Bellori, and Lomazzo or Félibien, Dufresnoy, and de Piles, which were addressed to the artist. Dufresnoy's

De Arte Graphica (which Hogarth cites in his Preface) was simply the painter's version of Horace's *De Arte Poetica*. The aesthetic treatise was addressed not to the artist but to the spectator, the appreciator of beauty. Shaftesbury wrote for both audiences, adding to his *Characteristicks* his *Notion of the Historical Draught or Tablature of the Judgment of Hercules* (1713), which explains to the painter how to paint history, the most exalted of painterly genres. In the *Analysis* also, after laying the foundation of his argument in aesthetics, Hogarth turns increasingly to questions of primary interest to an artist. It is difficult at times to say whether he is addressing the spectator of the aesthetic object or its maker; both, he makes clear, need to understand the principle he enunciates.[11]

In practical terms aesthetics served as an aspect of the Whig reaction to Stuart absolutism and High Church Anglicanism. It was introduced by Shaftesbury in the empiricist, anticlerical, and Whig context of the 1690s. Grandson of the founder of the Whig party (the opposition or "Country" party, born in the Exclusion Crisis, against the succession of the Roman Catholic Duke of York), tutored by Locke and writing in the wake of the deist John Toland, Shaftesbury began with the empiricist assumption that all knowledge arrives through the senses. While raised a Lockean, he rejected his master's *tabula rasa* and contractualism. What struck him was that virtue is not possible within a contractual system of clerical doctrine and education, based on a system of rewards and punishments; and, further, that the god posited by such a system as the Judeo-Christian religion (the god who ordered Abraham to sacrifice his son Isaac) is an ogre, the invention of a self-perpetuating clergy. An action, he argued, can only be virtuous if it is disinterested.[12]

Shaftesbury was a deist, a believer in a transcendent but not immanent deity, in a divine nature but not miracles or priests who meddle in government. Recovering a form of Renaissance Platonism, he replaced Judeo-Christian theology with classical mythology (Christ with Hercules in his *Judgment of Hercules*), religious worship with aesthetics, and the deity with the beauty of harmony and order.

Hogarth notes in the *Analysis*, at his most Shaftesburian, "All that the ancient sculptors could do, notwithstanding their enthusiastic endeavours to raise the characters of their deities to aspects of sagacity above human, was to give them features of beauty" (p. 99). He states his position more plainly in a rejected passage in the manuscripts where he proposes a kind of painting that will be more "usefull and entertaining in this Nation than by the Eternal proposition of beaten subjects either

from the Scriptures or from the old ridiculous stories of the Heathen gods as neither the Religion of the one or the other require promoting among protestants as they formerly did in greece and more lately at Rome in the more bigoted times of nonsense in one and popery in the other."[13]

Most radically because most graphically, on the title page of the *Analysis* Hogarth places, as his logogram, the triangle of the Holy Trinity but replaces the Tetragrammaton (the four Hebrew letters that form the name of God) with his Line of Beauty, naturalized with the head of a serpent and accompanied by verses that connect it with Milton's Satan tempting Eve (ills. 2, 11a,b). This is a far bolder configuration than the Line of Beauty inscribed on his palette in *Gulielmus Hogarth*. It extends the Line from a tool of the artist to a principle of aesthetic response, the *succedaneum* (one of his favorite words) of religion.

Again, in figure 70 of Plate 2 he shows a Greek cross and two Latin crosses. In the text he discusses them as schemata for "the figure of a man" (p. 66). In order to "produce a figure of tolerable variety," he shows in the illustration one Latin cross made of straight lines, the other of serpentine Lines of Beauty. The Latin cross is of course the Christian crucifix, which he has thereby rendered beautiful. Later in the text he introduces the crosses in the context of "attitude," living human bodies extended and spread (implicitly nailed to a cross) as "in distortions of pain": "It is easy to conceive that the attitude of a person upon the cross, may be fully signified by the two straight lines of the cross" (p. 102); and he remarks that "A man must have a good deal of practice to *mimic* such very *straight* or round motions, which being incompatible with the *human* form, are therefore *ridiculous*" (p. 106, emphasis added). In effect he beautifies, or aestheticizes, the central symbol of Christianity by humanizing it. The contrasting Latin crosses are, like the logogram on the title page, a symbol of the way Hogarth arrives at aesthetics.

We recall the cross Belinda wears in *The Rape of the Lock* (1714), "Which Jews might kiss, and Infidels adore." It has lost its religious significance and now merely draws the attention of the male gaze to Belinda's bosom. To Alexander Pope, the Roman Catholic, aestheticization was a secular degeneration of the religious symbol into jewelry. But contemporaneously, from the point of view of the dissenter Daniel Defoe, the cross was an object of papist idolatry. As he wrote in his *Review* (1704): "For a Protestant to wear a cross about her Neck is a

Ridiculous, Scandalous piece of Vanity"; "to wear that which in all Countries is the Badge and Signal of a *Roman* Catholick, and which for that Reason has been left off by all the Protestant Ladies in the World, is a tacit owning themselves in the Wrong, and is Scandalous to Protestants."[14]

Hogarth shared this view with Defoe; he came from a dissenter family, joined the anticlerical wing of the Whig opposition to Sir Robert Walpole, was a Freemason of the freethinking sort, and invoked the deist Thomas Woolston in *A Harlot's Progress*, shortly after the publication of which he showed his scorn for organized religion by relieving himself against the door of a church in Kent. He could have justified his aestheticization of the cross as a correction of popish and priestly idolatry – a sort of iconoclasm, which recovers the idol as beauty, but beauty in the particular sense of fitness or utility. The altar is reconstituted as a dinner table, the surplice as a chair cushion, and an icon, melted down, as an ordinary plate to eat from. The mystified object is thus transformed into (or returned to) its original, material, common form, its living use.[15]

Hogarth has radicalized Shaftesbury's aesthetics. As early as *A Harlot's Progress*, his first "modern moral subject," he had demystified both classical and Christian icons, replacing Shaftesbury's Hercules as well as Christ with a contemporary, a "living" woman. Specifically he reproduced the history painting topoi "of dead *Christs, Holy Families, Madona's,* and other dismal Dark Subjects" with a parodic Annunciation, Visitation, and Last Supper; but he filled them with the figures of recognizable Londoners – the harlot Kate Hackabout, the bawd Elizabeth Needham, the rapist Colonel Francis Charteris, and the harlot-hunting magistrate Sir John Gonson. All were implicated in the corruption of a society ruled by priests who ignore the harlot in Plate 1 and grope another harlot at her wake in plate 6 (ill. 12).[16]

A few years after the publication of the *Analysis*, in *Enthusiasm Delineated* (c. 1759), Hogarth recapitulated his aestheticization of the Trinity: a triangle with Paraclete and Tetragrammaton sits atop a pleasure thermometer (which rises from "Love-Heat" to "Lust-Hot" to "EXTACY" to "Madness" and "Revelation," ill. 11c) and God the Father holds out a common trivet (ill. 11d). Of the two examples, one represents the reduction of the religious image to an object of physical desire, the other to a utilitarian object. The first reflects the insight of Swift and other satirists on enthusiastic sects by showing that the basis for their mystical experiences is no more than sexual desire. The second is a case

of Protestant iconoclasm, the Trinity reconstituted as a device for holding hot dishes.

Fitness or function, the subject of Hogarth's first chapter, is the crucial additive that makes beauty. He takes off from Xenophon's dialogue in the *Memorabilia*, translated for him by his friend Thomas Morell: Aristippus asks Socrates, "Is then a labourer's hod, or a dung basket a beautiful thing?" – to which Socrates answers: "Undoubtedly, . . . and a shield of Gold may be a vile thing, consider'd as a shield; the former being adapted to their proper use, and this not." Socrates shows that the beauty of a dung basket is embodied in its suitability for holding dung.[17] Hogarth makes clear in his later chapter, "On Proportion," that fitness includes moral utility – the everyday morality, such as that of *A Harlot's Progress*, that replaces the golden but "vile thing" known as priestcraft with a basket suitable for containing dung.

The *Analysis* not only radicalized but subverted Shaftesbury's aesthetics. As Hogarth, the astute mirror of his society, recognized, Shaftesbury's aesthetic disinterestedness had a political underside: the alliance of monarch and church is corrected by a government of disinterested (because property-owning, well-off) civic humanist gentlemen; royal patronage of art is corrected by similarly disinterested connoisseurs (the same persons). The only people who can *afford* to appreciate virtue and beauty are the Whig oligarchs – the "many" with which the Shaftesburys wanted to balance the "one" of the monarch. Shaftesbury depended for disinterested virtue upon an elite who would never accept a harlot for a Hercules: "the perfection and grace and comeliness in action and behaviour" cannot be found in "rustics," "plain artisans and people of lower rank," or even in those "happily formed by Nature herself," but "only among the people of a liberal education."[18]

Hogarth opens and punctuates the *Analysis* with the insistence on judging aesthetic "matters by common observation," by "appealing to the reader's eye, and common observation," and by dismissing "the blind veneration that generally is paid to antiquity" by the human understanding: such principles, he argues, "have appear'd *mysterious*, and have drawn mankind into a sort of *religious esteem*, and even *bigotry*, to the works of antiquity" (pp. 18, 69, 72, 74, emphasis added).

He draws upon the assumptions of a less reputable deist, the notorious John Toland, author of *Christianity not Mysterious* (1696), who claimed that ordinary human understanding is the only criterion of

meaning and belief; that the common man is the authoritative interpreter of Scripture.[19] The terms Toland pitted against "nonsensical Superstitions" and "priestcraft" were "the Vulgar," "the Poor" (instructed by Jesus, not by "the intricate ineffectual Declarations of the Scribes"), "the People," as well as "the disinterested common sort." Toland focused his argument on the duping of the common man by clergymen and "experts," and Hogarth's attacks on the clergy, from the 1720s onward, extended "priestcraft" and "mysteries" to physicians and lawyers, but in particular to Shaftesburian connoisseurs, the "men of taste" who instructed artists how to paint and patrons what to buy. The *Analysis* is based on the assumption that true theory is reasonable, whereas academic theory, like religion, is based on authority and mystery.[20]

The common man, Hogarth assumes, is unwilling to dissociate the senses from sensuality, as Shaftesbury the Platonist is so eager to do. Shaftesbury applied his paradigm for painters (the Choice of Hercules) to aestheticians as well. At the crossroads, Hercules is confronted by Virtue and Pleasure, an erect reasoning woman and a prone and languid courtesan. Both painter and connoisseur should avoid the corrupting charms of such sensual beauties as those of Pleasure. If Hercules chooses her he will sink into inactive luxuriance; but Virtue will direct him upward to a life of honor and courage.

For his revision of Shaftesbury's aesthetics Hogarth's model was yet another deist, Bernard Mandeville. In the 1724 edition of his *Fable of the Bees* Mandeville's strategy was to expose the desire, economic and sexual, under the supposed disinterestedness of Shaftesbury's civic humanist.[21] In his earliest "modern moral subjects" Hogarth revealed beneath the supposed disinterestedness and benevolence of the Shaftesburian man of taste (the connoisseur and collector) a subtext of ownership, control, and desire; and beneath the idealized classical images their use by Whig politicians as icons of status and power. In *Analysis*, Plate 1, when a civic humanist gentleman regards a Roman sculpture such as those for sale in Henry Cheere's yard, he sees a possession that proves his status or an icon that proclaims him a Roman senator or emperor – or even, as in the statue of Antinous, an object of desire. The dancing master is seen as a disinterested Shaftesburian aesthetician admiring male beauty, offering an alternative to the heterosexual pair of Venus and Apollo at the center. But, as the Mandevillian observer would have noted, beneath the aesthetic disinterestedness the foppish civic humanist is more likely propositioning Antinous.

Hogarth substitutes for Shaftesbury's classical figure of male Heroic Virtue the figure of Venus and shows her enticing Apollo by her charms. (A Shaftesburian Hercules has turned his back on her.) Behind her, serpents are encircling Laocoön and his sons, and in the text Hogarth connects Milton's Eve, Shakespeare's Cleopatra, and Pope's Belinda.

Coming at aesthetics from the controversy surrounding the art academy, Hogarth addresses the error of copying and studying "imitations." (Copying art had been thematized in his "modern moral subjects" as "aping" the fashionable behavior of the higher orders.) He repeatedly urges the replacement of copying by direct experience "of the objects themselves in nature" (pp. 18–20). Shaftesbury's words, that "the best artists are said to have been indefatigable in studying the best statues: as esteeming them a better rule than the perfectest human bodies could afford" (notably ungendered bodies), are rewritten by Hogarth when, at the conclusion of his chapter on the human body, he notes (in the passage already quoted) the greater beauty of a living woman over the most perfect antique Venus.[22]

Hogarth centers his aesthetics on the beautiful woman, more beautiful than men because she consists of more Lines of Beauty (pp. 49 and 58–59). Even the chapter "Of Colour" is focused on the female – her eyes and mouth and above all "the whole neck and breast," colored with "tender tints" and so an example of "the great principle of varying by all the means of varying, and on the proper and artful union of that variety" (pp. 90–92).

Like Mandeville, Hogarth represents the exposure of interest in supposedly disinterested objects and of beauty in what Shaftesbury would regard as both gross heterosexual desire and rude mechanical utility. In the chapter "Of Intricacy" his argument moves from a smokejack to men and women dancing and to a woman's flowing hair as the source of sexual attraction. Besides the living woman Hogarth places smokejacks, candlesticks, stays, and chair legs, the most commonplace and useful as well as democratic of possessions. Both the smokejack and the "living woman," both fitness and beauty, are the subject of Hogarth's aesthetics.[23]

The element that connects the smokejack and the beautiful woman is her serpentine lock of hair, "the flowing curl," the "*wanton* ringlets" that are "waving in the wind"; "the many waving and contrasted turns of naturally intermingling locks *ravish* the eye with the *pleasure of the pursuit*" (pp. 34–35, emphasis added).

Hogarth returns to the subject in his chapter "Of Quantity," where the lock is singled out when displayed asymmetrically, "falling thus across the temples, and by that means breaking the regularity of the oval" of the face (p. 39). The lock (with its associations of both Milton's Eve and Pope's Belinda) serves Hogarth as the contingency that distinguishes the real from Shaftesbury's ideal, the living woman from a sculptured simulacrum or the perfect geometrical figure. Later he remarks of the Apollo Belvedere that "what has been hitherto thought so unaccountably *excellent* in its general appearance, hath been owing to what hath seem'd a *blemish* in a part of it" (pp. 71–72).

The Shaftesburian Beautiful, with nothing opposed to it but the Ugly, was the ideal without blemish. Hogarth prefers the oval to the circle (and the broken oval at that), the triangle to the square, odd numbers to even, and irregular patterns to regular (of beauty patches, "no two patches are ever chosen of the same size" [p. 39]).

The consequence of breaking the oval, Hogarth explains, is "an effect too alluring to be strictly decent, as is very well known to the loose and lowest class of women" (p. 39), by which, of course, he means harlots or the Pleasure who tempts Hercules. The aesthetic object as well as its observer is "common" (in both Toland's and the demotic sense). This passage is followed by an account of dress and undress, the basis of "curiosity" and "play" in the tantalizing revelation (curiosity must be "not too soon gratified") of the body, which ends with the metaphor of an angler catching a fish (p. 40).

Addison was the other founding father of aesthetics in England, and for Hogarth a more congenial figure than Shaftesbury. While Shaftesbury divided sense stimuli between the Beautiful and the Ugly, Addison recovered from the Ugly areas he designated the Great (rugged mountains, vast oceans, raging torrents) and the Novel, New, Uncommon, and Strange. The first Addison raised from a rhetorical category (sublimity) to an aesthetic one, which came to dominate the field, pushing even the Beautiful to the side. The second was Addison's original contribution and his privileged aesthetic object, essentially the area of spectatorship itself – the imaginative pleasure derived from contemporary London life.

The "pleasures" Addison associates with the Novel are "surprise," "the pursuit of knowledge," "curiosity," and "variety." "It is this," he writes, "that recommends Variety, where the Mind is every Instant

called off to something new, and the Attention not suffered to dwell too long, and waste it self on any particular object." It "gratifies" the soul's "Curiosity." He remarks that the Novel can absorb aspects of both the Beautiful and the Great because it "improves what is great or beautiful, and makes it afford the Mind a double Entertainment" (*Spectator* No. 412; 3:541).

Hogarth introduces his *Analysis* as Addison introduced the "Pleasures of the Imagination" essays, as "entirely new" (p. 3; No. 409, 3:531).[24] His aesthetic object corresponds to Addison's Beautiful – small, smooth, curved objects, sometimes female and involving courtship. He designates the beautiful woman the ultimate attraction of the male gaze, which keeps "the eye and the mind in constant play" with "imaginary pursuits." He calls his aesthetic category the Beautiful, whereas only its object is beautiful; its actual aesthetics, or response of the senses to an object, is that of Addison's middle term, the Novel, with the name appropriately congruent with that of the emergent literary form.

Hogarth also draws on Addison for his allusions to Milton's *Paradise Lost*. Addison hesitated to aestheticize the deity, but he applied this process to *Paradise Lost*. He diverted attention from its antimonarchical and revolutionary (indeed, regicidal) politics to what he designated its "beauties." He wrote essays on each of the twelve books, describing the "beauties" of that book, eliding both theology and morality. But also, within the context of the *Spectator*'s political agenda, he was cleansing *Paradise Lost* in order to recover it as the "great English poem" – and in this sense, to aestheticize was to repoliticize it, recovering the crucial Protestant-Whig element at the center of Milton's myth, which is the liberty of human choice.

It was the Miltonic association with liberty (vs. tyrannous confinement) that Addison invoked in his "Pleasures of the Imagination" (No. 412, 3:540). Toland, a more radical Whig, celebrated Milton the apostle of liberty, implicitly extending the term to regicide: "As he look'd upon true and absolute Freedom to be the greatest Happiness of this Life, whether to Societies or single Persons, so he thought Constraint of any sort to be the utmost Misery." Toland argued that "to display the different Effects of Liberty and Tyranny, is the chief design of his *Paradise Lost*."[25]

Hogarth picks up both Addison's and Toland's sense of liberty in his aesthetics. This permits him to extend surprise and discovery into a revision of another Shaftesburian aesthetician who preceded him.

Francis Hutcheson's *Inquiry concerning Beauty, Order, Harmony, and Design* (1725) defined beauty as the perception of unity in variety. Hutcheson's examples were geometrical figures, rising in order of preference from the triangle to the duodecagon. Hogarth rejects the idea that mathematical proportion, let alone unity, is a source of beauty ("All mathematical schemes are foreign to this purpose" [p. 65]); and he rejects Hutcheson's pleasure of recognizing the "Uniformity amidst Variety," that is, beauty as unity that subordinates variety. He greatly increases the emphasis on discovery – that is, as an active process as part of the aesthetic experience – and reverses Hutcheson's order of priority: it is the pleasure of discovering not uniformity but variety ("infinite Variety"). He calls this "a composed variety" ("for variety uncomposed, and without design, is confusion and deformity" [p. 28]) but adds that the more variety there is, the more beauty. His version of Addisonian aesthetics is the surprising discovery of the utmost variety within apparent uniformity.

Addison's aesthetics functioned as the recovery of a discredited object as an object of sensuous pleasure. Thus he recovered Whig liabilities – the mad enthusiast "imagination" as a "pleasure" of the imagination, the regicide politics of *Paradise Lost* as "beauty." In the same way he recovered the "malicious lampoons" of his opponents, the Tory satirists (in particular Swift), as a generous Whig comedy.[26] His redefinition of satire as sympathetic laughter served, in the chronology of the *Spectator*, as foundation for the category of the Novel later introduced in the "Pleasures of the Imagination." If aesthetics records the admiration that is a response to beauty, it can also record the laughter that is a response to the ridiculous or ludicrous. Addison's novelty is implicitly grounded in the disinterested laughter he has recovered from satire.

Mark Akenside's *Pleasures of Imagination* appeared in 1744, renaming Addison's three categories the sublime (anticipating Edmund Burke in this respect), the wonderful, and the fair. Akenside replaced the Novel or Uncommon with its outer limit, what Addison called the Strange, essentially romance rather than the local and diurnal which are the daily *Spectator*'s (and Hogarth's) prime concern. Akenside was revising Addison's "Pleasures" for the 1740s, laying the groundwork for the poetics and the odes of Joseph Warton and William Collins that followed a year or so later. Akenside's final Book 3, however, recovered the Novel as the "ridiculous," which he defined as "some incongruous form,

/ Some stubborn dissonance of things combin'd."[27] From the incongru-
ity of the ridiculous he moved without transition to "the relations of
different objects one to another," that is, metaphor, wit, and the associa-
tion of ideas; and proceeded to the redefinition of Addison's secondary
"Pleasures" as the "resemblance of imitations to the original appearances
of nature," which presupposes the pleasure of noting differences as well
as similarities.[28] In all of these Akenside was basing the "Pleasures of
Imagination" on a conflict of similarity and difference which, in its first
form, is the ridiculous. In case Hogarth had not noticed that Addison's
transformation of satire into comedy was an enabling factor for his
theory of the Novel, Akenside demonstrated this by singling out ridi-
cule and then using it as the basis for the climactic category (unnamed)
that in fact covers Addison's Novel (as opposed to the wonderful he had
discussed in Book 1).

Akenside's examples, however, were of vanity and affectation, objects
that are plainly satirized, laughed at, not with. Fielding in the preface
to *Joseph Andrews* (1742) had written that "The only Source of the true
Ridiculous (as it appears to me) is Affectation."[29] Akenside uses the
word ridiculous, gives a definition based on pure incongruity, but offers
examples that correspond to Fielding's affectation.[30] In the *Analysis*
Hogarth does not use the word, and his definition is of formal incongru-
ity, and yet he arrives at it through burlesque and the result is, once
again, affectation.

Hogarth follows his chapter "Of Intricacy" with one "Of Quantity";
his progression is from the mental pursuit, which Addison defined in
terms of the subject's faculty of wit, to the object and a formal explana-
tion of the cause of laughter based on incongruity: "When improper, or
incompatible excesses meet, they always excite laughter; more especially
when the forms of those excesses are inelegant, that is, when they are
composed of unvaried lines" (p. 37). This is the opposite of satire, where
one "incompatible excess" is normative and used to condemn the other.
But he first introduced "quantity" as a version of Addison's Great:
"quantity . . . adds greatness to grace." Opposite this phrase in the
margin of his first draft he introduced his aesthetics of laughter, by
transforming greatness into the ridiculous: quantity exaggerated be-
comes "a burlesque." The example that opens the discussion is the
juxtaposition of a robe or full-bottomed wig with the person who wears
it. Were "an improper person to put it on, it would then too be
ridiculous."[31] He alludes to the magistrate in plate 1, figure 16, related
in the illustration to hanging justice, in the text to bad aesthetic

judgment. The ridiculous lies in Hogarth's connecting the idea of incongruity with "burlesque" and "contrivance" and locating them "at Bartholomew-fair" – in an actor *plus* a wig or a dancing master plus the stage role of a deity.[32]

In this way Hogarth posits a beautiful object discovered by an epistemology of novelty, but unsurprisingly given his credentials the latter is grounded, implicitly and explicitly, in the response of laughter. The risible discovery of variety in unity (of similarity in difference, of difference in similarity) is based on wit. As Corbyn Morris reformulated Addison's essays on wit in his *Essay towards Fixing the True Standards of Wit, Humour, Raillery, Satire, and Ridicule* (1744), wit is "the quick Elucidation of *one Subject, by a* just *and* unexpected Arrangement *of it with another Subject,*" the purpose of which is "to enlighten thereby the original subject."[33] The "original subject" (or object) of wit in Addison's formulation is the Novel; in Morris's it is the humorous character, and the result is, according to Morris, laughter. Hogarth alludes to Morris's theory in his manuscript notes, and his examples are two of Morris's three – Falstaff and Don Quixote (Morris's third was Addison's Sir Roger de Coverley).

Morris validated the "humorous character," the man with one predominant humor, foible, or (also his word) flaw, as lovable. This male "character" corresponds to the beautiful woman, as the amiable foible corresponds to the blemish, and both are based on the reality of a living person. In fact, the foible or blemish proves the reality of the person in nature, as opposed to the Platonic ideal. Morris's "Person in real Life" corresponds to Hogarth's "living woman," and in the *Analysis* his beautiful woman is analogous to the "humorous character" who has a foible, is living, and is pleasantly sociable, or (in Addison's terms) new or uncommon. The English, especially in the Whig myth, were supposed to be the most "humorous" of nations. Addison had recovered (or aestheticized) the flawed character of the Duke of Marlborough, and Morris, thirty years later, recovered Sir Robert Walpole – both objects of opposition satire – as "humorous characters."[34]

A central question concerning the *Analysis* is bound to be its relationship to Hogarth's earlier moral subjects. In Steele's *Spectator* No. 266 Mr. Spectator described a "slim Girl of about Seventeen," obviously a prostitute, who stops him in Covent-Garden Piazza. He would "have indulged [his] Curiosity" and followed her if he did not fear he would be recognized by a tavern keeper; moreover, he reminds his reader that "I am wholly unconcerned in any Scene I am in, but meerly as a

Spectator." So he stands "under one of the Arches [of the Piazza] by Twilight; and there I could observe as exact Features as I had ever seen, the most agreeable Shape, the finest Neck and Bosom, in a Word, the whole Person of a Woman exquisitely beautiful." Further, as if adumbrating precisely the terms Hogarth would formulate in his *Analysis of Beauty*, Steele adds: "She affected to *allure* me with a forced *Wantonness* in her Look and Air" (emphasis added). Mr. Spectator does nothing but "observe," experience a frisson, and go on his way in order to record it in the next *Spectator* essay.

A memory of this *Spectator* essay was the basis for the first scene of Hogarth's *Harlot's Progress*.[35] It is likely that his response was elicited by the example the *Spectator* put before him of a moral issue and moral action replaced by an aesthetic response, by sheer disinterested spectatorship. He corrects the aestheticism of the *Spectator*, but in a particular way: he retains Steele's sympathetic attention on the figure of the "beautiful country Girl," but he makes her error the ridiculous one of affectation – of a "lady" and of a "connoisseur." He also replaces the conventional morality of rewards and punishments, which on the surface defines the consequences of the poor girl's error, with guilt that extends beyond the girl's affectation to include the ladies and gentlemen she "apes," who exploit, punish, infect, and survive her.

In effect, he recalls Mandeville's ironic comparison of society's utilization of the prostitute with the butcher who saves his meat from the flies by "very Judiciously cut [ting] off a fragment already blown, which serves to hand up for a cure; and thus, by sacrificing a Small Part, already Tainted, and not worth Keeping, he wisely secures the Safety to the rest."[36] Thus Hogarth ends by showing his harlot to be a Sacrifice or Atonement for the men of London. In the final plate, in her coffin, in the composition of a Last Supper (ill. 12), surrounded by London whores, bawds, pimps, and a sexually distracted clergyman, she fills the position of the Host in a modern Eucharist.

In the satires that followed the *Harlot's* and *Rake's Progress* Hogarth came to associate value, displaced from organized religion and its "idolatry," with a beautiful and young, contemporary and "living" woman. He adopts the Addisonian muse of comedy, Milton's laughing Mirth (*Spectator* No. 249), and elaborates the figure in actresses and milkmaids (his most celebrated painting, *The Shrimp Girl*, is an example) – and eventually in the "living woman" he prefers in the *Analysis* to the most perfect antique Venus. He has, in effect, replaced morality with aesthetics as the only sort of ideal he can find in a world as utterly

corrupt as the London of the *Harlot's Progress*. Mirth is a muse of comedy who reconciles incongruities for the artist through laughter. In *The Distrest Poet* (1737) the poet's wife mediates between the impractical poet and the real world of unpaid bills and hungry dogs; in *The Enraged Musician* (1741), a milkmaid mediates between the musician, up in his window with his musical score, and the crowd of plebeian noise makers down in the street (scissor-grinders, sow-gelders, chimneysweeps, and ballad-mongers, whose noise, given Hogarth's principle of fitness, *is* music). In this context, we might conclude that the Venus in *Analysis*, plate 1, mediates between Hercules and Apollo; that Hogarth intends them to be "a composed variety" representing the tension (a correction of Shaftesbury's harmony) between unity and variety, discovered by the artist.

Theorists of comedy have tended to distinguish the laughter of ridicule from the laughter of sympathy, and one locus has been Addison's aestheticization of satire into a disinterested laughter related to spectatorship.[37] But when Addison aestheticized laughter it was at least in part a political strategy for discrediting Tory satire. Addison's humane, sympathetic laughter is not as pure as he claims, any more than was Shaftesbury's disinterestedness. As Akenside, Fielding, and Hogarth realized, there *is* no purely comic incongruity; some sort of judgment is being passed on the object by the incongruity (which, in Hogarth's word, is "improper"). Rather, the satiric (or moral) contrast of good and evil has been replaced by what can be called an aesthetic contrast of nature and art. The metamorphosis is not from ridicule to pure comedy but from ridicule based on right and wrong, good and evil, to ridicule based on nature and art ("the hand of nature" vs. "the limited and insufficient one of art" [p. 98]).

In both plates of the *Analysis* a young lady formed by Lines of Beauty is also, incongruously, an adultress. By implication it is Shaftesbury's Platonic aesthetics, with its equation of beauty and virtue, that is being labeled Quixotic by the astonished Sancho Panza, who observes these women from the margin of plate 2 (his "astonishment" at what he sees is close to laughter).[38] The Samaritan woman outside the picture stands just next to, and echoes, the Lines of the young nobleman inside: he is clearly a model of graceful deportment; she represents grace *and* artful deception (indeed, deception of Jesus, her interlocutor), the attempt to hide her adultery. If wit operates here, the discovery is that the two are parallel and grace and virtue are discontinuous. Here "affectation" figures as Shaftesburian "virtue"; or rather, as the conventional aesthetic

appreciation of such a figure as the graceful nobleman. One assumes an equivalence of beauty, virtue, and rank (designated by the order he wears across his chest); then one sees, via Sancho's surprise and the Samaritan woman's adultery, that beauty, virtue, and rank are *not* equivalent but "improper, or incompatible excesses" meeting. This is, however, satire aimed at Shaftesburian aesthetics, not at the figures themselves: Hogarth is passing judgment on conventional aesthetics as it collapses in the comparison with nature, not on the people who embody it, certainly not on the Prince of Wales (who replaces the nobleman in the third state).

Judged aesthetically, the "living" woman has liberated herself from the canonical sculpture of Venus, broken out of the mold of Shaftesburian beauty, and shown herself a "living woman," therefore truly "beautiful." She is not ridiculous because there is no affectation, only human passion, release, and liberty. Hogarth is in the process, in the illustrative plates if not the text, of redefining beauty, virtue, and disinterestedness. Beauty is independent of virtue, virtue is something that is closer to liberty than to the Ten Commandments, and disinterestedness is not moral judgment but understanding – and the artist's function is not to enforce morality but to analyse it as another object with its own formal properties.

Hogarth is attempting to create an aesthetics that acknowledges that if we place a beautiful woman on a pedestal we will inevitably and appropriately desire her and may discover, moreover, that she is not strictly virtuous. This is an anti-aesthetics, or a practical aesthetics, in relation to the theoretically pure aesthetics of Shaftesbury, where the human body can only be beautiful if divorced from function, fitness, and utility. Hogarth says that in the real world (again, the daily world of the *Spectator*'s novelty) the beautiful object cannot be separated from any of these – only that the moral judgment is replaced by a subtler, more "disinterested" (in his reinterpreted sense of Addison's word) "pleasure," the "pleasure of pursuit."

While rejecting much of Shaftesbury's doctrine, Hogarth retained his view of the artist as, if not a surrogate Creator, at least one whose wit discovers and defines the beauty in women and smokejacks.[39] In *Columbus Breaking the Egg* (ill. 1), both subscription ticket and frontispiece to the *Analysis*, he tells the story of his discovery of the Line of Beauty in terms of Columbus's discovery of the "new world"; but he does so in a composition that evokes a Last Supper, which in effect puts himself in the role, not only of the discoverer of the "new world" but the "savior of

mankind." The eggs and eels before him on the table replace the Host of the Last Supper, his messianic mission the Sacrament of the Eucharist. In the last plate of *A Harlot's Progress* (ill. 12) he had burlesqued the composition of a Last Supper to satirize a brutal society that uses harlots to atone for its sins. In *Columbus Breaking the Egg* he again burlesques a Last Supper but now in order to celebrate Columbus's (his own) discovery of a new world. In this case he uses the Last Supper to indicate that religion is demystified not to condemn priestcraft but to be recovered as natural beauty (as the Trinity will be recovered as a trivet).

This is parody; its irony qualifies the artist's claims. But, as in the aesthetic transformation on the title page, it is also an embodiment of the wit that juxtaposes incompatible excesses such as novelty and religion, nature and art. Throughout the *Analysis*, text and plates, Hogarth presents witty references such as "Obit. 1752" on the funeral monument of the judge in plate 1, which suggests that his *Analysis* has laid to rest false judgment.

One paradox of the *Analysis*, however (as Allan Ramsay pointed out),[40] is that Hogarth invokes both contingency and an absolute; he both humanizes and abstracts. Although he prefers the living woman to a sculpture of Venus, in the Preface he invokes an ancient symbol of Venus enclosed in a pyramid. A grape stalk folded about with a serpentine vine and topped with an ear of corn was one of Venus's attributes;[41] Hogarth shows a serpent twining about the stump which supports her in plate 1. In figure 26 of plate 1 he reduces her (and traces her form back) to a cone encircled with a serpentine line. Juxtaposed with the vertical Venus de Medici below, the cone is turned on its side into a recumbent Venus (a *grande horizontale*). He was still seeking ancient authority for this "Venus" in the diagrams and text that supplemented his last print, *Tailpiece; or The Bathos* (1764, ill. 14).

The citation of a primitive Venus in the preface may suggest that Hogarth felt he needed a safer classical reading for his logogram on the title page. However, it also suggests an attempt to merge populism and esotericism, clarity to the common man and yet a mystery known only to an elite. Hogarth gives his serpentine line, which he claims is the result of observation, a genealogy from Egypt to Greece and from Pythagoras to Socrates to Aristotle – and again from Egypt to Greece by means of Pythagoras, connecting the serpentine line, the triangle, Isis, and serpents (pp. 7–11).

In reacting against the aristocratic fraternity of civic humanists, Toland had adapted as a counter the model of Freemasonry, which claimed to be democratic, capable of including members of the artisan classes as well as the aristocracy. Freemasonry, of which Hogarth was an observing member at least into the mid-1730s, as a social substitute for religion, may have been the ultimate source of his serpentine Line of Beauty. The Freemasons, who had already secularized the Trinity as a triangle/pyramid with an eye of reason, traced their "mystery" (the plan for building the Temple) back to Isis.[42] Montfaucon showed Isis, like Venus, folded about with a serpent. The staff and serpent, the sign of Isis–Venus, is essentially the hieroglyph Hogarth represented, along with the pyramid, sphinx, and other symbols of Egypt, in *Moses Brought to Pharaoh's Daughter* (ill. 8). The icon Hogarth invoked in *Boys Peeping at Nature* (ill. 13), the programmatic ticket that announced his first "modern moral subject," *A Harlot's Progress*, was Diana of the Ephesians, the Egyptian Isis except for the headgear; Diana wore a tower, Isis a lotus (plate 1, figs. 75, 85, and p. 12).[43]

William Warburton, who wrote Hogarth a flattering letter subscribing for two copies of the *Analysis* (28 March 1753), presumably did so because he had heard that Hogarth admired his *Divine Legation of Moses* (1738–41). In this work he had invoked Pythagoras, emphasized the origins of Pythagorean doctrine in Egypt, and traced all the mysteries back to Isis and Osiris. "The whole mystical system of Pythagoras," he wrote, "was expressed by signs and symbols, which the initiated understood while the rest of the world, though in the midst of light, remained forever enveloped in the impenetrable darkness."[44] He noted the secrecy of hieroglyphs, their stimulation to "curiosity," and their employment of two meanings, "the greater and the less" – the lesser being regarded as "preparation for the *greater*."[45]

In his discussion of Egyptian hieroglyphs he cited the Diana Multimammia that Hogarth had employed in *Boys Peeping at Nature*, distinguishing the Diana as a natural symbol for Universal Nature from "a winged globe with a Serpent issuing from it" – an artful, enigmatic, mystical symbol metaphorically considered.[46] Hogarth would have noticed both the natural designation of the many-breasted woman *and* the enigmatic designation of the serpent (with a capital S), and connected them with his Venus on the one hand and his serpentine line on the other. But the most significant of Warburton's arguments was that hieroglyphs began as natural signs – pictures simplified to a characteristic (a serpent to a curve), an ideogram, a letter (S) – but were

subsequently appropriated by the clergy and mystified for their own benefit.[47] Warburton's excursus on the history of writing may have given Hogarth the idea for his spectrum at one end of which is the natural representation, the picture, which is simplified until at the other end it becomes the "perfect," "mysterious" line.

Such a process of abstraction, mentioned in a passage omitted from the final text, was Hogarth's system of mnemonics (see MSS., below, p. 121).[48] In his youth he sought "a shorter way of attaining what I intended to aim at than that usually taught among artists." His solution was to go out "strolling" around London and "catching" what he saw, combining his studies and pleasures; and "by this Idle way of proceeding I grew so profane as to admire *Nature* beyond *Pictures* and I confess sometimes objected to the devinity of even Raphael Urbin Correggio and Michael Angelo for which I have been severly treated."[49]

He locates the origin of his theory in experience, which connects with his anti-Shaftesburian argument. He repeatedly links his "studies" and his "pleasures" (recalling not only Shaftesbury's Pleasure but Addison's "pleasures" of pursuit and of the imagination). His remark that the method involved "retaining in my mind lineally such objects as fitted any purpose best" supports the story of his making thumbnail sketches which he later fleshed out in his studio.[50] Most significantly, when he says the method is "to draw by memory" and retain "in my minds Eye without drawing upon the spot," he is indicating some sort of a linear code. He evidently strolled the streets, reducing scenes to mental diagrams such as that in *Analysis*, plate 2, figure 71, and out of this experience he presumably abstracted the Line of Beauty, as well as a Line of Astonishment (Sancho Panza's response to Don Quixote's attack on the puppet show, figure 75) and others.

At this point he seems to draw upon the games the Carracci brothers played, in which a face or body was reduced to a minimal number of lines – a guardsman carrying a pike followed by his dog rounding a corner was reduced to three lines (a vertical one for the corner, a diagonal for the pike, and a curve for the dog's tail). Bernini developed this aspect of caricature: in only "three or four strokes" of the pen he produced a synecdoche, a part for the whole that embodied the formal essence of a person.

Hogarth is also invoking the tradition of demotic art in graffiti or commercial signboards (as he does in plate 2, figure 105).[51] He utilized graffiti in the stick figures of a hanged man in *Harlot* 4 and *Cruelty* 1,

apotropaic representations of Justice Gonson and Tom Nero. The Line of Beauty on the palette in *Gulielmus Hogarth*, especially in conjunction with the mascot pug, served the same purpose in a positive way, invoking the artist and his magical symbols.[52] Sympathetic magic represents a primitive level of expression based on pure desire, which in the aesthetics of the *Analysis* Hogarth refines but still invokes. While he presupposes a larger audience than can read Italian Renaissance tracts and painting, he also points the way for artists to revive the art of painting. Both spectators and artists are referred back to origins (as in the epigraph of *Boys Peeping at Nature*, referring to the goddess's skirt, *Antiquam exquirite matrem*: Seek out your ancient mother).

Where he tantalizingly alludes to the mnemonic system Hogarth associates it with his puzzling method of understanding form by seeing it from within. He asserts that the "scooping out" of figures will give the artist "perfect ideas" of "even the most irregular figures [that] will gradually arrive at the knack of recalling them into his mind when the objects themselves are not before him" (p. 22). One source was Addison's remarks on architecture in *Spectator* No. 415, where he explains the effect of seeing a dome from inside: "we generally see more of the Body. . . . Look upon the Outside of a Dome, your Eye half surrounds it; look up into the Inside, and at one Glance you have all the Prospect of it; the entire Concavity falls into your Eye at once, the Sight being as the Center that collects and gathers into it the Lines of the whole Circumference."[53] Feeling oneself into an inner space also connects with the "theater of memory" in which one imagines the interior of a theater, filling its empty stage with a variety of figures and objects, which can be reconstructed later in the studio.[54]

But "scooping out" also suggests the source of anatomical study in dissection (muscles, we read, gain beauty in the imagination "by the idea of their being flayed" [p. 53]), which recalls the radical image that connects Hogarth's moralities and his aesthetics just two years before the publication of the *Analysis* – *The Reward of Cruelty* (ill. 16; cf. in particular, p. 64). This is an image that goes back to the faun's lifting Nature's skirt in *Boys Peeping*, wishing both to get under and inside (*Antiquam exquirite matrem*), and, a grim parody, the clergyman searching under the whore's skirt in *Harlot's Progress* 6 (ill. 12).[55] Even Venus in *Analysis*, plate 1, by covering her breasts and pubis with her hands invites the "pleasure of pursuit" whose end is to see under them. This is the aesthetics of seeing under or into, stripping

away and returning to essentials, that first informed Hogarth's graphic works.

Hogarth's position is nicely summed up – and in precisely the terms he would use in the *Analysis* – in David Hume's *Philosophical Essays concerning Human Understanding* of 1748.[56] The painter needs the anatomist, because he must, "besides a delicate taste and a quick apprehension possess an accurate knowledge of the internal fabric":

> How painful soever this inward search or enquiry may appear, it becomes, in some measure, requisite to those, who would describe with success the obvious and outward appearances of life and manners. The anatomist presents to the eye the most hideous and disagreeable objects; but his science is useful to the painter in delineating even a Venus or an Helen. While the latter employs all the richest colours of his art, and gives his figures the most graceful and engaging airs; he must still carry his attention to the inward structure of the human body, the position of the muscles, the fabric of the bones, and the use and figure of every part or organ.[57]

In Hume's version the naturalist epistemology of the inside is the realm of the philosopher; the outside is the realm of the moralist. By philosophy he means essentially the area laid out by Hogarth in the *Analysis*: understanding rather than religious moralism of an either/or sort.

Insofar as there is in fact a "mystery" in the *Analysis* it lies not simply in Hogarth's rediscovery of the Line of Beauty but in the model into which he fits this Line: the "proportions" of a body and its parts. While in the text he designates a "precise" Line of Beauty among deviant ones, in figure 49 of plate 1 we see not a static line (or an ideal "middle" line between the stiffness of the French painters and the "too bold and swelling" S-lines of Rubens) but a dynamic variety of lines.

A great deal of space in the Preface is given over to a quotation from Christopher le Blon, describing an unpublished work by a Dutch connoisseur named ten Kate. Peter de Bolla, in his essay "Criticism's Place," is certainly right that Hogarth's intention is to repudiate the le Blon–ten Kate principle of analogy (an aestheticization of the old Divine Analogy) in favor of his own principle, which is synecdoche. Hogarth, in fact, takes off from ten Kate's phrase, "an infinite variety of parts," that is, the relation of parts to whole rather than a simple endlessly extended analogy (from an originary Line of Beauty).[58] Everywhere in

the *Analysis* he deprecates the principle of analogy, extending it to the folly of analogies between seeing and listening to music or tasting food.[59] And everywhere he relates the two words, *part* and *whole* based on variety, intricacy, contrast, and climactically on the anatomical model of the body. The lock of hair representing the whole body is only the most obvious example. And the woman is said to be more beautiful than men because her body contains more Lines of Beauty.

The Line of Beauty itself functions as a part relative to a whole – rather than analogous to the whole composition in the most extreme baroque manner (as in a composition by Rubens, which can be reduced to this single dominant form, all the parts analogues). To overemphasize Hogarth's "precise" Line is to forget his emphasis on the beautiful whole of which the precise line can be a "part," or indeed the "variety" of the "whole" series of "deviations" from the "precise line." The parts that deviate – whether in lines, stays, candlesticks, or goats' horns – are necessary constituents of the pleasing whole.

Hogarth is writing within Roger de Piles's discourse of *l'unité d'objet*. De Piles's definition of the *Tout-ensemble* could be Hogarth's: "a general subordination of objects one to another, as makes them all concur to constitute but one" (*Une subordination générale des objects les uns aux autres, qui les fait concourir tous ensemble à n'en faire qu'un*).[60] Hogarth's example of a beautiful whole is the nosegay: "Observe the well-composed nosegay how it loses all its distinctness when it dies; each leaf and flower then shrivels and loses its distinct shape; and the firm colours fade into a kind of sameness: so that the whole gradually becomes a confused heap (pp. 44–45)." This is essentially a revision of de Piles's *grappe de raisin* (bunch of grapes).[61]

And yet Hogarth's other lines do not merely set off and define the precise line on the model of de Piles's central object (*celui qui se trouve au centre de la vision*). Hogarth clearly distinguishes his principle of composition from that of de Piles. In plate 1, figure 14, illustrating "Of Intricacy," he uses the same diagram of the eye vis-à-vis the object that de Piles employed in *Cours de Peinture* to show how the eye (A) will focus on the central point (B) and peripherally take in the points on either side.[62] This is to see the bunch of grapes as a central grape with grapes on each side receding toward the periphery. But while de Piles labels only the central object of the eye's gaze (B), Hogarth labels them all, the central and peripheral, equally A. In the text his example is both the turning smokejack and the page of a book. The moving eye does focus on a center-point, but it keeps moving "to and fro with great

celerity," paying "due attention to these letters [on the page] in succes-
sion," in *each* case forming a new gestalt (p. 33). Hogarth's notion of
form corresponds more closely to de Piles's alternative (in figure 4,
opposite p. 382, *Cours de Peinture*), grapes "dispersé, et par conséquent
sans effet," than to the bunch of grapes, figure 3. All a reader has to do
is turn to the *Analysis* plates themselves, with (as the advertisements had
noted) "a great Variety of Figures," and note the absence of a central
object, the shifting gestalts, the irregularity of the numbering, and all
the figures (beautiful and ugly) that nevertheless comprise the maxi-
mum number of parts within a "beautiful" whole.[63]

Hogarth makes a further distinction in his chapter "Of Proportion":
The part–whole relation is, first, ornamental and, second, a case of
"fitness" (pp. 60–61). He does not let his reader forget that, however
much he is concerned with vision and form, he remains within the
discourse of le Brun and Félibien and the humanist theory of painting.
The importance of the central object for de Piles lies in the necessity of
striking the eye at first sight (*d'abord frapper les yeux*) – which Reynolds
made much of in his *Discourses*. Hogarth would have disagreed with de
Piles's definition of grace: "'Tis what pleases, and gains the heart,
without concerning itself with the understanding."[64] If we look back at
Gulielmus Hogarth (ill. 9), which first displayed the Line of Beauty on
Hogarth's palette, we see that the Line is not alone but accompanied by
Hogarth, his pug, and a pile of books by Shakespeare, Milton, and Swift
– or beauty by "fitness," which here clearly signifies morality.

The emblem that defines the form *and* content of the *Analysis* is not
the nosegay (or, another example, the pineapple) but, at the bottom
right of plate 2 (figure 59), the cornucopia – the last of a series of
metamorphoses deriving from a cone, and in fact recapturing the cone
encircled with the Line of Beauty of plate 1 (figure 26).[65] This is the
horn of plenty, which Hogarth first associates with Venus (as symbol as
well as attribute) and later displays as a prime example of beauty.[66] The
goat's horn was given by Zeus to Amalthea (in some stories a goat, in
others a nymph), who had suckled him; it had the power of producing
ad infinitum whatever its possessor wished – unlimited parts individu-
ally significant in relation to a whole which both contains and does not
contain them.

Hogarth proceeds from the mystery of the cornucopia to the human
form: the perfect figure of Antinous (p. 69) embodies (is in effect
consubstantive with) the heavy Atlas and the lithe Mercury. The two

"may be imagined to grow more and more alike, till at a certain point of time, they meet in just similitude" (a phrase that invokes the "divine Similitude" of the Son and Father in the third book of *Paradise Lost* where the Trinity is introduced); as, Hogarth adds, the green of a rainbow embodies its yellow and blue. Then he replaces the rainbow with the painter's palette, completing the process of aestheticization.

Finally, Beauty extended into a third dimension, the "joint-sensation of bulk and motion" (p. 73), is elevated to Grace. Bodies in motion are exemplified by a *commedia dell'arte* performance (with Scaramouch, Pierrot and Punchinello) and a dance, both a minuet and a country dance. The most beautiful dance is the minuet – "the perfection of all dancing," because it contains the most serpentine lines. The country dance is comic because of its mixture of serpentine and other lines, but this still pleases as a "composed variety of lines." These dances are defined against both the "pompous, unmeaning grand ballets" (memories of Counter-Reformation history paintings) and "the dances of barbarians . . . wild skiping, jumping, and turning round, or running backward and forward, with convulsive shrugs, and distorted gestures" (p. 111).

The principle that unites the numerous parts with the whole as a single synecdoche is fitness; and the principle of fitness includes the moral utility of the "modern moral subject" as well as the functionality of the dung basket. Thus, the cornucopia is the emblem of Hogarth's own "modern moral subject" – at its most elaborate in *The March to Finchley* (1751, ill. 17) of three years before the *Analysis*, or the *Election* paintings that immediately followed.[67] The crowd in *Finchley* has a dozen foci and, like *Analysis*, plate 2, at the lower right it is emblematized – by a hen and her lost chicks, the variety within unity of an army "on the march" or an overcrowded Foundling Hospital.

As these prints suggest, Hogarth's aesthetics is based on the human body and a political model – the body politic, as represented in the frontispiece of Hobbes's *Leviathan*.[68] The Tory–Jacobite model subordinated the many to the one (the monarch); the Whig model replaced the one with the oligarchic few; but Hogarth, while invoking the familiar topos of *concordia discors*, defines it as the pleasure of discovering the greatest variety in uniformity, or the greatest number of different parts within a whole. He might have called his formula – finally materialized in the performance of a comedy and a dance – an aesthetics of the crowd: the greatest number of parts in movement within (which serve as

synecdoche for) the whole; the more parts, the more beautiful. In the context of *The March to Finchley* and its referent, the quelling of the Jacobite rebellion of 1745, the heterogeneous array of people together epitomizes the whole of England. Politically Hogarth's aesthetics is based on the model of the body politic in which the emphasis falls on the many rather than the one, on the mixture of parts (people, Lords, and Commons) rather than the imposed unity of an absolute monarch. The act of discovering the utmost variety within a supposed unity becomes a political act. The many "people," not subordinated to a head but rather a synecdoche for the body, comprise the body politic.

The woman remains primary: the actress who plays Venus is preferred to the actor who plays Apollo; the man's role in the minuet is only beautiful "as the main drift of it represents repeated addresses to the lady." The "true spirit of dancing" is the expression of "elegant wantonness." The erotic version of the Body Politic is the blazon, the genre of Renaissance poetry based on the shield that stands for the female body, containing the enumerated body parts (in Hogarth's case, lock of hair, neck, breast) that focus desire. In England, however, blazonry had joined the body politic in the "corporeal presence" of Queen Elizabeth, which in her time had been "linked to the vitality of the nation through metaphors of nutrition, partition, and commercial exchange."[69]

In the eighteenth century Elizabeth was a symbol of the Country Party, the opposition to Sir Robert Walpole which had in many ways shaped Hogarth's relationship to aesthetic theory as one of opposition satire with an anti-authoritarian and anticlerical bias. In the discourse of opposition, Elizabeth was one of the ideals of the past to which the English were urged to return.[70] In plate 2 of the *Analysis* there are portraits on the wall of both Henry VIII and Elizabeth: Henry presides over the elegant couple, the nobleman and his lady, and Elizabeth over the variety of rustic shapes – a composition of comical incongruities but also a representation of the "people" as opposed to the oligarchy (placed on the periphery of the crowd). Hogarth apparently associated Henry with tyranny (as in *The Times, Plate 1* of 1763) and Elizabeth with the "people."[71]

It is the comedy that receives the final nod. The last word is given to the "comedian," whose task it is "to imitate" these "particular characters in nature, . . . for whatever he copies from the life, by these principles [Hogarth's aesthetics] may be strengthened, altered, and adjusted as his judgment shall direct, and" – he adds the last words of the treatise – "the part the author has given him shall require." The "author" is

presumably the author of the treatise, whether Christopher Columbus, William Hogarth, or Shaftesbury's surrogate Creator.

The most vivid response to Hogarth's *Analysis* was a set of caricatures by Paul Sandby which attacked the *Analysis* and its author.[72] *Puggs Graces* (ill. 22) shows Hogarth (with the legs of his mascot pug) at an easel painting *Moses Brought to Pharaoh's Daughter*; his models are nude women, monstrously deformed to conform to his Line. His collaborators Hoadly and Morell flank him, "unable to find out His Meaning of ye Book." (His shop sign, which was in fact the Golden Head, a head of van Dyck, is designated "the Sign of the Harlot's Head.") References to his opposition to the academy abound, and the numbers designating the figures are wildly irregular, parodying those of the *Analysis* plates.

In the context of the academy controversy, Sandby draws attention to Hogarth's *hubris* in attempting to write a treatise, his lack of originality (plagiarism of Lomazzo), his doubtful authorship of the treatise, and his self-serving attempt to undermine the efforts of his colleagues of the St. Martin's Lane Academy in their plan for a state academy of art. Hogarth's references to himself as a Columbus and a Messiah reappear in Sandby's caricatures as delusions of grandeur. One caricature, *The Author Run Mad* (ill. 23), shows him scrawling his theories on the walls of a madhouse; he stands in "a circle that ye Devil may not fetch him" to which he is attached by a chain in the shape of the Line of Beauty – presumably a reference to the blasphemous triangle of his title page.[73] Another shows him as Herostratus, assisted by his collaborator, the portly Hoadly, setting fire to the Temple of Diana at Ephesus simply to ensure his own fame (ill. 24). The temple stands for the projected state academy, but, ironically, it is also the temple that contained the very goddess with whom Hogarth had identified himself in *Boys Peeping at Nature*. The attacks came not only from the pro-academy faction among the artists but, predictably, from the connoisseurs.[74]

The Line was the focus of ridicule, parodied as a Line of Deformity embodied in hunchbacked humans and malformed snuffboxes. A poem called *The Anti-Line of Beauty* was published on 15 February 1754 with such lines as:

If we th'Idea of the Crooked Line
Adopt for Beauty's, and for Grace's Sign;
Then Bandy Legs must, henceforth, Strait outshine.

If Curves contrasted still more beauty shew,
Humps then are Charms; deform'd the Belle and Beau;
. . . The ugliest Camel then more Charms may claim,
Than e'er adorned th' Arabian Courser's Frame.[75]

In the review journals the *Analysis* was respectfully received by the literary (as opposed to the art) establishment; though, as was the custom, the reviews consisted largely of summary, quotation, and the broadest generalities. The *Gentleman's Magazine* showed its awareness of the caricatures, concluding that "A Book, by which the author has discovered such superiority, could scarce fail of creating many enemies."[76] William Rose wrote in the *Monthly Review* that

> Mr. *Hogarth* has treated his subject with great accuracy, and in a manner entirely new; has thrown out several curious hints, which may be of no small service to painters and statuaries, &c. has fairly overthrown some long-received and deeply-rooted opinions; and that his essay may be read with considerable advantages by all who are desirous of acquiring a perfect knowledge of the elegant and beautiful, in artificial as well as natural forms.[77]

The comments in private correspondence were generally favorable: "It surprized me agreeably," wrote Lady Luxborough to William Shenstone;

> for I had conceived the performance to be a set of prints only, whereas I found a book which I did not imagine Hogarth capable of writing; for in his pencil I always confided, but never imagined his pen would have afforded me so much pleasure. As to his not fixing *the precise degree of obliquity*, which constitutes beauty, I forgive him, because I think the task too hard to be performed literally; but yet he conveys an idea between his pencil and his pen, which makes one conceive his meaning pretty well.[78]

Catherine Talbot wrote in her journal that she and her friends had "studied Hogarth's Analysis of beauty with his two Prints, & were much entertained with the little we read tho' some of it is toutefois peu unintelligible."[79]

On the other hand, Charles Rogers, the collector and associate of the picture dealer Arthur Pond, wrote to Horatio Paul: "The Town is not I think divided in its Opinion concerning his [Hogarth's] Performance, for the Unlearned confess they are not instructed, and the Learned

declare they are not improved by it." He cites as his authority James Wills, a failed painter and author of a literal (i.e., "correct") translation of Dufresnoy's *De Arte Graphica*: "Mr Wills is sorry anyone of the profession should derogate so much from it as to print such stuff as Mr Hogarth has done."[80]

A German translation of the *Analysis* by Christlob Mylius, finished and its preface dated 11 December 1753, was published early in 1754, and shortly after Gotthold Ephraim Lessing was citing and praising the work.[81] Lessing (who was to publish his *Laokoön* in 1766) singled out the usefulness of Hogarth's theory to the philosopher, naturalist, antiquary, and orator as well as the artist. On 24 June 1754, again referring to the unity of the arts, Lessing announced a new, revised, and cheaper edition of the German translation, which he brought out himself (published by Christian Friedrich Voss), in order to make Hogarth's theory available to a wider public. The proposals published on 1 July assert that the *Analysis* will narrow the thousand different ideas of the word "beautiful" to one, "so that . . . where nothing reigned but occasional caprice, something of certainty will take its place by the assistance of this theory." The new edition ("Verbesserter und vermehrter Abdruck"), with Lessing's preface, was published in August. Significantly for Hogarth's reception in Germany, this edition of the *Analysis* was accompanied by a translation of Rouquet's *Lettres de Monsieur * * * (his commentary on the "modern moral subjects"), suggesting the close connection for Lessing between the art treatise and the engravings.[82] As Lessing must have noticed, if nothing else the *Analysis of Beauty* constituted a remarkable *Gesamtkunstwerk*.

Anonymous Italian translations appeared in 1754 and in 1761; but a French edition (translated by the Dutch scholar Hendrik Jansen) appeared only in 1805. Another English edition was not called for until 1772: "A New Edition, printed by W. Strahan, for Mrs. Hogarth, and Sold by her at her House in Leicester Fields."

Hogarth recorded his own sense of the reaction to the *Analysis* a few years after its publication:

> it is a trite observation that as life is checquer'd every success or advantage in this world is attended with a reverse of one kind or other. So this work however well receiv'd both at home and abroad by the generality yet I sufferd more uneasiness from the abuse it occations me than satisfaction from its success altho it was nothing less than I expected as may be seen by my preface to that work.

The experts on optics and other sciences "honoured" the book "with their approbation," but "those who adhere to the old notions and either cannot or are determined not to understand a word tell you it is a heap of nonsense or that there is nothing new in the whole book" – and these writers, he adds, are "of my own profession."[83]

All these works emphasize, to the exclusion of much else, Hogarth's fixation on the Line of Beauty. The painter Allan Ramsay's response, in his *Essay on Taste* (March 1755), argued that Hogarth's Line, as well as "beauty" in general, depends not on any intrinsic qualities but to a large extent on convention. A toad contains no Line of Beauty in its figure, says Ramsay, yet "it hardly admits of a doubt, that a blooming she-toad is the most beautiful sight in the creation of all the crawling young gentlemen of her acquaintance."[84] The examples critics used against Hogarth – toads and spiders – were the ones he had cited himself as ugly because lacking the Line (p. 49).

Hogarth had introduced "the Power of habit and custom" in his Preface to beat the connoisseurs and their dupes. The "most remark-able instance" of the power of custom, he notes in an example he did not use in the published text, is "that the Nigro who finds great beauty in the black females of his own country, may find as much deformity in the european Beauty as we see in theirs" (p. 115). He seemed unaware that the argument could be turned against his own Line of Beauty, which might be as locally and perhaps as ethnically conditioned.

Ramsay goes to the heart of the matter when he notes the incongruity of the practical Hogarth formulating a principle of beauty, and draws attention to the basic idealism of Hogarth's position beneath his vaunted empiricism.[85] At the same time, while disagreeing in a friendly way with the *Analysis*, Ramsay praises Hogarth's histories and shows that he understands the egalitarian instincts that connect his "modern moral subjects" and his theory. He has "reason to be convinced, by a thousand experiments, that the leading principle in criticism in poetry and painting . . . is known to the lowest and most illiterate of the people." What makes a country girl enjoy art, whether by Quentin de la Tour or George Lambert, is the painting's naturalness: "The same country girl who applauds the exact representation of a man and a house which she has seen will, for the same reason, be charmed with Hogarth's *March to Finchley*, as that is a representation, though not of persons, yet of general manners and characters with which we may suppose her to be acquainted."[86]

Edmund Burke's *Philosophical Enquiry into the Origin of our Ideas of the Sublime and Beautiful* was published only four years after the *Analysis*. In the second edition (1759) Burke warmly acknowledges the congruence of some of Hogarth's ideas and his own. On the one hand, "It gives me no small pleasure to find that I can strengthen my theory in this point [of gradual variation], by the opinion of the very ingenious Mr. Hogarth." On the other, Burke also comments on the rigidity of Hogarth's theory: "there is no particular line which is always found in the most completely beautiful; and which is therefore beautiful in preference to all other lines."[87]

Insofar as Burke is concerned with the Beautiful, he dissociates himself from Hogarth's epistemology of pursuit (Addison's Novel) and lowers his gaze from the lock of hair, which breaks the perfect oval of the face, to the neck and breast, the locus where *he* finds "the deceitful maze, through which the unsteady eye slides giddily, without knowing where to fix" that Hogarth had located higher up.[88]

Given Burke's emphasis on his new term, the Sublime, and the great success of his treatise, Hogarth came to feel that the significant Burkean contribution to aesthetic discourse was to shift attention from the Beautiful to the Sublime, from social love to power and pain, and to the mad crowd of *The Cockpit* and *Enthusiasm Delineated* (1759) rather than the healthy "crowd ritual" of *The March to Finchley*. He identified sublime chaos with Bedlam in his revision of *Rake*, plate 8, and with the "end" of all things in *Finis: or The Tailpiece* (ill. 14), which shows his Line of Beauty distorted, broken, and destroyed by the aesthetics/politics of Burke's Sublime.[89]

Alexander Gerard's *Essay on Taste* was published in 1759. In the chapter called "Taste of Novelty" he sounds very like Hogarth in his discussion of the "exertions of the mind" and (a term Gerard uses repeatedly) "moderate difficulty." The last becomes, toward the end of the chapter, the extra pleasure of "very considerable difficulty," which seems to correspond to the sort of mental exercise Hogarth asked of his readers. At the same time, however, Gerard returns Hogarth's sense of the Beautiful to its more carefully demarcated place in Addison's Novelty.

Though writing before he could have read Burke (the essay won a prize offered by the Philosophical Society of Edinburgh in 1756), Gerard regards the Sublime with much the same suspicion as Hogarth will do in the later 1750s: it is "without limit or termination," that is, total variety without closure or subordination; moreover, it *possesses* the

mind rather than allowing it the freedom of the exploration of novelty – or in a gentler way of beauty: "the mind *expands* itself to the extent of that [limitless] object, and is *filled* with one grand sensation, which totally *possessing* it, composes it into a solemn sedateness, and strikes it with deep silent wonder and admiration." About this time Hogarth materialized "possession" in the congregation of *Enthusiasm Delineated*, and he would have agreed that another result is that (as Gerard concludes) the mind "entertains a lofty conception of its own capacity." The notions of expansion (tumescence and imperialism) and possession support the sexual associations Hogarth applied to the Sublime.[90]

Gerard counts Hogarth among the "moral" artists, against not only those concerned with sublime transport but also against those who ridicule. Though a few steps lower down, Hogarth is nevertheless on the same ladder with Raphael, rather than with Samuel Butler and Swift. Gerard's moral position is still, however, that of Shaftesbury and Hutcheson: "What is virtuous and obligatory," Gerard writes, "is often also beautiful or sublime. What is vicious may be at the same time mean, deformed, or ridiculous."[91] Gerard, like Shaftesbury, replaces moral imperatives with "Taste," and therefore sensibility. This is the aesthetic position Hogarth undermines in the *Analysis* from the direction of ethical discourse itself, showing the error of using taste as a substitute for morals.[92]

Joshua Reynolds, who may have been behind the campaign of 1753– 54 to discredit the *Analysis*, published his own attack on Hogarth's Line of Beauty in three of Samuel Johnson's *Idlers* of September–November 1759. In *Idler* no. 76 he employs satire, a parody of Hogarth's own "Britophil" essay but with Mr. Bubbleman now a Hogarth advocate talking up the "flowing line, which constitutes grace and beauty," as well as "the art of contrast," pyramids, and art "reduced to principles." Reynolds's support for the Burkean Sublime appears in the middle of the three papers, No. 79, which urges the painter toward "enthusiasm." In No. 82 he returns with a more serious argument, which goes to the heart of his disagreement with Hogarth, and lays the foundation for his *Discourses*. He defends "the invariable general form" against "accidental blemishs and excrescences which are continually varying the surface of nature's works."[93]

He uses the argument of "habit and custom: custom makes, in a certain sense, white black, and black white; it is custom alone determines our preference of the colour of the Europeans to the Aethiopians, and they, for the same reason, prefer their own colour to ours."[94] What

Hogarth presents as a universal is in fact only a "preference . . . given from custom, or some association of ideas." Acknowledging the origin of Hogarth's aesthetics, he connects custom with the terminology Hogarth adapted from Addison: "Novelty is said to be one of the causes of beauty: that novelty is a very sufficient reason why we should admire, is not denied; but because it is uncommon, is it therefore beautiful?" His resounding, Johnsonian conclusion makes absolutely clear the distinction between Hogarth's and the old academic theory of art: "if it has been proved, that the painter, by attending to the invariable and general ideas of nature, produces beauty, he must, by regarding minute particularities, and accidental discriminations, deviate from the universal rule, and pollute his canvas with deformity" (the last six words are Johnson's addition).

A few artists preferred in their different ways Hogarth's aesthetics of novelty, variety, intricacy, curiosity, formal play, and wit. For example, both Reynolds and Thomas Gainsborough painted portraits of the great tragedienne Sarah Siddons (1784, 1785). Reynolds painted a "general idea" of Mrs. Siddons as the Tragic Muse, flanked by allegorical figures of Pity and Terror, alluding not only to Aristotle but to the Old Testament prophets Michelangelo painted in the Sistine Chapel (San Marino, Huntington). Gainsborough reduced Reynolds's icon to an irreverent "particular," a playful synecdoche. In this case it is Mrs. Siddons's nose: "Damn the nose – there's no end to it," Gainsborough is supposed to have said, and so he constructed her portrait on a series of long slightly downward-tilting ovals that parallel the form of her nose, balanced by a few strong lines like that of her left shoulder and the stripes of her dress. The lines traced by the downward-tilting ovals are, incidentally, serpentine (London, National Gallery).[95]

Johan Zoffany constructed group portraits in the 1760s and 1770s around the incongruous relationships between humans and art works that were aesthetic fables on the model of the *Analysis* plates. Joseph Wright of Derby and George Stubbs produced versions of Hogarth's demystification of the sacred, replacing god with an ingot or candle, a hero with a horse. Even J.M.W. Turner questioned the most general ideas (sublime forms) with tiny irreverent Hogarthian particulars.[96]

Hogarth wrote the *Analysis* not in the discourse of the academic art treatises but of Addison's Novel and the (lower case) novel of Fielding, Sterne, and Smollett, and for that reason it contributed an aesthetic

whose implications reach far beyond the work of the British School of painters to the great tradition of British literature.

The reader of the first volumes of *Tristram Shandy* (1759) was invited to a Hogarthian pursuit, based on pleasure, curiosity, and surprise. Curiosity, or inquisitiveness, as a principle first set forth in the beginning of volume 1, leads straight to the last page of the volume and its challenge to the reader: "if I thought you was able to form the least judgment or probable conjecture to yourself, of what was to come in the next page, – I would tear it out of my book."[97] Tristram's own character is established as a child by "a most unaccountable obliquity . . . in my manner of setting up my top, and justifying the principles upon which I had done it."[98] As soon as the first two volumes were published, Sterne requested and received Hogarth's imprimature in the form of two illustrations, the first showing Corporal Trim's deviations from the precise Line as he reads the "Sermon on Conscience."[99]

The odd number, the digression, the combination of visual image and words, and the hobby-horse: these are the Shandean inheritance from Hogarth's *Analysis*.[100] The Shandean reading structure (serpentine, not straight lines; avoid all rules; digressive is progressive) is based on the practice of reading a Hogarth print, a "modern moral subject," as formulated in the aesthetics of the *Analysis*. Sterne accordingly opposes to the muleteer who drives "straight forward," which "is, morally speaking, impossible," the man who, "if he is a man of the least spirit, . . . will have fifty deviations from a straight line to make with this or that party as he goes along, which he can no ways avoid. He will have views and prospects to himself perpetually solliciting his eye . . ." (41).

Uncle Toby, responding to Walter Shandy's invocation of Locke's association of ideas (to explain how their conversation has taken so many digressions), lays claim to the Hogarthian smokejack as his model for the association of ideas, which corresponds, in a half-parodic way, to Tristram's own explanation of his memoir's reading structure. The smokejack is Toby's version of the "two contrary motions" of progressive and digressive of Tristram's narrative, the way they have both worked out their hobby-horse of describing how they were "wounded," Toby at Namur, Tristram from conception. The hobby-horse is the emblem of "fitness" that justifies the "pleasure of pursuit" in *Tristram Shandy*.

The discussion of the smokejack is followed in volume 3 by the "Preface," which finally makes its appearance at just this point, and its

aim is to adjudicate between wit and judgment. Yet it is followed by the "wit" of the different interpretations (based on each "humorous character's" hobby-horse) of hinges, mortars, and bridges. The senses of bridge – a structure over a depression or obstacle; a transition; the upper bony part of the nose *and* its prosthetic equivalent (something that fills a gap); and the name of the woman (Bridget) to whom Trim makes love on the bridge – sum up the Hogarthian aesthetics of the "love of pursuit" (cf. pp. 33–35).[101]

In landscape theory Hogarth's Line of Beauty became associated with the principle of "Capability" Brown's landscape gardening. William Gilpin responded (largely associating Hogarth, as Brown did, with his Line) by attacking the static Line with the other part of the Hogarthian doctrine: intricacy, variety, and novelty.[102] It is notable that in his *Three Essays* (1791) Gilpin's Picturesque does not, like the later versions of Uvedale Price and Richard Payne Knight, suppose the gradual transformation of the landscape by benign neglect but an energetic action by an artist. In the case of Palladian architecture, the picturesque artist must be a destroyer (a role that recalls Hogarth's satires on Palladianism): "Should we wish to give it picturesque beauty, we must *use the mallet, instead of the chissel*: we must *beat down* one half of it, *deface* the other, and *throw* the mutilated members around in heaps. In short, from a *smooth* building, we must turn it into a *rough* ruin" (emphasis added). In the *Analysis* Hogarth had advocated a "break" in a building (that is, with its Vitruvian orders) "by throwing a tree before it, or the shadow of an imaginary cloud" in order to add "variety" (p. 29).[103]

The same iconoclasm is called for when confronted with Capability Brown's "beautiful" serpentine gardens: "Turn the lawn into a piece of broken ground: plant rugged oaks instead of flowering shrubs: break the edges of the walk: give it the rudeness of a road; mark it with wheeltracks; and scatter around a few stones, and brushwood; in a word, instead of making the whole *smooth*, make it *rough*; and you make it also *picturesque*."[104]

Gilpin's correlation of the Beautiful with positive moral values, the Picturesque with what is ordinarily thought of as negative (idleness and decrepitude), creates the aesthetic object. Like Hogarth's aesthetics, it also asks that the Picturesque be utilized to counteract and correct the officially Beautiful, in terms of "taste" a proscriptive category he associates with tyranny. His active verbs of breaking tend to imply the satiric

potential of the picturesque artist, which was primary in Hogarth's intention. Gilpin follows Hogarth in privileging the local, marginal, and specifically English against the Continental "high art" tradition which homogenizes art and culture. The picturesque scene works on behalf of the indigenous against the forces of "improvement" and protests against those who, ignorant or dismissive of cultural heterogeneity, seek to impose the same pattern and order everywhere. The emphasis in the *Spectator* as in Hogarth was on the English, the national, and the local as against the French and Italian art, cuisine, entertainments, and government; and in this argument the Novel, along with England, became politically normative.

Gilpin's Picturesque is essentially a retitling of Hogarth's Beautiful/ Novel, including the need for the Beautiful as a foil. Hogarth's beautiful object, his ontology, and his epistemology of intricacy, surprise, and curiosity based on contrast and variety have been suitably divided but re-presented within a scene in which they relate, as, for example, a smooth face to the same face with unruly hair caught in a strong wind.

In his *Three Essays* Gilpin argued that the human figure is always more picturesque when "it is agitated by passion," and "in action, than at rest" (his examples of sculptures are Hogarth's in *Analysis* plate 1, the *Laocoön* and *Antinous*).[105] "Action," as in Hogarth's chapter "Of Action," is what Gilpin sees as the element that transforms the Beautiful into the Picturesque.

Gilpin imagines the portraitist Reynolds *throwing* the hair of his sitter "dishevelled" about her shoulders. And from Reynolds's disheveling his sitter's hair Gilpin moves to Virgil's "portrait of Venus," "which is highly finished in every part, [but] the artist has given her hair, – dissundere ventis," has made it stream in the wind; as Milton *represents* Eve in *Paradise Lost* with "unadorned golden tresses . . . / Dishevelled, and in wanton ringlets waved."[106] It is not surprising then that Gilpin also chooses the chase to sum up the "love of novelty": "The *pleasures* of the chase are universal. A hare started before dogs is enough to set a whole country in an uproar."[107]

In short, what came to be known as the Picturesque in many ways carries on the Novel, especially Hogarth's version of it as the Novel/ Beautiful, by applying it to natural rather than human phenomena. Landscape, however, was the primary vehicle of both Beautiful and (the victorious member of the trio) Sublime, against which Gilpin, Price, and Payne Knight carried Hogarth's argument from history painting. They argued for an area in nature between the cosmetic and coiffured

Beautiful and the chaotic Sublime, in effect a landscape equivalent of the "modern moral subject." While their attack on Brown's gardens was on Hogarth's own Serpentine Line, they treated it as Hogarth had the geometrical straitjacket of Shaftesbury–Hutcheson's Beautiful, and they discredited the Serpentine Line as aesthetic object by applying Hogarth's skeptical epistemology of curiosity. Their distrust of the Sublime was a natural equivalent of Hogarth's fear of the anarchic political implications of Burke, Pitt, and Whitefield. Price and Payne Knight regarded the Picturesque as politically as well as aesthetically a "middle term," liberty, between the extremes of tyranny (Brown's Beautiful) and license (Burke's Sublime).[108] In this form Hogarth's theory and practice survived in landscape, the one painterly mode which proved to be a viable vehicle for new ideas in art.

Rowlandson merged the natural and human in a comic synthesis. His illustrations for William Combe's satiric poems on Dr. Syntax sum up his aesthetics.[109] These show him critiquing the Picturesque with the Hogarthian "living" woman. Dr. Syntax, himself Picturesque, appears with a beautiful young woman and rough, shaggy beasts or trees, turning his back on the one in order to focus pedantic attention on the other. Rowlandson believes that a spectator should look at, indeed desire to mate with, the beautiful woman (who faintly recalls the serpentine lines of Brown's garden), while at the same time distinguishing the serpentine forms of nature from man-made architectural forms.

Rowlandson's subject is the pure pleasure or play of the *Analysis* text; he takes his compositions and contrasts from the two illustrative plates, but, reading them as purely aesthetic texts, he drops their moral subtext (ill. 25). He picks up and develops Hogarth's discussion of laughter in his chapter "On Quantity," and so depicts not simply a beautiful woman, which would presumably be a representation of the Beautiful, or a beautiful woman and a handsome young man in love, but rather one or both of these played off in a variety of ways against ugly, deformed, fat, and aging creatures.

The result is a comic analysis of Hogarth's *Analysis* as well as Gilpin's. Rowlandson's *Exhibition Stare-case* (ill. 26) turns the staircase that led up to the exhibition gallery in the Royal Academy into Hogarth's Line of Beauty. The irony is that even Hogarth's subversive Line has been institutionalized (as by Capability Brown in his gardens), but the spirit of variety, intricacy, and the love of pursuit, embodied in the unruly bodies of the living humans ascending toward the picture

gallery, has broken out of this container. The human bodies sprawl
down it, and in the process the women fall into poses pleasureful to the
voyeuristic men, and in some cases into their arms.[110]

NOTES

1. For a fuller publication history of the *Analysis*, see *Hog.3*, chaps. 3–5.

2. Hogarth applies the phrase "modern moral subjects" (just once) to his works in
"Autobiographical Notes," Burke, p. 216. What he means is summed up in other
phrases: "in the historical way [i.e., of history painting]" an "intermediate species of
subjects for painting between the sublime and the grotesque," to which he adds: "We
will therefore compare subjects for painting with those of the stage" (p. 212). Fielding's
term, "comic history-painting" (preface, *Joseph Andrews* [1742]), though in many ways
apposite, was not used by Hogarth himself.

3. BL. Add. MS. 4310, f. 122. The vice-chancellor of Cambridge had his copy and
returned his thanks on the 28th (BL. Add. MS. 27995, f. 10).

4. Hogarth added the serpentine line in the engraving. The painting, finished in
1746, had in the roundel a face of the "fluvial god" type (Foundling Hospital, London).
See *HGW* No. 193.

5. Vertue, 3:126; Garrick to Benjamin Hoadly, 14 Sept. 1746, *Letters of David
Garrick*, ed. David M. Little and George M. Kahrl (Cambridge, 1963), 2:86.

6. *St. James's Evening Post*, 7–9 June 1937; see *Hog.2*, pp. 136–38. The reprint of
the essay in the July *London Magazine* attributed it to "the finest painter in England,
perhaps in the world, in his Way" (a common mode of reference to Hogarth in his
lifetime). For Thornhill, see below, p. 92n.

7. Even before his reference in the "Britophil" essay to the "dead *Christs, Holy
Families, Madona's*, and other dismal Dark subjects," Hogarth had painted *The Marriage
Contract* (Ashmolean Museum, Oxford), which showed the contract being negotiated
between Tom Rakewell and the rich old woman he marries to recoup his lost fortune in
A Rake's Progress (1735). A painting above their heads shows the Virgin Mary dropping
the Christ Child into a hopper, out the other end of which drops the Host. Hogarth's
strongly anticatholic and anticlerical consciousness equated these evils with the Old
Master paintings that represented them: examples of counter-reformation baroque in
art, popery in religion, and Jacobitism in politics. This painting was not used in the
final series, *A Rake's Progress*; the setting was incorporated in Plate 2 but the Christian
iconography of the painting was replaced by classical (a *Judgment of Paris*).

8. He had founded the St. Martin's Lane Academy himself in 1735.

9. On 23 October 1753 "a scheme" was announced "for creating a public academy"
(see *Hog.3*, pp. 132–33).

10. The word *aesthetic* was first used by Alexander Baumgarten in his *Meditationes
Philosophicae* of 1735 and further developed in his *Aesthetica* of 1750. Derived from the
Greek *aisthetikos*, it means simply *perception* and has nothing per se to do with art or
beauty; Baumgarten applies the word to poetics and discourse. In the *Meditationes* he
wrote: "Therefore, *things known* are to be known by the superior faculty as the object of

logic; *things perceived* [are to be known by the inferior faculty, as the object] of the science of perception, or *aesthetic*." His attempt to raise the lower faculty of perception to the level of thought in poetry (which Addison had accomplished with the intermediate word *imagination*) parallels Hogarth's in the visual arts. There is no reason, however, to think that Hogarth had read Baumgarten or the more popular disseminator of his ideas, Georg Friedrick Meier. (See Baumgarten, *Meditationes* [*Reflections on Poetry*], trans. Karl Aschenbrenner and William B. Holther [Berkeley, 1954], 78; Meier, *Anfangsgründe aller Schönen Wissenschaften* [Halle, 1748–50]; see also *BNS*, p. 43.)

11. For example, the "shell-like surface" of the skin is "the most proper subject of the study of every one, who desires to imitate the works of nature, *as a master should do*, or to judge by the performances of others *as a real connoisseur ought*" (p. 55). Again, he endeavors "to be understood by every reader" as well as "by painters" (p. 75).

12. The central Shaftesburian text was *The Moralists*, in which the perception of beauty in an object is divorced from any personal utility to be obtained from it (*Characteristics of Men, Manners, Opinions, Times, etc.*, ed. John M. Robertson [New York, 1900], 2:126ff.).

13. See below, MSS., p. 123.

14. Defoe, *Review*, 18 July 1704; ed. Arthur Secord, 9 vols. (New York, 1938), 1:171.

15. See *Hog.1*; for the episode of the church door, pp. 322–23. For a discussion of English Protestant iconoclasm in relation to Hogarth, see Paulson, *Breaking and Remaking* (New Brunswick, 1989), chap. 1.

16. Further back, in 1724, Hogarth published his print *Cunicularii*, which uses the "hoax" of Mary Toft the "rabbit woman" – presented as another beautiful, "living" woman – to parody a Nativity and the "hoax" of the Virgin Birth. For an analysis of this work and Hogarth's involvement in the anticlerical wing of Whig opposition politics, see Paulson, "Putting out the Fire in the Empress of Lilliput's Apartments: Opposition Politics, Anticlericalism, and Aesthetics," *ELH*, 63 (1996):79–108. For the *Harlot's Progress*, see *Hog.1*, chaps. 8 and 9, and *BNS*, chap. 1.

17. For his use of Xenophon's *Memorabilia*, see Text, note 19.

18. Shaftesbury, *Characteristics*, 1:125.

19. This is a view that for Hogarth goes back beyond Toland's rationalist deism to the radical politics of John Lilburne, the Model Army, and the Putney Debates. See Paulson, *Don Quixote in England: The Aesthetics of Laughter* (Baltimore, 1997), chap. 2.

20. The ideal connoisseur proposed by Jonathan Richardson, in *Essay on the Art of Criticism* and *Science of a Connoisseur*, shares some of the traits of Hogarth's common man. Like Hogarth, Richardson draws on religious discourse, associating authority with priestcraft, the proper connoisseur with Protestantism: "as when a man receives a proposition in divinity, (for example) not because it was believed by his ancestors, or established a thousand years ago, or for whatever other such like reasons; but because he has examined, and considered the thing itself as if it were just now offered to the world. . . ." The "rules must be our own; whether as being the result of our own study and observation, and drawn up and composed by us; or by some other, and examined, and approved by us" (*Works*, pp. 170–71). In many ways Hogarth learned from Richardson's treatises, but remained on balance decidedly Shaftesburian. Hogarth could never have written, as Richardson did, that "the noisy, tumultuous pleasures of the vulgar are not equivalent to those which the most refined wits taste," adding that "an oyster is not capable of the same degree of pleasure as a man" (p. 175).

21. In his critique of Shaftesbury's theory of art, Mandeville had focused on the missing female. He used the woman Fulvia to speak for reason and common sense against the idealism of Horatio, fully aware that Shaftesbury would have regarded her as another figure of effeminate Pleasure (First Dialogue in *Fable of the Bees, Part 2*). For Shaftesbury, see, as well as the *Judgment of Hercules*, his *Characteristics*, 1:116–18, 178, 213–14. Cf. John Barrell's discussion of Shaftesbury's anti-Venus in " 'The Dangerous Goddess': Masculinity, Prestige and the Aesthetic in early Eighteenth-Century Britain," in *The Birth of Pandora and the Division of Knowledge* (Philadelphia, 1992), 67; and *BNS*, chap. 2.

22. Shaftesbury, "Freedom of Wit and Humour," *Characteristics*, 1:96. Jonathan Richardson also consistently urged copying from the antique casts, however secondary: "Supposing two men perfectly equal in all other respects, only, that one is conversant with the works of the best masters . . . and the other not; the former shall, necessarily, gain the ascendant, and have nobler ideas, more love to his country, more moral virtue, more piety and devotion than the other; he shall be a more ingenious, and a better man" (*Theory of Painting*, in *Works*, 6).

23. Echoing the passage on the "living woman," Hogarth also writes of a painter of flower pieces, that even "with his best art, and brightest colours, how far short do they fall of the freshness and rich brilliancy of nature" (p. 91n.).

24. This is an adjective Fielding also echoes when writing of his innovative genre in the preface to *Joseph Andrews* (1742).

25. Toland, *Life of John Milton*, prefaced to his edition of Milton's prose works (1698); in Helen Darbishire, ed., *The Early Lives of Milton* (London, 1932), pp. 194, 182.

26. See *Spectator* Nos. 23, 47, 249, 335.

27. *Pleasures of Imagination*, ll. 250–52, in *Poetical Works of Mark Akenside*, ed. Robin Dix (London, 1996). His point of departure from Addison lies in his term "passions": the passions exaggerate sense experience into imagination, whether into tragedy (pity, terror) or vice (abhorrence) or, finally, folly (laughter).

28. These are the words of his précis, *Poetical Works*, pp. 87–88.

29. Fielding's preface was largely dedicated to setting up an analogy between his own "comic epic in prose" and Hogarth's "comic history-painting."

30. *Ridiculous* was a word whose root was *rideo, risi, risum* (either to laugh at or laugh with, though it was usually used as the former); the word *comedy* usually applied to plays with a happy ending; and *ludicrous*, whose root was *ludus*, referred to the jocular or playful (as in *Spectator* No. 191).

31. The size of the full-bottomed wig, however, Hogarth notes a few paragraphs later, is only a matter of custom and fashion. To be laughable it must be seen as "a burlesque," or in excess of custom – and so an affectation. Unless, of course, the custom itself is exaggerated and so shown to be ridiculous.

32. Compare Devin Burnell, "The Good, the True and the Comical: Problems Occasioned by Hogarth's *The Bench*," *Art Quarterly*, n.s. 2 (1978):5; see esp. pp. 17–46.

33. Morris, *Essay towards Fixing the True Standards of Wit, Humour, Raillery, Satire, and Ridicule* (1744), 1. Addison deals with wit in *Spectator* Nos. 58–63.

34. Morris's *Essay* begins with a fulsome dedication to Walpole and proves, by the time he is finished, to be an answer to Swift, Pope, Fielding, and the other satirists who had pursued Walpole to his final fall in 1742. For a fuller discussion of the blemish, foible, and humor, see Paulson, *Don Quixote in England*, chap. 4.

35. Hogarth more specifically reproduced the second encounter described by Mr. Spectator: "The last Week I went to an Inn in the City, to enquire for some provisions which were sent by a Waggon out of the Country," and he overhears a conversation between "a most beautiful Country-Girl, who had come up in the same Waggon with my things," and a bawd, "the most artful Procuress in the Town."

36. Mandeville, *A Modest Defense of Publick Stews* (1724), xi–xii.

37. I include Stuart Tave, in *The Amiable Humorist* (Chicago, 1960), and myself in *Satire and the Novel* (New Haven, 1967).

38. Michael Podro also argues that the *Analysis* is a response to Shaftesbury's pure formalism in "The Line Drawn from Hogarth to Schiller," in *"Sind Briten hier?": Relations between British and Continental Art, 1680–1880*," ed. Willibald Sauerländer (Munich, 1981), pp. 45–56.

39. With an immanent deity and his miracles discredited replaced by a model based on harmonious proportions, Shaftesbury regards the artist as "a second *Maker*; a just Prometheus under Jove. Like that sovereign artist or universal plastic nature, he forms a whole, coherent and proportioned in itself, with due subjection and subordinacy of constituent parts," which is a platonic ideal of beauty equated with virtue. This is the "moral artist who can thus imitate the Creator, and is thus knowing in the inward form and structure of his fellow-creatures" (*Characteristics*, 1:136).

40. See below, p. xlvi.

41. See Montfaucon's *Antiquity Explained*, cited below, text, n. 26. Montfaucon also shows Venus with a cornucopia (which Hogarth uses in plate 2, fig. 59).

42. For the Masonic importance of the pyramid, see *Séthos* (trans. "Mr. Lediard," 1732), 1:114 and 148ff.; and on the serpent, 1:127–47; on the trinity of Isis-Osiris-Horus, 1:164. As I have shown elsewhere, Hogarth had close ties to Freemasonry, from the early 1720s (*Hog.* 2:56–60, 147–48). The center of the Masonic ritual was the martyrdom of Hiram, the architect, who had been murdered by jealous rivals when he refused to divulge the secret. Hiram was another artist with whom Hogarth seems to have identified.

43. While the *Harlot's Progress* replaced a classical Hercules and a Christian icon of Mary with a living London woman of the 1730s, the subscription ticket showed an antique goddess. Toland had replaced Christianity with a more heterogeneous Nature, Jesus on the cross with the "Great Mother," whom Hogarth recovers as *Diana Multimammia*, her fecundity being unveiled by a faun (Toland, *Pantheisticon* [1720], p. 65).

44. Warburton, *Divine Legation*, 2:40. Besides Warburton, Shaftesbury also held forth on the subject of the origin of art in Egypt, see "Miscellaneous Reflections," *Characteristics*, 2:183ff.

45. *Divine Legation*, 1:2, 4, 142–44. Pythagoras, whose school at Crotona was taken by many Masonic writers as the model after which Masonic lodges were constructed, divided his scholars into Exoterics and Esoterics, a distinction he borrowed from the Egyptian priests (whom he had studied before returning to Greece). The Exoterics attended the public lectures, but only the Esoterics constituted the true school of Pythagoras (Albert G. Mackey, *Encyclopedia of Freemasonry* [Chicago-New York-London, 1921], 602).

46. *Divine Legation*, 4.4, 2:112–13.

47. Thus the Church Fathers incorporated the Eleusinian Mysteries (another version of the Mysteries of Isis, with Ceres and Isis interchangeable deities) into their rituals for

political reasons. Warburton's assumption, that such rituals and religions were always "formed and propagated by Statesmen, and directed to Political Ends" (2:174, 179) fitted perfectly (if inadvertently) into the belief shared by the deists Mandeville and Hogarth.

48. Joseph Burke first pointed out the possible importance of the mnemonic system to the theory of the *Analysis* (pp. xxxvii–xli).

49. "Autobiographical Notes," Burke, p. 209.

50. *Gen. Works*, 1:24.

51. See below, plates, p. 151.

52. Richardson cites Lomazzo's *Idea del Tempio della Pittura* for characterizing the great painters by animals and great men: Michelangelo by a dragon and Socrates, Leonardo by a lion and Prometheus (*Treatise on Connoisseurs*, in *Works*, p. 210).

53. *Spectator* 3:557. See also the example of the bell, p. 43.

54. Compare Dobai, 364; Jack Lindsay, *Hogarth: His Art and his World* (London, 1977), pp. 167, 183.

55. Five years before *Boys Peeping*, in *Cunicularii, or The Wise Men of Godlimen*, Hogarth had identified the foremost Wise Man, coming to worship Mary the "Rabbit Woman," as "An Occult Philosopher searching into the Depth of Things," in this case the same area in which the faun and clergyman are interested.

56. Fielding's library contained a copy of Hume's *Philosophical Essays*, and it is possible that he drew Hogarth's attention to the passage, with which the book opens, which would have been of most interest to him. Hogarth could also have known Hume's work through his Scottish and/or his deist connections. Like Hume, Hogarth does not think that reason can prove much; his senses are not that far removed from Hume's "belief." In its original form the passage on painter-anatomists ends Hume's *Treatise of Human Nature* (1739), a book that did not attract much attention; but, in his attempt to reframe his argument in a more accessible form, Hume opened his *Philosophical Essays* with a new version of it, and this carried over into *An Enquiry concerning Human Understanding*. For Fielding's library, see *A Catalogue of the Entire and Valuable Library of Books of the Late Henry Fielding, Esq.* (10–13 Feb. 1755), No. 539. His copy of Hogarth's *Analysis* was No. 581.

57. Hume, *Enquiries concerning Human Understanding and concerning the Principles of Morals*, ed. L.A. Selby-Bigge, revised P.H. Nidditch (Oxford, 1975), 1.5.10.

58. De Bolla, "Criticism's Place," *Theory and Interpretation: The Eighteenth Century*, 25, No. 2 (1984):199–214.

59. Hogarth does, however, use analogy when it suits him (pp. 77–78, 82n, 87). And his prints work by both synecdoche and analogy – of form and of content, Mary Toft or Hackabout analogized to the Virgin Mary, Rakewell to Paris and to Christ.

60. De Piles, *Cours de Peinture par principes* (Paris, 1708), p. 105; trans. *The Principles of Painting* (London, 1743), p. 65. Or again: "This subordination, by which several objects concur to make but one" (*Cette subordination qui fait concourir les objets à n'en faire qu'un*) (*Cours de Peinture*, p. 105; *Principles of Painting*, p. 65). I am indebted to Thomas Puttfarken, *Roger de Piles' Theory of Art* (New Haven and London, 1985), chap. 4.

61. De Piles, *Cours de Peinture*, p. 382; *Principles of Painting*, p. 231. Richardson also invoked the grapes in his *Theory of Painting* (*Works*, p. 69). As to the nosegay: in Pope's *Rape of the Lock* Ariel, when he sees "an Earthly Lover lurking at [Belinda's] Heart," is "reclin'd" "on the Nosegay in her Breast" (3.141–44). The withering of the flowers in

Hogarth's nosegay, beautiful as long as they are distinct, into ugly undifferentiation recalls the "go, lovely rose" theme of the *Rape*. It is suggestive how much of the imagery of Hogarth's *Analysis* is appropriated from Pope's Belinda: the Miltonic echoes, the Eve-like associations of "wanton ringlets" (2.23–28, including the fishing metaphor), the synecdoche of her lock (the asymmetrical lock, not balanced locks), the reference to the round, comic form of Sir Plume, and even the Miltonic quotation of the "mystic . . . mazes" that recalls Pope's "mystic mazes"; certainly the wit and playfulness as well as the separation of beauty from virtue, the association of beauty with affectation and idolatry and, of course, with the Fall.

62. De Piles, *Cours de Peinture*, p. 106; *Principles of Painting*, pp. 65–66. "The eye is at liberty to see all the objects about it, by fixing successively on each of them; but, when 'tis once fix'd, of all those objects, there is but one which appears in the centre of vision, that can be clearly and distinctly seen; the rest, because seen by oblique rays, become obscure and confused, in proportion as they are out of the direct ray" (*Cours*, pp. 107–08; *Principles*, p. 66).

63. An extreme case would be the painting known as *Hogarth's Servants* (Tate, London) with its pointed defiance of compositional devices and all attention directed to the character and structure of each sitter's physiognomy and expression (noted by Lawrence Gowing, *Hogarth* [Tate catalogue, 1971], no. 197).

64. *Cours de Peinture*, p. 12, and *Principles*, p. 7; *Art of Painting*, pp. 7–8 (Puttfarken's citation, *Roger de Piles' Theory of Art*, p. 109). As Puttfarken notes, de Piles's "argument is not about subject-matter or understanding at all, but about vision" (p. 82).

65. See *Analysis*, chap. 10, pp. 50–51; the cornucopia is compared to the screw, p. 51. In another way, however, it is the pineapple that sums up proportion: recalling the aestheticization of the Trinity and the cross, Hogarth suggests that Sir Christopher Wren might have preferred the pineapple to the globe and cross atop the dome of St. Paul's, "if a religious motive had not been the occasion" (p. 32).

66. For Venus and the cornucopia, see Montfaucon, *Antiquity Explained*, 1:102, pl. 52, fig. 3; below, p. 154.

67. The transition from *Finchley* to the *Election* paintings also shows Hogarth moving from the kind of composition in which "lights and shades . . . are scattered about in little spots" and "the eye is constantly disturbed, and the mind is uneasy, especially if you are eager to understand every object in the composition," to one with "large, strong, and smart oppositions" which give "great respose to the eye" (p. 86). See *HGW* No. 184; *Hog*.3:73.

68. A better example, because it defines the state in terms of the body parts, is Meninius's speech in Shakespeare's *Coriolanus* (1.1). De Piles had specified the political analogy for *l'unité d'objet*: "Where the great have need of the lower people, and these have need of the great" (*Cours de Peinture*, p. 104; *Principles of Painting*, p. 64).

69. Jonathan Sawday, *The Body Emblazoned* (London, 1995), p. 197.

70. See, e.g., Samuel Johnson's *London* (1738), ll. 23–30; also Akenside, Ode 1, *Odes, Book the Second* (1749), 11. 23–34. See also Christine Gerrard, *The Patriot Opposition to Walpole: Politics, Poetry, and National Myth, 1723–1742* (Oxford, 1994), pp. 9–10, 150–56.

71. *The Times, Plate 1*, state 1; *HGW* No. 211. He introduced words from one of Elizabeth's patriotic speeches in his portrait of that free spirit, Mary Edwards (Frick, New York; see *Hog*.3:475n10).

72. See *Hog.3*, chap. 5. Sandby's caricatures are reproduced, figs. 26–33. For fuller quotations of reviews and responses to the *Analysis*, see Paulson, *Hogarth: His Life, Art, and Times* (New Haven and London, 1971), Appendix G, 2:493–502.

73. A print in his defense showed his critics with books labeled "Defense of Atheism" and "Romains *Philosophy*," trampling on the *Analysis* and the works of Shakespeare and Milton. This is a print called *A Collection of Connoisseurs*, published early in 1754 (BM. Sat. 3246), by a less talented caricaturist than Sandby, Thomas Burgess. William Romaine was a zealous Calvinist, famous for his fiery sermons.

74. The spokesman for the connoisseurs was *The World* (13 Dec. 1753); the *Analysis* was defended by *The Connoisseir*, a parodic journal written by Bonnell Thornton and George Colman (1 [Feb. 1754]:8).

75. *Public Advertiser*, 15 February 1754.

76. *Gentleman's Magazine*, 23 (Dec. 1753):593; 24 (Jan. 1754):11–15 (rpt. in the *Scots Magazine*, 16 [Jan. 1754]:36–40); attributed to John Hawkesworth in *Gen. Works*, 1:331.

77. *Monthly Review*, 10 (Feb. 1754):100–10; see also Matthew Maty in the *Journal Britannique*, 12 (Nov.–Dec. 1753):360–80.

78. Henrietta Knight, Lady Luxborough, to William Shenstone, 16 March 1754, *Letters written by the late right honourable Lady Luxborough, to William Shenstone, Esq.* (London, 1775), pp. 380–81. Compare Shenstone, to Richard Graves, 19 April: "it is really entertaining; and has in some measure, adjustd my notions with regard to beauty in general" (*Letters of William Shenstone*, ed. Marjorie Williams [Oxford, 1775], p. 396, also p. 400).

79. Catherine Talbot, 20 December 1753, MS. Journal, BL. Add. MS. 46689 [722E].

80. Rogers to Paul, 21 January 1754, in the Plymouth, City Museum, Cottonian Collection, transcripts of letters; quoted, Louise Lippincott, *Selling Art in Georgian London* (New Haven and London, 1983), p. 123. Wills's translation of *De Arte Graphica* was published early in 1754; not much later he gave up painting and took holy orders.

81. *Zergliederung der Schönheit, die schwankenden Begriffe von dem Geschmack festzusetzen, geschrieben von Wilhelm Hogarth* (London and Hanover, 1754). In March 1754 Lessing mentioned the *Analysis* in the *Berlinische Priviligierte zeitung* and on 3 May praised Hogarth's ideas.

82. He quotes with approbation the passage about the "blemish" in the Apollo Belvedere (*Laokoön*, chap. 22; trans. Edward Allen McCormick [Baltimore, 1962], 120). See Lessing, *Werke*, ed. Julius Petersen and Waldemar von Olshausen (Berlin, 1929–35), pt. 9, ed. F. Rudder, pp. 316, 330–31, 337–19; *Gen. Works*, 1:241.

83. "Autobiographical Notes," in Burke, *Analysis*, p. 203; *Apology for Painters*, ed. Kitson, p. 109.

84. Ramsay, *The Investigator* (1762 ed.), p. 189. Ramsay's *Essay on Taste* was published in London in a volume called *The Investigator, Number 332* (the first number, 331, had appeared in Jan. 1754). Ramsay writes in the context of the *Analysis's* subtitle ("Written with a view of fixing the fluctuating Ideas of Taste") and Hume's "The Skeptic" (1741), whose argument was the relativity of aesthetic response and whose example was the Shaftesburian circle ("The beauty is not a quality of the circle. . . . It is only the effect which that figure produces upon the mind. . . ."), and his more recent essay "On the Standard of Taste" (1748).

85. This had been the point of the satire in *The World*: Hogarth's theory was like one of his stays, too constricting.

86. Ramsay, *Investigator*, p. 56.

87. Burke, *Philosophical Enquiry*, ed. James T. Boulton (London, 1958), pp. 115–16; see Boulton, Introduction, pp. lxx–lxxii.

88. Burke, p. 115. Frances Ferguson refers to Burke's "beheaded woman" (*Solitude and the Sublime: Romanticism and the Aesthetics of Individuation* [New York, 1992], p. 51).

89. See *Hog.3*, chaps. 9 and 16.

90. Gerard, *Essay on Taste* (1759), p. 14.

91. Gerard, *Essay on Taste*, p. 206.

92. See Peter de Bolla, *The Discourse of the Sublime: History, Aesthetics & the Subject* (Oxford, 1989), pp. 80–81.

93. Samuel Johnson, *The Idler and Adventurer*, ed. W.J. Bate, John M. Bullitt, and L.F. Powell (New Haven, 1963), pp. 237–38; 255–58.

94. He picks up this point in *Discourse* No. 7; he cannot have read Hogarth's *Analysis* MSS., though he may have heard him use this argument in conversation.

95. See Paulson, *Emblem and Expression*, pp. 209–11.

96. I discuss this genealogy at some length in *Emblem and Expression*, chaps. 9–12; *BNS*. chaps. 4 and 9; and *Literary Landscape: Turner and Constable* (New Haven and London, 1982), pt. 3.

97. Sterne, *The Life and Opinions of Tristram Shandy, Gentleman*, ed. Melvyn and Joan New (Gainesville, 1978), 1:89.

98. *Tristram Shandy*, 1:4.

99. See *Hog.3*, pp. 276–84; *BNS*, chap. 6.

100. See William Holtz, *Image and Immortality: A Study of "Tristram Shandy"* (Providence, 1970), esp. pp. 21–38; Jonathan Lamb offers suggestive remarks on the *Analysis* and *Tristram Shandy* in *Sterne's Fiction and the Double Principle* (Cambridge, 1989), pp. 24–26, 89.

101. The advent of Sterne's *Tristram Shandy* at the end of the decade, and its great popularity on the Continent, also affected the subsequent readings in Germany of the *Analysis* and Hogarth's engraved works as well. Georg Christoph Lichtenberg's commentaries on Hogarth's "modern moral subjects" is an aesthetic reading mediated by the *Analysis* and *Tristram Shandy*. See Lichtenberg, *Ausführliche Erklärung der Hogarthischen Kupferstiche*, published in the 1780s and 1790. On the German reception, see Dobai, pp. 345–52; on the influence of the *Analysis* and *Tristram Shandy* on Lichtenberg's commentaries on Hogarth's prints, see *BNS*, chap. 10.

102. In the mid-nineteenth century Charles Eastlake still saw only the static dimension of Hogarth's Line of Beauty, asserting that it "constantly repeats itself, and is therefore devoid of variety and elasticity, the never-failing accompaniments of perfect vitality" (*Contributions to the Literature of the Fine Arts* [1848], ed. H. Bellenden Ker; cited in Jack Lindsay, *The Sunset Ship: The Poems of J.M.W. Turner* [London, 1966], pp. 73–74.).

103. Gilpin's *Essay on Prints* (1764), pp. 168–77, discusses Hogarth's work in general, and pp. 216–34 focus on *A Rake's Progress*. For Gilpin's personal relationship with Hogarth, see Carl P. Barbier, *William Gilpin* (Oxford, 1963), p. 24. Patricia Crown has noted some of the parallels between the terms of the *Analysis* and of the theory of Payne Knight and Price ("A Note on Hogarth and the Picturesque," *British Journal for Eighteenth-Century Studies*, 5 [1982]:233–37).

104. Gilpin, *Three Essays* (1791, 2nd ed., 1794), pp. 7, 8.

105. Gilpin, *Three Essays*, pp. 12–13.

106. Gilpin, *Three Essays*, pp. 8 9 (Virgil, *Aeneid*, 1.453). Sterne had picked up Hogarth's ringlets in the wind in Tristram's description of the transience of his Jenny: "whilst thou art twisting that lock, – see! it grows grey; and every time I kiss thy hand to bid adieu, and every absence which follows it, are preludes to that eternal separation which we are shortly to make" (*Tristram Shandy*: 754).

107. Gilpin, *Three Essays*, p. 48.

108. Brown's words, in Price's parody, were, "You shall never wander from my walks – never exercise your own taste and judgment – never form your own compositions – neither your eyes nor your feet will be allowed to stray from the boundaries I have traced." This "species of thralldom unfit for a free country" suppresses "variety, amusement and humanity" (Price, *Essay on the Picturesque* [1796 ed.], 378; cited, Sidney K. Robinson, *Inquiry into the Picturesque* [Chicago, 1991], 74; on picturesque politics, 73–93).

109. They began to appear in 1809 and were published as three *Tours of Doctor Syntax in Search of the Picturesque* (1812, 1820, 1821).

110. In one drawing Rowlandson shows a contemporary Adam and Eve intertwined in S-curves as they recoil from a large, rearing, S-curving serpent, a fleshed-out version of the upright Line of Beauty that appears on the title page of the *Analysis* (*Landscape with Snake*, Metropolitan Museum, New York, repro. *BNS*, fig. 39; see also Paulson, *Rowlandson: A New Interpretation* [London, 1972]).

The question may have occurred to the reader why Hogarth's religious heterodoxy (or even blasphemy) was not commented on by his immediate contemporaries. Any concern (as reflected perhaps in the reference to his impiety in *The Author Run Mad*, ill. 23) was deflected onto the more volatile subject of a state academy. Second, the visual image was both more telling and easier to overlook than words (as in the case of Hogarth's closest contemporary parallel, Woolston). Third, Hogarth's references to the sacraments and doctrines of the church were part of an aesthetics of play and so did not ask to be taken in a polemical context. Finally, they focused on art, not on religion.

THE
ANALYSIS
OF
BEAUTY

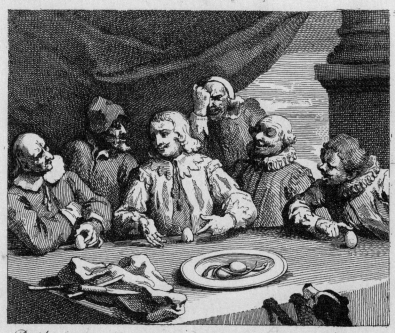

Rec'd 4 *August* of
five Shillings being the first Payment for a Short Tract in Quarto
call'd the Analysis of Beauty; wherein Forms are consider'd in a new
light, to which will be added two explanatory Prints Serious and
Comical, Engrav'd on large Copper Plates fit to frame for Furniture.

N.B. The Price will be rais'd after the Subscription is over Wm Hogarth

1. *Columbus Breaking the Egg* (subscription ticket). Courtesy of the Trustees of the British Museum, London.

THE
ANALYSIS
OF
BEAUTY.

Written with a view of fixing the fluctuating IDEAS of
TASTE.

BY *WILLIAM HOGARTH.*

So vary'd he, and of his tortuous train
Curl'd many a wanton wreath, in fight of Eve,
To lure her eye.-------- Milton.

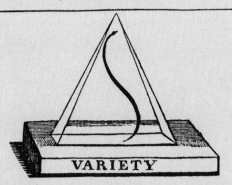

VARIETY.

LONDON:

Printed by *J. REEVES* for the *AUTHOR,*
And Sold by him at his Houfe in LEICESTER-FIELDS.

MDCCLIII.

2. Title Page.

PREFACE

I F a preface was ever necessary, it may very likely be thought so to the
following work; the title of which (in the proposals publish'd some
time since) hath much amused, and raised the expectation of the
curious, though not without a mixture of doubt, that its purport could
ever be satisfactorily answered. For though beauty is seen and confessed
by all, yet, from the many fruitless attempts to account for the cause of
its being so, enquiries on this head have almost been given up; and the
subject generally thought to be a matter of too high and too delicate a
nature to admit of any true or intelligible discussion. Something there-
fore introductory ought to be said at the presenting a work with a face
so entirely new; especially as it will naturally encounter with, and
perhaps may overthrow, several long received and thorough establish'd
opinions: and since controversies may arise how far, and after what
manner this subject hath hitherto been consider'd and treated, it will
also be proper to lay before the reader, what may be gathered concerning
it, from the works of the ancient and modern writers and painters.

It is no wonder this subject should have so long been thought
inexplicable, since the nature of many parts of it cannot possibly come
within the reach of mere men of letters; otherwise those ingenious
gentlemen who have lately published treatises upon it (and who have
written much more learnedly than can be expected from one who never
took up the pen before) would not so soon have been bewilder'd in their
accounts of it, and obliged so suddenly to turn into the broad, and more
beaten path of moral beauty;[1] in order to extricate themselves out of the
difficulties they seem to have met with in this: and withal forced for the
same reasons to amuse their readers with amazing (but often misapplied)

1. The allusion is to Anthony Ashley Cooper, third earl of Shaftesbury (and perhaps
Francis Hutcheson). This sentence is all that remains of a double parody, of Plato's myth of
the cave and Shaftesbury's *Judgment of Hercules*, elaborated in Draft C; for the whole, see
below, appendix, Manuscripts of *The Analysis of Beauty*, Supplementary Passages (henceforth
MSS.) I, p. 115.

encomiums on deceased painters and their performances;[2] wherein they
are continually discoursing of effects instead of developing causes; and
after many prettinesses, in very pleasing language, do fairly set you down
just where they first took you up; honestly confessing that as to GRACE,
the main point in question, they do not even pretend to know any thing
of the matter. And indeed how should they? when it actually requires a
practical knowledge of the whole art of painting (sculpture alone not
being sufficient) and that too to some degree of eminence, in order to
enable any one to pursue the chain of this enquiry through all its parts:
which I hope will be made to appear in the following work.

It will then naturally be asked, why the best painters within these
two centuries, who by their works appear to have excelled in grace and
beauty, should have been so silent in an affair of such seeming impor-
tance to the imitative arts and their own honour? to which I answer,
that it is probable, they arrived at that excellence in their works, by the
mere dint of imitating with great exactness the beauties of nature, and
by often copying and retaining strong ideas of graceful antique statues;
which might sufficiently serve their purposes as painters, without their
troubling themselves with a farther enquiry into the particular causes of
the effects before them. It is not indeed a little strange, that the great
Leonardo da Vinci (amongst the many philosophical precepts which he
hath at random laid down in his treatise on painting) should not have
given the least hint of any thing tending to a system of this kind;[3]
especially, as he was cotemporary with Michael Angelo, who is said to
have discover'd a certain principle in the trunk only of an antique
stature, (well known from this circumstance by the name of Michael
Angelo's Torso, or Back, fig. [64, plate 1]) which principle gave his
works a grandeur of gusto equal to the best antiques. Relative to which
tradition, Lomazzo who wrote about painting at the same time, hath
this remarkable passage, vol. 1. book 1.

"And because in this place there falleth out a certaine precept of
Michael Angelo much for our purpose, I wil not conceale it, leaving the
farther interpretation and understanding thereof to the judicious reader.
It is reported then that *Michael Angelo* upon a time gave this observation
to the Painter *Marcus de Sciena* his scholler;[4] *that be should alwaies make a*

2. The reference of "encomiums on deceased painters" is to Roger de Piles, *Abrégé de la
Vie des Peintres* (Paris, 1699), trans., *Art of Painting with the Lives and Characters . . . of the Most
Eminent Painters* (London, 1706), and, probably, Jonathan Richardson, *Essay on the Theory of
Painting* (1715).

3. Leonardo's *Treatise of Painting* had been published in 1721.

4. Marco da Siena (Marco da Pino, c. 1520–87).

figure Pyramidall, Serpentlike, and multiplied by one two and three. In which precept (in mine opinion) the whole mysterie of the arte consisteth. For the greatest grace and life that a picture can have, is, that it expresse *Motion*: which the Painters call the *spirite* of a picture: Nowe there is no forme so fitte to expresse this *motion*, as that of the flame of fire, which according to *Aristotle* and the other Philosophers, is an elemente most active of all others: because the forme of the flame thereof is most apt for motion: for it hath a *Conus* or sharpe pointe wherewith it seemeth to divide the aire, that so it may ascende to his proper sphere. So that a picture having this forme will bee most beautifull."*

Many writers since Lomazzo have in the same words recommended the observing this rule also; without comprehending the meaning of it: for unless it were known systematically, the whole business of grace could not be understood.

Du Fresnoy, in his art of painting, says "large flowing, gliding outlines which are in waves, give not only a grace to the part, but to the whole body; as we see in the Antinous, and in many other of the antique figures: a fine figure and its parts ought always to have a serpent-like and flaming form: naturally those sort of lines have I know not what of life and seeming motion in them, which very much resembles the activity of the flame and of the serpent." Now if he had understood what he had said, he could not, speaking of grace, have expressed himself in the following contradictory manner. – "But to say the truth, this is a difficult undertaking, and a rare present, which the artist rather receives from the hand of heaven than from his own industry and studies†." But De Piles, in his lives of the painters, is still more contradictory,

* See Haydocks's translation printed at Oxford, 1598.[5]

† See Dryden's translation of his latin poem on Painting, verse 28, and the remarks on these very lines, page 155, which run thus, "It is difficult to say what this grace of painting is, it is to be conceiv'd, and understood much more easy than to be expressed by words; it proceeds from the illuminations of an excellent mind, (but not to be acquired) by which we give a certain turn to things, which makes them pleasing."[6]

5. Giovanni Paolo Lomazzo, *Trattato dell'Arte della Pittura, Scultura ed Architettura* (Milan, 1584), trans. Richard Haydock as *A Tracte Containing the Artes of Curious Paintinge* (Oxford, 1598), p. 17 ("Of Proportion"). Hogarth's quotation is exact. In the first and final drafts the Lomazzo quotation appeared in the preface; in the second Hogarth moved it to chapter 10, "Of Composition." See MSS. II, p. 117.

6. Charles Alphonse Dufresnoy, *De Arte Graphica* (Paris, 1668), trans. John Dryden as *The Art of Painting* (London, 1694; 1716 ed.), pp. 17 and 125 (Hogarth is loosely paraphrasing). Hogarth's Dryden citation in his note is in fact to verse 222, pp. 31, 155. Dufresnoy's *De Arte Graphica* would have interested him as a version of Horace's *De Arte Poetica*, which he had invoked in one of the epigraphs for *Boys Peeping at Nature* (ill. 13), and for its claim that experience, not rules, was the authority Dufresnoy offered an artist.

where he says, "that a painter can only have it (meaning grace) from nature, and doth not know that he hath it, nor in what degree, nor how he communicates it to his works: and that grace and beauty are two different things; beauty pleases by the rules, and grace without them."[7]

All the English writers on this subject have eccho'd these passages; hence *Je ne sçai quoi*, is become a fashionable phrase for grace.[8]

By this it is plain, that this precept which Michael Angelo deliver'd so long ago in an oracle-like manner, hath remain'd mysterious down to this time, for ought that has appear'd to the contrary. The wonder that it should do so will in some measure lessen when we come to consider that it must all along have appeared as full of contradiction as the most obscure quibble ever deliver'd at Delphos, because, *winding lines are as often the cause of deformity as of grace*, the solution of which, in this place, would be an anticipation of what the reader will find at large in the body of the work.

There are also strong prejudices in favour of straight lines, as constituting true beauty in the human form, where they never should appear. A middling connoisseur thinks no profile has beauty without a very straight nose, and if the forehead be continued straight with it, he thinks it is still more sublime. I have seen miserable scratches with the pen, sell at a considerable rate for only having in them a side face or two, like that between fig. 22, and fig. 105, plate 1, which was made, and any one might do the same, with the eyes shut. The common notion that a person should be straight as an arrow, and perfectly erect is of this kind. If a dancing-master were to see his scholar in the easy and gracefully-turned attitude of the Antinous (fig. 6, plate 1), he would cry shame on him, and tell him he looked as crooked as a ram's horn, and bid him hold up his head as he himself did. See fig. 7, plate 1.

The painters, in like manner, by their works, seem to be no less divided upon the subject than the authors. The French, except such as have imitated the antique, or the Italian school, seem to have studiously

7. De Piles, *Art of Painting*, p. 8 (again, paraphrased). Hogarth's interest in de Piles, reflected throughout the *Analysis*, would have been based on his reputation as an opponent of the academic rules.

8. On the *je ne sais quoi*, see, besides ten Kate's *Beau Ideal* (to which Hogarth is leading up), e.g., Dominque Bouhours, "Le Je ne sais quoi," in *Les Entretiens d'Ariste et d'Eugène* (1671); more recently, William Whitehead's poem, "The *Je ne scai quoi*," in *Dodsley's Collection of Poems* (1748). On *grace*, Hogarth relies primarily on de Piles: *la grace plais sans les règles* (*Art of Painting*, p. 8; *Abrégé*, p. 11). On the one hand *grace*, like the *je ne sais quoi*, was too vague, but as *un poco piu* it led Hogarth to the three-dimensional Line of Grace that exceeds by just so much the two-dimensional Line of Beauty (e.g., p. 56).

avoided the serpentine line in all their pictures, especially Anthony Coypel, history painter, and Rigaud, principal portrait painter to Lewis the 14th.[9]

Rubens, whose manner of designing was quite original, made use of a large flowing line as a principle, which runs through all his works, and gives a noble spirit to them; but he did not seem to be acquainted with what we call the *precise line*; which hereafter we shall be very particular upon, and which gives the delicacy we see in the best Italian masters; but he rather charged his contours in general with too bold and S-like swellings.

Raphael, from a straight and stiff manner, on a sudden changed his taste of lines at sight of Michael Angelo's works, and the antique statues;[10] and so fond was he of the serpentine line, that he carried it into a ridiculous excess, particularly in his draperies: though his great observance of nature suffer'd him not long to continue in this mistake.

Peter de Cortone form'd a fine manner in his draperies of this line.

We see this principle no where better understood than in some pictures of Corregio, particularly his Juno and Ixion: yet the proportions of his figures are sometimes such as might be corrected by a common sign painter.[11]

Whilst Albert Durer, who drew mathematically, never so much as deviated into grace, which he must sometimes have done in copying the life, if he had not been fetter'd with his own impracticable rules of proportion.[12]

9. Antoine Coypel (1661–1722) and Hyacinthe Rigaud (1659–1743), principal official painters to the courts of Louis XIV, the Regent, and Louis XV.

10. De Piles was probably Hogarth's source for the story of how Raphael stole into the Sistine Chapel and learned from the innovations of Michelangelo (*Art of Painting*, p. 124). Always in the back of Hogarth's mind were the Raphael Cartoons, echoed in many of his works.

11. Hogarth means Correggio's *Jupiter and Io* (Vienna, Kunsthistorisches Museum); but his misidentification casts light on *Marriage A-la-mode* 4, where the painting hangs on the wall above Countess Squander. Hogarth reads the cloud as the one Jupiter formed to deceive Ixion, who thought it was Juno, impregnated it, and produced the race of centaurs. In this case, the painting suggests that Silvertongue is as deluded as Ixion, believing he has seduced Juno when in fact it was only a cloud. For the cult of Correggio in England, see J.R. Hale, *England and the Italian Renaissance* (London, 1954) and Gerald Reitlinger, *Economics of Taste* (London, 1961).

12. For Hogarth's criticism of Dürer, "who drew mathematically," see plate 1, fig. 55. By "rules of proportion," he refers to *Les Quatre livres d'A. Durer . . . de la proportion des parties & pourtraicts des corps humaines* (1613). Dürer was sometimes used in this period to illustrate mathematical treatises.

But that which may have puzzled this matter most, may be, that Vandyke, one of the best portrait painters in most respects ever known, plainly appears not to have had a thought of this kind.[13] For there seems not to be the least grace in his pictures more than what the life chanced to bring before him. There is a print of the Dutchess of Wharton (fig. 52, plate 2), engraved by Van Gunst, from a true picture by him, which is thoroughly divested of every elegance. Now, had he known this line as a principle, he could no more have drawn all the parts of this picture so contrary to it, than Mr. Addison could have wrote a whole Spectator in false grammar; unless it were done on purpose. However, on account of his other great excellencies, painters chuse to stile this want of grace in his attitudes, &c. *simplicity*, and indeed they do often very justly merit that epithet.

Nor have the painters of the present times been less uncertain and contradictory to each other, than the masters already mentioned, whatever they may pretend to the contrary: of this I had a mind to be certain, and therefore, in the year 1745, published a frontispiece to my engraved works, in which I drew a serpentine line lying on a painter's pallet, with these words under it, THE LINE OF BEAUTY.[14] The bait soon took; and no Egyptian hierogliphic ever amused more than it did for a time, painters and sculptors came to me to know the meaning of it, being as much puzzled with it as other people, till it came to have some explanation; then indeed, but not till then, some found it out to be an old acquaintance of theirs, tho' the account they could give of its properties was very near as satisfactory as that which a day-labourer who constantly uses the leaver, could give of that machine as a mechanical power.[15]

Others, as common face painters and copiers of pictures, denied that there could be such a rule either in art or nature, and asserted it was all stuff and madness; but no wonder that these gentlemen should not be ready in comprehending a thing they have little or no business with. For though the *picture copier* may sometimes to a common eye seem to vye with the original he copies, the artist himself requires no more

13. See MSS. III, p. 117.
14. The painting of Hogarth with his pug (Tate Gallery) is dated on the palette 1745; but here he refers to the engraving, *Gulielmus Hogarth* (*HGW* No. 181, ill. 9), which is dated 1749 (and by Vertue March 1748/9 [6:200]); Hogarth used it as "frontispiece to [his] engraved works," where it remained until it was replaced in 1758 by *Hogarth Painting the Comic Muse* (*HGW* No. 204).
15. Compare the subscription ticket, *Columbus Breaking the Egg* (ill. 1).

ability, genius, or knowledge of nature, than a journeyman-weaver at the Gobelins, who in working after a piece of painting, bit by bit, scarcely knows what he is about, whether he is weaving a man or a horse, yet at last almost insensibly turns out of his loom a fine piece of tapestry, representing, it may be, one of Alexander's battles painted by Le Brun.[16]

As the above-mention'd print thus involved me in frequent disputes by explaining the qualities of the line, I was extremely glad to find it (which I had conceiv'd as only part of a system in my mind) so well supported by the above precept of Michael Angelo: which was first pointed out to me by Dr. Kennedy, a learned antiquarian and connoisseur, of whom I afterwards purchased the translation, from which I have taken several passages to my purpose.[17]

Let us now endeavour to discover what light antiquity throws upon the subject in question.

Egypt first, and afterward Greece, have manifested by their works their great skill in arts and sciences, and among the rest painting, and sculpture, all which are thought to have issued from their great schools of philosophy.[18] Pythagoras, Socrates, and Aristotle, seem to have pointed out the right road in nature for the study of the painters and sculptors of those times (which they in all probability afterwards followed through those nicer paths that their particular professions required them to pursue) as may be reasonably collected from the

16. Charles Lebrun (1619–90) painted the series *The Battles of Alexander* for Louis XIV, starting in 1660; they were woven into tapestries by the Gobelin works. Hogarth parodied one of them, *The Battle of Arbella* (1689), in *Election* 4 (1754–58).

17. Dr. John Kennedy was a learned numismatist, author of *Oriuna, said to be Empress, or Queen of England* (1751), an argument based on his coin collection. He died in 1760; on 8–9 May his collection was auctioned (*Catalogue of the Genuine and Entire Collection of Greek and Roman Medals and Medalions . . .*).

18. Hogarth could have found the genealogy from Egypt and the emphasis on Pythagoras in Jonathan Richardson's *Science of a Connoisseur*, Warburton's *Divine Legation of Moses*, Freemason rituals, and many other sources. Pythagoras was an honorific name among the Freemasons. As James Anderson had written in his *Defense of Masonry* (1730), "I am fully convinced that Freemasonry is very nearly allied to the old Pythagorean Discipline, whence, I am persuaded, it may in some circumstances very justly claim a descent" (see also *Constitutions of the Free Masons* [1723], 20–21). Hogarth's friend the Rev. James Townley sent him a note suggesting the anagram of Hogarth/Pythagoras, which Hogarth saved among his papers. This half facetious, half flattering note is "From an Old Greek Fragment," citing a delphic oracle that claimed "that the source of beauty should never be again rigidly discovered, till a Person should arise, whose Name was perfectly included in the Name of Pythagoras" (BL Add. MS. 27995, f. 2; see *Hog.3*, 130). For William Warburton, see Introduction, p. xxxv.

answers given by Socrates to Aristippus his disciple, and Parrhasius the
painter, concerning FITNESS, the first fundamental law in nature with
regard to beauty.[19]

I am in some measure saved the trouble of collecting an historical
account of these arts among the ancients, by accidentally meeting with
a preface to a tract, call'd the *Beau Ideal*: this treatise* was written by
Lambert Hermanson Ten Kate, in French, and translated into English
by James Christopher le Blon;[20] who in that preface says, speaking of
the Author, "His superior knowledge that I am now publishing, is
the product of the Analogy of the ancient Greeks; or the true key
for finding all harmonious proportions in painting, sculpture, architec-
ture, musick, &c. brought home to Greece by Pythagoras. For after this
great philosopher had travell'd into Phœnicia, Egypt and Chaldea,
where he convers'd with the learned; he return'd into Greece about
Anno Mundi 3484, before the christian æra 520, and brought with him
many excellent discoveries and improvements for the good of his coun-
trymen, among which the Analogy was one of the most considerable
and useful.

"After him the Grecians, by the help of this Analogy, began (and not
before) to excel other nations in sciences and arts; for whereas before this
time they represented their *Divinities* in plain human figures, the Gre-
cians now began to enter into the Beau Ideal; and Pamphilus, (who
flourish'd A. M. 3641, before the christian æra 363, who taught, that no

* Publish'd in 1732, and sold by A. Millar.

19. The passage concerning Socrates' dialogue with Aristippus and Parrhasius on "fit-
ness" was translated for Hogarth by the Rev. Thomas Morell, D.D., the classical scholar and
librettist of Handel's oratorios (MS. Add. 27992, ff. [33–35]; *Memorabilia*, trans. O.J. Todd
[Cambridge, Mass., Loeb Library, 1923], 3.8).

20. James Christopher le Blon, preface, Lambert Hermansz ten Kate, *The Beau Ideal*,
trans. le Blon (London, 1732), pp. ii–iii. Le Blon dedicated the book to Lady Walpole, who
had secured him permission to copy the Raphael Cartoons for tapestries. His argument about
the mysterious "Analogy" is that because artists do not understand it, most copies of the
Cartoons have been "so unhappily executed" (p. iv). The purpose of his preface is essentially
to praise the Cartoons and puff his tapestries. The treatise in which ten Kate explains the
"Analogy," however, is *not* the one le Blon has translated but an unpublished manuscript.
"Many years ago," le Blon tells us, ten Kate "wrote an excellent Book of the Grecian Analogy,
with most curious Figures drawn by his own Hand." Le Blon hopes to publish this separately
but does not seem to have done so. This is the reason Hogarth's curiosity was not satisfied
when he proceeded to ten Kate's text, which is about the *je ne sais quoi*. He may have learned
of ten Kate's book through the Richardsons, who acknowledged ten Kate's help on the
French translation of their *Account of Some of the Statues, Bas-reliefs, Drawings, and Pictures in
Italy* (vol. 3 of their works, *Traité de la Peinture* [1728]). Ten Kate was a Dutch polymath,
collector of books and drawings, and authority on Dutch phonology.

man could excel in painting without mathematicks) the scholar of Pausias and master of Apelles, was the first who artfully apply'd the said Analogy to the art of painting; as much about the same time the sculpturers, the architects, &c. began to apply it to their several arts, without which science, the Grecians had remain'd as ignorant as their forefathers.

"They carried on their improvements in drawing, painting, architecture, sculpture, &c. till they became the wonders of the world; especially after the Asiaticks and Egyptians (who had formerly been the teachers of the Grecians) had, in process of time and by the havock of war, lost all the excellency in sciences and arts; for which all other nations were afterwards obliged to the Grecians, without being able so much as to imitate them.

"For when the Romans had conquer'd Greece and Asia, and had brought to Rome the best paintings and the finest artists, we don't find they discover'd the great key of knowledge, the Analogy I am now speaking of; but their best performances were conducted by Grecian artists, who it seems cared not to communicate their secret of the Analogy; because either they intended to be necessary at Rome, by keeping the secret among themselves, or else the Romans, who principally affected universal dominion, were not curious enough to search after the secret, not knowing the importance of it, nor understanding that, without it, they could never attain to the excellency of the Grecians: though nevertheless it must be own'd that the Romans used well the proportions, which the Grecians long before had reduced to certain fixed rules according to their ancient Analogy; and the Romans could arrive at the happy use of the proportions, without comprehending the Analogy itself."

This account agrees with what is constantly observed in Italy, where the Greek, and Roman work, both in medals and statues, are as distinguishable as the characters of the two languages.

As the preface had thus been of service to me, I was in hopes from the title of the book (and the assurance of the translator, that the author had by his great learning discover'd the secret of the ancients) to have met with something there that might have assisted, or confirm'd the scheme I had in hand; but was much disappointed in finding nothing of that sort, and no explanation, or even after-mention of what at first agreeably alarm'd me, the word *Analogy*. I have given the reader a specimen, in his own words, how far the author has discover'd this grand secret of the ancients, or *great key of knowledge*, as the translator calls it.

"The sublime part that I so much esteem, and of which I have begun to speak, is a real *Je ne sçai quoi*, or an unaccountable something to most people, and it is the most important part to all the connoisseurs. I shall call it an harmonious propriety, which is a touching or moving unity, or a pathetick agreement or concord, not only of each member to its body, but also of each part to the member of which it is a part: *It is also an infinite variety of parts*, however conformable, with respect to each different subject, so that all the attitude, and all the adjustment of the draperies of each figure ought to answer or correspond to the subject chosen. Briefly, it is a true decorum, a bienseance or a congruent disposition of ideas, as well for the face and stature, as for the attitudes. A bright genius, in my opinion, who aspires to excel in the ideal, should propose this to himself, as what has been the principal study of the most famous artists. 'Tis in this part that the great masters cannot be imitated or copied but by themselves, or by those that are advanced in the knowledge of the ideal, and who are as knowing as those masters in the rules or laws of the pittoresque and poetical nature, altho' inferior to the masters in the high spirit of invention."[21]

The words in this quotation "*It is also an infinite variety of parts*,"[22] seem at first to have some meaning in them, but it is entirely destroy'd by the rest of the paragraph, and all the other pages are filled, according to custom, with descriptions of pictures.

Now, as every one has a right to conjecture what this discovery of the ancients might be, it shall be my business to shew it was a key to the thorough knowledge of variety both in form, and movement. Shakespear, who had the deepest penetration into nature, has sum'd up all the charms of beauty in two words, INFINITE VARIETY; where, speaking of Cleopatra's power over Anthony, he says,

—————— Nor custom stale
Her infinite variety: —————— Act 2. Scene 3.[23]

It has been ever observed, that the ancients made their doctrines mysterious to the vulgar, and kept them secret from those who were not of their particular sects, and societies, by means of symbols, and hiero-

21. Ten Kate, *Beau Ideal*, p. 3.

22. Ten Kate reiterates this phrase in his last paragraph, where he writes that he has been reflecting "upon the mutual *Harmony* and the charming *Variety of Parts*" in the "*sublime* part of the Art" (p. 21). Hogarth develops the idea in the chapter "Of Proportion."

23. Shakespeare, *Antony and Cleopatra*, 2.3.240–41. Shakespeare was popularly associated with both nature and variety.

glyphics. Lomazzo says, chap. 29, book 1. "The Grecians in imitation of antiquity searched out the truly renowned proportion, wherein the exact perfection of most exquisite beauty and sweetness appeareth; dedicating the same in a triangular glass unto Venus the goddess of divine beauty, from whence all the beauty of inferior things is derived."[24]

If we suppose this passage to be authentic, may we not also imagine it probable, that the symbol in the triangular glass, might be similar to the line Michael Angelo recommended; especially, if it can be proved, that the triangular form of the glass, and the serpentine line itself, are the two most expressive figures that can be thought of to signify not only beauty and grace, but the whole *order of form*.

There is a circumstance in the account Pliny gives of Apelles's visit to Protogenes, which strengthens this supposition. I hope I may have leave to repeat the story.[25] Apelles having heard of the fame of Protogenes, went to Rhodes to pay him a visit, but not finding him at home asked for a board, on which he drew a *line*, telling the servant maid, that line would signify to her master who had been to see him; we are not clearly told what sort of a line it was that could so particularly signify one of the first of his profession: if it was only a stroke (tho' as fine as a hair as Pliny seems to think) it could not possibly, by any means, denote the abilities of a great painter. But if we suppose it to be a line of some extraordinary quality, such as the serpentine line will appear to be, Apelles could not have left a more satisfactory signature of the complement he had paid him. Protogenes when he came home took the hint, and drew a finer *or rather more expressive line* within it, to shew Apelles if he came again, that he understood his meaning. He, soon returning, was well-pleased with the answer Protogenes had left for him, by which he was convinced that fame had done him justice, and so correcting the line again, perhaps by making it more precisely elegant, he took his leave. The story thus may

24. Lomazzo, *Tracte*, "Whence all Proportions doe Arise," p. 115. A pyramid is reproduced on the page opposite.
25. The original source is Pliny, *Historia Naturalis*, 35.81–83. Hogarth could have found the story in de Piles's *Art of Painting* (p. 85), which also cites how Giotto proved his mastery by drawing a "perfect circle" freehand (p. 98); and in Matthew Prior's poem "Protogenes and Apelles" (1718), in which Protogenes' line – a circle – amplifies Apelles' "flowing Line" ("Full, and Round, and Fair"). He might have noted that in Prior's poem Apelles' line is amplified by Protogenes' in such a way "That Paris' Apple stood confest, / Or Leda's Egg, or Cloe's Breast." (See Prior, *Literary Works*, ed. H.B. Wright and M.K. Spears [Oxford, 1959], 1:463–65; also H. van de Waal, "The *linea summae tenuitatis* of Apelles: Pliny's Phrase and Its Interpreters," in *Zeitschrift fur Asthetik und allgemeine Kunstwissenschaft*, 12 [1967]:5–32.)

be reconcil'd to common sense, which, as it has been generally receiv'd, could never be understood but as a ridiculous tale.

Let us add to this, that there is scarce an Egyptian, Greek, or Roman deity, but hath a twisted serpent, twisted cornucopia, or some symbol winding in this manner to accompany it.[26] The two small heads (over the busto of the Hercules, fig. 4, in plate 1) of the goddess Isis, one crowned with a globe between two horns, the other with a lily,* are of this kind. Harpocrates, the god of silence, is still more remarkably so, having a large twisted horn growing out of the side of his head, one cornucopia in his hand, and another at his feet, with his finger placed on his lips, indicating secrecy: (see Montfaucon's antiquities) and it is as remarkable, that the deities of barbarous and gothic nations never had, nor have to this day, any of these elegant forms belonging to them.[27] How absolutely void of these turns are the pagods of China, and what a mean taste runs through most of their attempts in painting and sculpture, notwithstanding they finish with such excessive neatness; the whole nation in these matters seem to have but one eye: this mischief naturally follows from the prejudices they imbibe by copying one anothers works, which the ancients seem seldom to have done.

Upon the whole, it is evident, that the ancients studied these arts very differently from the moderns: Lomazzo seems to be partly aware of this, by what he says in the division of his work, page 9,[28] "There is a two-folde proceeding in all artes and sciences: the one is called the order of nature, and the other of teaching. Nature proceedeth ordinarily,

* The leaves of this flower as they grow, twist themselves various ways in a pleasing manner, as may be better seen by figure 43, in plate 1, but there is a curious little flower called the Autumn Syclamen, fig. 47, the leaves of which elegantly twist one way only.

26. One of Venus's attributes, in Bernard de Montfaucon's compendium of antique sculpture, is a grape stalk folded about with a serpentine vine and topped with an ear of corn. Venus (rising from the sea) was portrayed with a cornucopia "to denote the Plenty of things the Sea produces for Men." But Montfaucon begins with an image of Isis, folded about with a serpent (her husband, Serapis, is equally served). (For Venus, see Montfaucon, *Antiquity Explained and Represented in Sculptures*, trans. David Humphreys [1721–22], 1:93–98; 1:102–3, pl. 52, figs. 3, 10; for Isis-Serapis, see *Supplement to Antiquity Explained*, trans. Humphreys [1725], pp. 215 and 212, pls. 46 and 45.)

Asclepius also has as an attribute a staff encircled with a single serpent (*Antiquity Explained*, 1:180–81). As son of Apollo, a healer, and a Christological figure, he fitted into Hogarth's scheme as well. All of these are distinct from the more familiar caduceus of Mercury, "a Rod wreathed round with two Serpents, with their Heads meeting over the top of it," a "Symbol of Peace" (1:78).

27. Montfaucon, *Antiquity Explained*, 2:190–93 (Harpocrates was the son of Isis and Osiris).

28. Lomazzo, *Tracte*, pp. 9–10.

beginning with the unperfect, as the particulars, and ending with the perfect, as the universals. Now if in searching out the nature of things, our understanding shall proceede after that order, by which they are brought forth by nature, doubtlesse it will be the most absolute and ready method that can bee imagined. For we beginne to know things by their first and immediate principles, &c. and this is not only mine opinion but Aristotles also," yet, mistaking Aristotle's meaning, and absolutely deviating from his advice, he afterwards says, "all which if we could comprehend within our understanding, we should be most wise; but it is *impossible*," and after having given some dark reasons why he thinks so, he tells you "he resolves to follow the order of teaching," which all the writers on painting have in like manner since done.

Had I observed the foregoing passage, before I undertook this essay, it probably would have put me to a stand, and deterred me from venturing upon what Lomazzo calls an impossible task: but observing in the foremention'd controversies that the torrent generally ran against me; and that several of my opponents had turn'd my arguments into ridicule, yet were daily availing themselves of their use, and venting them even to my face as their own; I began to wish the publication of something on this subject; and accordingly applied myself to several of my friends, whom I thought capable of taking up the pen for me, offering to furnish them with materials by word of mouth: but finding this method not practicable, from the difficulty of one man's expressing the ideas of another, especially on a subject which he was either unacquainted with, or was new in its kind, I was therefore reduced to an attempt of finding such words as would best answer my own ideas, being now too far engaged to drop the design.[29] Hereupon, having digested the matter as well as I could, and thrown it into the form of a book, I submitted it to the judgment of such friends whose sincerity and abilities I could best rely on, determining on their approbation or dislike to publish or destroy it: but their favourable opinion of the manuscript being publicly known, it gave such a credit to the undertaking, as soon changed the countenances of those, who had a better

29. Hogarth wrote the first draft (A) on small sheets of paper (8 × 6 or $6^1/_2$ in.) folded to leave half for additions: he wrote in the right half and added on the left and sometimes on the back as well. The second draft (B) is written on paper of the same size but straight across. The third draft (C) is in the hand of an amanuensis with additions and corrections by Hogarth and Morell. Morell's corrections are only of style, not of sense. The MSS., bound in six volumes, are in the BL (Egerton MSS. 3011–16). See MSS. IV, below, p. 118.

opinion of my pencil, than my pen, and turn'd their sneers into expectation: especially when the same friends had kindly made me an offer of conducting the work through the press. And here I must acknowledge myself particularly indebted to one gentleman for his corrections and amendment of at least a third part of the wording.[30] Through his absence and avocations, several sheets went to the press without any assistance, and the rest had the occasional inspection of one or two other friends.[31] If any inaccuracies shall be found in the writing, I shall readily acknowledge them all my own, and am, I confess, under no great concern about them, provided the matter in general may be found useful and answerable in the application of it to truth and nature; in which material points, if the reader shall think fit to rectify any mistakes, it will give me a sensible pleasure, and be doing great honour to the work.

30. Benjamin Hoadly, M.D. (d. 1757), son of the bishop and Hogarth's close friend. "Pencil", in this period, meant paint brush.

31. Primarily Morell and Townley, who corrected the preface, but also James Ralph, the journalist. See *Gen. Works*, 1:222, for all these identifications. The best evidence, however, is Paul Sandby's caricatures, which place the portly Hoadly and the slender Morell and Townley in Hogarth's company (see ills. 22, 24).

CONTENTS

INTRODUCTION. *The use and advantage of considering solid objects as only thin shells composed of lines, like the outer-coat of an onion.* 17

CHAPTER I. *Of* FITNESS, 25

CHAP. II. *Of* VARIETY, 27

CHAP. III. *Of* UNIFORMITY, REGULARITY, *or* SYMMETRY, 28

CHAP. IV. *Of* SIMPLICITY, *or* DISTINCTNESS, 30

CHAP. V. *Of* INTRICACY, 32

CHAP. VI. *Of* QUANTITY, 35

CHAPTER VII. *Of* LINES, 41

CHAP. VIII. *Of what sort of parts and how* PLEASING FORMS *are composed,* 42

CHAP. IX. *Of* COMPOSITIONS *with the* WAVING LINE, 48

CHAP. X. *Of* COMPOSITIONS *with the* SERPENTINE LINE, 50

CHAP. XI. *Of* PROPORTION, 59

CHAP. XII. *Of* LIGHT *and* SHADE, *and the manner in which objects are explained to the eye by them,* 75

CHAP. XIII. *Of* COMPOSITION *with regard to* LIGHT, SHADE, *and* COLOURS, 83

CHAP. XIV. *Of* COLOURING, 87

CHAP. XV. *Of the* FACE. 1. *In the highest taste, and the reverse.* 2. *As to character and expression.* 3. *Of the manner in which the lines of the Face alter from infancy upwards, and shew the different Ages,* 94

CHAP. XVI. *Of* ATTITUDE, 102

CHAP. XVII. *Of* ACTION. 1. *A new method of acquiring an easy and graceful movement of the hand and arms.* 2. *Of the head, &c.* 3. *Of dancing, particularly the minuet.* 4. *Of country-dancing, and, lastly, of stage-action.* 104

INTRODUCTION

I NOW offer to the public a short essay, accompanied with two explana- tory prints, in which I shall endeavour to shew what the principles are in nature, by which we are directed to call the forms of some bodies beautiful, others ugly; some graceful, and others the reverse; by consid- ering more minutely than has hitherto been done, the nature of those lines, and their different combinations, which serve to raise in the mind the ideas of all the variety of forms imaginable. At first, perhaps, the whole design, as well as the prints, may seem rather intended to trifle and confound, than to entertain and inform: but I am persuaded that when the examples in nature, referr'd to in this essay, are duly consider'd and examined upon the principles laid down in it, it will be thought worthy of a careful and attentive perusal: and the prints them- selves too will, I make no doubt, be examined as attentively, when it is found, that almost every figure in them (how odly soever they may seem to be group'd together) is referr'd to singly in the essay, in order to assist the reader's imagination, when the original examples in art, or nature, are not themselves before him.

And in this light I hope my prints will be consider'd, and that the figures referr'd to in them will never be imagined to be placed there by me as examples themselves, of beauty or grace, but only to point out to the reader what sorts of objects he is to look for and examine in nature, or in the works of the greatest masters. My figures, therefore, are to be consider'd in the same light, with those a mathematician makes with his pen, which may convey the idea of his demonstration, tho' not a line in them is either perfectly straight, or of that peculiar curvature he is treating of. Nay, so far was I from aiming at grace, that I purposely chose to be least accurate, where most beauty might be expected, that no stress might be laid on the figures to the prejudice of the work itself. For I must confess, I have but little hopes of having a favourable attention given to my design in general, by those who have already had a more fashionable introduction into the mysteries of the arts of

painting, and sculpture. Much less do I expect, or in truth desire, the countenance of that set of people, who have an interest in exploding any kind of doctrine, that may teach us to *see with our own eyes*.

It may be needless to observe, that some of the last-mention'd, are not only the dependents on, but often the only instructors and leaders of the former; but in what light they are so consider'd abroad, may be partly seen by a burlesque representation of them [fig. 1, plate 1 top], taken from a print publish'd by Mr. Pond, design'd by Cavr. Ghezzi at Rome.[32]

To those, then, whose judgments are unprejudiced,[33] this little work is submitted with most pleasure; because it is from such that I have hitherto received the most obligations, and now have reason to expect most candour.

Therefore I would fain have such of my readers be assured, that however they may have been aw'd, and over-born by pompous terms of art, hard names, and the parade of seemingly magnificent collections of pictures and statues; they are in a much fairer way, ladies, as well as gentlemen, of gaining a perfect knowledge of the elegant and beautiful in artificial, as well as natural forms, by considering them in a systematical, but at the same time familiar way, than those who have been prepossess'd by dogmatic rules, taken from the performances of art only: nay, I will venture to say, sooner, and more rationally, than even a tolerable painter, who has imbibed the same prejudices.

The more prevailing the notion may be, that painters and connoisseurs are the only competent judges of things of this sort; the more it becomes necessary to clear up and confirm, as much as possible, what has only been asserted in the foregoing paragraph: that no one may be deterr'd, by the want of such previous knowledge, from entring into this enquiry.

The reason why gentlemen, who have been inquisitive after knowledge in pictures, have their eyes less qualified for our purpose, than others, is because their thoughts have been entirely and continually employ'd and incumber'd with considering and retaining the various

32. For the career of Arthur Pond and his merchandising of Pier-Leone Ghezzi's caricatures in England, see Louise Lippincott, *Selling Art in Georgian London: The Rise of Arthur Pond* (New Haven and London, 1983). Hogarth satirized Ghezzi's caricatures in *Characters and Caricaturas* (1743, *HGW* No. 156 [ill. 15]).

33. This is one of Richardson's criteria for a connoisseur with which Hogarth agrees, while taking issue with most others (*Essay on the Art of Criticism*, in *Works*, pp. 170–75; also *Science of a Connoisseur*). See Introduction, n. 20.

manners in which pictures are painted, the histories, names, and charac-
ters of the masters, together with many other little circumstances
belonging to the mechanical part of the art; and little or no time has
been given for perfecting the ideas they ought to have in their minds, of
the objects themselves in nature: for by having thus espoused and
adopted their first notions from nothing but *imitations*, and becoming
too often as bigotted to their faults, as their beauties, they at length, in
a manner, totally neglect, or at least disregard the works of nature,
merely because they do not tally with what their minds are so strongly
prepossess'd with.

Were not this a true state of the case, many a reputed capital picture,
that now adorns the cabinets of the curious in all countries, would
long ago have been committed to the flames: nor would it have been
possible for the Venus and Cupid, represented by the figure [under fig.
49, plate 1 top], to have made its way into the principal apartment of
a palace.

It is also evident that the painter's eye may not be a bit better fitted
to receive these new impressions, who is in like manner too much
captivated with the works of art; for he also is apt to pursue the shadow,
and drop the substance. This mistake happens chiefly to those who go to
Rome for the accomplishment of their studies,[34] as they naturally will,
without the utmost care, take the infectious turn of the connoisseur,
instead of the painter: and in proportion as they turn by those means
bad proficients in their own arts, they become the more considerable in
that of a connoisseur. As a confirmation of this seeming paradox, it has
ever been observ'd at all auctions of pictures, that the very worst
painters sit as the most profound judges, and are trusted only, I suppose,
on account of their *disinterestedness*.[35]

I apprehend a good deal of this will look more like resentment, and
a design to invalidate the objections of such as are not likely to set the
faults of this work in the most favourable light; than merely for the
encouragement, as was said above, of such of my readers, as are neither
painters, nor connoisseurs: and I will be ingenuous enough to confess
something of this may be true; but, at the same time, I cannot allow that
this alone would have been a sufficient motive to have made me risk

34. "Rome" was a loaded word for Hogarth, connoting not only the Grand Tour but
popery and Jacobitism.

35. Hogarth's ironic use of "disinterestedness" refers to the criterion of Shaftesbury and
Hutcheson for distinguishing the aesthetic attitude toward an object from one stimulated by
desire, hunger, or the need to possess.

giving offence to any; had not another consideration, besides that already alledg'd, of more consequence to the purpose in hand, made it necessary. I mean the setting forth, in the strongest colours, the surprising alterations objects seemingly undergo through the prepossessions and prejudices contracted by the mind. —— Fallacies, strongly to be guarded against by such as would learn to see objects truly!

Altho' the instances already given are pretty flagrant, yet it is certainly true, (as a farther confirmation of this, and for the consolation of those, who may be a little piqued at what has been said) that painters of every condition are stronger instances of the almost unavoidable power of prejudice, than any people whatever.

What are all the *manners*,[36] as they are call'd, of even the greatest masters, which are known to differ so much from one another, and all of them from nature, but so many strong proofs of their inviolable attachment to falshood, converted into establish'd truth in their own eyes, by self-opinion? Rubens would, in all probability, have been as much disgusted at the dry manner of Poussin, as Poussin was at the extravagant of Rubens. The prejudices of inferior proficients in favour of the imperfections of their own performances, is still more amazing. —— Their eyes are so quick in discerning the faults of others, at the same time they are so totally blind to their own! Indeed it would be well for us all, if one of Gulliver's flappers could be placed at our elbows to remind us at every stroke how much prejudice and self-opinion perverts our sight.[37]

From what has been said, I hope it appears that those, who have no bias of any kind, either from their own practice, or the lessons of others, are fittest to examine into the truth of the principles laid down in the following pages. But as every one may not have had an opportunity of being sufficiently acquainted with the instances, that have been given: I will offer one of a familiar kind, which may be a hint for their observing a thousand more. How gradually does the eye grow reconciled even to a disagreeable dress, as it becomes more and more the fashion, and how soon return to its dislike of it, when it is left off, and a new one has taken possession of the mind? —— so vague is taste, when it has no solid principles for its foundation!

Notwithstanding I have told you my design of considering minutely

36. Richardson makes much of painters' "manners" in his *Treatise on Painting*. The *querelle* in Paris, centered on the polemics of Roger de Piles, was over the relative value of the "manners" of Poussin and Rubens, argued by the *Poussinistes* and *Rubenistes*.

37. Swift, *Gulliver's Travels* (1726), Voyage 3.

the variety of lines, which serve to raise the ideas of bodies in the mind, and which are undoubtedly to be consider'd as drawn on the surfaces only of solid or opake bodies: yet the endeavouring to conceive, as accurate an idea as is possible, of the *inside* of those surfaces, if I may be allow'd the expression, will be a great assistance to us in the pursuance of our present enquiry.[38]

In order to my being well understood, let every object under our consideration, be imagined to have its inward contents scoop'd out so nicely, as to have nothing of it left but a thin shell, exactly corresponding both in its inner and outer surface, to the shape of the object itself: and let us likewise suppose this thin shell to be made up of very fine threads, closely connected together, and equally perceptible, whether the eye is supposed to observe them from without, or within; and we shall find the ideas of the two surfaces of this shell will naturally coincide. The very word, shell, makes us seem to see both surfaces alike.

The use of this conceit, as it may be call'd by some, will be seen to be very great, in the process of this work: and the oftner we think of objects in this shell-like manner, we shall facilitate and strengthen our conception of any particular part of the surface of an object we are viewing, by acquiring thereby a more perfect knowledge of the whole, to which it belongs: because the imagination will naturally enter into the vacant space within this shell, and there at once, as from a center, view the whole form within, and mark the opposite corresponding parts so strongly, as to retain the idea of the whole, and make us masters of the meaning of every view of the object, as we walk round it, and view it from without.

Thus the most perfect idea we can possibly acquire of a sphere, is by conceiving an infinite number of straight rays of equal lengths, issuing from the center, as from the eye, spreading every way alike; and circumscribed or wound about at their other extremities with close connected circular threads, or lines, forming a true spherical shell.

But in the common way of taking the view of any opake object, that part of its surface, which fronts the eye, is apt to occupy the mind alone, and the opposite, nay even every other part of it whatever, is left unthought of at that time: and the least motion we make to reconnoitre

38. Hogarth's elaborate instructions about scooping out and getting inside an object may have been suggested to him by Addison's discussion of "the Concave and the Convex" in *Spectator* No. 415. For another explanation, cf. Dobai, p. 358. See above, Introduction, p. xxxvii.

any other side of the object, confounds our first idea, for want of the connexion of the two ideas, which the complete knowledge of the whole would naturally have given us, if we had considered it in the other way before.

Another advantage of considering objects thus merely as shells composed of lines, is, that by these means we obtain the true and full idea of what is call'd the *outlines* of a figure, which has been confin'd within too narrow limits, by taking it only from drawings on paper; for in the example of the sphere given above, every one of the imaginary circular threads has a right to be consider'd as an out-line of the sphere, as well as those which divide the half, that is seen, from that which is not seen; and if the eye be supposed to move regularly round it, these threads will each of them as regularly succeed one another in the office of out-lines, (in the narrow and limited sense of the word:) and the instant any one of these threads, during this motion of the eye, comes into sight on one side, its opposite thread is lost, and disappears on the other. He who will thus take the pains of acquiring perfect ideas of the distances, bearings, and oppositions of several material points and lines in the surfaces of even the most irregular figures, will gradually arrive at the knack of recalling them into his mind when the objects themselves are not before him:[39] and they will be as strong and perfect as those of the most plain and regular forms, such as cubes and spheres; and will be of infinite service to those who invent and draw from fancy, as well as enable those to be more correct who draw from the life.

In this manner, therefore, I would desire the reader to assist his imagination as much as possible, in considering every object, as if his eye were placed within it. As straight lines are easily conceiv'd, the difficulty of following this method in the most simple and regular forms will be less than may be first imagined; and its use in the more compounded will be greater: as will be more fully shewn when we come to speak of composition.

But as fig. [2, plate 1 left] may be of singular use to young designers in the study of the human form, the most complex and beautiful of all, in shewing them a mechanical way of gaining the opposite points in its surface, which never can be seen in one and the same view; it will be proper to explain the design of it in this place, as it may at the same time add some weight to what has been already said.

39. This remark (and earlier, p. 20, "serve to raise the ideas of bodies in the mind") may be the place where the important passage on visual mnemonics fitted into Hogarth's text; for which see MSS. V, p. 121.

It represents the trunk of a figure cast in soft wax, with one wire pass'd perpendicularly through its center, another perpendicularly to the first, going in before and coming out in the middle of the back, and as many more as may be thought necessary, parallel to and at equal distances from these, and each other; as is mark'd by the several dots in the figure. —— Let these wires be so loose as to be taken out at pleasure, but not before all the parts of them, which appear out of the wax, are carefully painted close up to the wax, of a different colour from those, that lie within it. By these means the horizontal and perpendicular *contents* of these parts of the body (by which I mean the distances of opposite points in the surface of these parts) through which the wires have pass'd, may be exactly known and compared with each other; and the little holes, where the wires have pierced the wax, remaining on its surface, will mark out the corresponding opposite points on the external muscles of the body; as well as assist and guide us to a readier conception of all the intervening parts. These points may be mark'd upon a marble figure with calipers properly used.

The known method, many years made use of, for the more exactly and expeditiously reducing drawings from large pictures, for engravings; or for enlarging designs, for painting cielings and cupolas, (by striking lines perpendicular to each other, so as to make an equal number of squares on the paper design'd for the copy, that hath been first made on the original; by which means, the situation of every part of the picture is mechanically seen, and easily transferred) may truly be said to be somewhat of the same kind with what has been here proposed, but that one is done upon a flat surface, the other upon a solid; and that the new scheme differs in its application, and may be of a much more useful and extensive nature than the old one.

But it is time now to have done with the introduction: and I shall proceed to consider the fundamental principles, which are generally allowed to give elegance and beauty, when duly blended together, to compositions of all kinds whatever; and point out to my readers, the particular force of each, in those compositions in nature and art, which seem most to *please and entertain the eye*, and give that grace and beauty, which is the subject of this enquiry. The principles I mean, are FITNESS, VARIETY, UNIFORMITY, SIMPLICITY, INTRICACY, and QUANTITY; —— *all which co-operate in the production of beauty, mutually correcting and restraining each other occasionally.*

THE

ANALYSIS

OF

BEAUTY

CHAPTER I

Of FITNESS

Fitness of the parts to the design for which every individual thing is form'd, either by art or nature, is first to be consider'd, as it is of the greatest consequence to the beauty of the whole. This is so evident, that even the sense of seeing, the great inlet of beauty, is itself so strongly bias'd by it, that if the mind, on account of this kind of value in a form, esteem it beautiful, tho' on all other considerations it be not so; the eye grows insensible of its want of beauty, and even begins to be pleas'd, especially after it has been a considerable time acquainted with it.

It is well known on the other hand, that forms of great elegance often disgust the eye by being improperly applied. Thus twisted columns are undoubtedly ornamental; but as they convey an idea of weakness, they always displease, when they are improperly made use of as supports to any thing that is bulky, or appears heavy.

The bulks and proportions of objects are govern'd by fitness and propriety. It is this that has establish'd the size and proportion of chairs,

tables, and all sorts of utensils and furniture. It is this that has fix'd the dimensions of pillars, arches, &c. for the support of great weight, and so regulated all the orders in architecture, as well as the sizes of windows and doors, &c. Thus though a building were ever so large, the steps of the stairs, the seats in the windows must be continued of their usual heights, or they would lose their beauty with their fitness: and in ship-building the dimensions of every part are confin'd and regulated by fitness for sailing. When a vessel sails well, the sailors always call her a beauty; the two ideas have such a connexion!

The general dimensions of the parts of the human body are adapted thus to the uses they are design'd for. The trunk is the most capacious on account of the quantity of its contents, and the thigh is larger than the leg, because it has both the leg and foot to move, the leg only the foot, &c.

Fitness of parts also constitutes and distinguishes in a great measure the characteristics of objects; as for example, the race-horse differs as much in quality, or character, from the war-horse, as to its figure, as the Hercules from the Mercury.[40]

The race-horse, having all its parts of such dimensions as best fit the purposes of speed, acquires on that account a consistent character of one sort of beauty. To illustrate this, suppose the beautiful head and grace-fully-turn'd neck of the war-horse were placed on the shoulders of the race-horse, instead of his own aukward straight one: it would disgust, and deform, instead of adding beauty; because the judgment would condemn it as unfit.

The Hercules, by Glicon [fig. 3, plate 1], hath all its parts finely fitted for the purposes of the utmost strength, the texture of the human form will bear. The back, breast and shoulders have huge bones, and muscles adequate to the supposed active strength of its upper parts; but as less strength was required for the lower parts, the judicious sculptor, contrary to all modern rule of enlarging every part in proportion, lessen'd the size of the muscles gradually down towards the feet; and for the same reason made the neck larger in circumference than any

40. Hogarth substitutes the race horse and war horse for Socrates's examples in Xenophon's *Memorabilia*: "a man that is beautiful and well made for running a race is very different from one that is so for wrestling" (Morell's translation, Add. MS. 27992; *Memorabilia*, 3.8). The dialogue on "fitness" in the *Memorabilia* is the basis for Hogarth's chapter (see n. 19 above). See Burke, "A Classical Aspect of Hogarth's 'Theory of Art,'" *Journal of the Warburg and Courtauld Institutes*, 6 (1943):151–53; *Analysis* ed., p. xxxiv.

part of the head [fig. 4, plate 1]; otherwise the figure would have been burden'd with an unnecessary weight, which would have been a drawback from his strength, and in consequence of that, from its characteristic beauty.

These seeming faults, which shew the superior anatomical knowledge as well as judgment of the ancients, are not to be found in the leaden imitations of it near Hyde-park.[41] These saturnine genius's imagin'd they knew how to correct such apparent *disproportions*.

These few examples may be sufficient to give an idea of what I mean, (and would have understood) by the beauty of fitness, or propriety.

CHAPTER II

Of VARIETY

HOW great a share variety has in producing beauty may be seen in the ornamental part of nature.[42]

The shapes and colours of plants, flowers, leaves, the paintings in butterflies wings, shells, &c. seem of little other intended use, than that of entertaining the eye with the pleasure of variety.

All the senses delight in it, and equally are averse to sameness. The ear is as much offended with one even continued note, as the eye is with being fix'd to a point, or to the view of a dead wall.

Yet when the eye is glutted with a succession of variety, it finds relief in a certain degree of sameness; and even plain space becomes agreeable, and properly introduced, and contrasted with variety, adds to it more variety.

41. Henry Cheere's sculpture yard at Hyde Park Corner is materialized in plate 1 of the *Analysis*. Richardson and his son Jonathan, Jr., in their *Account of Some of the Statues* (1722), had revealed the truth, elided by other antiquaries, that the best antique sculptures had not survived and that the canonical works were all copies by lesser "geniuses" of lost originals (Haskell and Penny, pp. 99–100).

42. Variety is a central term of the art treatises, but Hogarth's particular usage is based on Addison's "variety" in his discussion of the Novel and Francis Hutcheson's in his *Inquiry into the Original of our Ideas of Beauty and Virtue* (1725). For further notes on variety and fitness, see MSS. VI, p. 123.

I mean here, and every where indeed, a composed variety; for variety uncomposed, and without design, is confusion and deformity.[43]

Observe, that a gradual lessening is a kind of varying that gives beauty. The pyramid diminishing from its basis to its point, and the scroll or voluta, gradually lessening to its center, are beautiful forms. So also objects that only seem to do so, though in fact they do not, have equal beauty: thus perspective views, and particularly those of buildings, are always pleasing to the eye.

The little ship, between figure 47 and 88 [plate 1 right], suppos'd moving along the shore even with the eye, might have its top and bottom bounded by two lines at equal distances all the way, as A; but if the ship puts out to sea, these lines at top and bottom would seem to vary and meet each other by degrees, as B, in the point C, which is in the line where the sky and water meets, call'd the horizon. Thus much of the manner of perspectives adding beauty, by seemingly varying otherwise unvaried forms, I thought, might be acceptable to those, who have not learnt perspective.

CHAPTER III

Of UNIFORMITY, REGULARITY, *or* SYMMETRY

IT may be imagined that the greatest part of the effects of beauty results from the symmetry of parts in the object, which is beautiful: but I am very well persuaded, this prevailing notion will soon appear to have little or no foundation.

It may indeed have properties of greater consequence, such as propriety, fitness, and use; and yet but little serve the purposes of pleasing the eye, merely on the score of beauty.

We have, indeed, in our nature a love of imitation from our infancy, and the eye is often entertained, as well as surprised, with mimicry, and

43. In "composed variety" Hogarth invokes the topos of *concordia discors* (again, pp. 42, 45, 109).

delighted with the exactness of counterparts: but then this always gives way to its superior love of variety, and soon grows tiresom.

If the uniformity of figures, parts, or lines were truly the chief cause of beauty, the more exactly uniform their appearances were kept, the more pleasure the eye would receive: but this is so far from being the case, that when the mind has been once satisfied, that the parts answer one another, with so exact an uniformity, as to preserve to the whole the character of fitness to stand, to move, to sink, to swim, to fly, &c. without losing the balance: the eye is rejoiced to see the object turn'd, and shifted, so as to vary these uniform appearances.

Thus the profile of most objects, as well as faces, are rather more pleasing than their full fronts.

Whence it is clear, the pleasure does not arise from seeing the exact resemblance, which one side bears the other, but from the knowledge that they do so on account of fitness, with design, and for use. For when the head of a fine woman is turn'd a little to one side, which takes off from the exact similarity of the two halves of the face, and somewhat reclining, so varying still more from the straight and parallel lines of a formal front face: it is always look'd upon as most pleasing. This is accordingly said to be a graceful air of the head.

It is a constant rule in composition in painting to avoid regularity. When we view a building, or any other object in life, we have it in our power, by shifting the ground, to take that view of it which pleases us best; and in consequence of this, the painter if he is left to his choice, takes it on the angle rather than in front, as most agreeable to the eye; because the regularity of the lines is taken away by their running into perspective, without losing the idea of fitness: and when he is of necessity obliged to give the front of a building, with all its equalities and parallelisms, he generally breaks (as it is term'd) such disagreeable appearances, by throwing a tree before it, or the shadow of an imaginary cloud, or some other object that may answer the same purpose of adding variety, which is the same with taking away uniformity.

If uniform objects were agreeable, why is there such care taken to contrast, and vary all the limbs of a statue?

The picture of Henry the eighth [fig. 72, plate 2], would be preferable to the finely contrasted figures of Guido or Correggio; and the Antinous's easy sway [fig. 6, plate 1), must submit to the stiff and straight figure of the dancing master [fig. 7, plate 1]; and the uniform out-lines of the muscles in the figure taken from Albert Durer's book of proportions [fig. 55, plate 1], would have more taste in them than those

in the famous part of an antique figure [fig. 54, plate 1] from which Michael Angelo acquired so much of his skill in grace.

In short, whatever appears to be fit, and proper to answer great purposes, ever satisfies the mind, and pleases on that account. Uniformity is of this kind. We find it necessary, in some degree, to give the idea of rest and motion, without the possibility of falling. But when any such purposes can be as well effected by more irregular parts, the eye is always better pleased on the account of variety.

How pleasingly is the idea of firmness in standing convey'd to the eye by the three elegant claws of a table, the three feet of a tea-lamp, or the celebrated tripod of the ancients?[44]

Thus you see regularity, uniformity, or symmetry, please only as they serve to give the idea of fitness.

CHAPTER IV

Of SIMPLICITY, *or* DISTINCTNESS

SIMPLICITY, without variety, is wholly insipid, and at best does only not displease; but when variety is join'd to it, then it pleases, because it enhances the pleasure of variety, by giving the eye the power of enjoying it with ease.

There is no object composed of straight lines, that has so much variety, with so few parts, as the pyramid: and it is its constantly varying from its base gradually upwards in every situation of the eye, (without giving the idea of sameness, as the eye moves round it) that has made it be esteem'd in all ages, in preference to the cone, which in all views appears nearly the same, being varied only by light and shade.

Steeples, monuments, and most compositions in painting and sculpture are kept within the form of the cone or pyramid, as the most eligible boundary on account of their simplicity and variety. For the same reason equestrian statues please more than the single figures.

44. In the oracular shrine of Apollo in his temple at Delphi the priestess sat on a tripod over a fissure in the rock, uttering divine wisdom, which was interpreted by a priest. On tripods, see Montfaucon, *Antiquity Explained*, 2:85–86. Cf. above, p. 4.

The authors (for there were three concern'd in the work) of as fine a group of figures in sculpture, as ever was made, either by ancients or moderns, (I mean Laocoon and his two sons) chose to be guilty of the absurdity of making the sons of half the father's size, tho' they have every other mark of being design'd for men, rather than not bring their composition within the boundary of a pyramid [fig. 9, plate 1 top]. Thus if a judicious workman were employ'd to make a case of wood, for preserving it from the injuries of the weather, or for the convenience of carriage; he would soon find by his eye, the whole composition would readily fit and be easily pack'd up, in one of a pyramidal form.

Steeples, &c. have generally been varied from the cone, to take off from their too great simplicity, and instead of their circular bases, polygons of different, but even numbers of sides, have been substituted, I suppose for the sake of uniformity. These forms however may be said to have been chosen by the architect, with a view to the cone, as the whole composition might be bounded by it.

Yet, in my mind, odd numbers have the advantage over the even ones, as variety is more pleasing than uniformity, where the same end is answer'd by both; as in this case, where both polygons may be circumscrib'd by the same circle, or in other words, both compositions bounded by the same cone.

And I can't help observing, that nature in all her works of fancy, if I may be allow'd the expression, where it seems immaterial whether even or odd numbers of divisions were prefer'd, most frequently employs the odd; as for example, in the indenting of leaves, flowers, blossoms, &c.

The oval also, on account of its variety with simplicity, is as much to be prefer'd to the circle, as the triangle to the square, or the pyramid to the cube; and this figure lessen'd at one end, like the egg, thereby being more varied, is singled out by the author of all variety, to bound the features of a beautiful face.

When the oval has a little more of the cone added to it than the egg has, it becomes more distinctly a compound of those two most simple varied figures. This is the shape of the pine-apple [fig. 10, plate 1 top], which nature has particularly distinguish'd by bestowing ornaments of rich mosaic upon it, composed of contrasted serpentine lines, and the pips [fig. 11, plate 1 top], as the gardeners call them, are still varied by two cavities and one round eminence in each.

Could a more elegant simple form than this have been found; it is probable that judicious architect, Sir Christopher Wren, would not have

chosen the pine-apples for the two terminations of the sides of the front of St. Paul's: and perhaps the globe and cross, tho' a finely varied figure, which terminates the dome, would not have had the preference of situation, if a religious motive had not been the occasion.

Thus we see simplicity gives beauty even to variety, as it makes it more easily understood, and should be ever studied in the works of art, as it serves to prevent perplexity in forms of elegance; as will be shewn in the next chapter.

CHAPTER V

Of INTRICACY

THE active mind is ever bent to be employ'd. Pursuing is the business of our lives; and even abstracted from any other view, gives pleasure. Every arising difficulty, that for a while attends and interrupts the pursuit, gives a sort of spring to the mind, enhances the pleasure, and makes what would else be toil and labour, become sport and recreation.[45]

Wherein would consist the joys of hunting, shooting, fishing, and many other favourite diversions, without the frequent turns and difficulties, and disappointments, that are daily met with in the pursuit? —— how joyless does the sportsman return when the hare has not had fair play? how lively, and in spirits, even when an old cunning one has baffled, and out-run the dogs!

This love of pursuit, merely as pursuit, is implanted in our natures, and design'd, no doubt, for necessary, and useful purposes. Animals have it evidently by instinct. The hound dislikes the game he so eagerly pursues; and even cats will risk the losing of their prey to chase it over

45. "Intricacy" and the vocabulary of pursuit invoke Locke's metaphor of the chase from the beginning of the *Essay concerning Human Understanding* (1690): the mind's "searches after truth are a sort of hawking and hunting, wherein the very pursuit makes a great part of the pleasure" (*Essay*, ed. Peter H. Nidditch [1975; Oxford, 1979], p. 7 [cf. p. 508]); this was picked up by Addison in the context of his aesthetic category the Novel, connecting the words *start, hunt, pleasure, variety, odd Creatures, puzzle,* and *chace.* For elaboration, in particular of the implicit concept of curiosity, introduced on pp. 1 and 6 (a significant aspect of Addison's Novel), see MSS. VII, p. 124.

again. It is a pleasing labour of the mind to solve the most difficult problems; allegories and riddles, trifling as they are, afford the mind amusement: and with what delight does it follow the well-connected thread of a play, or novel, which ever increases as the plot thickens, and ends most pleas'd, when that is most distinctly unravell'd?

The eye hath this sort of enjoyment in winding walks, and serpentine rivers, and all sorts of objects, whose forms, as we shall see hereafter, are composed principally of what, I call, the *waving* and *serpentine* lines.

Intricacy in form, therefore, I shall define to be that peculiarity in the lines, which compose it, that *leads the eye a wanton kind of chace*, and from the pleasure that gives the mind, intitles it to the name of beautiful: and it may be justly said, that the cause of the idea of grace more immediately resides in this principle, than in the other five, except variety; which indeed includes this, and all the others.

That this observation may appear to have a real foundation in nature, every help will be requir'd, which the reader himself can call to his assistance, as well as what will here be suggested to him.

To set this matter in somewhat a clearer light, the familiar instance of a common jack, with a circular fly, may serve our purpose better than a more elegant form: preparatory to which, let figure [14, plate 1 top] be consider'd, which represents the eye, at a common reading distance viewing a row of letters, but fix'd with most attention to the middle letter A.

Now as we read, a ray may be supposed to be drawn from the center of the eye to that letter it looks at first, and to move successively with it from letter to letter, the whole length of the line: but if the eye stops at any particular letter, A, to observe it more than the rest, these other letters will grow more and more imperfect to the sight, the farther they are situated on either side of A, as is express'd in the figure: and when we endeavour to see all the letters in a line equally perfect at one view, as it were, this imaginary ray must course it to and fro with great celerity. Thus though the eye, strictly speaking, can only pay due attention to these letters in succession, yet the amazing ease and swiftness, with which it performs this task, enables us to see considerable spaces with sufficient satisfaction at one sudden view.

Hence, we shall always suppose some such principal ray moving along with the eye, and tracing out the parts of every form, we mean to examine in the most perfect manner: and when we would follow with exactness the course any body takes, that is in motion, this ray is always to be supposed to move with the body.

In this manner of attending to forms, they will be found whether *at rest*, or *in motion*, to give *movement* to this imaginary ray; or, more properly speaking, to the eye itself, affecting it *thereby* more or less *pleasingly*, according to their different *shapes* and *motions*. Thus, for example, in the instance of the jack, whether the eye (with this imaginary ray) moves slowly down the line, to which the weight is fix'd, or attends to the slow motion of the weight itself, the mind is equally fatigu'd: and whether it swiftly courses round the circular rim of the flyer, when the jack stands; or nimbly follows one point in its circularity whilst it is whirling about, we are almost equally made giddy by it. But our sensation differs much from either of these unpleasant ones, when we observe the curling worm, into which the worm-wheel is fixt [fig. 15, plate 1 top]: for this is always pleasing, either at rest or in motion, and whether that motion is slow or quick.

That it is accounted so, when it is *at rest*, appears by the ribbon, twisted round a stick (represented on one side of this figure) which has been a long-establish'd ornament in the carvings of frames, chimney-pieces, and door-cases; and call'd by the carvers, *the stick and ribbon ornament*: and when the stick, through the middle is omitted, it is call'd the *ribbon edge*; both to be seen in almost every house of fashion.

But the pleasure it gives the eye is still more lively when *in motion*. I never can forget my frequent strong attention to it, when I was very young, and that its beguiling movement gave me the same kind of sensation then, which I since have felt at seeing a country-dance; tho' perhaps the latter might be somewhat more engaging; particularly when my eye eagerly pursued a favourite dancer, through all the windings of the figure, who then was bewitching to the sight, as the imaginary ray, we were speaking of, was dancing with her all the time.

This single example might be sufficient to explain what I mean by *the beauty of a composed intricacy of form*; and how it may be said, with propriety, to *lead* the eye a *kind of chace*.

But the hair of the head is another very obvious instance, which, being design'd chiefly as an ornament, proves more or less so, according to the form it naturally takes, or is put into by art. The most amiable in itself is the flowing curl; and the many waving and contrasted turns of naturally intermingling locks ravish the eye with the pleasure of the pursuit, especially when they are put in motion by a gentle breeze. The

poet knows it, as well as the painter, and has described the wanton ringlets waving in the wind.[46]

And yet to shew how excess ought to be avoided in intricacy, as well as in every other principle, the very same head of hair, wisp'd, and matted together, would make the most disagreeable figure; because the eye would be perplex'd, and at a fault, and unable to trace such a confused number of uncomposed and entangled lines; and yet notwithstanding this, the present fashion the ladies have gone into, of wearing a part of the hair of their heads braided together from behind, like intertwisted serpents, arising thickest from the bottom, lessening as it is brought forward, and naturally conforming to the shape of the rest of the hair it is pin'd over, is extremely picturesque.[47] Their thus interlacing the hair in distinct varied quantities is an artful way of preserving as much of intricacy, as is beautiful.

CHAPTER VI

Of QUANTITY

FORMS of magnitude, although ill-shaped, will however, on account of their vastness, draw our attention and raise our admiration.

Huge shapeless rocks have a pleasing kind of horror in them, and the wide ocean awes us with its vast contents; but when forms of beauty are

46. Cf. Milton's description of Eve in *Paradise Lost*, 4.304–11 (emphasis added):

> She as a veil down to the slender waist
> Her unadorned golden tresses wore
> *Dishevell'd*, but in *wanton ringlets wav'd*
> As the vine curls her tendrils, which implied
> *Subjection*, but required with *gentle sway*,
> And by her yielded, by him best received,
> *Yielded with coy submission*, modest pride,
> And *sweet reluctant amorous delay*.

These lines are echoed by Pope: Belinda's locks are "labyrinths," "slender chains," and "Hairy Sprindges" that "betray," "surprise," and "draw" men to her (*Rape of the Lock* [1714], 2.23–28).

47. At this time *picturesque* meant resembling a picture, picturable, not what later became known as the Picturesque.

presented to the eye in large quantities, the pleasure increases on the mind, and horror is soften'd into reverence.

How solemn and pleasing are groves of high grown trees, great churches, and palaces? has not even a single spreading oak, grown to maturity, acquir'd the character of the venerable oak?

Windsor castle is a noble instance of the effect of quantity. The hugeness of its few distinct parts strikes the eye with uncommon grandeur at a distance, as well as nigh. It is quantity, with simplicity, which makes it one of the finest objects in the kingdom, tho' void of any regular order of architecture.

The Façade of the old Louvre at Paris is also remarkable for its quantity. This fragment is allow'd to be the finest piece of building in France, tho' there are many equal, if not superior, to it in all other respects, except that of quantity.

Who does not feel a pleasure when he pictures in his mind the immense buildings which once adorn'd the lower Egypt, by imagining the whole complete, and ornamented with colossal statues?

Elephants and whales please us with their unwieldy greatness. Even large personages, merely for being so, command respect: nay, quantity is an addition to the person which often supplies a deficiency in his figure.

The robes of state are always made large and full, because they give a grandeur of appearance, suitable to the offices of the greatest distinction. The judge's robes have an awful dignity given them by the quantity of their contents, and when the train is held up, there is a noble waving line descending from the shoulders of the judge to the hand of his train-bearer. So when the train is gently thrown aside, it generally falls into a great variety of folds, which again employ the eye, and fix its attention.

The grandeur of the Eastern dress, which so far surpasses the European, depends as much on quantity as on costliness.

In a word, it is quantity which adds greatness to grace. But then excess is to be avoided, or quantity will become clumsy, heavy, or ridiculous.[48]

48. In the margin of Draft A opposite these words Hogarth added: "When Improper or Incompatible excesses meet they generally excite our Laughter especially when the forms of those excesses are Inelegant that is when they are composed of unvaried lines" (BL. Eg.MS. 3011, f. 50). From this sentence he began to develop his thoughts on an analysis of the "ridiculous" (written on the reverse of the preceding page). For elaboration, see MSS. VIII, p. 125.

The full-bottom wig, like the lion's mane, hath something noble in it, and adds not only dignity, but sagacity to the countenance [fig. 16, plate 1]: but were it to be worn as large again, it would become a burlesque; or was an improper person to put it on, it would then too be ridiculous.

When improper, or *incompatible* excesses meet, they always excite laughter; more especially when the forms of those excesses are inelegant, that is, when they are composed of unvaried lines.

For example, the figure refer'd to in the margin [fig. 17, plate 1], represents a fat grown face of a man, with an infant's cap on, and the rest of the child's dress stuff'd, and so well placed under his chin, as to seem to belong to that face. This is a contrivance I have seen at Bartholomew-fair, and always occasion'd a roar of laughter. The next [fig. 18, plate 1] is of the same kind, a child with a man's wig and cap on. In these you see the ideas of youth and age jumbled together, in forms without beauty.

So a Roman general [fig. 19, plate 1], dress'd by a modern tailor and peruke-maker, for tragedy, is a comic figure. —— The dresses of the times are mix'd, and the lines which compose them are straight or only round.

Dancing-masters, representing deities, in their grand ballets on the stage, are no less ridiculous. See the Jupiter [fig. 20, plate 1].

Nevertheless custom and fashion will, in length of time, reconcile almost every absurdity whatever, to the eye, or make it over-look'd.

It is from the same joining of opposite ideas that makes us laugh at the owl and the ass, for under their aukward forms, they seem to be gravely musing and meditating, as if they had the sense of human beings.

A monkey too whose figure, as well as most of his actions, so odly resembles the human, is also very comical; and he becomes more so when a coat is put on him, as he then becomes a greater burlesque on the man.

There is something extremely odd and comical in the rough shock dog. The ideas here connected are the inelegant and inanimate figure of a thrum mop, or muff, and that of a sensible, friendly animal; which is as much a burlesque of the dog, as the monkey when his coat is on, is of the man.

What can it be but this inelegance of the figure, join'd with impropriety, that makes a whole audience burst into laughter, when they see

the miller's sack, in Dr. Faustus, jumping cross the stage?[49] was a well-shap'd vase to do the same, it would equally surprise, but not make every body laugh, because the elegance of the form would prevent it.

For when the forms, thus join'd together, are each of them elegant, and composed of agreeable lines, they will be so far from making us laugh, that they will become entertaining to the imagination, as well as pleasing to the eye. The sphinx and siren have been admired and accounted ornamental in all ages. The former represents strength and beauty join'd; the latter, beauty and swiftness, in pleasing and graceful forms.

The griffin, a modern hieroglyphic, signifying strength and swiftness, united in the two noble forms of the lion and eagle, is a grand object. So the antique centaur hath a savage greatness as well as beauty.

These may be said to be monsters, it's true, but then they convey such noble ideas, and have such elegance in their forms as greatly compensates for their being unnaturally join'd together.

I shall mention but one more instance of this sort, and that the most extraordinary of all, which is an infant's head of about two years old, with a pair of duck's-wings placed under its chin, supposed always to be flying about, and singing psalms [fig. 22, plate 1 right].[50]

A painter's representation of heaven would be nothing without swarms of these little inconsistent objects, flying about, or perching on the clouds; and yet there is something so agreeable in their form, that the eye is reconciled and overlooks the absurdity, and we find them in the carving and painting of almost every church. St. Paul's is full of them.

As the foregoing principles are the very ground work of what is to follow; we will, in order to make them the more familiar to us, just speak of them in the way they are daily put in practice, and may be seen, in every dress that is worn; and we shall find not only that ladies of fashion, but that women of every rank, who are said to dress prettily, have known their force, without considering them as principles.

49. *Harlequin Doctor Faustus*, one of the popular harlequinades played at John Rich's Lincoln's Inn Theatre (see *Masquerades and Operas*, *HGW* No. 44).

50. Hogarth satirized such figures in his *Burlesque on Kent's Altarpiece* of 1724 (*HGW* No. 63).

Fitness is first considered by them, as knowing that their dresses should be useful, commodious, and fitted to their different ages; or rich, airy, and loose, agreeable to the character they would give out to the public by their dress.[51]

II. Uniformity is chiefly complied with in dress on account of fitness, and seems to be extended not much farther than dressing both arms alike, and having the shoes of the same colour. For when any part of dress has not the excuse of fitness or propriety for its uniformity of parts, the ladies always call it *formal*.

For which reason, when they are at liberty to make what shapes they please in ornamenting their persons, those of the best taste choose the irregular as the more engaging; for example, no two patches are ever chosen of the same size, or placed at the same height; nor a single one in the middle of a feature, unless it be to hide a blemish. So a single feather, flower, or jewel is generally placed on one side of the head; or if ever put in front, it is turn'd awry to avoid formality.

It was once the fashion to have two curls of equal size, stuck at the same height close upon the forehead, which probably took its rise from seeing the pretty effect of curls falling loosely over the face.

A lock of hair falling thus cross the temples, and by that means breaking the regularity of the oval, has an effect too alluring to be strictly decent, as is very well known to the loose and lowest class of women: but being pair'd in so stiff a manner, as they formerly were, they lost the desired effect, and ill deserv'd the name of favourites.

III. Variety in dress, both as to colour and form, is the constant study of the young and gay —— But then,

IV. That taudriness may not destroy the proper effect of variety, simplicity is call'd in to restrain its superfluities, and is often very artfully made use of to set native beauty off to more advantage. I have

51. On dress, see MSS. IX, p. 127. The following passage recalls Pope's *Rape of the Lock* (1714), although Belinda's twin locks (before being rendered asymetrical by the Baron's scissors) were on her neck, not her face.

not known any set of people, that have more excell'd in this principle of simplicity, or plainness, than the Quakers.

V. Quantity, or fulness in dress has ever been a darling principle; so that sometimes those parts of dress, which would properly admit of being extended to a great degree, have been carried into such strange excesses, that in the reign of Queen Elizabeth a law was made to put a stop to the growth of ruffs: nor is the enormous size of the hoops at present, a less sufficient proof of the extraordinary love of quantity in dress, beyond that of convenience or elegance.[52]

VI. The beauty of intricacy lies in contriving winding shapes, such as the antique lappets belonging to the head of the sphinx [fig. 21, plate 1], or as the modern lappet when it is brought before. Every part of dress, that will admit of the application of this principle, has an air (as it is term'd) given to it thereby; and altho' it requires dexterity and a taste to execute these windings well, we find them daily practised with success.

This principle also recommends modesty in dress, to keep up our expectations, and not suffer them to be too soon gratified. Therefore the body and limbs should all be cover'd, and little more than certain hints be given of them thro' the cloathing.

The face indeed will bear a constant view, yet always entertain and keep our curiosity awake, without the assistance either of a mask, or veil; because vast variety of changing circumstances keeps the eye and the mind in constant play, in following the numberless turns of expression it is capable of. How soon does a face that wants expression, grow insipid, tho' it be ever so pretty? —— The rest of the body, not having these advantages in common with the face, would soon satiate the eye, were it to be as constantly exposed, nor would it have more effect than a marble statue. But when it is artfully cloath'd and decorated, the mind at every turn resumes its imaginary pursuits concerning it. Thus, if I may be allow'd a simile, the angler chooses not to see the fish he angles for, until it is fairly caught.

52. See the hoop-skirted woman in Hogarth's *Beer Street* (1751, *HGW* No. 185).

CHAPTER VII

Of LINES

IT may be remember'd that in the introduction, the reader is desired to consider the surfaces of objects as so many shells of lines, closely connected together, which idea of them it will now be proper to call to mind, for the better comprehending not only this, but all the following chapters on composition.

The constant use made of lines by mathematicians, as well as painters, in describing things upon paper, hath establish'd a conception of them, as if actually existing on the real forms themselves. This likewise we suppose, and shall set out with saying in general – That *the straight line*, and *the circular line*, together with their different combinations, and variations, &c. bound, and circumscribe all visible objects whatsoever, thereby producing such endless variety of forms, as lays us under the necessity of dividing, and distinguishing them into general classes; leaving the intervening mixtures of appearances to the reader's own farther observation.

First, [fig. 23, plate 1 top] objects composed of straight lines only, as the cube, or of circular lines, as the sphere, or of both together, as cylinders and cones, &c.

Secondly, [fig. 24, plate 1 top] those composed of straight lines, circular lines, and of lines partly straight, and partly circular, as the capitals of columns, and vases, &c.

Thirdly, [fig. 25, plate 1 top] those composed of all the former together with an addition of the waving line, which is a line more productive of beauty than any of the former, as in flowers, and other forms of the ornamental kind: for which reason we shall call it the line of beauty.

Fourthly, [fig. 26, plate 1 top] those composed of all the former together with the serpentine line, as the human form, which line hath the power of super-adding grace to beauty. Note, forms of most grace have least of the straight line in them.

It is to be observed, that straight lines vary only in length, and therefore are least ornamental.

That curved lines as they can be varied in their degrees of

curvature as well as in their lengths, begin on that account to be ornamental.

That straight and curv'd lines join'd, being a compound line, vary more than curves alone, and so become somewhat more ornamental.

That the waving line, or line of beauty, varying still more, being composed of two curves contrasted, becomes still more ornamental and pleasing, insomuch that the hand takes a lively movement in making it with pen or pencil.

And that the serpentine line, by its waving and winding at the same time different ways, leads the eye in a pleasing manner along the continuity of its variety, if I may be allowed the expression; and which by its twisting so many different ways, may be said to inclose (tho' but a single line) varied contents; and therefore all its variety cannot be express'd on paper by one continued line, without the assistance of the imagination, or the help of a figure; see [fig. 26, plate 1 top] where that sort of proportion'd, winding line, which will hereafter be call'd the precise serpentine line, or *line of grace*, is represented by a fine wire, properly twisted round the elegant and varied figure of a cone.

CHAPTER VIII

Of *what sort of* PARTS, *and how* PLEASING FORMS *are composed*

THUS far having endeavoured to open as large an idea as possible of the power of variety, by having partly shewn that those lines which have most variety in themselves, contribute most towards the production of beauty; we will next shew how lines may be put together, so as to make pleasing figures or compositions.

In order to be as clear as possible, we will give a few examples of the most familiar and easy sort, and let them serve as a clue to be pursued in the imagination: I say in the imagination chiefly, for the following method is not meant always to be put in practice, or follow'd in every case, for indeed that could hardly be, and in some it would be

ridiculously losing time if it could —— Yet there may be cases where it may be necessary to follow this method minutely; as for example, in architecture.

I am thoroughly convinc'd in myself, however it may startle some, that a completely new and harmonious order of architecture in all its parts, might be produced by the following method of composing, but hardly with certainty without it; and this I am the more apt to believe, as upon the strictest examination, those four orders of the ancients, which are so well established for beauty and true proportion, perfectly agree with the scheme we shall now lay down.[53]

This way of composing pleasing forms, is to be accomplished by making choice of variety of lines, as to their shapes and dimensions; and then again by varying their situations with each other, by all the different ways that can be conceived: and at the same time (if a solid figure be the subject of the composition) the contents or space that is to be inclosed within those lines, must be duly consider'd and vary'd too, as much as possible, with propriety. In a word, it may be said, the art of composing well is the art of varying well. It is not expected that this should at first be perfectly comprehended, yet I believe it will be made sufficiently clear by the help of the examples following.

The figure [29, plate 1 top], represents the simple and pleasing figure of a bell; this shell, as we may call it, is composed of waving lines, encompassing, or bounding within it, the varied space marked with dotted lines: here you see the variety of the space within is equal to the beauty of its form without, and if the space, or contents, were to be more varied, the outward form would have still more beauty.

As a proof, see a composition of more parts, and a way by which those parts may be put together by a certain method of varying: i.e. how the one half of the socket of the candlestick A [fig. 30, plate 1 top], may be varied as the other half B. Let a convenient and fit height be first given for a candlestick, as [fig. 31, plate 1 top], then let the necessary size of the socket be determined, as at (a) [fig. 32] after which, in order to give it a better form, let every *distance* or length of divisions differ from the length of the socket, as also vary in their distances from each other, as is seen by the points on the line under the socket (a); that is let any two points, *signifying distance*, be plac'd farthest from any other two near points, observing always that there should be one distance or part larger than all the rest; and you will readily see that variety could not be so

53. For Hogarth's supplement on architecture, see MSS. X, p. 130.

complete without it. – In like manner, let the horizontal distances (always keeping within the bounds of fitness) be varied both as to distances and situations, as on the opposite side of the same figure (b); then unite and join all the several distances into a complete shell, by applying several parts of curves and straight lines; varying them also by making them of different sizes, as (c): and apply them as at (d) in the same figure, and you have the candlestick [fig. 33, plate 1 top], and with still more variations on the other side. If you divide the candlestick into many more parts, it will appear crouded, as [fig. 34, plate 1 top] it will want distinctness of form on a near view, and lose the effect of variety at a distance: this the eye will easily distinguish on removing pretty far from it.

Simplicity in composition, or distinctness of parts, is ever to be attended to, as it is one part of beauty, as has been already said: but that what I mean by distinctness of parts in this place, may be better understood, it will be proper to explain it by an example.

When you would compose an object of a great variety of parts, let several of those parts be distinguish'd by themselves, by their remarkable difference from the next adjoining, so as to make each of them, as it were, one well-shap'd quantity or part, as is marked by the dotted lines in figure [35, plate 1 top] (these are like what they call passages in music, and in writing paragraphs) by which means, not only the whole, but even every part, will be better understood by the eye: for confusion will hereby be avoided when the object is seen near, and the shapes will seem well varied, tho' fewer in number, at a distance; as figure [36, plate 1 top] supposed to be the same as the former, but removed so far off that the eye loses sight of the smaller members.

The parsley-leaf [fig. 37, plate 1 top], in like manner, from whence a beautiful foliage in ornament was originally taken, is divided into three distinct passages; which are again divided into other odd numbers; and this method is observ'd, for the generality, in the leaves of all plants and flowers, the most simple of which are the trefoil and cinquefoil.

Light and shade, and colours, also must have their distinctness to make objects completely beautiful; but of these in their proper places ——— only I will give you a general idea of what is here meant by the beauty of distinctness of forms, lights, shades, and colours, by putting you in mind of the reverse effects in all them together.

Observe the well-composed nosegay how it loses all its distinctness when it dies; each leaf and flower then shrivels and loses its distinct

shape; and the firm colours fade into a kind of sameness: so that the whole gradually becomes a confused heap.

If the general parts of objects are preserv'd large at first, they will always admit of farther enrichments of a small kind, but then they must be so small as not to confound the general masses or quantities. ——— thus you see variety is a check upon itself when overdone, which of course begets what is call'd a *petit taste* and a confusion to the eye.

It will not be amiss next to shew what effects an object or two will have that are put together without, or contrary to these rules of composing variety. Figure [38, plate 1 left], is taken from one of those branches fixt to the sides of common old-fashion'd stove-grates by way of ornament, wherein you see how the parts have been varied by fancy only, and yet pretty well: close to which [fig. 39, plate 1 left] is another, with about the like number of parts; but as the shapes, neither are enough varied as to their contents, nor in their situations with each other, but one shape follows its exact likeness: it is therefore a disagreeable and tasteless figure, and for the same reason the candle-stick fig. [40, plate 1 top] is still worse, as there is less variety in it. Nay, it would be better to be quite plain, as figure [41, plate 1 top], than with such poor attempts at ornament.

These few examples, well understood, will, I imagine, be sufficient to put what was said at the beginning of this chapter out of all doubt, viz. that *the art of composing well* is no more than the *art of varying well*; and to shew, that the method which has been here explain'd, must consequently produce a pleasing proportion amongst the parts; as well as that all deviations from it will produce the contrary. Yet to strengthen this latter assertion, let the following figures, taken from the life, be examin'd by the above rules for composing, and it will be found that the indian-fig or torch-thistle, figure [42, plate 1 top], as well as all that tribe of uncouth shaped exotics, have the same reasons for being ugly, as the candlestick, fig. 40; as also that the beauties of the Lily [fig. 43, plate 1 top] and the calcidonian Iris [fig. 44, plate 1 top] proceeds from their being composed with great variety, and that the loss of variety, to a certain degree, in the imitations of those flowers underneath them (fig. 45 and 46) is the cause of the meanness of their shapes, tho' they retain enough to be call'd by the same names.

Hitherto, with regard to composition, little else but forms made up of straight and curv'd lines have been spoken of, and though these lines have but little variety in themselves, yet by reason of the great diversifications that they are capable of in being join'd with one another; great

variety of beauty of the more useful sort is produced by them, as in necessary utensils and building: but in my opinion, buildings as I before hinted, might be much more varied than they are, for after *fitness* hath been strictly and mechanically complied with, any additional ornamental members, or parts, may, by the foregoing rules, be varied with equal elegance; nor can I help thinking, but that churches, palaces, hospitals, prisons, common houses and summer houses, might be built more in distinct characters than they are, by contriving orders suitable to each; whereas were a modern architect to build a palace in Lapland, or the West-Indies, Paladio must be his guide, nor would he dare to stir a step without his book.[54]

Have not many gothic buildings a great deal of consistent beauty in them? perhaps acquired by a series of improvements made from time to time by the natural persuasion of the eye, which often very near answers the end of working by principles; and sometimes begets them. There is at present such a thirst after variety, that even paltry imitations of Chinese buildings have a kind of vogue, chiefly on account of their novelty:[55] but not only these, but any other new-invented characters of building might be regulated by proper principles. The mere ornaments of buildings, to be sure, at least might be allow'd a greater latitude than they are at present; as capitals, frizes, &c. in order to increase the beauty of variety.

Nature, in shells and flowers, &c. affords an infinite choice of elegant hints for this purpose; as the original of the Corinthian capital was taken from nothing more, as is said, than some dock-leaves growing up against a basket. Even a capital composed of the aukward and confin'd forms of hats and periwigs, as fig. [48, plate 1] in a skilful hand might be made to have some beauty.[56]

However, tho' the moderns have not made many additions to the art of building, with respect to mere beauty or ornament, yet it must be confess'd, they have carried simplicity, convenience, and neatness of

54. Andrea Palladio, *I Quatro Libri dell' Architettura* (Venice, 1570), trans. as *The Four Books of Architecture* by Giacomo Leoni (1715), bible of the Burlingtonians (the architectural wing of the Shaftesburian aesthetic program).

55. William Halfpenny's *Rural Architecture in the Chinese Taste* had appeared before 1750 (the second edition is dated in that year); Horace Walpole mentioned the Chinese buildings at Wroxton in 1753 (John Summerson, *Architecture in Britain*, *1530–1830* [Harmondsworth, 1963], p. 215).

56. For the new order of architecture, see MSS. XI, p. 131.

workmanship, to a very great degree of perfection, particularly in England; where plain good sense hath prefer'd these more necessary parts of beauty, which every body can understand, to that richness of taste which is so much to be seen in other countries, and so often substituted in their room.

St. Paul's cathedral is one of the noblest instances that can be produced of the most judicious application of every principle that has been spoken of. There you may see the utmost variety without confusion, simplicity without nakedness, richness without taudriness, distinctness without hardness, and quantity without excess. Whence the eye is entertain'd throughout with the charming variety of all its parts together; the noble projecting quantity of a certain number of them, which presents bold and distinct parts at a distance, when the lesser parts within them disappear; and the grand few, but remarkably well-varied parts that continue to please the eye as long as the object is discernable, are evident proofs of the superior skill of Sir Christopher Wren, so justly esteem'd the prince of architects.[57]

It will scarcely admit of a dispute, that the outside of this building is much more perfect than that of St. Peter's at Rome: but the inside, though as fine and noble, as the space it stands on, and our religion will allow of, must give way to the splendor, shew, and magnificence of that of St. Peter's, on account of the sculptures and paintings, as well as the greater magnitude of the whole, which makes it excel as to quantity.

There are many other churches of great beauty, the work of the same architect, which are hid in the heart of the city, whose steeples and spires are raised higher than ordinary, that they may be seen at a distance above the other buildings; and the great number of them dispers'd about the whole city, adorn the prospect of it, and give it an air of opulency and magnificence: on which account their shapes will be found to be particularly beautiful. Of these, and perhaps of any in Europe, St. Mary-le-bow is the most elegantly varied. St. Bride's in Fleet-street diminishes sweetly by elegant degrees, but its variations,

57. Sir Christopher Wren, the architect of St. Paul's and many of the London churches to which Hogarth refers, was associated by him with Sir James Thornhill and the Board of Works, all replaced by Burlington and his followers. Hogarth probably read Wren's posthumously published treatises; he would have agreed with the attack in Treatise 2 on the architectural rules (*Parentalia, or Memoirs of the Family Wren* [1750]).

tho' very curious when you are near them, not being quite so bold, and distinct, as those of Bow, it too soon looses variety at a distance. Some gothic spires are finely and artfully varied, particularly the famous steeple of Strasburg.

Westminster-Abbey is a good contrast to St. Paul's, with regard to simplicity and distinctness, the great number of its filligrean ornaments, and small divided and subdivided parts appear confused when nigh, and are totally lost at a moderate distance; yet there is nevertheless such a consistency of parts altogether in a good gothic taste, and such propriety relative to the gloomy ideas, they were then calculated to convey, that they have at length acquir'd an establish'd and distinct character in building. It would be look'd upon as an impropriety and as a kind of profanation to build places for mirth and entertainment in the same taste.

CHAPTER IX

Of COMPOSITION *with the* WAVING-LINE

THERE is scarce a room in any house whatever, where one does not see the waving-line employ'd in some way or other. How inelegant would the shapes of all our moveables be without it? how very plain and unornamental the mouldings of cornices, and chimney-pieces, without the variety introduced by the *ogee* member, which is entirely composed of waving-lines.

Though all sorts of waving-lines are ornamental, when properly applied; yet, strictly speaking, there is but one precise line, properly to be called the line of *beauty*, which in the scale of them [fig. 49, plate I top] is number 4: the lines 5, 6, 7, by their bulging too much in their curvature becoming gross and clumsy; and, on the contrary, 3, 2, 1, as they straighten, becoming mean and poor; as will appear in the next figure [50, plate I top] where they are applied to the legs of chairs.

A still more perfect idea of the effects of the precise waving-line, and

of those lines that deviate from it, may be conceived by the row of stays, figure [53, plate 1 bottom], where number 4 is composed of precise waving-lines, and is therefore the best shaped stay. Every whale-bone of a good stay must be made to bend in this manner: for the whole stay, when put close together behind, is truly a shell of well-varied contents, and its surface of course a fine form; so that if a line, or the lace were to be drawn, or brought from the top of the lacing of the stay behind, round the body, and down to the bottom peak of the stomacher; it would form such a perfect, precise, serpentine-line, as has been shewn, round the cone, figure 26 in plate 1. —— For this reason all ornaments obliquely contrasting the body in this manner, as the ribbons worn by the knights of the garter, are both genteel and graceful. The numbers 5, 6, 7, and 3, 2, 1, are deviations into stiffness and meanness on one hand, and clumsiness and deformity on the other. The reasons for which disagreeable effects, after what has been already said, will be evident to the meanest capacity.

It may be worth our notice however, that the stay, number 2, would better fit a well-shaped man than number 4; and that number 4, would better fit a well-form'd woman, than number 2; and when on considering them, merely as to their forms, and comparing them together as you would do two vases, it has been shewn by our principles, how much finer and more beautiful number 4 is, than number 2: does not this our determination enhance the merit of these principles, as it proves at the same time how much the form of a woman's body surpasses in beauty that of a man?

From the examples that have been given, enough may be gathered to carry on our observations from them to any other objects that may chance to come in our way, either animate or inanimate; so that we may not only *lineally* account for the ugliness of the toad, the hog, the bear and the spider, which are totally void of this waving-line, but also for the different degrees of beauty belonging to those objects that possess it.

CHAPTER X

Of COMPOSITIONS *with the* SERPENTINE-LINE

THE very great difficulty there is in describing this line, either in words, or by the pencil (as was hinted before, when I first mention'd it) will make it necessary for me to proceed very slowly in what I have to say in this chapter, and to beg the reader's patience whilst I lead him step by step into the knowledge of what I think the sublime in form, so remarkably display'd in the human body; in which, I believe, when he is once acquainted with the idea of them, he will find this species of lines to be principally concern'd.

First, then, let him consider fig. [56, plate 2 bottom), which represents a straight horn, with its contents, and he will find, as it varies like the cone, it is a form of some beauty, merely on that account.

Next let him observe in what manner, and in what degree the beauty of this horn is increas'd, in fig. [57, plate 2 bottom] where it is supposed to be bent two different ways.

And lastly, let him attend to the vast increase of beauty, even to grace and elegance, in the same horn, fig. [58, plate 2 bottom], where it is supposed to have been twisted round, at the same time, that it was bent two different ways, (as in the last figure).

In the first of these figures, the dotted line down the middle expresses the straight lines of which it is composed; which, without the assistance of curve lines, or light and shade, would hardly shew it to have contents.

The same is true of the second, tho' by the bending of the horn, the straight dotted line is changed into the beautiful waving-line.

But in the last, this dotted line, by the twisting as well as the bending of the horn, is changed from the waving into the serpentine-line; which, as it dips out of sight behind the horn in the middle, and returns again at the smaller end, not only gives play to the imagination, and delights the eye, on that account; but informs it likewise of the quantity and variety of the contents.

I have chosen this simple example, as the easiest way of giving a plain and general idea of the peculiar qualities of these serpentine-lines, and

the advantages of bringing them into compositions, where the contents you are to express, admit of grace and elegance.

And I beg the same things may be understood of these serpentine-lines, that I have said before of the waving-lines. For as among the vast variety of waving-lines that may be conceiv'd, there is but one that truly deserves the name of *the line of beauty*, so there is only one precise serpentine-line that I call *the line of grace*. Yet, even when they are made too bulging, or too tapering, though they certainly lose of their beauty and grace, they do not become so wholly void of it, as not to be of excellent service in compositions, where beauty and grace are not particularly design'd to be express'd in their greatest perfection.

Though I have distinguish'd these lines so particularly as to give them the titles of *the lines of beauty and grace*, I mean that the use and application of them should still be confined by the principles I have laid down for composition in general; and that they should be judiciously mixt and combined with one another, and even with those I may term *plain* lines, (in opposition to these) as the subject in hand requires. Thus the cornu-copia, fig. [59, plate 2 bottom], is twisted and bent after the same manner, as the last figure of the horn; but more ornamented, and with a greater number of other lines of the same twisted kind, winding round it with as quick returns as those of a screw.

This sort of form may be seen with yet more variations, (and therefore more beautiful) in the goat's horn, from which, in all probability, the ancients originally took the extreme elegant forms they have given their cornu-copias.[58]

There is another way of considering this last figure of the horn I would recommend to my reader, in order to give him a clearer idea of the use both of the waving and serpentine-lines in composition.

This is to imagine the horn, thus bent and twisted, to be cut length-ways by a very fine saw into two equal parts; and to observe one of these in the same position the whole horn is represented in; and these two observations will naturally occur to him. First, that the edge of the saw must run from one end to the other of the horn in the line of beauty; so that the edges of this half of the horn will have a beautiful shape: and, secondly, that wherever the dotted serpentine-line on the surface of the whole horn dips behind, and is lost to the eye, it immediately comes into sight on the hollow surface of the divided horn.

58. For Venus and the cornucopia, see above, n. 26.

The use I shall make of these observations will appear very consider-
able in the application of them to the human form, which we are next
to attempt.

It will be sufficient, therefore, at present only to observe, first, that
the whole horn acquires a beauty by its being thus genteely bent two
different ways; secondly, that whatever lines are drawn on its external
surface become graceful, as they must all of them, from the twist that is
given the horn, partake in some degree or other, of the shape of the
serpentine-line: and, lastly, when the horn is split, and the inner, as well
as the outward surface of its shell-like form is exposed, the eye is
peculiarly entertained and relieved in the pursuit of these serpentine-
lines, as in their twistings their concavities and convexities are alter-
nately offer'd to its view. Hollow forms, therefore, composed of such
lines are extremely beautiful and pleasing to the eye; in many cases
more so, than those of solid bodies.

Almost all the muscles, and bones, of which the human form is
composed, have more, or less of these kind of twists in them; and give
in a less degree, the same kind of appearance to the parts which cover
them, and are the immediate object of the eye: and for this reason it is
that I have been so particular in describing these forms of the bent, and
twisted, and ornamented horn.

There is scarce a straight bone in the whole body. Almost all of them
are not only bent different ways, but have a kind of twist, which in some
of them is very graceful; and the muscles annex'd to them, tho' they are
of various shapes, appropriated to their particular uses, generally have
their component fibres running in these serpentine-lines, surrounding
and conforming themselves to the varied shape of the bones they belong
to: more especially in the limbs. Anatomists are so satisfied of this, that
they take a pleasure in distinguishing their several beauties. I shall only
instance in the thigh-bone, and those about the hips.

The thigh-bone fig. [62, plate 2 right], has the waving and twisted
turn of the horn, 58: but the beautiful bones adjoining, call'd the ossa
innominata [fig. 60, plate 2 bottom], have, with greater variety, the
same turns and twists of that horn when it is cut; and its inner and
outward surfaces are exposed to the eye.

How ornamental these bones appear, when the prejudice we conceive
against them, as being part of a skeleton, is taken off, by adding a little
foliage to them, may be seen in fig. [61, plate 2 bottom] —— such
shell-like winding forms, mixt with foliage, twisting about them, are
made use of in all ornaments; a kind of composition calculated merely

to please the eye. Divest these of their serpentine twinings and they immediately lose all grace, and return to the poor gothic taste they were in an hundred years ago [fig. 63, plate 2 bottom].

Fig. [64, plate 2 bottom] is meant to represent the manner, in which most of the muscles, (those of the limbs in particular) are twisted round the bones, and conform themselves to their length and shape; but with no anatomical exactness. As to the running of their fibres, some anatomists have compared them to skains of thread, loose in the middle, and tight at each end, which, when they are thus consider'd as twisted contrary ways round the bone, gives the strongest idea possible of a composition of serpentine-lines.

Of these fine winding forms then are the muscles and bones of the human body composed, and which, by their varied situations with each other, become more intricately pleasing, and form a continued waving of winding forms from one into the other, as may be best seen by examining a good anatomical figure, part of which you have here represented, in the muscular leg and thigh, fig. [65, plate 1]: which shews the serpentine forms and varied situations of the muscles, as they appear when the skin is taken off. It was drawn from a plaister of paris figure cast off nature, the original of which was prepared for the mould by Cowper, the famous anatomist.[59] In this last figure, as the skin is taken off the parts are too distinctly traced by the eye, for that intricate delicacy which is necessary to the utmost beauty; yet the winding figures of the muscles, with the variety of their situations, must always be allow'd elegant forms: however, they lose in the imagination some of the beauty, which they really have, by the idea of their being flayed; nevertheless, by what has already been shewn both of them and the bones, the human frame hath more of its parts composed of serpentine-lines than any other object in nature; which is a proof both of its superior beauty to all others, and, at the same time, that its beauty proceeds from those lines: for although they may be required sometimes to be bulging in their twists, as in the thick swelling muscles of the Hercules, yet elegance and greatness of taste is still preserved; but when these lines lose so much of their twists as to become almost straight, all elegance of taste vanishes.

Thus fig. [66, plate 1], was also taken from nature, and drawn in the same position, but treated in a more dry, stiff, and what the painters

59. William Cowper, *Myotomia Reformata: or an Anatomical Treatise on the Muscles of the Human Body* (1724 ed.), fig. 65, tab. 55.

call, *sticky manner*, than the nature of flesh is ever capable of appearing in, unless when its moisture is dryed away:[60] it must be allowed, that the parts of this figure are of as right dimensions, and as truly situated, as in the former; it wants only the true twist of the lines to give it taste.

To prove this further, and to put the mean effect of these plain or unvaried lines in a stronger light, see fig. [67, plate 1], where, by the uniform, unvaried shapes and situation of the muscles, without so much as a waving-line in them, it becomes so wooden a form, that he that can fashion the leg of a joint-stool may carve this figure as well as the best sculptor. In the same manner, divest one of the best antique statues of all its serpentine winding parts, and it becomes from an exquisite piece of art, a figure of such ordinary lines and unvaried contents, that a common stone-mason or carpenter, with the help of his rule, calipers, and compasses, might carve out an exact imitation of it: and were it not for these lines a turner, in his lathe, might turn a much finer neck than that of the grecian Venus, as according to the common notion of a beautiful neck, it would be more truly round. For the same reason, legs much swoln with disease, are as easy to imitate as a post, having lost their *drawing*, as the painters call it; that is, having their serpentine-lines all effaced, by the skin's being equally puffed up, as figure [68, plate 1].

If in comparing these three figures one with another, the reader, notwithstanding the prejudice his imagination may have conceiv'd against them, as anatomical figures, has been enabled only to perceive that one of them is not so disagreeable as the others; he will easily be led to see further, that this tendency to beauty in one, is not owing to any greater degree of exactness in the *proportions* of its parts, but merely to the more *pleasing turns, and intertwistings of the lines*, which compose its external form; for in all the three figures the same proportions have been observ'd, and, on that account, they have all an equal claim to beauty.

And if he pursues this anatomical enquiry but a very little further, just to form a true idea of the elegant use that is made of the skin and fat beneath it, to conceal from the eye all that is hard and disagreeable, and at the same time to preserve to it whatever is necessary in the shapes of the parts beneath, to give grace and beauty to the whole limb: he will

60. These remarks are at the expense of the "scheem of Triangles" of the portraitist Giles Hussey (Vertue, 3:126); see below, plate 1, fig. 66, with its superimposed triangle.

find himself insensibly led into the principles of that grace and beauty which is to be found in well-turn'd limbs, in fine, elegant, healthy life, or in those of the best antique statues; as well as into the reason why his eye has so often unknowingly been pleased and delighted with them.

Thus, in all others parts of the body, as well as these, wherever, for the sake of the necessary motion of the parts, with proper strength and agility, the insertions of the muscles are too hard and sudden, their swellings too bold, or the hollows between them too deep, for their out-lines to be beautiful; nature most judiciously softens these hardnesses, and plumps up these vacancies with a proper supply of fat, and covers the whole with the soft, smooth, springy, and, in delicate life, almost transparent skin, which, conforming itself to the external shape of all the parts beneath, expresses to the eye the idea of its contents with the utmost delicacy of beauty and grace.

The skin, therefore, thus tenderly embracing, and gently conforming itself to the varied shapes of every one of the outward muscles of the body, soften'd underneath by the fat, where, otherwise, the same hard lines and furrows would appear, as we find come on with age in the face, and with labour, in the limbs, is evidently a shell-like surface (to keep up the idea I set out with) form'd with the utmost delicacy in nature; and therefore the most proper subject of the study of every one, who desires to imitate the works of nature, *as a master should do*, or to judge of the performances of others *as a real connoisseur ought*.

I cannot be too long, I think, on this subject, as so much will be found to depend upon it; and therefore shall endeavour to give a clear idea of the different effect such anatomical figures have on the eye, from what the same parts have, when cover'd by the fat and skin; by suppos-ing a small wire (that has lost its spring and so will retain every shape it is twisted into) to be held fast to the out-side of the hip (figure 65[, plate 1]) and thence brought down the other side of the thigh obliquely over the calf of the leg, down to the outward ancle (all the while press'd so close as to touch and conform itself to the shape of every muscle it passes over) and then to be taken off. If this wire be now examined it will be found that the general uninterrupted flowing twist, which the winding round the limbs would otherwise have given to it, is broke into little better than so many separate plain curves, by the sharp indentures it every where has receiv'd on being closely press'd in between the muscles.

Suppose, in the next place, such a wire was in the same manner

twisted round a living well-shaped leg and thigh, or those of a fine statue; when you take it off you will find no such sharp indentures, nor any of those regular *engralings* (as the heralds express it) which displeased the eye before. On the contrary, you will see how *gradually* the changes in its shape are produced; how imperceptibly the different curvatures run into each other, and how easily the eye glides along the varied wavings of its sweep. To enforce this still further, if a line was to be drawn by a pencil exactly where these wires have been supposed to pass, the point of the pencil, in the muscular leg and thigh, would perpetually meet with stops and rubs, whilst in the others it would flow from muscle to muscle along the elastic skin, as pleasantly as the lightest skiff dances over the gentlest wave.

This idea of the wire, retaining thus the shape of the parts it passes over, seems of so much consequence, that I would by no means have it forgot; as it may properly be consider'd as one of the threads (or outlines) of the shell (or external surface) of the human form: and the frequently recurring to it will assist the imagination in its conceptions of those parts of it, whose shapes are most intricately varied: for the same sort of observations may be made, with equal justice, on the shapes of ever so many such wires twisted in the same manner in ever so many directions over every part of a well made man, woman, or statue.

And if the reader will follow in his imagination the most exquisite turns of the chissel in the hands of a master, when he is putting the finishing touches to a statue; he will soon be led to understand what it is the real judges expect from the hand of such a master, which the Italians call, the little more, Il poco piu, and which in reality distinguishes the original master-pieces at Rome from even the best copies of them.[61]

An example or two will sufficiently explain what is here meant; for as these exquisite turns are to be found, in some degree of beauty or other, all over the whole surface of the body and limbs: we may by taking any one part of a fine figure (though so small a one that only a few muscles are express'd in it) explain the manner in which so much beauty and grace has been given to them, as to convince a skilful artist, almost at sight, that it must have been the work of a master.

I have chosen, for this purpose, a small piece of the body of a statue, fig. [76, plate 2 top], representing part of the left side under the arm,

61. *Il poco piu*, originating in musical notation, was part of the vocabulary of "the grace beyond the reach of art" and "je ne sais quoi."

together with a little of the breast, (including a very particular muscle, which, from the likeness its edges bear to the teeth of a saw, is, if consider'd by itself, void of beauty) as most proper to the point in hand, because this its regular shape more peculiarly requires the skill of the artist to give it a little more variety than it generally has, even in nature.

First, then, I will give you a representation of this part of the body, from an anatomical figure [77, plate 2 top], to show what a sameness there is in the shapes of all the teeth-like insertions of this muscle; and how regularly the fibres, which compose it, follow the almost parallel outlines of the ribs they partly cover.

From what has been said before of the use of the natural covering of the skin, &c. the next figure [78, plate 2 top] will easily be understood to mean so tame a representation of the same part of the body, that tho' the hard and stiff appearance of the edges of his muscle is taken off by that covering, yet enough of its regularity and sameness remains to render it disagreeable.

Now as regularity and sameness, according to our doctrine, is want of elegance and true taste, we shall endeavour in the next place to show how this very part (in which the muscles take so very regular a form) may be brought to have as much variety as any other part of the body whatever. In order to this, though some alteration must be made in almost every part of it, yet it should be so inconsiderable in each, that no remarkable change may appear in the shape and situation of any.

Thus, let the parts mark'd 1, 2, 3, 4, (which appear so exactly similar in shape, and parallel in situation in the muscular figure 77) and not much mended in fig. 78, be first varied in their sizes, but not gradually from the uppermost to the lowest, as in fig. [79, plate 2 top], nor alternately one long and one short, as in fig. [80, plate 2 top], for in either of these cases there would still remain too great a formality. We should therefore endeavour, in the next place, to vary them every way in our power, without losing entirely the true idea of the parts themselves. Suppose them then to have changed their situations a little, and slip'd beside each other irregularly, (some how as is represented in fig. [81, plate 2 top], merely with regard to their situation) and the external appearance of the whole piece of the body, now under our consideration, will assume the more varied and pleasing form, represented in fig. 76; easily to be discern'd by comparing the three figures 76, 77, 78, one with another; and it will as easily be seen, that were lines to be drawn,

or wires to be bent, over these muscles, from one to the other, and so on to the adjoining parts; they would have a continued waving flow, let them pass in any direction whatever.

The unskilful, in drawing these parts after the life, as their regularities are much more easily seen and copied than their fine variations, seldom fail of making them more regular and poor than they really appear even in a consumptive person.

The difference will appear evident by comparing fig. 78, purposely drawn in this tasteless manner, with fig. 76. But will be more perfectly understood by examining this part in the Torso of Michael Angelo [fig. 54, plate 1], whence this figure was taken.

Note, there are casts of a small copy of that famous trunk of a body to be had at almost every plaster-figure makers, wherein what has been here described may be sufficiently seen, not only in the part which figure 76 was taken from, but all over that curious piece of antiquity.

I must here again press my reader to a particular attention to the windings of these superficial lines, even in their passing over every joint, what alterations soever may be made in the surface of the skin by the various bendings of the limbs: and tho' the space allow'd for it, just in the joints, be ever so small, and consequently the lines ever so short, the application of this principle of varying these lines, as far as their lengths will admit of, will be found to have its effect as gracefully as in the more lengthen'd muscles of the body.

It should be observ'd in the fingers, where the joints are but short, and the tendons straight; and where beauty seems to submit, in some degree, to use, yet not so much but you trace in a full-grown taper finger, these little winding lines among the wrinkles, or in (what is more pretty because more simple) the dimples of the nuckles. As we always distinguish things best by seeing their reverse set in opposition with them; if fig. [82, plate 2 top], by the straightness of its lines, shews fig. [83, plate 2 top], to have some little taste in it, tho' it is so slightly sketch'd; the difference will more evidently appear when you in like manner compare a straight coarse finger in common life with the taper dimpled one of a fine lady.

There is an elegant degree of plumpness peculiar to the skin of the softer sex, that occasions these delicate dimplings in all their other joints, as well as these of the fingers; which so perfectly distinguishes them from those even of a graceful man; and which, assisted by the more soften'd shapes of the muscles underneath, presents to the eye all the varieties in the whole figure of the body, with gentler and fewer parts

more sweetly connected together, and with such a fine simplicity as will always give the turn of the female frame, represented in the Venus [fig. 13, plate 1], the preference to that of the Apollo [fig. 12, plate 1].

Now whoever can conceive lines thus constantly flowing, and delicately varying over every part of the body even to the fingers ends, and will call to his remembrance what led us to this last description of what the Italians call, Il poco piu (*the little more* that is expected from the hand of a master) will, in my mind, want very little more than what his own observation on the works of art and nature will lead him to, to acquire a true idea of the word *Taste*, when applied to form; however inexplicable this word may hitherto have been imagined.

We have all along had recourse chiefly to the works of the ancients, not because the moderns have not produced some as excellent; but because the works of the former are more generally known: nor would we have it thought, that either of them have ever yet come up to the utmost beauty of nature. Who but a bigot, even to the antiques, will say that he has not seen faces and necks, hands and arms in living women, that even the Grecian Venus doth but coarsely imitate?

And what sufficient reason can be given why the same may not be said of the rest of the body?

CHAPTER XI

Of PROPORTION

IF any one should ask, what it is that constitutes a fine-proportion'd human figure? how ready and seemingly decisive is the common answer: *a just symmetry and harmony of parts with respect to the whole.*[62] But as probably this vague answer took its rise from doctrines not belonging to form, or idle schemes built on them, I apprehend it will cease to be thought much to the purpose after a proper enquiry has been made.

Preparatory to which, it becomes necessary in this place, to mention one reason more which may be added to those given in the introduction,

62. The reference is to Shaftesbury, who characteristically writes of "the admiration and love of order, harmony, and proportion" (*Inquiry concerning Virtue and Merit* [1699, 1711], *Characteristics*, 1:279). On the basic theories of proportion, see Dobai, pp. 353–54.

for my having persuaded the reader to consider objects scoop'd out like thin shells; which is, that partly by this conception, he may be the better able to separate and keep asunder the two following *general ideas*, as we will call them, belonging to form; which are apt to coincide and mix with each other in the mind, and which it is necessary (for the sake of making each more fully and particularly clear) should be kept apart, and consider'd singly.

First, the *general ideas* of what hath already been discussed in the foregoing chapters, which only comprehends the surface of form, viewing it in no other light than merely as being ornamental or not.

Secondly, that *general idea*, now to be discussed, which we commonly have of form altogether, as arising chiefly from a fitness to some design'd purpose or use.

Hitherto our main drift hath been to establish and illustrate the first idea only, by shewing, first the nature of variety, and then its effects on the mind; with the manner how such impressions are made by means of the different feelings given to the eye, from its movements in tracing and coursing* over surfaces of all kinds.

The surface of a piece of ornament, that hath every turn in it that lines are capable of moving into, and at the same time no way applied, nor of any manner of use, but merely to entertain the eye, would be such an object as would answer to this first idea alone.

The figure like a leaf, at the bottom of plate 1, near to fig. 67, is something of this kind; it was taken from an ash-tree, and was a sort of Lusus naturæ, growing only like an excrescence, but so beautiful in the lines of its shell-like windings, as would have been above the power of a Gibbons to have equalled, even in its own materials; nor could the graver of an Edlinck, or Drevet, have done it justice on copper.[63]

Note, the present taste of ornaments seems to have been partly taken from productions of this sort, which are to be found about autumn among plants, particularly asparagus, when it is running to seed.

I shall now endeavour to explain what is included in what I have called for distinction sake, the second *general idea* of form, in a much fuller manner than was done in chapter I, of Fitness. And begin with

* See Chap. 5. page 33.

63. Grinling Gibbons (1648–1721), the English sculptor in wood; one of the Edelinckes (Gérard, 1641–1703, or his son Nicolas Etienne, 1681–1767); one of the Drevets (Pierre, 1663–1738, or his son Pierre Imbert, 1697–1739, who engraved after Charles-Antoine Coypel, among others).

observing, that though surfaces will unavoidably be still included, yet we must no longer confine ourselves to the particular notice of them as surfaces only, as we heretofore have done; we must now open our view to general, as well as particular bulk and solidity; and also look into what may have filled up, or given rise thereto, such as certain *given* quantities and dimensions of parts, for inclosing any substance, or for performing of *motion, purchase, stedfastness*, and other matters of use to living beings, which, I apprehend, at length, will bring us to a tolerable conception of the word *proportion*.

As to these *joint-sensations* of bulk and motion, do we not at first sight almost, even without making trial, seem to *feel* when a leaver of any kind is too weak, or not long enough to make such or such a purchase? or when a spring is not sufficient? and don't we find by experience what weight, or dimension should be given, or taken away, on this or that account? if so, as the general as well as particular bulks of form, are made up of materials moulded together under mechanical directions, for some known purpose or other; how naturally, from these considerations, shall we fall into a judgment of *fit proportion*; which is one part of beauty to the mind tho' not always so to the eye.

Our necessities have taught us to mould matter into various shapes, and to give them fit proportions, for particular uses, as bottles, glasses, knives, dishes, &c. Hath not offence given rise to the form of the sword, and defence to that of the shield? And what else but proper fitness of parts hath fix'd the different dimensions of pistols, common guns, great guns, fowling-pieces and blunderbusses; which differences as to figure, may as properly be called the different characters of fire-arms, as the different shapes of men are called characters of men.

We find also that the profuse variety of shapes, which present themselves from the whole animal creation, arise chiefly from the nice fitness of their parts, designed for accomplishing the peculiar movements of each.

And here I think will be the proper place to speak of a most curious difference between the living machines of nature, in respect of fitness, and such poor ones, in comparison with them, as men are only capable of making; by means of which distinction, I am in hopes of shewing what particularly constitutes the utmost beauty of proportion in the human figure.

A clock, by the government's order, has been made, and another now making, by Mr. Harrison, for the keeping of true time at sea; which

perhaps is one of the most exquisite movements ever made.[64] Happy the
ingenious contriver! although the form of the whole, or of every part of
this curious machine, should be ever so confused, or displeasingly
shaped to the eye; and although even its movements should be disagree-
able to look at, provided it answers the end proposed: an ornamental
composition was no part of his scheme, otherwise than as a pollish
might be necessary; if ornaments are required to be added to mend its
shape, care must be taken that they are no obstruction to the movement
itself, and the more as they would be superfluous, as to the main design.
—— But in nature's machines, how wonderfully do we see beauty and
use go hand in hand!

Had a machine for this purpose been nature's work, the whole and
every individual part might have had exquisite beauty of form without
danger of destroying the exquisiteness of its motion, even as if ornament
had been the sole aim; its movements too might have been graceful,
without one superfluous tittle added for either of these lovely purposes.
—— Now this is that curious difference between the fitness of nature's
machines (one of which is man) and those made by mortal hands: which
distinction is to lead us to our main point proposed; I mean, to the
shewing what constitutes the utmost beauty of proportion.

There was brought from France some years ago, a little clock-work
machine, with a duck's head and legs fixt to it,[65] which was so contrived
as to have some resemblance of that animal standing upon one foot, and
stretching back its leg, turning its head, opening and shutting its bill,
moving its wings, and shaking its tail; all of them the plainest and
easiest directions in living movements: yet for the poorly performing
of these few motions, this silly, but much extoll'd machine, being
uncover'd, appeared a most complicated, confused and disagreeable

64. John Harrison (1693–1776), the horologist, constructed a chronometer that could
determine the longitude at sea. His first model had been shown in 1737 and his second in
1741–42 (reported on by the Royal Society, *Some Account of Mr Harrison's Invention for
Determining the Longitude at Sea* [Jan. 1741–2]). Hogarth had satirized earlier attempts at
establishing the longitude in *Rake* 8. Harrison's final, successful version (H-4) was tested in
1761.

65. In 1738 Jacques de Vaucanson (1709–82) exhibited in Paris a mechanical duck, a
simulacrum so realistic (each wing had four hundred moving parts) that it could, among
other things, eat, digest, and excrete. In 1742 the duck performed, together with human
automata, four times daily in the Long Room of the Opera House, London. See Alfred
Chapuis and Edmond Droz, *Les Automates, figures artificiels d'homme et d'animaux* (Neuchatel,
1949), pp. 239–43; Richard Altick, *The Shows of London* (Cambridge, Mass., 1978), pp. 64–
65.

object: nor would its being covered with a skin closely adhering to its parts, as that of a real duck's doth, have much mended its figure; at best, a bag of hob-nails, broken hinges, and patten-rings, would have looked as well, unless by other means it had been stuffed out to bring it into form.

Thus again you see, the more variety we pretend to give to our trifling movements, the more confused and unornamental the forms become; nay chance but seldom helps them. —— How much the reverse are nature's! the greater the variety her movements have, the more beautiful are the parts that cause them.

The finny race of animals, as they have fewer motions than other creatures, so are their forms less remarkable for beauty. It is also to be noted of every species, that the handsomest of each move best: birds of a clumsy make seldom fly well, nor do lumpy fish glide so well through the water as those of a neater make; and beasts of the most elegant form, always excel in speed; of this, the horse and greyhound are beautiful examples: and even among themselves, the most elegantly made seldom fail of being the swiftest.

The war-horse is more equally made for strength than the race-horse, which surplus of power in the former, if suppos'd added to the latter, as it would throw more weight into improper parts for the business of mere speed, so of course it would lessen, in some degree, that admirable quality, and partly destroy that delicate fitness of his make; but then a quality in movement, superior to that of speed, would be given to him by the addition, as he would be render'd thereby more fit to move with ease in such varied, or graceful directions, as are so delightful to the eye in the carriage of the fine manag'd war-horse; and as at the same time, something stately and graceful would be added to his figure, which before could only be said to have an elegant neatness. This noble creature stands foremost amongst brutes; and it is but consistent with nature's propriety, that the most useful animal in the brute-creation, should be thus signalized also for the most beauty.

Yet, properly speaking, no living creatures are capable of moving in such truly varied and graceful directions, as the human species; and it would be needless to say how much superior in beauty their forms and textures likewise are. And surely also after what has been said relating to figure and motion, it is plain and evident that nature has thought fit to make beauty of proportion, and beauty of movement, necessary to each other: so that the observation before made on animals, will hold equally good with regard to man: *i. e.* that he who is most exquisitely

well-proportion'd is most capable of exquisite movements, such as ease and *grace in deportment*, or in dancing.

It may be a sort of collateral confirmation of what has been said of this method of nature's working, as well as otherwise worth our notice, that when any parts belonging to the human body are conceal'd, and not immediately concern'd in movement, all such ornamental shapes, as evidently appear in the muscles and bones,* are totally neglected as unnecessary, for nature doth nothing in vain! this is plainly the case of the intestines, none of them having the least beauty, as to form, except the *heart*; which noble part, and indeed kind of first mover, is a simple and well-varied figure; conformable to which, some of the most elegant Roman urns and vases have been fashion'd.

Now, thus much being kept in remembrance, our next step will be to speak of, first, general measurements; such as the whole height of the body to its breadth, or the length of a limb to its thickness: and, secondly, of such appearances of dimensions as are too intricately varied to admit of a description by lines.

The former will be confined to a very few straight lines, crossing each other, which will easily be understood by every one; but the latter will require somewhat more attention, because it will extend to the precision of every modification, bound, or limit, of the human figure.

To be somewhat more explicit. As to the first part, I shall begin with shewing what practicable sort of measuring may be used in order to produce the most proper variety in the proportions of the parts of any body. I say, *practicable*, because the vast variety of intricately situated parts, belonging to the human form, will not admit of measuring the distances of one part by another, by lines or points, beyond a certain degree or number, without great perplexity in the operation itself, or confusion to the imagination. For instance, say, a line representing one breadth and an half of the wrist, would be equal to the true breadth of the thickest part of the arm above the elbow; may it not then be ask'd, what part of the wrist is meant? for if you place a pair of calipers a little nearer or further from the hand, the distance of the points will differ, and so they will if they are moved close to the wrist all round, because it is flatter one way than the other; but suppose, for argument sake, one certain diameter should be fix'd upon; may it not again be ask'd, how is it to be apply'd, if to the flattest side of the arm or the roundest, and how far from the elbow, and must it be when the arm is extended or when

* See chap. x, on Compositions with the Serpentine-line.

it is bent? for this also will make a sensible difference, because in the latter position, the muscle, call'd the biceps, in the front of that part of the arm, swells up like a ball one way, and narrows itself another; nay all the muscles shift their appearances in different movements, so that whatever may have been pretended by some authors, no exact mathematical measurements by lines, can be given for the true proportion of a human body.

It comes then to this, that no longer than whilst we suppose all the lengths and breadths of the body, or limbs, to be as regular figures as cylinders, or as the leg, figure 68 in plate 1, which is as round as a rolling-stone, are the measures of lengths to breadths practicable, or of any use to the knowledge of proportion: so that as all mathematical schemes are foreign to this purpose, we will endeavour to root them quite out of our way: therefore I must not omit taking notice, that Albert Durer, Lomazzo, (see two tasteless figures taken from their books of proportion [fig. 55, plate 1]) and some others, have not only puzzled mankind with a heap of minute unnecessary divisions, but also with a strange *notion* that those divisions are govern'd by the laws of music; which mistake they seem to have been led into, by having seen certain uniform and consonant divisions upon one string produce harmony to the ear, and by persuading themselves, that similar distances in lines belonging to form, would, in like manner, delight the eye. The very reverse of which has been shewn to be true, in chap. 3, on Uniformity. "The length of the foot," say they, "in respect to the breadth, makes a *double suprabipartient*, a *diapason* and a *diatesseron*:"*[65] which, in my opinion, would have been full as applicable to the ear, or to a plant, or to a tree, or any other form whatsoever; yet these sort of *notions* have so far prevail'd by time, that the words, *harmony of parts*, seem as applicable to form, as to music.

Notwithstanding the absurdity of the above schemes, such measures

* Note, these authors assure you, that this curious method of measuring, *will produce beauty far beyond any nature doth afford*. Lomazzo, recomends also another scheme, with a triangle, to correct the *poverty of nature*, as they express themselves. These *nature-menders* put one in mind of Gulliver's tailor at Laputa, who, having taken measure of him for a suit of clothes, with a rule, quadrant and compasses, after a considerable time spent, brought them home ill made.[66]

65. Lomazzo, *Tracte*, p. 35; in Hogarth's note, Lomazzo, *Tracte*, p. 115. With Lomazzo's terms Hogarth introduces the musical analogy, which he picks up in his additional notes on color: see MSS. XII, p. 131.

66. Swift, *Gulliver's Travels*, Voyage 3. Lomazzo's theory of triangles would have reminded WH of Hussey's (above, n. 60).

as are to be taken from antique statues, may be of some service
to painters and sculptors, especially to young beginners, but nothing
nigh of such use to them, as the measures, taken the same way,
from ancient buildings, have been, and are, to architects and builders;
because the latter have to do with little else but plain geometrical
figures: which measures, however, serve only in copying what has been
done before.

The few measures I shall speak of, for the setting out the general
dimensions of a figure, shall be taken by straight lines only, for the more
easy conception of what may indeed be properly call'd, *gaging the contents
of the body*, supposing it solid like a marble statue, as the wires were
described to do [fig. 2, plate 1] in the introduction: by which plain
method, clear ideas may be acquir'd of what *alone* seem to me to require
measuring, of what certain lengths to what breadths make the most
eligible proportions in general.

The most general dimensions, of a body, or limbs, are lengths,
breadths or thicknesses: now the whole gentility of a figure, according
to its character, depends upon the first proportioning these lines or wires
(which are its measures) properly one to another; and the more varied
these lines are, with respect to each other, the more may the future
divisions be varied likewise, that are to be made on them; and of course
the less varied these lines are, the parts influenced by them, as they must
conform themselves to them, must have less variety too. For example,
the exact cross [fig. 69, plate 2 right] of two equal lines, cutting each
other in the middle, would confine the figure of a man, drawn conform-
able to them, to the disagreeable character of his being as broad as he is
long. And the two lines crossing each other, to make the height and
breadth of a figure, will want variety a contrary way, by one line being
very short in proportion to the other, and therefore, also incapable of
producing a figure of tolerable variety. To prove this, it will be very easy
for the reader to make the experiment, by drawing a figure or two (tho'
ever so imperfectly) confin'd within such limits.

There is a medium between these, proper for every character, which
the eye will easily and accurately determine.

Thus, if the lines, fig. [70, plate 2 right], were to be the measure of
the extreme length and breadth, set out either for the figure of a man or
a vase, the eye soon sees the longest of these is not quite sufficiently so,
in proportion to the other, for a genteel man; and yet it would make a
vase too taper to be elegant; no rule or compasses would decide this
matter either so quickly or so precisely as a good eye. It may be

observed, that minute differences in great lengths, are of little or no consequence as to proportion, because they are not to be discerned; for a man is half an inch shorter when he goes to bed at night, than when he rises in the morning, without the possibility of its being perceived. In case of a wager the application of a rule or compasses may be necessary, but seldom on any other occasion.

Thus much I apprehend is sufficient for the consideration of general lengths to breadths. Where, by the way, I apprehend I have plainly shewn, that there is no practicable rule, by lines, for minutely setting out proportions *for* the human body, and if there were, the eye alone must determine us in our choice of what is most pleasing to itself.

Thus having dispatch'd general dimension, which we may say is almost as much of proportion, as is to be seen when we have our cloaths on: I shall in the second, and more extensive method proposed for considering it, set out in the familiar path of common observation, and appeal as I go on to our usual feeling, or joint-sensation, of figure and motion.

Perhaps by mentioning two or three known instances it will be found that almost every one is farther advanced in the knowledge of this speculative part of proportion than he imagines; especially he who hath been used to observe naked figures doing bodily exercise, and more especially if he be any way interested in the success of them; and the better he is acquainted with the nature of the exercise itself, still the better judge he becomes of the figure that is to perform it. For this reason, no sooner are two boxers stript to fight, but even a butcher, thus skill'd, shews himself a considerable critic in proportion; and on this sort of judgment, often gives, or takes the odds, at bare sight only of the combatants. I have heard a blacksmith harangue like an anatomist, or sculptor, on the beauty of a boxer's figure, tho' not perhaps in the same terms; and I firmly believe, that one of our common proficients in the athletic art, would be able to instruct and direct the best sculptor living, (who hath not seen, or is wholly ignorant of this exercise) in what would give the statue of an English-boxer, a much better proportion, as to character, than is to be seen, even in the famous group of antique boxers, (or as some call them, Roman wrestlers) so much admired to this day.[68]

68. Florence, Ufizzi; see Haskell and Penny, no. 94, fig. 179. Hogarth designed a monument to a pugilist, George Taylor (d. 1758) (drawings, Yale Center for British Art; for these and a second set, see Oppé cat. no. 79).

Indeed, as many parts of the body are so constantly kept cover'd, the proportion of the whole cannot be equally known; but as stockings are so close and thin a covering, every one judges of the different shapes and proportions of legs with great accuracy. The ladies always speak skilfully of necks, hands and arms; and often will point out such particular beauties or defects in their make, as might easily escape the observation of a man of science.

Surely, such determinations could not be made and pronounced with such critical truth, if the eye were not capable of measuring or judging of thicknesses by lengths, with great preciseness. Nay more, in order to determine so nicely as they often do, it must also at the same time, trace with some skill those delicate windings upon the surface which have been described in page 58, which altogether may be observ'd to include the two general ideas mention'd at the beginning of this chapter.

If so, certainly it is in the power of a man of science, with as observing an eye, to go still further, and conceive, with a very little turn of thought, many other necessary circumstances concerning proportion, as of what size and in what manner the bones help to make up the bulk, and support the other parts; as well as what certain weights or dimensions of muscles are proper (according to the principle of the steelyard) to move such or such a length of arm with this or that degree of swiftness or force.

But though much of this matter, may be easily understood by common observation, assisted by science, still I fear it will be difficult to raise a very clear idea of what constitutes, or composes the *utmost beauty of proportion*; such as is seen in the Antinous; which is allowed to be the most perfect in this respect, of any of the antique statues; and tho' the lovely likewise seems to have been as much the sculptor's aim, as in the Venus; yet a manly strength in its proportion is equally express'd from head to foot in it.

Let us try, however, and as this master-piece of art is so well known, we will set it up before us as a pattern, and endeavour to fabricate, or put together in the mind, such kind of parts as shall seem to build another figure like it. In doing which, we shall soon find that it is chiefly to be effected by means of the nice sensation we naturally have of what certain quantities or dimensions of parts, are fittest to produce the utmost strength for moving, or supporting great weights; and of what are most fit for the utmost light agility, as also for every degree, between these two extremes.

He who hath best perfected his ideas of these matters by common observations, and by the assistance of arts relative thereto, will probably be most precisely just and clear, in conceiving the application of the various parts and dimensions, that will occur to him, in the following descriptive manner of disposing of them, in order to form the idea of a fine-proportion'd figure.

Having set up the Antinous as our pattern, we will suppose there were placed on one side of it, the unwieldy elephant-like figure of an Atlas, made up of such thick bones and muscles, as would best fit him for supporting a vast weight, according to his character of extreme heavy strength. And, on the other side, imagine the slim figure of a Mercury, every where neatly formed for the utmost light agility, with slender bones and taper muscles fit for his nimble bounding from the ground. —— Both these figures must be supposed of equal height, and not exceeding six foot.*

Our *extremes* thus placed, now imagine the Atlas throwing off by degrees, certain portions of bone and muscle, proper for the attainment of light agility, as if aiming at the Mercury's airy form and quality, whilst on the other hand, see the Mercury augmenting his taper figure by equal degrees, and growing towards an Atlas in equal time, by receiving to the like places from whence they came, the very quantities that the other had been casting off, when, as they approach each other in weight, their forms of course may be imagined to grow more and more alike, till at a certain point of time, they meet in just similitude; which being an exact medium between the two extremes, we may thence conclude it to be the precise form of exact proportion, fitest for perfect active strength or graceful movement; such as the Antinous we proposed to imitate and figure in the mind.[†]

I am apprehensive that this part of my scheme, for explaining exact proportion, may not be thought so sufficiently determinate as could be wished: be this as it will, I must submit it to the reader, as my best resource in so difficult a case: and shall therefore beg leave to try to

* If the scale of either of these proportions were to exceed six foot in the life, the quality of strength in one, and agility in the other, would gradually decrease, the larger the person grew. There are sufficient proofs of this, both from mechanical reasonings and common observation.

[†] The jocky who knows to an ounce what flesh or bone in a horse is fitest for speed or strength, will as easily conceive the like process between the strongest dray-horse and the fleetest racer, and soon conclude, that the fine war-horse must be the medium between the two extremes.

illustrate it a little more, by observing, that, in like manner, any two opposite colours in the *rainbow*, form a third between them, by thus imparting to each other their peculiar qualities; as for example, the brightest yellow, and the lively blue that is placed at some distance from it, visibly approach, and blend by interchangable degrees, and, as above, *temper* rather than destroy each other's vigour, till they meet in one firm compound; whence, at a certain point, the sight of what they were originally, is quite lost; but in their stead, a most pleasing green is found, which colour nature hath chose for the vestment of the earth, and with the beauty of which the eye is never tired.

From the order of the ideas which the description of the above three figures may have raised in the mind, we may easily compose between them, various other proportions. And as the painter, by means of a certain order in the arrangement of the colours upon his pallet, readily mixes up what kind of tint he pleases, so may we mix up and compound in the imagination such fit parts as will be consistent with this or that particular character, or at least be able thereby to discover how such characters are composed when we see them either in art or nature.

But perhaps even the word *character, as it relates to form*, may not be quite understood by every one, tho' it is so frequently used; nor do I remember to have seen it explained any where. Therefore on this account – and also as it will farther shew the use of thinking of form and motion together, it will not be improper to observe, – that notwithstanding a character, in this sense, chiefly depends on a figure being remarkable as to its form, either in some particular part, or altogether; yet surely no figure, be it ever so singular, can be perfectly conceived as a character, till we find it connected with some remarkable circumstance or cause, for such particularity of appearance; for instance, a fat bloted person doth not call to mind the character of a Silenus, till we have joined the idea of voluptuousness with it; so likewise strength to support, and clumsiness of figure, are united, as well in the character of an Atlas as in a porter.

When we consider the great weight chairmen often have to carry, do we not readily consent that there is a propriety and fitness in the tuscan order of their legs, by which they properly become *characters* as to figure?

Watermen too, are of a distinct cast, or character, whose legs are no less remarkable for their smallness: for as there is naturally the greatest call for nutriment to the parts that are most exercised, so of course these that lye so much stretched out, are apt to dwindle, or not grow to their full size. There is scarcely a waterman that rows upon the Thames,

whose figure doth not confirm this observation. Therefore were I to paint the character of a Charon, I would thus distinguish his make from that of a common man's; and, in spite of the word *low*, venture to give him a broad pair of shoulders, and spindle shanks, whether I had the authority of an antique statue, or basso-relievo, for it or not.

May be, I cannot throw a stronger light on what has been hitherto said of proportion, than by animadverting on a remarkable beauty in the Apollo-belvedere; which hath given it the preference even to the Antinous: I mean a super-addition of *greatness*, to at least as much beauty and grace, as is found in the latter.

These two master-pieces of art, are seen together in the same palace at Rome, where the Antinous fills the spectator with admiration only, whilst the Apollo strikes him with surprise, and, as travellers express themselves, with an appearance of something *more than human*; which they *of course* are always at a loss to describe: and, this effect, they say, is the more astonishing, as upon examination its disproportion is evident even to a common eye. One of the best sculptors we have in England, who lately went to see them, confirm'd to me what has been now said, particularly as to the legs and thighs being too long, and too large for the upper parts. And Andrea Sacchi, one of the great Italian painters, seems to have been of the same opinion, or he would hardly have given his Apollo, crowning Pasquilini the musician, the exact proportion of the Antinous, (in a famous picture of his now in England) as otherwise it seems to be a direct copy from the Apollo.[69]

Although in very great works we often see an inferior part neglected, yet here it cannot be the case, because in a fine statue, just proportion is one of its essential beauties: therefore it stands to reason, that these limbs must have been lengthened on purpose, otherwise it might easily have been avoided.

So that if we examine the beauties of this figure thoroughly, we may reasonably conclude, that what has been hitherto thought so unaccount-

69. "One of the best sculptors": Hogarth's friend, Louis-François Roubiliac (1702–62), who had travelled to Rome in 1752. Sacchi, *Portrait of the Singer Marc' Antonio Pasqualini* (1636–40). This painting was in England by 1730 and by the late 1730s was in the collection of Henry Furnese; bought from Furnese by John, later 1st Earl Spencer, 1758 (see K. Garlick "A Catalogue of Pictures at Althorp," *Walpole Society*, XLV, 1976, p. 75); bought from the 8th Earl Spencer during the 1980s by the Metropolitan Museum, New York, where the picture now is. There is every reason to think Hogarth knew the original (while it was in the Furnese Collection in London) rather than the Jarvis copy.

ably *excellent* in its general appearance, hath been owing to what hath seem'd a *blemish* in a part of it: but let us endeavour to make this matter as clear as possible, as it may add more force to what has been said.

Statues by being bigger than life (as this is one, and larger than the Antinous) always gain some nobleness in effect, according to the principle of quantity* but this alone is not sufficient to give what is properly to be called, *greatness* in proportion; for were figures 17 and 18, in plate 1, to be drawn or carved by a scale of ten feet high, they would still be but pigmy proportions, as, on the other hand, a figure of but two inches, may represent a gigantic height.

Therefore *greatness* of proportion must be considered, as depending on the application of *quantity* to those parts of the body where it can give more scope to its grace in movement, as to the neck for the larger and swan-like turns of the head, and to the legs and thighs, for the more ample sway of all the upper parts together.

By which we find that the Antinous's being equally magnified to the Apollo's height, would not sufficiently produce that superiority of effect, as to greatness, so evidently seen in the latter. The additions necessary to the production of this *greatness* in proportion, as it there appears added to grace, must then be, by the proper application of them, to the parts mention'd only.

I know not how further to prove this matter than by appealing to the reader's eye, and common observation, as before.

The Antinous being allowed to have the justest proportion possible, let us see what addition, upon the principle of quantity, can be made to it, without taking away any of its beauty.

If we imagine an addition of dimensions to the head, we shall immediately conceive it would only deform —— if to the hands or feet, we are sensible of something gross and ungenteel, —— if to the whole lengths of the arms, we feel they would be dangling and aukward – if by an addition of length or breadth to the body, we know it would appear heavy and clumsy – there remains then only the *neck*, with the *legs* and *thighs* to speak of; but, to these we find, that not only certain additions may be admitted without causing any disagreeable effect, but that thereby *greatness*, the last perfection as to proportion, is given to the human form; as is evidently express'd in the Apollo: and may still be further confirmed by examining the drawings of Parmigiano, where these particulars are seen in excess; yet on this account his works are

* See chap. 6.

said, by all true connoisseurs, to have an inexpressible greatness of taste in them, though otherwise very incorrect.

Let us now return to the two general ideas we set out with at the beginning of this chapter, and recollect that under the first, on surface, I have shewn in what manner, and how far human proportion is measureable, by varying the contents of the body, conformable to the given proportion of two lines. And that under the second and more extensive general idea of form, as arising from fitness for movement, &c. I have endeavour'd to explain, by every means I could devise, that every particular and minute dimension of the body, should conform to such purposes of movement, &c. as have been first properly considered and determined: on which conjunctively, the true proportion of every character must depend; and is found so to do, by our joint-sensation of bulk and motion. Which account of the proportion of the human body, however imperfect, may possibly stand its ground, till one more plausible shall be given.

As the Apollo [fig. 12, plate 1] has been only mention'd on account of the greatness of its proportion, I think in justice to so fine a performance; and also as it is not foreign to the point we have been upon, we may subjoin an Observation or two on its perfections.

Besides, what is commonly allow'd, if we consider it by the rules here given for constituting or composing character, it will discover the author's great sagacity, in choosing a proportion for this deity, which has served two noble purposes at once; in that these very dimensions which appear to have given it so much dignity, are the same that are best fitted to produce the utmost speed. And what could characterise the god of day, either so strongly or elegantly, to be expressive in a statue, as superior swiftness, and beauty dignify'd? and how poetically doth the action it is put into, carry on the allusion to speed,* as he is lightly stepping forward, and seeming to shoot his arrows from him; if the arrows may be allowed to signify the sun's rays? This at least may as well be supposed as the common surmise, that he is killing the dragon, Python; which certainly is very inconsistent with so erect an attitude, and benign an aspect.[†70]

Nor are the inferior parts neglected: the drapery also that depends

* ——— the sun: which cometh forth as a bridegroom out of his chamber, and rejoiceth as a giant to run his course. Psalm xix. 5.

[†] The accounts given, in relation to this statue, make it so highly probable that it was the great Apollo of Delphos, that, for my own part, I make no manner of doubt of its being so.

70. Montfaucon, *Antiquity Explained*, 1:62–63, pl. 25.

from his shoulders, and folds over his extended arm, hath its treble office. As first, it assists in keeping the general appearance within the boundary of a pyramid, which being inverted, is, for a single figure, rather more natural and genteel than one upon its basis. Secondly, it fills up the vacant angle under the arm, and takes off the straightness of the lines the arm necessarily makes with the body in such an action; and, lastly, spreading as it doth, in pleasing folds, it helps to satisfy the eye with a noble quantity in the composition altogether, without depriving the beholder of any part of the beauties of the naked: in short, this figure might serve, were a lecture to be read over it, to exemplify every principle that hath been hitherto advanced. We shall therefore close not only all we have to say on proportion with it, but our whole lineal account of form, except what we have particularly to offer as to the face; which it will be proper to defer, till we have spoke of *light* and *shade* and *colour*.

As some of the ancient statues have been of such singular use to me, I shall beg leave to conclude this chapter with an observation or two on them in general.

It is allowed by the most skilful in the imitative arts, that tho' there are many of the remains of antiquity, that have great excellencies about them; yet there are not, moderately speaking, above twenty that may be justly called *capital*. There is one reason, nevertheless, besides the blind veneration that generally is paid to antiquity, for holding even many very imperfect pieces in some degree of estimation: I mean that *peculiar taste of elegance* which so visibly runs through them all, down to the most incorrect of their basso-relievos: which *taste*, I am persuaded, my reader will now conceive to have been entirely owing to the per- fect knowledge the ancients must have had of the use of the precise serpentine-line.

But this cause of *elegance* not having been since sufficiently under- stood, no wonder such effects should have appear'd mysterious, and have drawn mankind into a sort of religious esteem, and even bigotry, to the works of antiquity.

Nor have there been wanting of artful people, who have made good profit of those whose unbounded admiration hath run them into enthu- siasm. Nay there are, I believe, some who still carry on a comfortable trade in such originals as have been so defaced and maimed by time, that it would be impossible, without a pair of *double-ground* connoisseur- spectacles, to see whether they have ever been good or bad: they deal also in cook'd-up copies, which they are very apt to put off for originals. And whoever dares be bold enough to detect such impositions, finds himself

immediately branded, and given out as one of low ideas, ignorant of the true sublime, self-conceited, envious, &c.

But as there are a great part of mankind that delight most in what they least understand; for ought I know, the emolument may be equal between the *bubler* and the *bubled:* at least this seems to have been Butler's opinion:

> Doubtless the pleasure is as great
> In being cheated, as to cheat.[71]

CHAPTER XII

Of LIGHT *and* SHADE, *and the manner in which objects are explained to the eye by them*

ALTHOUGH both this and the next chapter may seem more particularly relative to the art of painting, than any of the foregoing; yet, as hitherto, I have endeavour'd to be understood by every reader, so here also I shall avoid, as much as the subject will permit, speaking of what would only be well-conceived by painters.

There is such a subtile variety in the nature of appearances, that probably we shall not be able to gain much ground by this enquiry, unless we exert and apply the full use of every sense, that will convey to us any information concerning them.

So far as we have already gone, the sense of feeling, as well as that of seeing, hath been apply'd to; so that perhaps a man born blind, may, by his better touch than is common to those who have their sight, together with the regular process that has been here given of lines, so feel out the

71. Samuel Butler, *Hudibras*, pt. 2, canto 3, ll. 1–2. Hogarth writes "In" instead of "Of" in the second line. The context is Hudibras's encounter with the magician Sidrophel. Hogarth illustrated *Hudibras* twice in the 1720s, including the meeting with Sidrophel (*HGW* Nos. 15–17, 89). "Bubler" refers to the South Sea Bubble of 1720–21, which Hogarth celebrated in a satiric print (*HGW* No. 43). See above, pp. xviii–xix.

nature of forms, as to make a tolerable judgment of what is beautiful to sight.

Here again our other senses must assist us, notwithstanding in this chapter we shall be more confined to what is communicated to the eye by rays of light; and tho' things must now be consider'd as appearances only; produced and made out merely by means of *lights*, *shades*, and *colours*.

By the various circumstances of which, every one knows we have represented on the flat surface of the looking-glass, pictures equal to the originals reflected by it. The painter too, by proper dispositions of lights, shades, and colours on his canvas, will raise the like ideas. Even prints, by means of lights and shades alone, will perfectly inform the eye of every shape and distance whatsoever, in which even lines must be consider'd as narrow parts of shade, a number of them, drawn or engrav'd neatly side by side, called *hatching*, serve as shades in prints, and when they are artfully managed, are a kind of pleasing *succedaneum* to the delicacy of nature's.

Could mezzo-tinto prints be wrought as accurately as those with the graver, they would come nearest to nature, because they are done without strokes or lines.

I have often thought that a landskip, in the process of this way of representing it, doth a little resemble the first coming on of day. The copper-plate it is done upon, when the artist first takes it into hand, is wrought all over with an edg'd-tool, so as to make it print one even black, like night: and his whole work after this, is merely introducing the lights into it; which he does by scraping off the rough grain according to his design, artfully smoothing it most where light is most required: but as he proceeds in burnishing the lights, and clearing up the shades, he is obliged to take off frequent impressions to prove the progress of the work, so that each proof appears like the different times of a foggy morning, till one becomes so finish'd as to be distinct and clear enough to imitate a day-light piece. I have given this description because I think the whole operation, in the simplest manner, shews what lights and shades alone will do.

As light must always be supposed, I need only speak of such privations of it as are called shades or shadows, wherein I shall endeavour to point out and regularly describe a certain order and arrangement in their appearance, in which order we may conceive different kinds of softnings and modulations of the rays of light which are said to fall upon the eye from every object it sees, and to cause those more or less-pleasing

vibrations of the optic nerves, which serve to inform the mind concerning every different shape or figure that presents itself.

The best light for seeing the shadows of objects truly, is, that which comes in at a common sized window, where the sun doth not shine; I shall therefore speak of their order as seen by this kind of light: and shall take the liberty in the present and following chapter, to consider colours but as variegated shades, which together with common shades, will now be divided into two general parts or branches.

The first we shall call PRIME TINTS, by which is meant any colour or colours on the surfaces of objects; and the use we shall make of these different hues will be to consider them as shades to one another. Thus gold is a shade to silver, &c. exclusive of those additional shades which may be made in any degree by the privation of light.

The second branch may be called RETIRING SHADES, which gradate or go off by degrees, as fig. [34, plate 2 top]. These shades, as they vary more or less, produce beauty, whether they are occasioned by the privation of light, or made by the pencilings of art or nature.

When I come to treat of colouring, I shall particularly shew in what manner the gradating of prime tints serve to the making a beautiful complexion; in this place we shall only observe how nature hath by these gradating shades ornamented the surfaces of animals; fish generally have this kind of shade from their backs downward; birds have their feathers enriched with it; and many flowers, particularly the rose, shew it by the gradually-increasing colours of their leaves.

The sky always gradates one way or other, and the rising or setting sun exhibits it in great perfection, the imitating of which was Claud. de Lorain's peculiar excellence, and is now Mr. Lambert's:[72] there is so much of what is called harmony to the eye to be produced by this shade, that I believe we may venture to say, in art it is the painter's gamut, which nature has sweetly pointed out to us in what we call the eyes of a peacock's tail: and the nicest needle-workers are taught to weave it into every flower and leaf, right or wrong, as if it was as constantly to be observed as it is seen in flames of fire; because it is always found to entertain the eye. There is a sort of needle-work called Irish-stitch, done in these shades only; which pleases still, tho' it has long been out of fashion.

There is so strict an analogy between shade and sound, that they may

72. George Lambert (1700–65), a friend of Hogarth's, was the most celebrated English follower of Claude Lorrain in the 1730s–40s. He was also a follower of Gaspard Dughet.

well serve to illustrate each other's qualities: for as sounds gradually decreasing and increasing give the idea of progression from, or to the ear, just so do retiring shades shew progression, by figuring it to the eye. Thus, as by objects growing still fainter, we judge of distances in prospects, so by the decreasing noise of thunder, we form the idea of its moving further from us. And, with regard to their similitude in beauty, like as the gradating shade pleases the eye, so the increasing, or swelling note, delights the ear.

I have call'd it the retiring shade, because by the successive, or continual change in its appearance, it is equally instrumental with converging lines,* in shewing how much objects, or any parts of them, retire or recede from the eye; without which, a floor, or horizontal-plane, would often seem to stand upright like a wall. And notwithstanding all the other ways by which we learn to know at what distances things are from us, frequent deceptions happen to the eye on account of deficiencies in this shade: for if the light chances to be so disposed on objects as not to give this shade its true gradating appearance, not only spaces are confounded, but round things appear flat, and flat ones round.

But although the retiring shade hath this property, when seen with converging lines, yet if it describes no particular form, as none of those do in fig. 94, on top of plate 2, it can only appear as a flat-pencil'd shade; but being inclosed within some known boundary or out-line, such as may signify a wall, a road, a globe, or any other form in perspective where the parts retire, it will then shew its retiring quality: as for example, the retiring shade on the floor, in plate 2, which gradates from the dog's feet to those of the dancer's, shews, that by this means a level appearance is given to the ground: so when a cube is put into true perspective on paper, with lines only, which do but barely hint the directions every face of it is meant to take, these shades make them seem to retire just as the perspective lines direct; thus mutually compleating the idea of those recessions which neither of them alone could do.

Moreover, the out-line of a globe is but a circle on the paper; yet, according to the manner of filling up the space within it, with this shade, it may be made to appear either flat, globular, or concave, in any of its positions with the eye; and as each manner of filling up the circle for those purposes must be very different, it evidently shews the necessity of distinguishing this shade into as many species or kinds, as there

* See p. 28. The two converging lines from the ship, to the point C, under fig. 47, plate 1.

are classes or species of lines, with which they may have a correspondence.

In doing which, it will be found, that, by their correspondency with, and conformity to objects, either composed of straight, curved, waving, or serpentine lines, they of course take such appearances of variety as are adequate to the variety made by those lines; and by this conformity of shades we have the same ideas of any of the objects composed of the above lines in their front aspects, as we have of them by their profiles; which otherwise could not be without feeling them.

Now instead of giving engraved examples of each species of shade, as I have done of lines, I have found that they may be more satisfactorily pointed out and described by having recourse to the life.

But in order to the better and more precisely fixing upon what may be there seen, as the distinct species, of which all the shades of the retiring kind in nature partake, in some degree or other, the following scheme is offered, and intended as an additional means of making such simple impressions in the mind, as may be thought adequate to the four species of lines described in chapter 7. Wherein we are to suppose imperceptible degrees of shade gradating from one figure to another. The first species to be represented by, 1, 2, 3, 4, 5.

the second by, 5, 4, 3, 2, 1, 2, 3, 4, 5.

and the third by, 5, 4, 3, 2, 1, 2, 3, 4, 5, 4, 3, 2, 1, 2, 3, 4, 5.

gradating from the dots underneath, repeated either way.

As the first species varies or gradates but one way, it is therefore least ornamental, and equal only to straight lines.

The second gradating contrary ways, doubling the others variety, is consequently twice as pleasing, and thereby equal to curved lines.

The third species gradating doubly contrary ways, is thereby still more pleasing in proportion to that quadruple variety which makes it become capable of conveying to the mind an equivalent in shade, which expresses the beauty of the waving line, when it cannot be seen as a line.

The retiring shade, adequate to the serpentine line, now should follow; but as the line itself could not be expressed on paper, without the figure of a cone [fig. 26, plate 1], so neither can this shade be described without the assistance of a proper form, and therefore must be deferred a little longer.

When only the ornamental quality of shades is spoken of, for the sake of distinguishing them from retiring shades, let them be considered as pencilings only; whence another advantage will arise, which is, that then all the intervening mixtures, with their degrees of beauty between

each species, may be as easily conceived, as those have been between each class of lines.

And now let us have recourse to the experiments in life, for such examples as may explain the retiring power of each species; since, as has been before observed, they must be considered together with their proper forms, or else their properties cannot be well distinguished.

All the degrees of obliquity that planes, or flat surfaces are capable of moving into, have their appearances of recession perfected by the first species of retiring shades, which may evidently be seen by sitting opposite a door, as it is opening outwards from the eye, and fronting one light.

But it will be proper to premise, that when it is quite shut, and flat or parallel to the eye and window, it will only have a penciling shade gradating upon it, and spreading all around from the middle, but which will not have the power of giving the idea of recession any way, as when it opens, and the lines run in perspective to a point; because the square figure or parallel lines of the door, do not correspond with such shade; but let a door be circular in the same situation, and all without side, or round about it, painted of any other colour, to make its figure more distinctly seen, and it will immediately appear concave like a bason, the shade continually retiring; because this circular species of shade would then be accompanied by its corresponding form, a circle.*

But to return; we observ'd that all the degrees of obliquity in the moving of planes or flat surfaces, have the appearances of their recession perfected to the eye by the first species of retiring shade. For example, then; when the door opens, and goes from its parallel situation with the eye, the shade last spoken of, may be observed to alter and change its round gradating appearance, into that of gradating one way only; as when a standing water takes a current upon the least power given it to descend.

Note, if the light should come in at the door-way, instead of the window, the gradation then would be reversed, but still the effect of

* Note, if the light were to come in at a very little hole not far from the door, so as to make the gradation sudden and strong, like what may be made with a small candle held near a wall or a wainscot, the bason would appear the deeper for it.

Note also, that when planes are seen parallel to the eye in open daylight, they have scarce any round gradating or penciling shade at all, but appear merely as uniform prime tints, because the rays of light are equally diffused upon them. Nevertheless, give them but obliquity, they will more or less exhibit the retiring shade.

recession would be just the same, as this shade ever complies with the perspective lines.

In the next place, let us observe the *ovolo*, or quarter-round in a cornice, fronting the eye in like manner, by which may be seen an example of the second species; where, on its most projecting part, a line of light is seen, from whence these shades retire contrary ways, by which the curvature is understood.

And, perhaps, in the very same cornice may be seen an example of the third species, in that ornamental member called by the architects *cyma recta*, or talon, which indeed is no more than a larger sort of waving or ogee moulding; wherein, by the convex parts gently gliding into the concave, you may see four contrasted gradating shades, shewing so many varied recessions from the eye; by which we are made as sensible of its waving form as if we saw the profile out-line of some corner of it, where it is miter'd, as the joiners term it. Note, when these objects have a little gloss on them these appearances are most distinct.

Lastly, the serpentine shade may be seen (light and situation as before) by the help of the following figure, as thus; imagine the horn, figure 57, plate 2, to be of so soft a nature, that with the fingers only, it might be pressed into any shape; then beginning gently from the middle of the dotted line, but pressing harder and harder all the way up the lesser end, by such pressure there would be as much concave above, as would remain convex below, which would bring it equal in variety or beauty to the ogee moulding; but after this, by giving the whole a twist, like figure 58, these shades must unavoidably change their appearances, and in some measure, twist about as the concave and convex parts are twisted, and consequently thereby add that variety, which of course will give this species of shade, as much the preference to the foregoing, as forms composed of serpentine lines have, to those composed only of the waving. See chap. 9 and chap. 10.

I should not have given my reader the trouble of compleating, by the help of his imagination, the foregoing figure, but as it may contribute to the more ready and particular conception of that intricate variety which twisted figures give to this species of shade, and to facilitate his understanding the cause of its beauty, wherever it may be seen on surfaces of ornament, when it will be found no where more conspicuous than in a fine face, as will be seen upon further enquiry.

The dotted line [fig. 97, plate 1 bottom], which begins from the concave part, under the arch of the brow, near the nose, and from

thence winding down by the corner of the eye, and there turning
obliquely with the round of the cheek, shews the course of that twist of
shades in a face, which was before described by the horn; and which
may be most perfectly seen in the life, or in a marble busto, together
with the following additional circumstances still remaining to be
described.

As a face is for the most part round, it is therefore apt to receive
reflected light on its shadowy side,* which not only adds more beauty
by another pleasing tender gradation, but also serves to distinguish the
roundess of the cheeks, &c. from such parts as sink and fall in: because
concavities do not admit of reflections, as convex forms do.[†]

I have now only to add, as before observed, chap. 4, page 31, that the
oval hath a noble simplicity in it, more equal to its variety than any
other object in nature; and of which the general form of a face
is composed; therefore, from what has been now shewn, the general
gradation-shade belonging to it, must consequently be adequate
thereto, and which evidently gives a delicate softness to the whole
composition of a face; insomuch that every little dent, crack, or scratch,
the form receives, its shadows also suffer with it, and help to shew the
blemish. Even the least roughness interrupts and damages that soft
gradating play of shades which fall upon it. Mr. Dryden, describing the
light and shades of a face, in his epistle to Sir Godfrey Kneller the
portrait painter, seems, by the penetration of his incomparable genius,
to have understood that language in the works of nature, which the
latter, by means of an exact eye and a strict obeying hand, could only
faithfully transcribe; when he says,

> Where light to shades descending, plays, not strives,
> Dies by degrees, and by degrees revives.[73]

* Note, though I have advised the observing objects by a front light, for the sake of the
better distinguishing our four fundamental species of shades, yet objects in general are more
advantagiously, and agreeably seen by light coming side-ways upon them, and therefore
generally chose in paintings; as it gives an additional reflected softness, not unlike the gentle
tone of an echo in music.

[†] As an instance that convex and concave would appear the same, if the former were to
have no reflection thrown upon, observe the ovolo and cavetto, or channel, in a cornice, placed
near together, and seen by a front light, when they will each of them, by turns, appear either
concave, or convex, as fancy shall direct.

73. John Dryden, "Epistle to Sir Godfrey Kneller," ll. 69–70, in *Fourth Miscellany* (1694
and frequently reprinted).

CHAPTER XIII

Of COMPOSITION *with regard to* LIGHT, SHADE *and* COLOURS

UNDER this head I shall attempt shewing what it is that gives the appearance of that hollow or vacant space in which all things move so freely; and in what manner light, shade and colours, mark or point out the distances of one object from another, and occasion an agreeable play upon the eye, called by the painters a fine keeping, and pleasing composition of light and shade. Herein my design is to consider this matter as a performance of nature *without*, or before the eye; I mean, as if the objects with their shades, &c. were in fact circumstanced as they appear, and as the unskill'd in optics take them to be. And let it be remarked throughout this chapter, that the pleasure arising from composition, as in a fine landskip, &c. is chiefly owing to the dispositions and assemblages of light and shades, which are so order'd by the principles called OPPOSITION, BREADTH and SIMPLICITY, as to produce a just and distinct perception of the objects before us.

Experience teaches us that the eye may be subdued and forced into forming and disposing of objects even quite contrary to what it would naturally see them, by the prejudgment of the mind from the better authority of feeling, or some other persuasive motive. But surely this extraordinary perversion of the sight would not have been suffer'd, did it not tend to great and necessary purposes, in rectifying some deficiences which it would otherwise be subject to (tho' we must own at the same time, that the mind itself may be so imposed upon as to make the eye see falsely as well as truly) for example, were it not for this controul over the sight, it is well known, that we should not only see things double, but upside down, as they are painted upon the retina, and as each eye has a distinct sight. And then as to distances; a fly upon a pane of glass is sometimes imagined a crow, or larger bird afar off, till some circumstance hath rectified the mistake, and convinced us of its real size and place.

Hence I would infer, that the eye generally gives its assent to such space and distances as have been first measured by the feeling, or

otherwise calculated in the mind: which measurements and calculations are equally, if not more, in the power of a blind man, as was fully experienced by that incomparable mathematician and wonder of his age, the late professor Sanderson.[74]

By pursuing this observation on the faculties of the mind, an idea may be formed of the means by which we attain to the perception or appearance of an immense space surrounding us; which cavity, being subject to divisions and subdivisions in the mind, is afterwards fashioned by the limited power of the eye, first into a hemisphere, and then into the appearance of different distances, which are pictured to it by means of such dispositions of light and shade as shall next be described. And these I now desire may be looked upon, but as so many *marks* or *types* set upon these distances, and which are remember'd and learnt by degrees, and when learnt, are recurred to upon all occasions.

If permitted then to consider light and shades as *types of distinction*, they become, as it were, our materials, of which *prime tints* are the principal; by these, I mean the fixed and permanent colours of each object, as the green of trees, &c. which serve the purposes of separating and relieving the several objects by the different strengths or shades of them being opposed to each other [fig. 86, plate 2 top].

The other shades that have been before spoken of, serve and help to the like purposes when properly opposed; but as in nature they are continually fleeting and changing their appearances, either by our or their situations, they sometimes oppose and relieve, and sometimes not, as for instance; I once observed the tower-part of a steeple so exactly the colour of a light cloud behind it, that, at the distance I stood, there was not the least distinction to be made, so that the spire (of a lead-colour) seemed suspended in the air; but had a cloud of the like tint with the steeple, supplied the place of the white one, the tower would then have been relieved and distinct, when the spire would have been lost to the view.

Nor is it sufficient that objects are of different colours or shades, to shew their distances from the eye, if one does not in part hide or lay over the other, as in fig. 86 [plate 2].

For as fig. [90, plate 2 top] the two equal balls, tho' one were black and the other white, placed on the separate walls, supposed distant from

74. Nicholas Saunderson (1682–1739), the blind mathematician, at the age of 22 began lecturing at Cambridge on the principles of Newtonian philosophy; his *Algebra* (1740) was a standard treatise on the subject. As Burke notes (p. xxxvi), Saunderson read mathematics at Corpus Christi, Cambridge, Benjamin Hoadly's college.

each other twenty or thirty feet, nevertheless, may seem both to rest upon one, if the tops of the walls are level with the eye; but when one ball hides part of the other, as in the same figure, we begin to apprehend they are upon different walls, which is determin'd by the perspective:* hence you will see the reason, why the steeple of Bloomsbury-church, in coming from Hamstead, seems to stand upon Montague-house, tho' it is several hundred yards distant from it.

Since then the opposition of one prime tint or shade to another, hath so great a share in marking out the recessions, or distances in a prospect, by which the eye is led onward step by step, it becomes a principle of consequence enough to be further discussed, with regard to the management of it in compositions of nature, as well as art. As to the management of it, when seen only from one point, the artist hath the advantage over nature, because such fix'd dispositions of shades as he hath artfully put together, cannot be displaced by the alteration of light, for which reason, designs done in two prime tints only, will sufficiently represent all those recessions, and give a just keeping to the representation of a prospect, in a print; whereas, the oppositions in nature, depending, as has been before hinted, on accidental situations and uncertain incidents, do not always make such a pleasing composition, and would therefore have been very often deficient, had nature worked in two colours only; for which reason she hath provided an infinite number of materials, not only by way of prevention, but to add lustre and beauty to her works.

By an infinite number of materials, I mean colours and shades of all kinds and degrees; some notion of which variety may be formed by supposing a piece of white silk by several dippings gradually dyed to a black; and carrying it in like manner through the prime tints of yellow, red, and blue; and then again, by making the like progress through all the mixtures that are to be made of these three original colours. So that

* The knowledge of perspective is no small help to the seeing objects truly, for which purpose Dr. Brook Taylor's Linear perspective made easy to those who are unacquainted with geometry, proposed to be publish'd soon by Mr. Kirby of Ipswich, may be of most service.[75]

75. Joshua Kirby (1716–74), Hogarth's agent in Norwich for selling his prints, wrote a treatise on the theory of perspective based on the work of Brook Taylor: *Dr. Brook Taylor's Method of Perspective Made Easy, Both in Theory and Practice*, dedicated to Hogarth, who provided a frontispiece, usually known as *False Perspective* (publ. Feb. 1754, *HGW* No. 232). In line with the *Analysis*, it was both a satire on untutored perspective and an example of the effects an artist could obtain by employing false perspective. Brook Taylor (1685–1731), another Freemason, was a mathematician who wrote *Linear Perspective* (1715) and, to explain it, *New Principles of Linear Perspective* (1719).

when we survey this infinite and immense variety, it is no wonder, that, let the light or objects be situated or changed how they will, oppositions seldom miss: nor that even every incident of shade should sometimes be so completely disposed as to admit of no further beauty, as to composition; and from whence the artist hath by observation taken his principles of imitation, as in the following respect.

Those objects which are intended most to affect the eye, and come forwardest to the view, must have large, strong, and smart oppositions, like the fore-ground in fig. [89, plate 2 top], and what are designed to be thrown further off, must be made still weaker and weaker, as expressed in figure 86, also 92 and 93, which receding in order make a kind of gradation of oppositions; to which, and all the other circumstances already described, both for recession, and beauty, nature hath added what is known by the name of aerial perspective; being that interposition of air, which throws a general soft retiring tint over the whole prospect; to be seen in excess at the rising of a fog. All which again receives still more distinctness, as well as a greater degree of variety, when the sun shines bright, and casts broad shadows of one object upon another; which gives the skilful designer such hints for shewing broad and fine oppositions of shades, as give life and spirit to his performances.

BREADTH of SHADE is a principle that assists in making distinction more conspicuous; thus fig. [87, plate 1 left], is better distinguish'd by its breadth or quantity of shade, and view'd with more ease and pleasure at any distance, than fig. [88, plate 1 left], which hath many, and these but narrow shades between the folds. And for one of the noblest instances of this, let Windsor-castle be viewed at the rising or setting of the sun.

Let breadth be introduced how it will, it always gives great repose to the eye; as on the contrary, when lights and shades in a composition are scattered about in little spots, the eye is constantly disturbed, and the mind is uneasy, especially if you are eager to understand every object in the composition, as it is painful to the ear when any one is anxious to know what is said in company, where many are talking at the same time.[76]

76. Hogarth is recalling, almost verbatim, a passage in de Piles's *Principles of Painting* (pp. 65–66; *Cours de Peinture*, pp. 106–07): "The eye has this in common with the other organs of sense, that it cares not to be obstructed in its office; and it must be agreed, that a great many people, met in one place, and talking together at the same time, and with the same tone of voice, so as that no one in particular could be distinguished, would give pain to

SIMPLICITY (which I am last to speak of) in the disposition of a great variety, is best accomplished by following nature's constant rule, of dividing composition into three or five parts, or parcels, see chap. 4 on simplicity: the painters accordingly divide theirs into foreground, middle-ground, and distance or back-ground; which simple and distinct quantities *mass* together that variety which entertains the eye; as the different parts of base, tenor, and treble, in a composition in music, entertain the ear.

Let these principles be reversed, or neglected, the light and shade will appear as disagreeable as fig. [91, plate 2 top], whereas, was this to be a composition of lights and shades only, properly disposed, tho' ranged under no particular figures, it might still have the pleasing effect of a picture. And here, as it would be endless to enter upon the different effects of lights and shades on lucid and transparent bodies, we shall leave them to the reader's observation, and so conclude this chapter.

CHAPTER XIV

Of COLOURING

B Y the beauty of colouring, the painters mean that disposition of colours on objects, together with their proper shades, which appear at the same time both distinctly varied and artfully united, in compositions of any kind; but, by way of pre-eminence, it is generally understood of flesh-colour, when no other composition is named.

To avoid confusion, and having already said enough of retiring shades, I shall now only describe the nature and effect of the prime tint of flesh; for the composition of this, when rightly understood,

those who heard them: it is just so in a picture, where many objects, painted with equal force, and illuminated by the same light, would divide and perplex the sight, which being drawn to several parts at once, would be at a loss where to fix; or else, being desirous to take in the whole at one view, must needs do it imperfectly. Now, to hinder the eye from being dissipated, we must endeavour to fix it agreeably, by a combination of lights and shades, by an union of colours, and by oppositions wide enough to support the groups, and give them repose." Hogarth, however, presents as a virtue (as difficulty) what de Piles presents as painful. Compare also de Piles's chapter on chiaroscuro (the *clair-obscur*) in *Principles of Painting* (esp. pp. 219–26; *Cours de Peinture*, pp. 361–76).

comprehends every thing that can be said of the colouring of all other objects whatever.[77]

And herein (as has been shewn in chap. 8, of the manner of composing pleasing forms) the whole process will depend upon the art of varying; i.e. upon an artful manner of varying every colour belonging to flesh, under the direction of the six fundamental principles there spoken of.

But before we proceed to shew in what manner these principles conduce to this design, we shall take a view of nature's curious ways of producing all sorts of complexions, which may help to further our conception of the principles of varying colours, so as to see why they cause the effect of beauty.

1. It is well known, the fair young girl, the brown old man, and the negro; nay, all mankind, have the same appearance, and are alike disagreeable to the eye, when the upper skin is taken away: now to conceal so disagreeable an object, and to produce that variety of complexions seen in the world, nature hath contrived a transparent skin, called the cuticula, with a lining to it of a very extraordinary kind, called the cutis; both which are so thin any little scald will make them blister and peel off. These adhering skins are more or less transparent in some parts of the body than in others, and likewise different in different persons. The cuticula alone is like gold-beaters-skin, a little wet, but somewhat thinner, especially in fair young people, which would shew the fat, lean, and all the blood-vessels, just as they lie under it, as through Isinglass, were it not for its lining the cutis, which is so curiously constructed, as to exhibit those things beneath it which are necessary to life and motion, in pleasing arangements and dispositions of beauty.

The cutis is composed of tender threads like network, fill'd with different colour'd juices. The white juice serves to make the very fair complexion; – yellow, makes the brunnet; —— brownish yellow, the ruddy brown; —— green yellow, the olive; —— dark brown, the mulatto; – black, the negro; – These different colour'd juices, together with the different *mashes* of the network, and the size of its threads in this or that part, causes the variety of complexions.

77. This discussion of color would have been read in the context of de Piles's chapter on color in *Principles of Painting* (esp. pp. 184–211; *Cours de Peinture*, pp. 303–48). Hogarth ignores de Piles' basic distinctions, such as between *coloris* and *couleur*, focusing almost exclusively on the representation of female flesh in terms of variety. For further notes on color, see MSS. XII, pp. 131–32.

A description of this manner of its shewing the rosy colour of the cheek, and, in like manner, the bluish tints about the temple, &c. see in the profile [fig. 95, plate 2 top], where you are to suppose the black strokes of the print to be the white threads of the network, and where the strokes are thickest, and the part blackest, you are to suposse the flesh would be whitest; so that the lighter part of it stands for the vermilion-colour of the cheek, gradating every way.

Some persons have the network so equally wove over the whole body, face and all, that the greatest heat or cold will hardly make them change their colour; and these are seldom seen to blush, tho' ever so bashful, whilst the texture is so fine in some young women, that they redden, or turn pale, on the least occasion.

I am apt to think the texture of this network is of a very tender kind, subject to damage many ways, but able to recover itself again, especially in youth. The fair fat healthy child of 3 or 4 years old hath it in great perfection; most visible when it is moderately warm, but till that age somewhat imperfect.

It is in this manner, then, that nature seems to do her work. ———— And now let us see how by art the like appearance may be made and penciled on the surface of an uniform coloured statue of wax or marble; by describing which operation we shall still more particularly point out what is to our present purpose: I mean the reason why the order nature hath thus made use of should strike us with the idea of beauty; which by the way, perhaps may be of more use to some painters than they will care to own.

There are but three original colours in painting besides black and white, viz. red, yellow and blue. Green, and purple, are compounded; the first of blue and yellow, the latter of red and blue; however these compounds being so distinctly different from the original colours, we will rank them as such. Fig. [94, plate 2 top], represents mixt up, as on a painter's pallet, scales of these five original colours divided into seven classes, 1, 2, 3, 4, 5, 6, 7. —— 4, is the medium, and most brillant class, being that which will appear a firm red, when those of 5, 6, 7, would deviate into white, and those of 1, 2, 3, would sink into black, either by twilight or at a moderate distance from the eye, which shews 4 to be brightest, and a more permanent colour than the rest. But as white is nearest to light it may be said to be equal if not superior in value as to beauty, with class 4. therefore the classes 5, 6, 7, have also, almost equal beauty with it too, because what they lose of their brillancy and permanency of colour, they gain from the white or light; whereas 3,

2, 1, absolutely lose their beauty by degrees as they approach nearer to black, the representative of darkness.

Let us then, for distinction and pre-eminence sake, call class 4 of each colour, *bloom tints*, or if you please, virgin tints, as the painters call them; and once more recollect, that in the disposition of colours as well as of forms, variety, simplicity, distinctness, intricacy, uniformity and quantity, direct in giving beauty to the colouring of the human frame, especially if we include the face, where uniformity and strong opposition of tints are required, as in the eyes and mouth, which call most for our attention. But for the general hue of flesh now to be described, variety, intricacy and simplicity, are chiefly required.

The value of the degrees of colour being thus consider'd and ranged in order upon the pallet, figure 94, let us next apply them to a busto, fig. [96, plate 2 right], of white marble, which may be supposed to let every tint sink into it, like as a drop of ink sinks in and spreads itself upon course paper, whereby each tint will gradate all around.

If you would have the neck of the busto tinged of a very florid and lively complexion, the pencil must be dipt in the bloom tints of each colour as they stand one above another at N°. 4. – if for a less florid, in those of N°. 5 – if for a very fair, from N°. 6 – and so on till the marble would scarce be ting'd at all: let therefore N°. 6, be our present choice, and begin with penciling on the red, as at r, the yellow tint at y, the blue tint at b, and the purple or lake tint at p.

These four tints thus laid on, proceed to covering the whole neck and breast, but still changing and varying the situations of the tints with one another, also causing their shapes and sizes to differ as much as possible; red must be oftenest repeated, yellow next often, purple red next, and blue but seldom, except in particular parts as the temples, backs of the hands, &c. where the larger veins shew their branching shapes (sometimes too distinctly) still varying those appearances. But there are no doubt infinite variations in nature from what may be called the most beautiful order and disposition of the colours in flesh, not only in different persons, but in different parts of the same, all subject to the same principles in some degree or other.

Now if we imagine this whole process to be made with the tender tints of class 7, as they are supposed to stand, red, yellow, blue, green and purple, underneath each other; the general hue of the performance will be a seeming uniform prime tint, at any little distance, that is a very fair, transparent and pearl-like complexion; but never quite

uniform as snow, ivory, marble or wax, like a poet's mistress, for either of these in living-flesh, would in truth be hideous.

As in nature, by the general yellowish hue of the cuticula, the gradating of one colour into another appears to be more delicately soften'd and united together; so will the colours we are supposed to have been laying upon the busto, appear to be more united and mellowed by the oils they are ground in, which takes a yellowish cast after a little time, but is apt to do more mischief hereby than good; for which reason care is taken to procure such oil as is clearest and will best keep its colour* in oil-painting.

* Notwithstanding the deep-rooted notion, even amongst the majority of painters themselves, that time is a great improver of good pictures, I will undertake to shew, that nothing can be more absurd. Having mention'd above the whole effect of the oil, let us now see in what manner time operates on the colours themselves; in order to discover if any changes in them can give a picture more union and harmony than has been in the power of a skilful master, with all his rules of art, to do. When colours change at all it must be somewhat in the manner following, for as they are made some of metal, some of earth, some of stone, and others of more perishable materials, time cannot operate on them otherwise than as by daily experience we find it doth, which is, that one changes darker, another lighter, one quite to a different colour, whilst another, as ultramarine, will keep its natural brightness even in the fire. Therefore how is it possible that such different materials, ever variously changing (visibly after a certain time) should accidentally coincide with the artist's intention, and bring about the greater harmony of the piece, when it is manifestly contrary to their nature, for do we not see in most collections that much time disunites, untunes, blackens, and by degrees destroys even the best preserved pictures.

But if for argument sake we suppose, that the colours were to fall equally together, let us see what advantage this would give to any sort of composition. We will begin with a flower-piece: when a master hath painted a rose, a lily, an african, a gentianella, or violet, with his best art, and brightest colours, how far short do they fall of the freshness and rich brillancy of nature; and shall we wish to see them fall still lower, more faint, sullied, and dirtied by the hand of time, and then admire them as having gained an additional beauty, and call them mended and heightened, rather than fouled, and in a manner destroy'd; how absurd! instead of mellow and softened therefore, always read yellow and sullied, for this is doing time the destroyer, but common justice. Or shall we desire to see complexions, which in life are often, literally, as brillant as the flowers above-mention'd, served in the like ungrateful manner. In a landskip, will the water be more transparent, or the sky shine with a greater lustre when embrown'd and darken'd by decay? surely no. I own it would be a pity that Mr. Addison's beautiful description of time at work in the gallery of pictures,[78] and the following lines of Mr. Dryden, should want a sufficient foundation; –

> For time shall with his ready pencil stand,
> Retouch your figures with his ripening hand;
> Mellow your colours, and imbrown the tint;
> Add every grace which time alone can grant;
> To future ages shall your fame convey,
> And give more beauties than he takes away. Dryden to Kneller.[79]

Upon the whole of this account we find, that the utmost beauty of
colouring depends on the great principle of varying by all the means of
varying, and on the proper and artful union of that variety; which may
be farther proved by supposing the rules here laid down, all or any part
of them reversed.

I am apt to believe, that the not knowing nature's artful, and intricate
method of uniting colours for the production of the variegated compo-
sition, or prime tint of flesh, hath made colouring, in the art of painting,
a kind of mystery in all ages; insomuch, that it may fairly be said, out
of the many thousands who have labour'd to attain it, not above ten or

were it not that the error they are built upon, hath been a continual blight to the growth of
the art, by misguiding both the proficient, and the encourager; and often compelling the
former, contrary to his judgment, to imitate the damaged hue of decayed pictures; so that
when his works undergo the like injuries, they must have a double remove from nature;
which puts it in the power of the meanest observer to see his deficiencies. Whence another
absurd notion hath taken rise, viz. that the colours now-a-days do not stand so well as
formerly; whereas colours well prepared, in which there is but little art or expence, have, and
will always have, in same properties in every age, and without accidents, as damps, bad
varnish, and the like, (being laid separate and pure), will stand and keep together for many
years in defiance of time itself.

In proof of this, let any one take a view of the cieling at Greenwich-hospital, painted by
Sir James Thornhil, forty years ago, which still remains fresh, strong and clear as if it had
been finished but yesterday: and altho' several french writers have so learnedly, and philo-
sophically proved, that the air of this island is too thick, or – too something, for the genius
of a painter, yet France in all her palaces can hardly boast of a nobler, more judicious, or richer
performance of its kind. Note, the upper end of the hall where the royal family is painted, was
left chiefly to the pencil of Mr. Andrea a foreigner, after the payment originally agreed upon
for the work was so much reduced, as made it not worth Sir James's while to finish the whole
with his own more masterly hand.[80]

78. In *Spectator* No. 83 (1:354–56) Addison projects a dream vision of a picture gallery
in which Time touches up the paintings. "However, as he busied himself incessantly, and
repeated Touch after Touch without Rest or Intermission, he wore off insensibly every little
disagreeable Gloss that hung upon a Figure. He also added such a beautiful Brown to the
Shades, and Mellowness to the Colours, that he made every Picture appear more perfect than
when it came fresh from the Master's Pencil." But while Addison sees Time (as the connois-
seurs did) as a mellowing agent, Hogarth sees it as a destructive force that confers a false value
on art. He sums these up in *Time Smoking a Picture* (1761, *HGW* No. 208). See MSS. XIII,
p. 134.

79. Dryden, "Epistle to Sir Godfrey Kneller," ll. 176–81.

80. Sir James Thornhill, later Hogarth's father-in-law, painted the ceiling and Upper
Hall in Greenwich Hospital between 1709 and 1725; dissatisfied with his payment,
Thornhill turned over much of the work on the Upper Hall to Andrea (Dietrich Ernst, a Pole;
c. 1680–1734?) (*Hog. 1*:137). Cf. above, p. xviii.

twelve painters have happily succeeded therein, Corregio (who lived in a country-village, and had nothing but the life to study after) is said almost to have stood alone for this particular excellence. Guido, who made beauty his chief aim, was always at a loss about it. Poussin scarce ever obtained a glimpse of it, as is manifest by his many different attempts: indeed France hath not produced one remarkable good colourist.[†]

Rubens boldly, and in a masterly manner, kept his bloom tints bright, separate and distinct, but sometimes too much so for easel or cabinet pictures; however, his manner was admirably well calculated for great works, to be seen at a considerable distance, such as his celebrated cieling at Whitehall-chapel:[*][81] which upon a nearer view, will illustrate what I have advanc'd with regard to the separate brightness of the tints; and shew, what indeed is known to every painter, that had the colours there seen so bright and separate, been all smooth'd and absolutely blended together, they would have produced a dirty grey instead of flesh-colour. The difficulty then lies in bringing *blue* the third original colour, into flesh, on account of the vast variety introduced thereby; and this omitted, all the difficulty ceases; and a common sign-painter that lays his colours smooth, instantly becomes, in point of colouring, a Rubens, a Titian, or a Corregio.[82]

[†] The lame excuse writers on painting have made for the many great masters that have fail'd in this particular, is, that they purposely deaden'd their colours, and kept them, what they affectedly call'd *chaste*, that the correctness of their outlines might be seen to greater advantage. Whereas colours cannot be too brillant if properly disposed, because the distinction of the parts are thereby made more perfect; as may be seen by comparing a marble busto with the variegated colours of the face either in the life, or one well painted: it is true, uncomposed variety, either in the features or the limbs, as being daubed with many, or one colour, will so confound the parts as to render them unintelligible.

[*] The front of this building by Inigo Jones, is an additional exemplification of the principles for varying the parts in building; (explained by the candlesticks, &c. chap. 8.) which would appear to be a stronger proof still, were a building formed of squares, on squares; with squares uniformly cut in each square to be opposed to it, to shew the reverse.

81. Rubens painted the "Apotheosis of James I" for the ceiling of Charles I's Banqueting House, Whitehall (1629–34).

82. The reference to the "common sign-painter" was picked up by the satiric exhibition of Signboards of 1762 in which Hogarth collaborated with Bonnell Thornton (*Hog.3*, chap. 13). There it was partly a comment on the "Society of Artists" exhibiting nearby and partly a rallying cry to English painters to rediscover a native art by "seeking out their ancient mother" in the primitive forms of the signboard.

CHAPTER XV

Of the FACE

HAVING thus spoken briefly of light, shade and colour, we now return to our lineal account of form, as proposed (page 74) with regard to the face.[83] It is an observation, that, out of the great number of faces that have been form'd since the creation of the world, no two have been so exactly alike, but that the usual and common discernment of the eye would discover a difference between them: therefore it is not unreasonable to suppose, that this discernment is still capable of further improvements by instructions from a methodical enquiry; which the ingenious Mr. Richardson, in his treatise on painting, terms *the art of seeing.*[84]

1. I shall begin with a description of such lines as compose the features of a face of the highest taste, and the reverse. See fig. [97, plate 1 bottom], taken from an antique head, which stands in the first rank of estimation: in proof of this, Raphael Urbin, and other great painters and sculptors, have imitated it for the characters of their heroes and other great men; and the old man's head, fig. [98, plate 1 left], was model'd in clay, by Fiamingo (and not inferior in its taste of lines, to the best antique) for the use of Andrea Sacchi, after which model he painted all the heads in his famous picture of St. Romoaldo's dream;[85] and this picture hath the reputation of being one of the best pictures in the world.[†]

These examples are here chosen to exemplify and confirm the force of serpentine lines in a face; and let it also be observed, that in these

83. See MSS. XIV, p. 136.

84. Jonathan Richardson, *Essay on the Theory of Painting*, in *Works*, 2–4. This could be a reference to the "variety" of faces in *Characters and Caricaturas* (ill. 15).

85. Sacchi, *Vision of St. Romuald* (1631, Vatican Gallery, Rome), engraved 1655–67 by "Io. Baronio Tolosini" and in the eighteenth century by Jacob Frey. For Fiammingo, see Plate 1, fig. 98.

† Note, I must refer the reader to the casts of both these pieces of sculpture, which are to be found in the hands of the curious; because it is impossible to express all that I intend, with sufficient accuracy, in a print of this size, whatever pains might have been taken with it; or indeed in any print were it ever so large.

master-pieces of art, all the parts are otherwise consistent with the rules
heretofore laid down: I shall therefore only shew the effects and use of
the line of beauty. One way of proving in what manner the serpentine
line appears to operate in this respect, may be by pressing several pieces
of wire close up and down the different parts of the face and features of
those casts; which wires will all come off so many serpentine lines, as is
partly marked in figure 97 [plate 1 bottom], by the dotted lines. The
beard and hair of the head, fig. 98, being a set of loose lines naturally,
and therefore disposable at the painter's or sculptor's pleasure, are
remarkably composed in this head of nothing else but a varied play of
serpentine lines, twisting together in a flame-like manner.

But as imperfections are easier to be imitated than perfections, we
shall now have it in our power to explain the latter more fully; by
shewing the reverse in several degrees, down to the most contemptible
meanness that lines can be form'd into.

Figure 99, is the first degree of deviation from figure 97; where the
lines are made straighter, and reduced in quantity; deviating still more
in figure 100, more yet in figure 101, and yet more visibly in 102; figure
103, still more so, figure 104 is totally divested of all lines of elegance,
like a barber's block;[86] and 105 is composed merely of such plain lines
as children make, when of themselves they begin to imitate in drawing
a human face. It is evident, the inimitable Butler was sensible of the
mean and ridiculous effect of such kind of lines, by the description he
gives of the shape of Hudibras's beard, fig. [106, plate 1 left],

> In cut and dye so like a tile,
> A sudden view it would beguile.[87]

2. With regard to character and expression; we have daily many
instances which confirm the common received opinion, that the face is
the index of the mind; and this maxim is so rooted in us, we can scarce
help (if our attention is a little raised) forming some particular concep-
tion of the person's mind whose face we are observing, even before we
receive information by any other means. How often is it said, on the
slightest view, that such a one looks like a good-natur'd man, that he
hath an honest open countenance, or looks like a cunning rogue; a man
of sense, or a fool, &c. And how are our eyes riveted to the aspects of

86. Hogarth developed the barber's block in his celebration of the coronation of 1761
(*Five Orders of Periwigs*, *HGW* No. 209); for the child's scrawl, see Plate 1, fig. 105.

87. Hudibras's beard is described in *Hudibras*, pt. 1, canto 1, ll. 241–42.

kings and heroes, murderers and saints; and as we contemplate their deeds, seldom fail making application to their looks. It is reasonable to believe that aspect to be a true and legible representation of the mind, which gives every one the same idea at first sight; and is afterwards confirm'd in fact: for instance, all concur in the same opinion, at first sight, of a down-right idiot.

There is but little to be seen by childrens faces, more than that they are heavy or lively; and scarcely that unless they are in motion. Very handsom faces of almost any age, will hide a foolish or a wicked mind till they betray themselves by their actions or their words: yet the frequent aukward movements of the muscles of the fool's face, tho' ever so handsom, is apt in time to leave such traces up and down it, as will distinguish a defect of mind upon examination: but the bad man, if he be an hypocrite, may so manage his muscles, by teaching them to contradict his heart, that little of his mind can be gather'd from his countenance, so that the character of an hypocrite is entirely out of the power of the pencil, without some adjoining circumstance to discover him, as smiling and stabing at the same time, or the like.

It is by the natural and unaffected movements of the muscles, caused by the passions of the mind, that every man's character would in some measure be written in his face, by that time he arrives at forty years of age, were it not for certain accidents which often, tho' not always prevent it. For the ill-natur'd man, by frequently frowning, and pouting out the muscles of his mouth, doth in time bring those parts to a constant state of the appearance of ill-nature, which might have been prevented by the constant affectation of a smile; and so of the other passions: tho' there are some that do not affect the muscles at all simply of themselves, as love and hope.

But least I should be thought to lay too great a stress on outward shew, like a physiognomist, take this with you, that it is acknowledg'd there are so many different causes which produce the same kind of movements and appearances of the features, and so many thwartings by accidental shapes in the make of faces, that the old adage, fronti nulla fides, will ever stand its ground upon the whole; and for very wise reasons nature hath thought fit it should. But, on the other hand, as in many particular cases, we receive information from the expressions of the countenance, what follows is meant to give a lineal description of the language written therein.

It may not be amiss just to look over the passions of the mind, from tranquillity to extreme despair; as they are in order described in the

common drawing-book, called, Le Brun's passions of the mind;[88] selected from that great master's works for the use of learners; where you may have a compendious view of all the common expressions at once. And altho' these are but imperfect copies, they will answer our purpose in this place better than any other thing I can refer you to; because the passions are there ranged in succession, and distinctly marked with lines only, the shadows being omitted.

Some features are formed so as to make this or that expression of a passion more or less legible; for example, the little narrow chinese eye suits a loving or laughing expression best, as a large full eye doth those of fierceness and astonishment; and round-rising muscles will appear with some degree of chearfulness even in sorrow: the features thus suiting with the expressions that have been often repeated in the face, at length mark it with such lines as sufficiently distinguish the character of the mind.

The ancients in their lowest characters have shewn as much judgment, and as great a degree of taste in the management and twisting of the lines of them, as in their statues of a sublimer kind; in the former varying only from the precise line of grace in some parts where the character or action required it. The dying gladiator and the dancing fawn, the former a slave, the latter a wild clown,[89] are sculptored in as high a taste of lines as the Antinous or the Apollo; with this difference, that the precise line of grace abounds more in the two last: notwithstanding which it is generally allow'd there is equal merit in the former, as there is near as much judgment required for the execution of them. Human nature can hardly be represented more debased than in the character of the Silenus, fig. [107, plate 1], where the bulging-line figure 49, N°. 7, runs through all the features of the face, as well as the other parts of his swinish body: whereas in the satyr of the wood, tho' the ancients have joined the brute with the man, we still see preserved an elegant display of serpentine lines, that make it a graceful figure.

Indeed the works of art have need of the whole advantage of this line to make up for its other deficiencies: for tho' in nature's works the line of beauty is often neglected, or mixt with plain lines, yet so far are they from being defective on this account, that by this means there is

88. Lebrun, *Méthode pour apprendre à dessiner les passions* (1698).
89. *The Dying Gladiator* (Rome, Capitoline Museum) and *The Dancing Faun* (Naples, National Museum); see Haskell and Penny, no. 44, fig. 116, and no. 35, fig. 107.

exhibited that infinite variety of human forms which always distin-
guishes the hand of nature from the limited and insufficient one of art;
and as thus she for the sake of variety upon the whole, deviates some-
times into plain and inelegant lines, if the poor artist is but able now
and then to correct and give a better taste to some particular part of
what he imitates, by having learnt so to do from her more perfect works,
or copying from those that have, ten to one he grows vain upon it, and
fancies himself a nature-mender; not considering, that even in these, the
meanest of her works, she is never wholly destitute of such lines of
beauty and other delicacies, as are not only beyond his narrow reach, but
are seen wanting even in the most celebrated attempts to rival her. But
to return,

As to what we call plain lines, there is this remarkable effect con-
stantly produced by them, that being more or less conspicuous in any
kind of character or expression of the face, they bring along with them
certain degrees of a foolish or ridiculous aspect.

It is the inelegance of these lines which more properly belonging to
inanimate bodies, and being seen where lines of more beauty and taste
are expected, that renders the face silly and ridiculous. See chap. 6,
p. 37.

Children in infancy have movements in the muscles of their faces
peculiar to their age, as an uninformed and unmeaning stare, an open
mouth, and simple grin: all which expressions are chiefly formed
of plain curves, and these movements and expressions ideots are apt
to retain; so that in time they mark their faces with these uncouth
lines; and when the lines coincide and agree with the natural forms
of the features, it becomes a more apparent and confirmed character of
an ideot. These plain shapes last mentioned, sometimes happen to
people of the best sense, to some when the features are at rest, to others
when they are put into motion; which a variety of constant regular
movements proceeding from a good understanding, and fashioned by a
genteel education, will often by degrees correct into lines of more
elegance.

That particular expression likewise of the face, or movement of a
feature which becomes one person, shall be disagreeable in another, just
as such expressions or turns chance to fall in with lines of beauty, or the
reverse; for this reason there are pretty frowns and disagreeable smiles:
the lines that form a pleasing smile about the corners of the mouth have
gentle windings, as fig. [108, plate 2 left], but lose their beauty in the
full laugh, as fig. [109, plate 2 left], the expression of excessive laughter,

oftener than any other, gives a sensible face a silly or disagreeable look, as it is apt to form regular plain lines about the mouth, like a parenthesis, which sometimes appears like crying; as, on the contrary, I remember to have seen a beggar who had clouted up his head very artfully, and whose visage was thin and pale enough to excite pity, but his features were otherwise so unfortunately form'd for his purpose, that what he intended for a grin of pain and misery, was rather a joyous laugh.

It is strange that nature hath afforded us so many lines and shapes to indicate the deficiencies and blemishes of the mind, whilst there are none at all that point out the perfections of it beyond the appearance of common sense and placidity. Deportment, words, and actions, must speak the good, the wise, the witty, the humane, the generous, the merciful, and the brave. Nor are gravity and solemn looks always signs of wisdom: the mind much occupied with trifles will occasion as grave and sagacious an aspect, as if it was charged with matters of the utmost moment; the balance-master's attention to a single point, in order to preserve his balance, may look as wise at that time as the greatest philosopher in the depth of his studies. All that the ancient sculptors could do, notwithstanding their enthusiastic endeavours to raise the characters of their deities to aspects of sagacity above human, was to give them features of beauty. Their god of wisdom hath no more in his look than a handsom manliness; the Jupiter is carried somewhat higher,[90] by giving it a little more severity than the Apollo, by a larger prominency of brow gently bending in seeming thoughtfulness, with an ample beard, which being added to the noble quantity of its other lines, invests that capital piece of sculpture with uncommon dignity, which in the mysterious language of a profound conoisseur, is stiled a divine idea, inconceivably great, and above nature.

3dly and lastly, I shall shew in what manner the lines of the face alter from infancy upwards, and specify the different ages. We are now to pay most attention to *simplicity*, as the difference of ages we are about to speak of, turn chiefly upon the use made of this principle in a greater or less degree, in the form of the lines.

From infancy till the body has done growing, the contents both of the body and the face, and every part of their surface, are daily changing into more variety, till they obtain a certain medium (see page 66 on

90. For the Jupiter, see Joseph Spence, *Polymetis* (1747), pl. 1. Hogarth does not directly represent a Jupiter, though in plate 1, fig. 20, he parodies Jupiter as a dancing master; perhaps also in the magistrate on a tomb.

proportion) from which medium, as fig. [113, plate 2 bottom], if we
return back to infancy, we shall see the variety decreasing, till by
degrees that simplicity in the form, which gave variety its due limits,
deviates into sameness; so that all the parts of the face may be circum-
scribed in several circles, as fig. [116, plate 2 left]†.

But there is another very extraordinary circumstance, (perhaps never
taken notice of before in this light) which nature hath given us to
distinguish one age from another by; which is, that tho' every feature
grows larger and longer, till the whole person has done growing, the
sight of the eye still keeps its original size; I mean the pupil, with its iris
or ring; for the diameter of this circle continues still the same, and so
becomes a fixt measure by which we, as it were, insensibly compare the
daily perceiv'd growings of the other parts of the face, and thereby
determine a young person's age. You may sometimes find this part of
the eye in a newborn infant, full as large as in a man of six foot; nay,
sometimes larger, see fig. [110, plate 2 bottom], and [fig. 114, plate 2
bottom, and fig. 115, plate 1 top] which represents three different sizes
of the pupil of the eye; the least, was exactly taken from the eye of a
large-featur'd man, aged 105, the biggest, from one of twenty, who
had this part larger than ordinary, and the other is the common size. If
this part of the eye in the pictures of Charles II. and James II. painted
by Vandyke at Kensington, were to be measured with a pair of com-
passes, and compared with their pictures painted by Lilly when they
were men, the diameters would be found in both pictures respectively
the same.[91]

In infancy the faces of boys and girls have no visible difference, but as
they grow up the features of the boy get the start, and grow faster in
proportion to the ring of the eye, than those of the girl, which shews the
distinction of the sex in the face. Boys who have larger features than
ordinary, in proportion to the rings of their eyes, are what we call
manly-featured children; as those who have the contrary, look more
childish and younger than they really are. It is this proportion of the
features with the eyes, that makes women, when they are dressed in
mens-cloaths, look so young and boyish: but as nature doth not always
stick close to these particulars, we may be mistaken both in sexes and
ages.

91. Hogarth refers to van Dyck's portrait of the children of Charles I, the Prince of Wales
and Duke of York with Mary, Princess Royal (Royal Collection). Cf. his own *Graham
Children* (1742, National Gallery, London; Beckett, No. 136).

By these obvious appearances, and the differences of the whole size, we easily judge of ages till twenty, but not with such certainty afterwards; for the alterations from that age are of a different kind, subject to other changes by growing fatter or leaner, which it is well known, often give a different turn to the look of the person, with regard to his age.

The hair of the head, which encompasses a face as a frame doth a picture, and contrasts with its uniform colour, the variegated inclosed composition, adding more or less beauty thereto, according as it is disposed by the rules of art, is another indication of advanced age.

What remains to be said on the different appearances of ages, being less pleasing than what has gone before, shall be described with more brevity. In the age from twenty to thirty, barring accidents, there appears but little change, either in the colours or the lines of the face; for tho' the bloom tints may go off a little, yet on the other hand, the make of the features often attain a sort of settled firmness in them, aided by an air of acquired sensibility; which makes ample amends for that loss, and keeps beauty till thirty pretty much upon a par; after this time, as the alterations grow more and more visible, we perceive the sweet simplicity of many rounding parts of the face, begin to break into dented shapes, with more sudden turns about the muscles, occasioned by their many repeated movements; as also by dividing the broad parts, and thereby taking off the large sweeps of the serpentine lines; the shades of beauty also consequently suffering in their softnesses. Something of what is here meant between the two ages of thirty and fifty, see in figures [117 and 118, plate 2 bottom], and what further havock time continues to make after the age of fifty, is too remarkable to need describing: the strokes and cuts he then lays on are plain enough; however, in spite of all his malice, those lineaments that have once been elegant, retain their flowing turns in venerable age, leaving to the last a comely piece of ruins.

CHAPTER XVI

Of ATTITUDE

Such dispositions of the body and limbs as appear most graceful when seen at rest, depend upon gentle winding contrasts, mostly govern'd by the precise serpentine line, which in attitudes of authority, are more extended and spreading than ordinary, but reduced somewhat below the medium of grace, in those of negligence and ease: and as much exaggerated in insolent and proud carriage, or in distortions of pain (see figure 9, plate 1) as lessen'd and contracted into plain and parallel lines, to express meanness, aukwardness, and submission.

The general idea of an action, as well as of an attitude, may be given with a pencil in very few lines. It is easy to conceive that the attitude of a person upon the cross, may be fully signified by the two straight lines of the cross; so the extended manner of St. Andrew's crucifixion is wholly understood by the X-like cross.

Thus, as two or three lines at first are sufficient to shew the intention of an attitude, I will take this opportunity of presenting my reader (who may have been at the trouble of following me thus far) with the sketch of a country-dance, in the manner I began to set out the design; in order to shew how few lines are necessary to express the first thoughts, as to different attitudes; see fig. [71, plate 2 top], which describe in some measure, the several figures and actions, mostly of the ridiculous kind, that are represented in the chief part of plate 2.

The most amiable person may deform his general appearance by throwing his body and limbs into plain lines, such lines appear still in a more disagreeable light in people of a particular make, I have therefore chose such figures as I thought would agree best with my first score of lines, fig. 71.

The two parts of curves next to 71, served for the figures of the old woman and her partner at the farther end of the room. The curve and two straight lines at right angles, gave the hint for the fat man's sprawling posture. I next resolved to keep a figure within the bounds of a circle, which produced the upper part of the fat woman, between the fat man and the aukward one in the bag wig, for whom I had made a sort of an X. The prim lady, his partner, in the riding-habit, by pecking

back her elbows, as they call it, from the waste upwards, made a
tolerable D, with a straight line under it, to signify the scanty stiffness
of her peticoat; and a Z stood for the angular position the body makes
with the legs and thighs of the affected fellow in the tye-wig; the upper
parts of his plump partner were confin'd to an O, and this chang'd into
a P, served as a hint for the straight lines behind. The uniform diamond
of a card, was filled up by the flying dress, &c. of the little capering
figure in the spencer-wig; whilst a double L mark'd the parallel position
of his poking partner's hands and arms: and lastly, the two waving lines
were drawn for the more genteel turns of the two figures at the hither
end.

The best representation in a picture, of even the most elegant danc-
ing, as every figure is rather a suspended action in it than an attitude,
must be always somewhat unnatural and ridiculous; for were it possible
in a real dance to fix every person at one instant of time, as in a picture,
not one in twenty would appear to be graceful, tho' each were ever so
much so in their movements; nor could the figure of the dance itself be
at all understood.

The dancing-room is also ornamented purposely with such statues
and pictures as may serve to a farther illustration. Henry viii, fig. [72,
plate 2], makes a perfect X with his legs and arms; and the position of
Charles the first, fig. [51, plate 2], is composed of less-varied lines than
the statue of Edward the sixth, fig. [73, plate 2]; and the medal over his
head is in the like kind of lines; but that over Q. Elizabeth, as well as her
figure, is in the contrary; so are also the two other wooden figures at the
end. Likewise the comical posture of astonishment (expressed by follow-
ing the direction of one plain curve, as the dotted line in a french print
of Sancho, where Don Quixote demolishes the puppet shew, fig. [75,
plate 2 right]), is a good contrast to the effect of the serpentine lines in
the fine turn of the Samaritan woman, fig. [74, plate 2 left], taken from
one of the best pictures Annibal Carrache ever painted.[92]

92. Charles-Antoine Coypel's *Don Quixote attacks the Puppets* (1724), illustrating pt. 2,
chap. 26, and Annibale Carracci's *Christ and the Woman of Samaria* (Brera, Milan); see ills. 18
and 20.

CHAPTER XVII

Of ACTION

To the amazing variety of forms made still infinitely more various in appearance by light, shade and colour, nature hath added another way of increasing that variety, still more to enhance the value of all her compositions. This is accomplished by means of action; the fullest display of which is put into the power of the human species, and which is equally subject to the same principles with regard to the effects of beauty, or the reverse, as govern all the former compositions; as is partly seen in chapter XI, on proportion. My business here shall be, in as concise a manner as possible, to particularise the application of these principles to the movement of the body, and therewith finish this *system* of variety in forms and actions.

There is no one but would wish to have it in his power to be genteel and graceful in the carriage of his person, could it be attained with little trouble and expence of time. The usual methods relied on for this purpose among well-bred people, takes up a considerable part of their time: nay even those of the first rank have no other recourse in these matters, than to dancing-masters, and fencing-masters: dancing and fencing are undoubtedly proper, and very necessary accomplishments; yet are they frequently very imperfect in bringing about the business of graceful deportment. For altho' the muscles of the body may attain a pliancy by these exercises, and the limbs, by the elegant movement in dancing, acquire a facility in moving gracefully, yet for want of knowing the meaning of every grace, and whereon it depends, affectations and misapplications often follow.

Action is a sort of language which perhaps one time or other, may come to be taught by a kind of grammar-rules; but, at present, is only got by rote and imitation: and contrary to most other copyings or imitations, people of rank and fortune generally excel their originals, the dancing-masters, in easy behaviour and unaffected grace; as a sense of superiority makes them act without constraint; especially when their persons are well turn'd. If so, what can be more conducive to that freedom and necessary courage which make acquired grace seem easy and natural, than the being able to demonstrate *when* we are actually

just and proper in the least movement we perform; whereas, for want of such certainty in the mind, if one of the most finish'd gentlemen at court was to appear as an actor on the public stage, he would find himself at a loss how to move properly, and be stiff, narrow, and aukward in representing even his own character: the uncertainty of being right would naturally give him some of that restraint which the uneducated common people generally have when they appear before their betters.

It is known that bodies in motion always describe some line or other in the air, as the whirling round of a fire-brand apparently makes a circle, the water-fall part of a curve, the arrow and bullet, by the swiftness of their motions, nearly a straight line; waving lines are formed by the pleasing movement of a ship on the waves. Now in order to obtain a just idea of action at the same time to be judiciously satisfied of being in the right in what we do, let us begin with imagining a line formed in the air by any supposed point at the end of a limb or part that is moved, or made by the whole part, or limb; or by the whole body together. And that thus much of movements may be conceived at once is evident, on the least recollection, for whoever has seen a fine arabian war-horse, unback'd and at liberty, and in a wanton trot, cannot but remember what a large waving line his rising, and at the same time pressing forward, cuts through the air; the equal continuation of which, is varied by his curveting from side to side; whilst his long mane and tail play about in serpentine movements.

After thus having form'd the idea of all movements being as lines, it will not be difficult to conceive, that grace in action depends upon the same principles as have been shewn to produce it in forms.

The next thing that offers itself to our consideration is the force of *habit* and custom in action; for a great deal depends thereon.

The peculiar movements of each person, as the gait in walking, are particularised in such lines as each part describes by the habits they have contracted. The nature and power of habit may be fully conceived by the following familiar instance, as the motions of one part of the body may serve to explain those of the whole.

Observe that whatever habit the fingers get in the use of the pen, you see exactly delineated to the eye by the shapes of the letters. Were the movements of every writer's fingers to be precisely the same, one hand-writing would not be known from another, but as the fingers naturally fall into, or acquire different habits of moving, every hand-writing is visibly different. Which movements must tally with the letters, tho'

they are too quick and too small to be as perfectly traced by the eye; but this shews what nice differences are caused, and constantly retained by habitual movements.

It may be remark'd, that all useful habitual motions, such as are readiest to serve the necessary purposes of life, are those made up of plain lines, i.e. straight and circular lines, which most animals have in common with mankind, tho' not in so extensive a degree: the monkey from his make hath it sufficiently in his power to be graceful, but as reason is required for this purpose, it would be impossible to bring him to move genteely.

Though I have said that the ordinary actions of the body are performed in plain lines, I mean only comparatively so with those of studied movements in serpentine lines, for as all our muscles are ever ready to act, when one part is moved, (as an hand, or arm, by its proper movers, for raising up or drawing down) the adjacent muscles act in some degree in correspondence with them: therefore our most common movements are but seldom performed in such absolutely mean lines, as those of jointed dolls and puppets. A man must have a good deal of practice to be able to mimic such very straight or round motions, which being incompatible with the human form, are therefore ridiculous.

Let it be observed, that graceful movements in serpentine lines, are used but occasionally, and rather at times of leisure, than constantly applied to every action we make. The whole business of life may be carried on without them, they being properly speaking, only the ornamental part of gesture; and therefore not being naturally familiarised by necessity, must be acquired by precept or imitation, and reduced to habit by frequent repetitions. *Precept* is the means I should recommend as the most expeditious and effectual way. But before we proceed to the method I have to propose, for the more ready and sure way of accustoming the limbs to a facility in the ornamental way of moving; I should observe, that quick time gives it spirit and vivacity, as slow time, gravity, and solemnity, and further, that the latter of these allows the eye an opportunity of seeing the line of grace to advantage, as in the address of heroes on the stage, or in any solemn act of ceremony; and that although time in movement is reduced to certain rules for dancing, it is left more at large and at discretion for deportment.

We come now to offer an odd, but perhaps efficacious method of acquiring a habit of moving in the lines of grace and beauty.

1. Let any one chalk the line fig. [119, plate 2 left], on a flat surface, beginning at either end, and he will move his hand and arm in a

beautiful direction, but if he chalks the same sort of line on an ogee-moulding of a foot or two in breadth, as the dotted line on figure [120, plate 2 left], his hand must move in that more beautiful direction, which is distinguished by the name of grace; and according to the quantity given to those lines, greatness will be added to grace, and the movement will be more or less noble.

Gentle movements of this sort thus understood, may be made at any time and any where, which by frequent repetitions will become so familiar to the parts so exercised, that on proper occasion they make them as it were of their own accord.

The pleasing effect of this manner of moving the hand, is seen when a snuff-box, or fan is presented gracefully or genteely to a lady, both in the hand moving forward and in its return, but care must be taken that the line of movement be but gentle, as N°. 3. fig. 49, plate 1, and not too S-like and twirling, as N°. 7 in the same figure: which excess would be affected and ridiculous.

Daily practising these movements with the hands and arms, as also with such other parts of the body as are capable of them, will in a short time render the whole person graceful and easy at pleasure.

2. As to the motions of the *head*; the awe most children are in before strangers, till they come to a certain age, is the cause of their dropping and drawing their chins down into their breasts, and looking under their foreheads, as if conscious of their weakness, or of something wrong about them. To prevent this aukward shyness, parents and tutors are continually teasing them to hold up their heads, which if they get them to do it is with difficulty, and of course in so constrain'd a manner that it gives the children pain, so that they naturally take all opportunities of easing themselves by holding down their heads; which posture would be full as uneasy to them were it not a relief from restraint: and there is another misfortune in holding down the head, that it is apt to make them bend too much in the back; when this happens to be the case, they then have recourse to steel-collars, and other iron-machines; all which shacklings are repugnant to nature, and may make the body grow crooked. This daily fatigue both to the children and the parents may be avoided, and an ugly habit prevented, by only (at a proper age) fastening a ribbon to a quantity of platted hair, or to the cap, so as it may be kept fast in its place, and the other end to the back of the coat, as fig. [121, plate 2 left], of such a length as may prevent them drawing their chins into their necks; which ribbon will always leave the head at liberty to move in any direction but this aukward one they are so apt to fall into.

But till children arrive at a reasoning age it will be difficult by any means to teach them more grace than what is natural to every well made child at liberty.

The grace of the upper parts of the body is most engaging, and sensible well made people in any station naturally have it in a great degree, therefore rules unless they are simple and easily retain'd and practised, are of little use; nay, rather are of disservice.

Holding the head erect is but occasionally right, a proper recline of it may be as graceful, but true elegance is mostly seen in the moving it from one position to another.

And this may be attain'd by a sensibility within yourself, tho' you have not a sight of what you do by looking in the glass, when with your head assisted by a sway of the body in order to give it more scope, you endeavour to make that very serpentine line in the air, which the hands have been before taught to do by the help of the ogee-moulding; and I will venture to say, a few careful repetitions at first setting out will make this movement as easy to the head as to the hands and arms.

The most graceful bow is got by the head's moving in this direction, as it goes downward and rises up again. Some aukward imitators of this elegant way of bowing, for want of knowing what they were about, have seem'd to bow with wry necks. The low solemn bow to majesty should have but a very little twist, if any, as more becoming gravity and submission. The clownish nod in a sudden straight line is quite the reverse of these spoken of.

The most elegant and respectful curtesy hath a gentle, or small degree of the above graceful bowing of the head as the person sinks, and rises, and retreats. If it should be said, that a fine curtesy consists in no more than in being erect in person at the time of sinking and rising; Madam Catherine in clock-work, or the dancing bears led about the streets for a shew, must be allow'd to make as good a curtesy as any body.[93]

N. B. It is necessary in bowing and curtesying to shun an exact sameness at all times; for however graceful it may be on some occasions,

93. Madam Catherine was a clockwork figure in one of the musical clocks or clockwork theaters popular in London from the 1720s, exhibited by Christopher Pinchbeck, his sons, or one of his epigones. (Pinchbeck's associate Isaac Fawks was referred to by Hogarth in *Masquerades and Operas* and *Southwark Fair*, *HGW* Nos. 43, 131, and p. 88.) Such "examples of mechanical science" were commented on by Samuel Johnson, *Rambler* No. 83 (1 Jan. 1750/ 1). See Altick, *Shows of London*, pp. 60–63.

at other times it may seem formal and improper. Shakespear seems to have meant the above spoken of ornamental manner of bowing, in Enobarbus's description of Cleopatra's waiting-women. ———

——— And made their bends adornings. Act 2.[94]

3. Of *Dancing*.[95] The minuet is allowed by the dancing-masters themselves to be the perfection of all dancing. I once heard an eminent dancing-master say, that the minuet had been the study of his whole life, and that he had been indefatigable in the pursuit of its beauties, yet at last he could only say with Socrates, *he knew nothing*: adding, that I was happy in my profession as a painter, in that some bounds might be set to the study of it. No doubt, as the minuet contains in it a composed variety of as many movements in the serpentine lines as can well be put together in distinct quantities, it is a fine composition of movements.

The ordinary undulating motion of the body in common walking (as may be plainly seen by the waving line, which the shadow a man's head makes against a wall as he is walking between it and the afternoon sun) is augmented in dancing into a larger quantity of *waving* by means of the minuet-step, which is so contrived as to raise the body by gentle degrees somewhat higher than ordinary, and sink it again in the same manner lower in the going on of the dance. The figure of the minuet-path on the floor is also composed of serpentine lines, as fig. [122, plate 2 top], varying a little with the fashion: when the parties by means of this step rise and fall most smoothly in time, and free from sudden starting and dropping, they come nearest to Shakespear's idea of the beauty of dancing, in the following lines,

——— What you do,
Still betters what is done, ———
——— When you do dance, I wish you
A wave o'th' sea, that you might ever do
Nothing but that; move still, still so,
And own no other function. – WINTER'S TALE.[96]

94. Shakespeare, *Antony and Cleopatra*, 2.2.213.
95. On the dance, see MSS. XV, p. 137. The "Country Dance" was located in chapter 10 in the first draft; was moved to chapter 4, "Of Deportment," in the second; and ended as the dénouement. Fielding's friend James (Hermes) Harris had remarked in "A Dialogue concerning Art" that "dance has its being or essence in a transition: call it a motion or an energy" (*Three Treatises* [1744], p. 54).
96. Shakespeare, *Winter's Tale*, 4.4.135–36, 140–43 (Florizel to Perdita).

The other beauties belonging to this dance, are the turns of the head, and twist of the body in passing each other, as also gentle bowing and presenting hands in the manner before described, all which together, displays the greatest variety of movements in serpentine lines imaginable, keeping equal pace with musical time.

There are other dances that entertain merely because they are composed of variety of movements and performed in proper time, but the less they consist of serpentine or waving lines, the lower they are in the estimation of dancing-masters: for, as has been shewn, when the form of the body is divested of its serpentine lines it becomes ridiculous as a human figure, so likewise when all movements in such lines are excluded in a dance, it becomes low, grotesque and comical; but however, being as was said composed of variety, made consistent with some character, and executed with agility, it nevertheless is very entertaining. Such are Italian peasant-dances, &c. But such uncouth contortions of the body as are allowable in a man would disgust in a woman; as the extreme graceful, so very alluring in this sex, is nauseous in the other; even the minuet-grace in a man would hardly be approved, but as the main drift of it represents repeated addresses to the lady.

There is a much greater consistency in the dances of the Italian theatre than of the French, notwithstanding dancing seems to be the genius of that nation; the following distinctly marked characters were originally from Italy; and if we consider them lineally as to their particular movements, we shall see wherein their humour consists.[97]

The attitudes of the harlequin are ingeniously composed of certain little, quick movements of the head, hands and feet, some of which shoot out as it were from the body in straight lines, or are twirled about in little circles.

Scaramouch is gravely absurd as the character is intended, in overstretch'd tedious movements of unnatural lengths of lines: these two characters seem to have been contrived by conceiving a direct opposition of movements.

Pierrott's movements and attitudes, are chiefly in perpendiculars and parallels, so is his figure and dress.

Punchinello is droll by being the reverse of all elegance, both as to movement, and figure, the beauty of variety is totally, and comically excluded from this character in every respect; his limbs are raised and let fall almost altogether at one time, in parallel directions, as if his

97. On the *commedia dell'arte*, see MSS. XVI, p. 137.

seeming fewer joints than ordinary, were no better than the hinges of a door.

Dances that represent provincial characters, as these above do, or very low people, such as gardeners, sailors, &c. in merriment, are generally most entertaining on the stage: the Italians have lately added great pleasantry and humour to several french dances, particularly the wooden-shoe dance, in which there is a continual shifting from one attitude in plain lines to another; both the man and the woman often comically fix themselves in uniform positions, and frequently start in equal time, into angular forms, one of which remarkably represents two W's in a line, as over figure 122, plate 2, these sort of dances a little raised, especially on the woman's side, in expressing elegant wantonness (which is the true spirit of dancing) have of late years been most delightfully done, and seem at present to have got the better of pompous, unmeaning grand ballets; serious dancing being even a contradiction in terms.

4thly, Of *Country Dancing*. The lines which a number of people together form in country or figure dancing, make a delightful play upon the eye, especially when the whole figure is to be seen at one view, as at the playhouse from the gallery; the beauty of this kind of mystic dancing, as the poets term it, depends upon moving in a composed variety of lines, chiefly serpentine, govern'd by the principles of intricacy, &c. The dances of barbarians are always represented without these movements, being only composed of wild skiping, jumping, and turning round, or running backward and forward, with convulsive shrugs, and distorted gestures.

One of the most pleasing movements in country dancing, and which answers to all the principles of varying at once, is what they call the hay; the figure of it altogether, is a cypher of S's, or a number of serpentine lines interlacing, or intervolving each other, which suppose traced on the floor, the lines would appear as fig. [123, plate 2 top], Milton in his Paradise lost, describing the angels dancing about the sacred hill, pictures the whole idea in words;

> Mystical dance! ———
> ——— Mazes intricate,
> Eccentric, intervolv'd, yet regular
> Then most, when most irregular they seem.[98]

98. Milton, *Paradise Lost*, 5.620, 622–24 (leading up to the war in heaven); cf. the fallen angels "in wand'ring mazes lost" (2.561).

I shall venture, lastly, to say a word or two of stage-action. From what has been said of habitually moving in waving lines, it may possibly be found that if stage-action, particularly the graceful, was to be studied lineally, it might be more speedily and accurately acquired by the help of the foregoing principles than the methods hitherto taken. It is known that common deportment, such as may pass for elegant and proper off the stage, would no more be thought sufficient upon it than the dialogue of common polite conversation, would be accurate or spirited enough for the language of a play. So that trusting to chance only will not do. The actions of every scene ought to be as much as possible a compleat composition of well varied movements, considered as such abstractly, and apart from what may be merely relative to the sense of the words. Action consider'd with regard to assisting the authors meaning, by enforcing the sentiments or raising the passions, must be left entirely to the judgment of the performer, we only pretend to shew how the limbs may be made to have an equal readiness to move in all such directions as may be required.

What I would have understood by action, abstractedly and apart from its giving force to the meaning of the words, may be better conceived by supposing a foreigner, who is a thorough master of all the effects of action, at one of our theatres, but quite ignorant of the language of the play; it is evident his sentiments under such limitations, would chiefly arise from what he might distinguish by the lines of the movements belonging to each character; the actions of an old man, if proper, or not, would be visible to him at once, and he would judge of low and odd characters, by the inelegant lines which we have already shewn to belong to the characters of punch, harlequin, pierrott, or the clown; so he would also form his judgment of the graceful acting of a fine gentleman, or hero, by the elegance of their movements in such lines of grace and beauty as have been sufficiently described. See chapters 5, 6, 7, 8, on the composition of forms. Where note, that as the whole of beauty depends upon *continually varying* the same must be observed with regard to genteel and elegant acting: and as plain space makes a considerable part of beauty in form, so cessation of movement in acting is as absolutely necessary; and in my opinion much wanted on most stages, to relieve the eye from what Shakespear calls, *continually sawing the air.*[99]

The actress hath sufficient grace with fewer actions, and those in less extended lines than the actor; for as the lines that compose the Venus are

99. Shakespeare, *Hamlet* (Hamlet to the players), 3.2.

simpler and more gently flowing, than those that compose the Apollo, so must her movements be in like proportion.

And here it may not be improper to take notice of a mischief that attends copied actions on the stage; they are often confin'd to certain sets and numbers, which being repeated, and growing stale to the audience, become at last subject to mimickry and ridicule, which would hardly be the case, if an actor were possest of such general principles as include a knowledge of the effects of all the movements that the body is capable of.

The comedian, whose business it is to imitate the actions belonging to particular characters in nature, may also find his account in the knowledge of lines; for whatever he copies from the life, by these principles may be strengthened, altered, and adjusted as his judgment shall direct, and the part the author has given him shall require.

FINIS

Manuscripts of the Analysis of Beauty
Supplementary Passages

I TEXT FOOTNOTE I
The Power of Custom. BL. Add. MS. 27,992, ff. 6–10 ("Something of a first Intended Introduction" {f. 12b})

the most remarkable instance, that is given in support of this [*struck through*: vulgar error] is, that the Nigro who finds great beauty in the black Females of his own country, may find as much deformity in the european Beauty as we see in theirs,[1] by the almost inumerable Instances, that might be given, of the Power of habit and custom. it is easy to conceive, how one brought up from Infancy in a coal Pit,[2] may find such pleasure and amusement there, as to disrelish, day light, and open air; and being Ignorant of the beautys above ground, grow uneasy, and disatisfied, till he descends again into his Gloomy cavern; so I have known the briliant beauties of nature, disreguarded, for even the imperfections of art, occationd by running into too great an attention to, and imbibing false oppinions, in favour of pictures, and statues, and thus by losing sight of nature, [*struck through*: these who take things upon trust] they blindly descend, by such kind of prejudices, into the coal pit of

1. On this passage, and above, p. 88, see David Dabydeen, *Hogarth's Blacks: Images of Blacks in Eighteenth Century English Art* (Kingston-upon-Thames, 1985), pp. 41–45.
2. Here Hogarth introduces overlapping parodies, reduced to brief allusions in the published text: (1) of Plato's myth of the cave, satirizing the Platonic foundation of authority in Shaftesbury's aesthetics as well as in the art treatises, and the idolatry of the "dark pictures" of the Old Masters (*Republic* Bk. 7); (2) of Shaftesbury's Hercules at the Crossroads, his model for the subject to be painted by British history painters (*Notion of the Historical Draught or Tablature of the Judgment of Hercules* [1713]). Shaftesbury and Hutcheson (the "natural philosophers" referred to) attempt to follow the straight road Hercules is urged to follow by Virtue, but they find themselves instead in the "labyrinth" of Hogarthian variety that is *not* confined to the limitations of their principle of "harmony and order." Hogarth is contrasting the steep road of moral order (that equates beauty with virtue and subordinates variety to uniformity) leading to the Palace of Wisdom with the labyrinthine paths "of sportiveness, and Fancy . . . which differ so greatly from her other beauties, of order, and usefulness," which he celebrates in the *Analysis* as "the love [or pleasure or joy] of pursuit."

conoiseiurship; where the cunning dealers in obscure works,[3] lie in wait, to make dupes of those, who thus turn their backs, on the perfections of Nature.

The cheif steps that have hitherto been taken by writers, to dispell these clouds of uncertainty, and error, with design to fix some true Ideas of taste, upon a surer basis; have been first, those set forth by the natural philosophers, who by their extended contemplations, on universal beauty, as to the harmony and order of things, were naturally led, into the wide Roads, of uniformity, and regularity; which they unexpectedly found cros'd, and interupted, by many other openings. Relating to a kind of Beauty, differing, from those they were so well acquainted with, they then, for a while travers'd these, seeming to them, contradictory paths, till they found themselves bewilder'd in the Labarinth of variety; not considering it was necessary first to go through the province of painting; before it was possible, to get into the right Road, of Natures more superficial beautys, of sportiveness, and Fancy, if they may be so term'd, & which differ so greatly from her other beauties, of order, and usefulness.

Thus wandering a while in the maze of uncertainty, without gaining ground; they then to extricate themselves out of these difficultys; suddenly ascend the mound of moral Beauty, contiguous with the open field of Divinity, where ranging at large, they seem to lose all remembrance of their first pursuit.

The profound conoiseur, joind to the man of letters, and deeply read in the works of antiquity, has been urg'd (since this little essay was first in agitation) as the only person, fully qualified in all respects, to undertake the Task; but let it be observ'd a few things well seen, and well understood, are more likely to furnish proper matter, for this purpose, than the cursory view of millions; the knowledge requisite to this end, in my opinion, differs as much from that, studied by the polite conoisieurs, as the art of Simpling, doth from the scientific knowledge of the Botanist.

The grand Tour, as its calld, taken by travailing conoiseiurs,[4] to see and pick up curiosities in art, which they are thought, to distinguish

3. Cf. Hogarth's "Britophil" essay of 1737 (above, p. xviii).

4. On the Grand Tour and connoisseurs the reference is probably to Jonathan Richardson's works: *Essay on the Art of Criticism* and *Discourse on the Dignity, Certainty, Pleasure and Advantage, of the Science of a Connoisseur* (both 1719), and especially, with Jonathan, Jr., *An Account of the Statues, Bas-reliefs, Drawings and Pictures in Italy* (1722).

nicely, from one another, by certain names, and marks, may, with no great impropriety, be call'd going a simpling [*added in the margin*: with this difference only that [a] Simpler never picks up a Nettle for a Marsh mallow]. this, by the by, as to the performance last hinted at, when it appear'd it rather seem'd calculated to Inform the curious, where beauty, and grace, were to be found, and how, they might be weighed, and engeniously measur'd, with reguard to their qualities, and degrees, than of what they were composed, and how constituted. When after having raisd your expectation and learnedly diverted you with quotations from the classick, you are at last set down just where you were taken up; particularly with reguard to grace, which [this] engenious Author frankly owns was entirely beyond his comprehension.[5]

II TEXT FOOTNOTE 5
In the first draft, opposite the Lomazzo quotation, WH writes (BL. Eg. MS. 3011, f. 11):

The main drift of this peice is to shew what forms or rather what appearances of those forms the Eye best likes as a book of cookery points out what is most relishable to the Pallate.

III TEXT FOOTNOTE 13
In the MS. WH designates the van Dyck as the portrait of Charles I, and elaborates (BL. Eg. MS. 3013, ff. 66b, 67):

as fine a picture as need be painted yet it hath simplicity without grace, bordering upon tameness, for want of given some parts of it a gentle turn or two which could not have hurt the simplicity nor would it have been inconsist[ent] with his character. . . . [*He includes Swift as well as Addison in the case of writers who cannot*] have wrote a description of the ladys person in false grammer . . . in answere to the nature of lines being understood sufficiently by those who have daily put it in execution in their works let anyone only question a cabinet maker about it and hear what account he will give of it as a principle Just as much a day labourer who uses the leaver every day would give of the Machanical Powers.

5. Here Hogarth picks up the argument with le Blon and ten Kate (see p. 8).

BL. Eg. MS. 3011, ff. 13–14:

It will naturally be ask'd why the great Italien masters, who are alow'd to have excell'd in grace, have not treated this subject of such seeming importance, in some such manner, as to have made it generally understood[.] it is certainly very strange that leonardo da Vinci who not only was equal to Raphael urbin as a painter but also had more universal knowledge than any painter ever known should not when he wrote upon the principles of painting take the least notice of it[.] Probably they all arriv'd at that excellency in their works, by the mere dint of Imitating with great accuracy the Beauties of nature, and by often Copying and retaining strong Ideas of the works of the Antiants, which serv'd their purpose sufficiently, without giving themselves the trouble of enquiring into the Phisical causes of their effects and therefore incapable of comunicating any regular account in words, any more than the cabinet maker who daily practises the use of the waving line which gives such elegance to the legs of his chairs and tables who in the instructing their prentices how to make them could not avoid making use of such words as the painters have always us'd when they instructed their scholars and with as throrough a knowledge of the Nature of the line. And tho ye latter were straingly surprisd when they first heard there was something uncommon in it, they since will all swere they knew it as well as falstaf knew the princ of wiles after his shamefall running away at gads hill[.][6]

IV TEXT FOOTNOTE 29
The Composition of the Analysis. Hogarth gives three accounts:

(1) Draft C, BL. Eg. MS. 3015, ff. 10–11

in short these notions [about the Line of Beauty] as they clash'd with most of the commonly receiv'd ones of the school[7] drew me into frequent disputes with my brethren in which as the torrent was against me I seldom got the better of the argument yet observing that several availd themselvs of the very doctrins they so warmly opposed and also as these

6. Shakespeare, *Henry IV, Part 1*, 2.2. We might speculate as to whether "wiles" (or later, p. 128, "restrin'd") evidences Hogarth's pronunciation. This passage is illustrated by the subscription ticket, *Columbus Breaking the Egg.*
7. The drawing school of the St. Martin's Lane Academy, which Hogarth had founded in 1735 and continued to support into the 1750s.

sentiments got ground, espousd them as their own, I began to think if I were but able to publish my thoughts in writing I might have fairer play and if there should be any merit in what I could suggest I should probably reap the credyt and advantage of it, instead of labouring as I then did under the imputation of a vain and obstinate opposer of establishd opinions. But as all the times of setting down to business have been necessarily appropriated either to the Graver or the pencil the Pen grew an Impliment I was affraid to take up. till I was encourag'd to it by a gentleman of distinction and known ability who flatter'd me in seeming to give into my opinion in these matters and also kindly offer'd me some assistance in the performance[,] nor has he been worse than his word.[8] And it would be ungratefull in me not [to] acknowledge my obligations for the many hints I receiv'd from him whilst I was going on with the work and the touches and corrections he at last gave to it. but as the Motliness of the Stile of one who never wrote before if it may [be] call'd any stile at all could not be set to rights without new writing the whole book which as neither the work deserv'd or time would permit must be submitted with the utmost resignation to the mercy of the critics.

(2) *BL. Add. MS. 27, 992, ff. 10–11*

For my own part, when this business first engag'd my attention, I was so conscious of the danger [of] acting out of my own sphere, and so sensible of my inability, that I used my utmost endeavour to perswade some able pen, to undertake the work, but found the nature of the subject rendred it impracticable, for me to communicate my thoughts by word of mouth. and having drawn myself into the scrape, of getting something done on this head, I was willing to take all advantages possible, and so like one who makes use of signs and jestures to convey his meaning, in a language he is but little master of, I, as an expedient, to make up for my deficiencys in writing, have had frequent recourse to my Pencil. Hopeing, that as the mechanick at his Loom is as likely to give as satisfactory an account of the materials, and composition, of the rich Brocade he weaves (tho uncouthly) as the smooth Tongue'd Mercer with all his parade of showy silks about him I may in like manner, make myself tolerably understood, by those who are at the pain of examining my Book, and prints together.

8. Dr. Benjamin Hoadly (see Text, n. 30).

(3) BL. Add. MS. 27, 992, ff. 17, 17b, 18

Had I observd this before I undertook this essay, it probably would have
put me to a stand, and detered me from venturing upon what this
author calls an impossible task;[9] but as in the foremention'd disputes
the Torrent generally ran against me; and observing that several of my
opponents had turn'd my arguments into ridicule, yet daily availing
themselves of their use, and venting them even to my face as their own;
I began to wish the Publication of something on this Topic; and
accordingly applied my self to several of my friends, whom I thought
capable of taking up the pen for me, offering to furnish them with
materials by word of mouth. but finding this method impracticable, by
reason of the difficulty for one man to express the Ideas of another,
especially in a subject they were either unacquainted with, or new in its
kind I was therefore reduced to an attempt of finding such precise words
as would best answer my own Ideas, being now too far engaged to drop
the design.

Whereupon having digested the matter as well as I could, and
thrown it into the form of a book, I submitted it to the judgement of a
gentleman whose friendship & great abilities I could rely upon;[10] and
was determind upon his approbation or dislike to Publish or distroy it.
he Ingenuously told me, *you may print it* but seeing me still fearfull of
the danger of acting out of my own sphere, in becoming an author, he
took me by the hand, and kindly assisted in conducting more than a
third part through the press. which being publicly known gave such a
credit to the undertaking, as soon changed the countenances of those
who had a better opinion of my pencil than my pen, and turnd their
Sneers into expectation. my point being thus far answer'd, I was the
more encouraged, to venture upon printing several sheets alone; as
indeed I was obliged to do, by reason of my learned friends distance, and
his particular avocations but again growing fearfull of mistakes in point
of writing, I applied myself ocationally to some other Ingenious
friends,[11] to whom I owe the obligation of revising the remaining sheets
but as incaccuracies may still remain, which may afford some hackney
scribler matter of triumph, I acknowledge them all my own and am
under no great concern, provided the matter in general may be found
usefull and answerable in the application of it to truth and nature. But

9. Compare above, p. 13, which this passage closely anticipates.
10. Again, Benjamin Hoadly.
11. James Ralph, Thomas Morell, and James Townley.

if any man of parts should undertake to rectify mistakes in this material point I shall think it doing my work an honour.

V TEXT FOOTNOTE 39
The Mnemonic System. Draft C, BL. Eg. MS. 3015, ff. 7–11[12]

Having in the beginning of life lost a great part of my time, in engraving coats of armes on Silver Plate, and being desirous of appearing in the more eligable light of an History Painter or engraver, but then considering the time it must of course in the ordinary way of study take me up [that] there would be left little or none to spare for the ordinary enjoyments of life unless a more expeditious method could be found for the atainment of what I aim'd at.[13] It therefore put me upon considering what might be done in this case[.] as I was copying in the usual way and had learnt by practice to do it with tolerable exactness, which is the first thing necessary to be obtaind, it occur'd to me that there were many disadvantages attended continually copying Prints and Pictures altho they should be those of the best masters nay in even drawing after the life itself at academys.

For as the Eye is often taken off the originall to draw a bit at a time, it is possible to know no more of the original when the drawing is finish'd than before it was begun. Thus it is common with the hackney writers to know no more of what they have been copying than if they had not wrote a line, unless they have paid attention to it with that design[.] it is true such attention may and often is carried on in copying in our way, but there is this difference what is wrote is what should be retaind as it may be word for word the same with the original whereas what is copied for example at an academy is not the truth, perhaps far from it, yet the performer is apt to retain his perform'd Idea instead of the original. more reasons I form'd to myself but [it is] not necessary [to give them] here[. I asked meyself][14] why I should not continue copying objects but rather read the Language of them and if possible find a

12. This fragment offers Hogarth's foundation for his theory in experience and in this mnemonic system of representation; it served as the starting point for the "Autobiographical Notes" he wrote in the years following publication of the *Analysis*.

13. Due to the ruin and imprisonment of his schoolmaster father, Hogarth was apprenticed to a silver engraver in 1713 (at the age of sixteen), from which he only emerged as an independent engraver in 1720, the same year he joined the art class at John Vanderbank's Academy in Peter's Court, St. Martin's Lane. See *Hog.1*, chap. 2.

14. Hogarth's shorthand makes this passage difficult to parse.

grammar to it and collect and retain a remembrance of what I saw by repeated observations only trying every now and then upon my canvas how far I was advanc'd by that means.

There can be no reasons assign'd why men of sense and real genious with strong inclinations to attain to the art of Painting should so often miscarry as they do [*on the left page*: and more that might be given why] but those gentilmen who have labour'd with the utmost assiduity abroad surrounded with the works of the great masters, and at home at academys for twenty years together without gaining the least ground, nay some have rather gon backwards in their study as their performance before they set out upon their travail and those done twenty years since will testifie. Whereas if I have acquired anything in my way it has been wholy obtain'd by Observation by which method be where I would with my Eyes open I could have been at my studys so that even my Pleasures became a part of them, and sweetned the pursuit.[15]

As this was the Doctrin I preach'd as well as practic'd an arch Brother of the pencil gave it this turn That the only way to learn to draw well was never to draw at all.[16]

MS. sold 5 March 1935, Sotheby's (lot 402) (quoted, Burke, p. 195)

and I would thus the most striking objects whether of Beauty or otherwise were by habit the most easily and strongly impressed and retained in my Imagination.

15. The linking of pleasures and studies in this passage is later developed in the "Autobiographical Notes" – a notion that seems to have been essential to Hogarth's idea of aesthetics. In one of these later notes Hogarth extends the discussion of his mnemonics to the "theater of memory": "my Picture was my Stage and men and women my actors who were by Means of certain actions and express[ions] to Exhibit a dumb shew." This suggests that he carries the image of a stage (another inheritance from the *Spectator*, in which it is a primary metaphor of London life, the Novel) around in his mind recalling the story of Simonides and the visualized room used by orators as an aide-mémoire. Hogarth's scenes are invariably constructed as a single-point perspective box, essentially a proscenium arch stage, filled with furniture and emblems. This can be seen to serve as the traditional memory structure for the artist who "furnishes" the room in his memory before setting it down on paper. But turned away from the orator toward his audience, it can serve the spectator in the same way; and this is perhaps what Hogarth does in *Analysis*, plate 1, where he not only places his sculptures in an architectural frame but numbers them and, within his text, discusses them – expecting them to remain in the memory of his readers. See BL. Add. MS. 27,991, ff. 10–12; in Burke's transcription, pp. 209–11.

16. This paragraph leads into the passage explaining how he set about putting his ideas down on paper (ff. 10–11, p. 118 above).

And a redundancy of matter was by this means constantly occurring to me

it may be easily conceived it was natural for me to make use of whatever my Idleness would suffer me to become possest of[.]} moreover I could not help thinking this way of painting might one time or other become in better hands more usefull and entertaining in this Nation than by the Eternal proposition of beaten subjects either from the Scriptures or from the old ridiculous stories of the Heathen gods as neither the Religion of the one or the other require promoting among protestants as they formerly did in greece and more lately at Rome in the more bigoted times of nonsense in one and popery in the other

VI TEXT FOOTNOTE 42
Variety. BL. Eg. MS. 3011, f. 18b (crossed out)[17]

As we pronounce our resolutions from the dictates of the mind, and heart, we will attempt shewing what and how those things are constructed, which excite such, and such, Sensations; and also what sort of Sensations and feelings, these are that make us resolve or determine in this or that manner with reguard to appearances. And as I can have no other way of doing this but by my own feeling describing how I have felt myself upon the careful examination and enquiry into the sight of objects [taken?] in the best manner I am capable of following[,] probably many will not agree with me. However let us suppose the inherent quallity of objects & the motions they excite in us to stand in the follow[ing] order, all which shall be discus'd more at large in Chapters as we proceed.

Fitness	{ uniformity and Regularity	{ Fitness excites a pleasure equall or similar to that of truth and Justice. uniformity and regularity, are pleasures of contentment.

17. This is Hogarth's diagram for the terms he introduces in the following chapters. Burke (p. 170) misses the point, arguing that in the Preface Hogarth is against "equating certain principles of beauty with moral qualities" but in this note does so himself. In fact, in both passages he is taking issue with the Shaftesburians' facile equation of beauty and virtue.

Variety $\left\{\begin{array}{l}\text{Simplicity and}\\\text{distinctness}\\\text{Intricacy}\\\text{quantity}\end{array}\right.$ $\left\{\begin{array}{l}\text{Variety excites the lively}\\\text{feeling of wantoness and play}\\\text{Intricacy like the joy of}\\\text{pursuite}\\\text{quantity excites the pleasure}\\\text{of admiration and wonder.}\end{array}\right.$

all which Joyning in their precise degrees in the human frame have the power of creating esteem love Honour. Simplicity and distinctness is like the pleasure of easy attainment.

VII TEXT FOOTNOTE 45
Intricacy. BL. Eg. MS. 3011, f. 47b

Curiosity is implanted in all our minds. We are naturaly inquisitif, and have a propensity to searching after, pursuing and surmounting, difficultys, by which means most things usefull and necessary are and have been attain and the difficulty, of obtaining often enhaunces the pleasure of the pursuit and makes it become a sport.[18] Hunting fishing, fowling &c are of this sort. even animals have a delight in pursuing and sometimes suffer their prey to eschape for the pleasure of chasing it again.

It is a pleasing labour of the mind to unfold mystery Allegory and Riddles.

With what pleasure doth the mind follow, the well conected thread of a play or novel which ever encreases as the Plot thickens, and ends, when that's disclos'd[.] the Eye hath this sort of enjoyment in winding walks and Serpentine Rivers.

Thus the Pleasure the Eye receives from objects composed of the Serpentine Line may in some measure be accounted for.

18. Addison had contrasted the "Pleasures of the Fancy" with "those of the Understanding, which are worked out by Dint of thinking, and attended with too violent a Labour of the Brain" (*Spectator* No. 411, 3: 539). For the concept of difficulty (*difficultas*), see Paulson, *Emblem and Expression: Meaning in English Art of the Eighteenth Century* (London, 1976), pp. 53–57. Dobai has shown that Hogarth takes Dürer's progression of lines from simple to difficult and equates difficult with beautiful (p. 340; Dürer, *Unterweysung mit Zirckel und Richtscheyt* [1525], probably through Gérard de Lairesse's *Grundlegginge ter Teek en Kunst* [1713; French trans. 1719]).

BL. Eg. MS. 3015, p. 159b, connects intricacy (the epistemology) and beauty (the object); the key terms of "difficulty," "parts," and "beauty":

So when a form is composed so as to give the Eye a certain degree of difficulty in tracing over its parts the mind is stimulated in a pleasing manner. And the object that is the cause is called a form of beauty.

VIII TEXT FOOTNOTE 48
The Analysis of the Ridiculous. Draft A, BL. Eg. MS. 3011, f. 49, opposite the first formulation ("When Improper or Incompatible excesses meet . . ."; p. 36 above), Hogarth adds:

It is the aforesaid junction of opposite Ideas that makes us laugh at the Ass and the Owl. We join the Idea of [a] Human face to theirs. Cut off the inelegant hair from the forehead of the Ass, and the round periwig from the owl and you'l take away this effect. the monkey for this reason is comical if you dress him like a man he is more so. I have seen a dutch dog walking upon his hind legs with a tyed periwig on set people of the utmost gravity a laughing and never fail.

Draft B, BL. Eg. MS. 3013, ff. 44b, 45:

[*Struck through*: The inexplicable word Humour hath been hammer'd at in all ages and yet remains undetermined in what it truly.] From the foregoing observations and examples may not a clearer Idea of what constitutes true humour be conceiv'd than hitherto has been. Is it not the same kind of Jumble or Junction of circumstances, that makes up the Humorous Characters of Trapolin in Duke and no Duke & nell in the Devil to Pay?[19] sure there is the same ridiculous connection also in most of Falstaff's Humourous saying as *stand before me boy I would not be seen to*

19. *A Duke and No Duke* (1685), adapted by Nahum Tate from Sir Aston Cokain's *Trappolin Suppos'd a Prince* (1658), was a popular farce. Trappolin is magically transformed to resemble the absent Duke and takes over from him, until at length the two "Dukes" meet. In "A Preface concerning Farce," in the second edition (1693), Tate argued for the antiquity of farce.

 The Devil to Pay; or the Wives Metamorphos'd (1731), the most popular of all eighteenth-century farces (reprinted in fifty editions), was Charles Coffey's adaptation of Thomas Jevon's *The Devil of a Wife, or a Comical Transformation* (1686). Nell, "an innocent Country Girl" with a boorish husband, is metamorphosed into Lady Lovewell, finding herself on "a bed of Violets and Roses, and [with] the sweetest Husband by my Side" (p. 39); and Lady Lovewell, a shrewish wife, finds herself with Nell's boorish husband. Hogarth refers to the play in *Strolling Actresses Dressing in a Barn* (1737, *HGW* No. 150).

his little page when the lord Chancelor was passing by, and again *this sighing and greiving blows a man up* &c.[20] [*Bracketed insert in pencil*: Hudibrass and don quixot afford many seeming confermations.] even storys of the utmost Horror by this means become matter of laughter and jest, as the known story of the wounded man in a sea fight who having first had his leg shot off had also afterwards his head shot off by a cannon ball as he [was] carried down to the surgeon, unknown to the Bearer. the surgeon being angry at the absurdity of bringing a man to be cur'd without a head the fellow who brought the body, returned for answere in a pet damn him he told me it was his leg. another Instance of this kind of Humour in a story of Horror is suppose[d] to be told by a Passenger aboard a ship in an engagement where dreadfull havock was made, who seeking about in a terable fright for the safest place, discover'd a fellow sitting in great tranquility & smoking a short pipe of tobacco across a Barril[.] on asking him why he sat there so composdly the fellow taking every now and then a wiff as he spoke and some times blowing a lighted match which he had in his other hand deliberately told him he expected every moment to have orders to Blow up the ship and that the place he was then in was the Powder room. in all these instances, it is plainely the Inconsistency and mixture of incompatible matter that causes involuntary laughter. [*added in pencil*:] only an officer plac'd ready to blow the ship up & all the Humorous part vanishes.

I mean that kind of humour which is comical and entertaining for there are two Ideas of the word humour and they are often confounded one with the other. The Humourist is generally as offensive as the Man of Humour is agreable and diverting. the latter sort of humour has puzzl'd bothe antients & moderns.[21]

The Incongruous juxtaposition of sizes. BL. Eg. MS. 3015, f. 65b

So Tom thumb in the Tragedy of Tragedys doth not a little contribute to the humour of that piece, fig. 18 p[late] 1 in both these examples you

20. Shakespeare, *Henry IV, Part 2*, 1.2.64: "Wait close; I will not see him"; Hogarth uses the expanded line in Thomas Betterton's version that held the stage in the early eighteenth century, *Sequel of Henry the Fourth: with the Humours of Sir John Falstaffe, and Justice Shallow* (1721), p. 2. He means the Lord Chief Justice. The second quotation is from *Henry IV, Part 1*, 2.4.36: "A plague of sighing and grief! it blows a man up like a bladder." One of Hogarth's earliest paintings was of *Henry IV*, Pt. 2 (Falstaff examining his recruits; Beckett no. 4).

21. In this passage Hogarth specifically recalls Corbyn Morris's *Essay towards Fixing the True Standards of Wit, Humour, Raillery, Satire, and Ridicule* (1744), which makes these distinctions.

see it is the inconsistancys and extravagant incompatibleness, that work drollery.[22]

Round shapes. BL. Eg. MS. 3014, f. 45

the effect [of round lines] is rather ridiculous than ugly. Sr. Plumes Empty look discrib'd in the rape of the Lock would not be so strong without the Idea of its roundness.

> With round unthinking face
> his snufbox first he opens then his case.[23]

IX TEXT FOOTNOTE 51
"Chapter of Dress." Draft A, BL. Eg. MS. 3011, ff. 59b, 60 margin, 60b, 61 margin, 61b, 62 margin, 62b[24]

Dress is so copious a Topick, it would aford sufficient matter for a Large Vollumn of itself (yet here must be but slightly handled as it would be departing too much from our present plan)[.] there was a book wrote about a hundred years agoe calld the artificial changling[25] that hath set the amazing force and folly of custom and Fashions of Dress in the most rediculous light imaginable by not only shewing the most extravagant wild and uncouth manners of coverring the body in different ages and countrys but their disgustefull and sometimes cruel methods of moulding and forcing the human form out of its natural figure and collour. many of his Instances remain to this day, one in China of bandaging the

22. Henry Fielding, *Tragedy of Tragedies* (1731), the revision of *Tom Thumb* (1730) to which Hogarth contributed a frontispiece (*HGW* No. 220).

23. Pope, *Rape of the Lock* (1714), 4.125–26. Hogarth misquotes from memory (omitting "With earnest eyes").

24. See Patricia Cunningham, "The Theoretical Bases of William Hogarth's Depictions of Dress," *Dress*, 7 (1981):53–68.

25. John Bulwer, *Anthropometamorphosis: Man Transformed; or, the Artificial Changeling. Historically Presented, In the mad and cruel Gallantry, Foolish Bravery, Ridiculous Beauty, Filthy Finesse, and loathsome Loveliness of most Nations, Fashioning & altering their Bodies from the Mould intended by Nature. With a Vindication of the Regular Beauty and Honesty of Nature* (1650). The frontispiece consists of twenty-one varying faces, not unlike those Hogarth shows in *Characters and Caricaturas*, including Bulwer's own (though Bulwer's are divided and framed). There is a chapter on the "Fashions of the Head, affected and contrived by the pragmatical invention and artificial endeavours of many Nations," followed by "of Haire," of the eyebrows, nose, ears, and so on. Hogarth may show the influence of Bulwer's treatise in his painting of c. 1746, *Taste a la Mode* (Beckett no. 140; engraving, *HGW*, pp. 21, 111; in *HGW*, 1965 and 1970 eds., repro. 1, opp. p. 25).

feet of the females to prevent their growing, which shocking dis-
proportion in Women is become a Beauty to them by the force of
custom. Fancy the love of change and private & Publick Interests
have always given the lead to the fasheons of Dress, and will ever
continue so to do[.] and so on all accounts its fit nothing should be
restrin'd but the folly I had almost said wickedness of Changing natures
form or Colour.

However with submision to the Ladys who often accurately know
how colours suit and forms agree, If natures rules should sometimes take
fancy by the hand she surely would not make their person less agreeable.

As to mens dress let Taylors &c do what they please with, so they
dont make it inconvenient.

In every Dress Convenience and fitness and propriety should be
first complied with but as it is also Fit it should be pleasing let us see
how our other five principles may be conducive. There is an absolute
demand for uniformity in many parts of dress or it could not be
commodious easy cumfertable. Yet when it can with propriety be
avoided the more elegant the dress appears. Feathers Jewels & flowers
[*struck through*: nosegays] are generally worn but on one side the head,
for this reason Painters call such dispositions Pictoresque & have
contrive[d] a dress wholy at their disposal call[ed] drapery [*marginal
insert*: to exercise all the principles of beauty upon but such dresses never
could be wore, they would have been so incomodious nor would they
have been at all agreeable if the folds were stir'd or seen in any other
Veiw than just as in their pictures] as often the Dress of the times
belonging [to] the story they have painted are not known Drapery serves
as a good succidanium, and is free'd from all criticisms on account of
impropriety. it also give[s] a fine latitude to light Shade and colour so
that it makes History painting in what is calld the grand stile as much
less difficult to perform than storys of the present age where every part
of dress is known to be a part of character, as writing comedy is more
difficult than writing Tragedy.[26] we speak of true comedy in painting
not of dutch drols.

We know the very minds of people by their dress

Character unjustly dressd would spoil the best otherwase represented
Play.

26. A two-page MS. in the Houghton Library, Harvard, is a "Dialogue on Comedy and
Tragedy" that could follow from this remark, though its focus seems to be on the subject of
caricature and the term *outré*, pointing to *The Bench* (ill. 21, 1758, *HGW* No. 205).

Simiplicity in dress is a beauty the least attended to yet it is the most inviting principle. [*struck through*: first it is the reverse of Tawdriness] by it is meant the generall parts of dress should be few that is not cut or devided into many little patches and bits like the old fashiond falbelowd and flounced petticoats. they confound the Eye excite the Idea of raggs and Tatters.

The plain dress of a country girl is often more inviting than the rich court dress. the Beauty of the person is often hid and obscurd by gaudiness and the heaping on of too many rich things (nay the Intended effect of gaity often distro'd by overdoing it)[.] See simplicity in composition.

Intricacy is that part which serves to correct the excess of simplicitys falling into meaness. Some parts of dress should be loose and at liberty to play into foulds some of which will be alway winding as the body moves. nay it is some times proper to contrive things to rest in winding forms as the Headdress of the Sphinx (figure)

quantity as has been before observd in Chap. [6] Add dignity to [grace.] This the lady are so thoroughly convinc'd of that they undergo for the sake of so much addition to their person as great an fatigue in the encumbrance of the large hoop peticoats as if they carried a panner upon their hips, and as long as they preserve the figure of the piramid as (fig.), there is an air of consequence in it but the excess (see the same chap.) makes it ridiculous (a fig.)

[*In margin:*] The horse granadeir mounted with sword drawn and all his accoutriments about him is a fine instance of the noble effect of quantity by the addition of various forms well composed about him all coming within piramidal lines[.] how mean would the little jocky as hes fitted for a race appear riding by him[.]

[*Struck through:*] There is no part of dress ought to be so much reguarded as that of adjusting the Hair. it is capable of being made to have variety of meaning[.] like all other beautys it

BL. Add. MS. 27, 992, f. 21b

An old Black Smith in his cloaths and leather apron is low. Strip him naked and then put on him his apron again and he becomes a god.[27] So a roman [illegible] a king now and antique Boxer.

27. That is, if an artist paints a blacksmith the result will be a Dutch genre painting; but if he undresses him, and puts a blacksmith's apron back on him, he might paint him as Vulcan and receive applause as a painter of history. Cf. Charon and the waterman (p. 71).

X TEXT FOOTNOTE 52

Supplement to the Orders of Architecture. BL. Add. MS. 27,992, ff. 21b–24b

Now in hand and will be publishd about two months time a short addenda or suplement [to] the Analysis of Beauty wherein by the doctrine of varying lines it will plainly be shewn to the meanest understanding [*passage illegible*] who had never either heard of or seen Roman architecture would as exactly produce those orders, which now are no otherwise done than [by] copying.

if a man goes several thousand miles to do what an account of its useful and necessary part may be as well or better done in his chair at home, it will appear but little meritorious. the prodigious stir that has been made of late years about the orders of architecture, seem to me very extraordinary and I believe were what is here laid down received and understood as I understand it, it would appear no less strange to other people.

Since it is highly probable that any man versed in drawing other things to a certain degree, tho he should have never seen a glimpse of any such form for a column or support in Building, provided he were properly versed in these rules would from a rude square Block of wood or stone produce one very like it by proceeding as follows.

It being required to vary the Block in the most Beautifull manner

he has nothing to do but to cut it round first and then apply the strait and curved lines variously by conforming strictly to the rules [*words illegible*] of varying Chapt . . . as follows – by variety corrected by simplicity quantity [*word illegible*] its 3 parts or four at the most

As I have ventured to say that Order in Architecture of the ancients will perfectly agree with the rules of composition laid down in the analysis and that new orders addapted to various purposes may be still invented notwithstanding the unshaken belief that any such thing is impossible we will here attempt to stagger that rooted perswasion.

Firstly showing Deviations &c
Secondly by taking a Block of wood or stone &c
Thirdly by shewing what chance or working at random &c
Fourthly how far a good genious by the Natural &c

If these instances of 1 part hold good, why may not all the rest of the parts of a Building from the first order to the last[?] the first or Tuscan is least varied in general therefore least Beautifull as to Beauty. the last viz the Corinthian is the most Delightfull because it hath the greatest variety of parts . . .

XI TEXT FOOTNOTE 55
*A capital based on periwigs and three-cornered hats. BL. Eg. MS. 3013, f. 65
(following a drawing of it, f. 64; plate 2, fig. 48)*

Yet were we but to hint, that the proceeding upon the foregoing
Principles in search of a new order, would not be a vain attempt, we fear
some biggoted Architect, or Builder, who holds the five orders as sacred
as the Jews do their Penteteuch or five books of Moses, and dares not
strike a stroke without book, would be much offended at so
presumtuous a suggestion, altho he were not able to give any other
reason why it is not practicable, but because attempts, have hitherto
been in vain, and therefore he would conclude it must be an Impos-
sibility; which conclusion might have had as good a foundation, if ye
Ancients had left us no more than two orders. however see two new
orders attempted. [*struck through:*] the violet or Larkspur order (fig) from
which flowers the hints were taken and the [*word illegible*] or Hat and
Peruke order

XII TEXT FOOTNOTES 65, 76
*The Analogy between Colours and Music ("Chap. 12 of Colours with reguard
to Beauty"). Draft A, BL. Eg. MS. 3012, ff. 15–17*

The knowledge of colours bears so strong an analogy with the science of
Musick that some have been Induc'd to think that the Identical prin-
ciples, for the compositions of musick would equally serve for those of
colours.[28]

So much was Pare Castle Dr. of the Surbon & a great projecter at Paris
perswaded of this that at a great expence of time and trouble he
contriv'd a harpsicord to play harmonious compositions of colours, and
on which he wrote a pretty large Treatise.[29] The Prism colours were
his notes which the Keys of the Instrument were to make appear at
Pleasure.

28. The locus for the discussion of the analogy between painting and music was de
Piles's *Cours de Peinture par principes* (1708, p. 9; tr. *Principles of Painting*, 1743, pp. 5–6). Cf.
Hogarth's own analogy between shade and sound, above, pp. 77–78.
29. Louis-Bertrand Castel (1688–1757), mathematician and physicist known for his
theory of the correspondence of sound and color (*L'optique des couleurs* [1740]). In 1735 he had
exhibited in Paris his "colororgan," which permitted the deaf to "see the music of the ears,"
the blind to hear "the music of the eyes," and normal people to "enjoy music and colours
better by enjoying them both at the same time" (see Erika von Erhardt-Siebold, "Harmony
of the Senses in English, German, and French Romanticism," *PMLA*, 47 [1932]:578).

but sure he would [not] have been drawn into makeing this extraor-
dinary experiment if he had not taken it for granted that colours and
sound were of the same Nature and that the like dispositions, of them
both would answere the same purpose i.e. that a jig in notes would be
litterally a jig in Colours.

It would not be surprising to hear of an Instrument invented in that
nation of Tast formd upon some such plan for Cookery which no doubt
would soon be brought over into England where it would certainly meet
with great encouragement. Would it not be pleasant to see Mounseiur
l'Quisnier[30] at his harpsicord in a Morning composing a grand festin for
the entertainment of foreign ministers?

Such an Improvement of this Instrument could not but be very
agreable to a certain eminent composer, nor could he fail getting the
hearts of all the court as well as of the citty by composing a banquet for
an instalation or a lords mayors day.[31]

The Principles of Color re the Human Complection. Draft A, BL. Eg. MS.
3012, ff. 33b, 34 margin, 36 margin

This network seems to be of a tender texture & subject to Injury by heat
& cold[.] the hand and arms of servants plunging suddenly from warm
into cold water become as red as beef cover[ed] only with the cuticula
which grows thicker with labour, so as to be quite callous in [some
parts?][.] when the fines[t] complexion by being overheated becomes
of a uniform red how is beauty lost or when cold redens the nose &c and
distroys the composed distinct differences of white red and blue
nature forms by the network, they then are confusd and brek into one
another.

See the same beauty in a winter morning in the park and a summers
evening.

Everyone knows that under the two skins called cutis and cuticula the
appearance of the large Vessels are blue, the flesh red and the fat a yellow
white, being ungradating Colours and uniting abruptly they displease
the eye which the Cutis or beauty making skin changes the appearances
of, into a composed order exibiting them softly gradating through its
own figure with intricacy for ye general hue of the body and limbs,
simplicity or distinct oppositions of firm colour for the parts which call

30. That is, Mr. Cook.
31. Probably Georg Friederich Handel, who in 1752 had launched *Jephtha*, with a
libretto by Morell, who claimed the piece was his own favorite Handel oratorio.

for our particular attention as the Eyes and mouth, uniformity as the cheeks, nipples &c. and quantity of white for the general hue at a distance which altogether makes up the great principle of Variety.

Draft A, BL. Eg. MS. 3012, ff. 62b, 62, 61, all reversed

Fine complexions or as the painters call it fine colouring doth not appear at all times alike in the same faces[.] the colouring of park beautys in a winters morning and a summers Evening differ as much as the Trees [*struck through:* along the mall at those times] they walk by.

Violent heat hath a worse effect than cold for the colours of the Eyes the lips and Eyebrows make a difference in the most pale or cold complexion unless it [changes?] very blue or purple but when an equal colour even like a red hot heater spreads the whole face it makes almost a sameness with the Eyes so that at a little distance the feature is all confused and lost in one uniform red like Bardolf in the play.[32]

Feavour cause[s] the same effect.

The gently glowing warmth brings out the Sweetest colouring, the tints are then clear broad and briliant.

It is the various sorts and various dispostions of such colours as these we would [have] describ'd but to do it with that nicety it doth require, is too much for the pencil much more the pen. We'll try to shew what doth not make it first and then we will try to shew what it is that doth. Before we begin the former recolect what has been said in the foregoing chap. that gradating shades are as the line of beauty in effect & that gradation is the same, and as the Intricate dispositions of the line makes the beauty of the Human form so the Intricate disposi-tions of the gradating shades of colour makes the Beauty of complexion, the manner of which Intricate disposition is to be describ'd with the latter.[33]

32. Shakespeare, *Henry IV* and *Henry V*.

33. Here, following from p. 118 and the note on Time in the text, Hogarth refers to the controversy over whether color should be applied in smooth, *léché* (licked) strokes or in broken paint. André Félibien, writing for the main tradition, advocated the former; Rembrandt, Kneller, and Vanderbank, as well as the Venetians, represented the second, as does Hogarth. Félibien, arguing for unity of coloring, thought a picture should be highly finished; thus old pictures are better than new ones, the colors having had time to blend, and they can also be unified by covering them with varnish, which makes colors fuse (*Entretiens sur les Vies . . . des plus excellens Peintres anciens et modernes* [publ]. between 1666 and 1685]). For the views of Richardson, who as an admirer of Rembrandt was relatively friendly toward the use of broken paint, see *Works*, pp. 70–71; and for Hogarth, "Autobiographical Notes," Burke, p. 207.

If this Intricate disposition of the tints is wanting in the general Hue of fair flesh the whole is of a doughy white or like drowned flesh[.] The unatural even colour of a waxwork hand or arm would be {a} frightfull sight alive.

Nay the finest pale red silk as near the colour of flesh as it could be made, would still be more offencive with its more eveness. and a black moor even colour'd as a cloath [whole?] or velvet mask perhaps would shock the moors as much as one milkwhite[.]

So a statue painted all over with even red and white would be less agreable than the marble milky white one & where animated they would be the same.

thus you see one even uniform colour is not [*struck through*: beauty] thing Variety of colours there must be.

But if those colours have not gradation they will appear like spots of blotches of disease or as the flesh appears when the network skin is fresh peald away after {a} blister.

If more gradating tints than what just serve the more distinguish the feature from one another they bread confusion, and simplicity is lost as when the nose or forehead [is] stung by gnats.

Distinct opposition of colour is plac'd where our attention most is call'd as to the mouth and Eyes but if this distinctness is wanting as when the spot of sight grows dim and pale with age and the white teeth are wanted as an opposition to the lips, this part of variety to[o] is lost.

If the Broad gradating of the Cheek is d[w]indled to a little spot no bigger [than] the childrens doll it would be mean and better none at all[.] if the excess appears as the french daube their cheak up to the Eyes its equally disagreable.

XIII TEXT FOOTNOTE 77
Addition to the note on faded pictures. BL. Eg. MS. 3013, ff. 115, 114b

And this general gradation, or vanishing off, of objects, is one great effect of beauty, may be seen not only in nature but in the well-preserv'd landskips of Claud de lorain but more distinctly in the fresh painted ones of Lambert.[34] and the reverse in some degree or other in most old pictures[.] this must enevitably be the case with all pictures in time as each colour differs in its nature one turning black another yellow

34. See above, Text n. 72.

another green a forth faint or fades quite away so that an old picture otherwise valuable must with respect to light shade and colour be like an air played by a great master of musick on an Instrument quite out of tune. would it not seem strange that prejudices should so far prevail that numbers with their Eyes and ears open should fancy they see & hear the more Harmony for this distruction of colours in pictures and untun'd strings in musick?

BL. Eg. MS. 3015, ff. 166b, 167b, 168b

we mention this of old pictures by way of caution to the improving Eye because this best sense of ours is subject to most delusion. Some have been so misled through prejudice, as almost to see black for white, in these matters ocation'd by one of the most absurd notions that ever sure prevail'd, viz that Pictures (from whence their Ideas of harmony of lights shades and colours were cheifly taken) improve with age. This strange mistake has got the stronger root for want of considering that as each colour is a different material and different in its nature one an earth another a mettle, &c time must in the nature of things operate differently on them all, but on some more than others, as one will turn Brown another yellow another green a fourth Black or else fade quite away, so that what ever harmony or keeping a picture might have had at first must absolutely be destroy'd by time. some pictures of great masters (for they do not equally decay) that have shard this fait and thus mislead the Eyes of their admirers are like an Instrument play'd upon by a good hand that hath lost some strings and all the rest quite out of tune.

Time by degrees will unharmonize and totally distroy, yet some continue pretty well for many years. Those of the greatest masters that thus have shared the Fate of time and thus misled the Eyes of their admirers are like fine concertos play'd on an old organ with batterd broken Pipes.

Is it not strange that many with all their senses clear enough in other things only by biggotry to names of Note should realy find more Harmony for such distruction? as this is often seen we thought this caution necessary.

In authors that speak of Pictures mellowing by time always read yellowing, because the oyle ground in the colours that gives that hue, would do the same by the fairest flesh in life and make it full as mellow as a picture that has stood some time.

MS., Houghton Library, Harvard University

In the course of thirty years as I have continually been amongst painters, the Business of preserving pictures by varnishes or otherwise has often come upon the Table. a great number of receipts both printed and written I have seen which have been used and recommended some by one some by another[,] all of which I found dis[colored?} and dis[proved?] at different times. that which after all has according to my own experience proved the best is what follows. but which if not used with proper caution may be very mischevious as {I} have found to my cost.

In short it is nothing more than a white of an Egg beat up to a froth, which froth must be laid on the Picture equally but not very Thick only sufficient to give it gloss. The great caution I have to give is that a fresh painted Picture [may] be spoild by laying it in the sun so as to render it faint and weak in all its darker part, and thereby make the Picture appear faded in less than a years time. to prevent this you have only to let your Colours be perfectly Dry and hard before you [*illegible*] it for should [you] put your Egg on whilst they are yet moist the Egg will somehow incorporate with the paint and as it drieth and hardens into a white substance every darkish part will partake of it and be made faint, nay more it will Eat into them in an honey comb manner especially where it lieth pretty thick. as proof of this,[35]

XIV TEXT FOOTNOTE 82
On the human face. BL. Eg. MS. 3014, f. 27

What farther Improvements, the Eye is capable of, is hard to say, but this particular is known to many, with reguard to hearing, that some deaf people can hold a conferance, and understand almost every word that is said, by the motions of the mouth, without so much as hearing the least sound of the voice, which is an almost inconceivable, and extraordinary, improvement of the sight, and more so, than that of a Musicians ear with reguard to sounds.

35. The MS. breaks off at this point. Hogarth is describing glair, a sizing liquid made from egg white. Reynolds's most disastrous experiment is said to have been to use a medium consisting of glair, wax, and varnish. Hogarth's warning may explain what happened.

XV TEXT FOOTNOTE 94
Dance. BL. Eg. MS. 3016, f. 85b, 88b

The Dance called the Sabatier is a continual shifting from one Attitude in plain Lines . . . to another.

The true characteristic of Dancing in general seems to be elegant Wantoness. therefore the genteel comick is the most entertaining Species of it. Serious dancing is a contradiction in terms.

XVI TEXT FOOTNOTE 96
Commedia dell'arte. BL. Eg. MS. 3014, ff. 76, 77

Thus the grotesque Italien dance of the man Peasant, entertains by being comically Ridiculous in a varied composition of movements in plane strait and curv'd lines, convuls'd & exaggerated agillity and changing from one uncouth attitude to another are comick in a man but are such as would be shocking and offencive in a woman dancer.

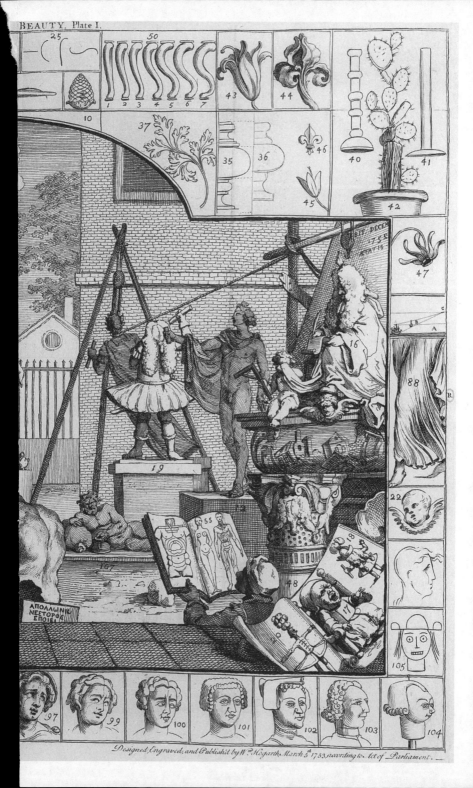

APOLLWNIK
NEOTOROC
EПOIEI

Designed, Engraved, and Publish'd by W.ᵐ Hogarth. March 5.ᵗʰ 1753, according to Act of Parliament.

Designed, Engraved, and Published by Wm. Hogarth, March 5th 1753 according to Act of Parliament.

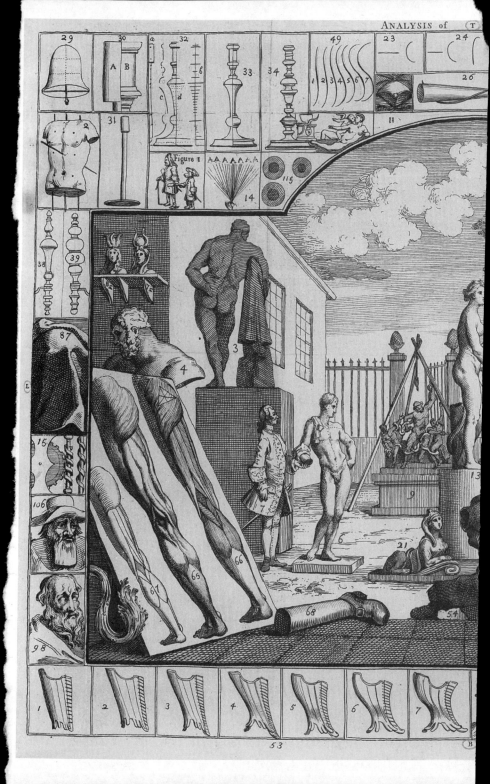

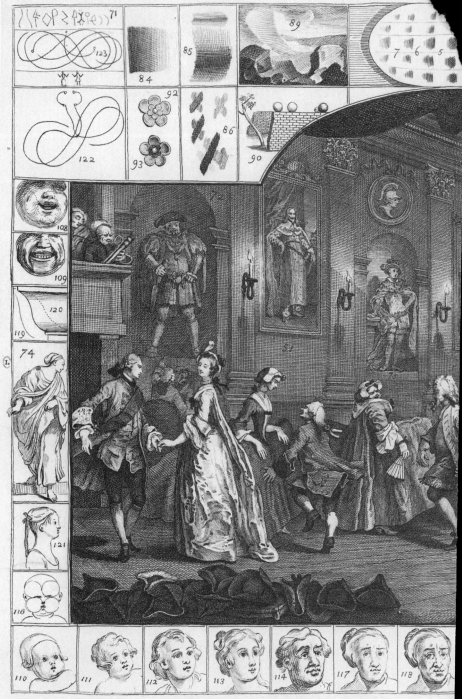

Notes to the Illustrations

1. *Columbus Breaking the Egg* (March 1752) (p. lxiv)

Etching; 5 $^5/_8$ × 7 $^1/_8$ in. (8 $^1/_8$ × 7 $^5/_8$ in.); BM Sat.3192, Nichols 243.1, Dobson 255.2, *HGW* No. 194.

 States: 1 Ill., 1, BM 1868-8-22-1601. Receipt beneath the design: "*Rec'd* [4. August 1752] *of* [Chas Rogers] *five Shillings being the first Payment for a Short Tract in Quarto call'd the Analysis of Beauty; wherein Forms are consider'd in a new light, to which will be added two explanatory Prints Serious and Comical, Engrav'd on large Copper Plates fit to frame for Furniture. N.B. The Price will be rais'd after the Subscription is over.*" This state, used as subscription ticket for the *Analysis*, was in circulation by March 1752. The earliest I have seen is 27 March, to a Major Gaddis, now in Hogarth's House, Chiswick. Other impressions are dated 2 April, for George Burges; 19 April, for George Knapton; and 17 July, for Mr. Symonds (all, BM); 25 April, for Charles Gray (Whitworth, Manchester); 27 April, for Thomas Lewis; 28 May, for Richard Owen Cambridge; and 11 July, for John Ranby (all for, Fitzwilliam Museum, Cambridge). One for George Lambert is dated 25 November (Royal Library).

 2. The receipt has been cut off (now 6 $^1/_2$ in.) and replaced by "*Design'd and Etch'd by Wm Hogarth Decem 1. 1753*" (BM, et al.). This state was used as frontispiece for the *Analysis* and, subsequently, was included in the Hogarth folios published by Jane Hogarth (1764–89), John Boydell (1790–95), Baldwin and Cradock (1820–35), and Henry G. Bohn (1835 onward).

 The story Hogarth illustrates was related by Girolamo Benzoni in his *Historia del Mondo Nuovo* (1565): After admiration for Columbus's discovery of the New World turned to envy, his enemies began to claim that anyone could have done the same.

> "It is not difficult now I have pointed out the way," was the answer of Columbus, "but easy as it will appear when you are possessed of my method, I do not believe that, without such instruction, any person present could place one of these eggs upright on the table." The cloth, knives, &c. were thrown aside, and two of the party, placing their eggs as required, kept them steady with their fingers, and one of them swore that there could be no other way. "We will try," said the navigator, and giving an egg, which he held in his hand, a smart stroke on the table, it remained upright [trans. BM Sat. 3192].

The story was earlier told by Vasari of Brunelleschi and the cupola of the Duomo in Florence (*Lives*, 1550, 2:347). Hogarth uses the better-known Columbus version in order to suggest the analogy between his discovery of the "Line of Beauty" and Columbus's "Discovery of the New World." He applies the story to his *Analysis* by

adding two eels on the plate which form "Lines of Beauty." The implication (as stated in the Preface, p. 6) is that he expects the same skepticism from the connoisseurs.

The composition parodies a Last Supper, suggesting that he is the Messiah of art (another object of skepticism). He has replaced the Host of the Eucharist with the two serpentine eels, which form "Lines of Beauty," and added two eggs. Eggs appear in theological writings as a *natural* symbol for the Host (while the egg remains the same on the outside, it is being transformed inside into a whole chicken). An example is the ostrich egg suspended above the Virgin and Child in Piero della Francesca's *Sacra Conversazione* (Brera, Milan). In the text Hogarth connects the oval (preferable to the circle) with the egg (less at one end) and "a beautiful face" (p. 31); later, recalling Columbus's *breaking* of the egg, a face is said to be more "alluring" when a lock of hair is "breaking the regularity of the oval" (p. 39). Hogarth is illustrating "fitness": the perfect oval is beautiful so long as it serves to make the egg stand – a woman's face so long as its allure wins her a lover or husband. Given the wit employed in the print, and in the *Analysis* text the emphasis on wanton pursuit, I would not want to rule out the possibility that the number of eggs reflects a reference to the reproductive function of the human male.

2. Title Page (p. lxv)

Logogram
Wood engraving; 2 $^7/_{16}$ × 3 $^5/_{16}$ in.
The engraver is unknown. A finished drawing is in the Royal Library (Oppé, fig. 24, cat. no. 80): The pyramid is shaded and has a ring at the apex; the Line of Beauty is suspended by a string tied with a bow. In the print the Line is differently placed, given the snake-head, and the pyramid is placed upon a plinth labeled "VARIETY" (*HGW* No. 231 [238]).

The triangle is primarily an aestheticization of the Christian symbol of the Trinity, a triangle inscribed with the Tetragrammaton. Hogarth has replaced the Name of God with his own Line of Beauty and naturalized his Line by turning it into a serpent and adding a third dimension to the triangle.

A second context is Shaftesbury's replacement of Judeo-Christian iconography with classical. In the Preface Hogarth cites Lomazzo's *Tracte* (Bk. I, chap. 29) to the effect that the Greeks "searched out the truly renowned proportion, wherein the exact perfection of most exquisite beauty and sweetness appeareth" and dedicated it "in a triangular glass unto Venus the goddess of divine beauty" (pp. 10–11). In this repect he responds to Shaftesbury's denigration of Venus (see Introduction).

Epigraph
> So vary'd he [i.e., Satan], and of his tortuous train
> Curl'd many a wanton wreath, in sight of Eve,
> To lure her eye. (*Paradise Lost*, 9.516–18)

The epigraph joins Eve, Satan, and the Fall. The seduction in this case is of Eve, by "his wit and native subtlety" (9.93). Like Hogarth's vertical Line, Milton's serpent first walked upright, before being degraded to a crawling creature. Hogarth's serpent is pre-lapsarian. See also *Paradise Lost*, 4.347–50. In an earlier painting, *Satan, Sin, and Death* (c. 1737), he combined the serpentine lines and the female figure of Sin. His association

with Milton goes beyond Eve and Satan. He had made two illustrations for *Paradise Lost* in the 1720s for Jacob Tonson (though they were not used [*HGW* Nos. 64–65]).

"Variety" Given the context of the epigraph, cf. the passage in *Paradise Lost* on the variety of Eden:

> all sorts are here that all the earth yields,
> Variety without end; but of the tree
> Which tasted works knowledge of good and evil,
> Thou mayst not . . . (7.541–44)

That is, "variety without end" is curtailed by the Fall ("composed" variety).

Printer John Reeves published, among others works, Garrick's *Ode on the Death of Mr. Pelham* (1754), an edition of *Joe Miller's Jests* (1755?), a translation of Quevedo's *Visions* (1750), Andrew Henderson's *Case of the Jews considered* (1753), works in French and German, and, according to John Nichols, various legal works (*Literary Anecdotes*, 3: 737).

3. Plate 1 (p. 139)

"Designed, Engraved, and Publish'd by Wm Hogarth, March 5th 1753, according to Act of Parliament."
Etching and engraving; $14^5/_8 \times 19^5/_{16}$ in. ($15^3/_8 \times 19^7/_8$ in.); BM Sat. 3217; *HGW* No. 195

Drawings (Oppé, cat. nos. 81, 82): A number of fragmentary sketches appear in the second draft of Hogarth's manuscript of the *Analysis* (BL). They are numbered, but the numbers do not correspond to those on the engraved plates.

States: 1 Trial proof before title and publication line, and with "ET TU BRUTE" inscribed on the pedestal of the statue of the Roman general, No. 19 (BM: Baker and Sheepshanks Colls.). This unique impression has notes by Hogarth in ink. The following boxes are empty: Nos. 22, 115, and the space under 49. All the numbers are in ink and differ from those of the later states; most of the objects in the central part of the print are unnumbered or numbered differently. A rough sketch appears in the unnumbered box between Nos. 47 and 88, and the figure that later appears there is now in box No. 1, where the group after Ghezzi is later placed. The "B" and "T" at bottom and top center, outside the margin, and the "L" and "R" at left and right, are indicated in ink. This impression was apparently used by Hogarth for cross referencing as he wrote the text.

2 Nichols, Dobson, and Stephens (*BM. Sat.*) claim that there was an intermediate state in which the plate is finished but still has "ET TU BRUTE." I suspect that they refer to impressions (e.g., BM or Lewis-Walpole Library) in which the inscription is still partially visible.

3 Ill. 3, BM 1868-8-22-1602. "ET TU BRUTE" omitted. Engraved title added: "Analysis of Beauty. Plate I." The boxes are filled in, and the publication line added (BM, Royal Library, et al.; Hogarth, Boydell, etc. folios).

The central panel shows a statuary's yard containing copies of the canonical sculptures of the ancients known to Hogarth's contemporaries, copied in artists' academies, and here awaiting sale to customers (all are reversed by Hogarth's engraving).

Three sheets among the Hogarth MSS. in the BL contain his friend Thomas Morell's translation of Socrates's discussion of the theory of beauty from Xenophon's *Memorabilia*.

Socrates is visiting the yard of his friend Clito, the statuary, and the sculptures provide
the topics and illustrations of his argument (MS. Add. 27992, ff. 33–35). Hogarth may
not have known the Renaissance text, Colonna's *Hypnerotomachia* (tr. 1592), which
updated Xenophon's dialogue, but he clearly knew Joseph Spence's *Polymetis: or, an
Enquiry concerning the Agreement between the Works of the Roman Poets, and the Remains of the
Antient Artists* (1747), which provided the joke about the Hyde Park statues that furnish
Polymetis's garden, where Spence's dialogue takes place. Spence apologizes for the fact
that the sculptures are Roman copies, remarking that "a Roman workman in the
Aemilian square was probably pretty near on a level with our artists by Hyde-Park-
Corner" (p. 5). Hogarth moves the setting from the garden to Hyde Park Corner itself
and his friend Henry Cheere's statuary yard, where they appear in a market context. This
yard, or factory, contained lead and plaster statues and busts, copies of antique and
modern statues, which were sold in great quantity for gardens and interiors. This source
of inferior "leaden imitations" of ancient statues (*Analysis*, p. 27) was often facetiously
referred to by contemporary writers (e.g., James Ralph in *The Weekly Register: or,
Universal Journal*, 24 Nov. 1733; quoted, *Hog.* 3: 101–02). Hogarth knew the Cheeres
(see M.I. Webb, "Henry Cheere, Sculptor and Businessman, and John Cheere – I,"
Burlington Magazine, 100 [1958]: 236, 239).

Spence's argument in *Polymetis*, summed up in Dialogues 17 and 18, was that we
should learn the nature of the ancient gods by directing our own eyes to the sculptures
rather than to the words of commentators like Cesare Ripa who impose the sort of
hermetic and hieroglyphic allegory that Shaftesbury had dismissed as outmoded in his
Notion of a Draught of the Tablature of Hercules. In short, he treated the commentaries as
Hogarth treats the connoisseurs and art critics. Spence writes in his preface that he has
couched his treatise in the form of a dialogue in a garden because "the introducing a
scene, and characters, helps to give life to a subject, that wants enlivening" (p. iv).
Hogarth takes up the need "to give life to a subject, the process of enlivening,"
highlights the paradoxes of dead sculpture and live human beings, and explores the
ironies of the sculptures' human behavior, their accidental and essential aspects as
represented in copies of copies of copies.

As his examples, Spence had chosen the Venus de Medici, Apollo Belvedere, and
Farnese Hercules – limiting his examples to deities, as he explained, with the single
exception of Hercules. Hogarth reproduces the same figures. These are the standard casts
of the classical canonical sculptures copied in art academies. Hogarth had inherited a set
from his father-in-law, Sir James Thornhill, which he donated to the St. Martin's Lane
Academy. (For accounts of the sculptures, see Haskell and Penny.)

While Spence follows Shaftesbury's preference of Virtue over effeminate Pleasure, he
is fascinated by the Venus, "one of the prettiest faces that can be conceived," and unable
to maintain Shaftesburian disinterestedness in the face of her charms. He has Polymetis
"confess the truth to you, I am so much in love with the Venus de Medici, that I rather
choose to court this impropriety, than to prefer any other figure to hers." The sculpture
is "wanton" and "bewitching," and he delights in "the beauty" and "softness" yet
"firmness" of her breasts. She is a Venus Pudica, and yet "if she is not really modest she
at least counterfeits modesty extremely well"; as you approach her, "you see aversion or
denial in her look; move on but a step or two further, and she has compliance in it" (pp.
66–68). "Her infidelities to her poor husband are notorious; and have been strongly
marked out, ever since the earliest ages of the world" (pp. 75–76). He proceeds to
recount how Mars was entrapped by Venus's charms, suggesting that she has "made a

conquest of you" as well. He later elaborated on how a woman can appear more or less attractive to a male eye in *Crito: or, a Dialogue on Beauty* (1752; pseud., Sir Harry Beaumont).

Figures

1. A copy of a print by Pier Leone Ghezzi ("*Cavalier Ghezzi delin. A.P.*[ond] *fecit, 1737*"), which Hogarth uses as a satire on connoisseurship (a bear led by a tutor). He opens the *Analysis* with the need to correct the connoisseurs by a more empirical approach to art – seeing through one's own eyes instead of through the eyes of fashion or the Old Masters (p. 18). An allusion to Ghezzi appeared earlier in Hogarth's *Characters and Caricaturas* (*HGW* No. 156, ill. 18); cf. fig. 105 below.

2. A wax torso through which wires are run to establish "opposite points in its surface" (pp. 22–23, 66).

3. The Farnese Hercules by Glicon (pp. 26, 57; drawing, Oppé, pl. 82, cat. no. 81a).

4. The head and shoulders of the Farnese Hercules (pp. 12, 27). Hercules in fact appears three times, since the Belvedere Torso (fig. 54) was also usually identified as Hercules. The first, the Farnese Hercules, was extensively restored (as is perhaps suggested by the appearance of the separate head-and-shoulders), while the other, the Torso, was remarkable among antique sculptures as a piece that was not restored, presumably because Michelangelo (as Hogarth notes) "is said to have discover'd a certain principle in the trunk" (p. 2), which was a source of (or authority for) his own principle of the serpentine line.

6–7. The Vatican (Belvedere) Antinous (pp. 3, 68–71, 97), whose stance Hogarth has exaggerated to make his point that the dancing master's stiff, straight, "correct" attitude is less beautiful than that of the sculpture (drawing, Oppé, pl. 82, cat. no. 81a).

The dancing master is supposed to be John Essex, author of treatises on the art of dancing and deportment; specifically, *The Young Ladies Conduct: or, Rules for Education* (1722) and *The Dancing-Master; or, The Art of Dancing Explain'd ... Done from the French of Monsierur Rameau* (1728). Essex, who was dead by 1751, was identified in *Analysis*, plate 1, and in *Rake* 2 by Nichols (*Biog. Anecd.*, 1781, p. 14; Dobson, p. 41). For Hogarth's point, cf. *Tom Jones*, 5.1 and 14.1; and, e.g., anon., *An Essay on Wit* (1748), p. 17: "Dancing Masters never make a handsome Bow, because they take too much Pains." Essex had been cited in Fielding's *Amelia* (publ. Dec. 1751) as one who regarded dancing as "the Rudiment of polite Education, as he would, I apprehend, exclude every other Art and Science" (5.2). In *The Young Ladies Conduct* Essex had asserted that he preferred dancing to all "other Arts and Sciences" (p. 82).

On the sculpture's identification as "Antinous," and its fame, see Haskell and Penny, pp. 141–42. Antinous was the minion of the Emperor Hadrian, deified and celebrated throughout the ancient world in versions of this statue erected by the emperor in memory of his drowned lover. The Christian Fathers were outraged by the emperor's making a god of this boy who seemed to them no more than a male whore. In the enlivening context of Hogarth's composition he is seemingly being approached – perhaps indecently propositioned – by the effeminate dancing master.

9. The *Laocoön*, under a tripod of poles from the apex of which a pulley hangs, which indicates the pyramidal structure of the group (pp. 31, 102; drawing, Oppé, pl. 83, cat. no. 81b). But the tripod also recovers the logo of the title page, inscribing more serpents

on a triangular ground; its contiguity to Venus recalls her display in "a triangular glass" (pp. 10–11); and it further connects the serpentine entanglement of Laocoön and his sons with the "romantic triangle" of Apollo, Venus, and Hercules (equivalent to Mars, Venus, and Vulcan in Spence's version). A second romantic "triangle" may be implied in the dancing master, Antinous, and Venus (toward whom Antinous turns his eyes).

10. and 11. A pineapple, regarded as the most complex pattern of beauty in nature (unity within variety, parts within a whole), and one of its "pips" (pp. 31–32; drawing, Oppé, pl. 83, cat. no. 81b). Two more pineapples appear on the gate to the statuary yard.

12. The Apollo Belvedere (pp. 59, 71, 73, 97) was, like most of the other sculptures, in the Vatican Collection.

13. At the center is the Venus de Medici (Uffizi, Florence), with two doves at her feet and a serpent twining about the stump which supports her (pp. 11, 54, 58–59, 68, 112). The Venus represents Beauty ("the standard of all female beauty": Spence, *Polymetis*, p. 66; cf. *Tom Jones*, 4.2) but also reserve (she is a Venus Pudica, trying to conceal her private parts from view: in this case another version of Nature in Hogarth's *Boys Peeping at Nature*). Here she is exchanging amorous looks with the Apollo Belvedere, while Hercules's back is turned in both his partial and full-length forms. Their relationship is emblematized by the pair of doves.

14. An eye, directly above Hercules's head (3), looking up at a semicircle of A's (p. 33). The diagram is adapted from de Piles's diagram opposite p. 108 in *Cours de Peinture par Principes* (1708, trans. 1743). De Piles's point is that the eye (A) will focus on the central object of its gaze (B) and subordinate all the others to the *unité d'objet*; see above, p. xxxix. In the context of Figs. 12–13, is it too much to suspect that Hogarth intends the A's to stand for Apollo, suggesting that Hercules should be keeping an eye on him as well as on Venus, but is in fact looking in the opposite direction?

15. A curling worm and worm-wheel with, to the right, a "stick and ribbon ornament" (p. 34), which in the text Hogarth also associates with a smokejack. The sequence is from the smokejack to the dance, the woman and her enticing lock of hair, and sexual pursuit of the sort suggested in the preceding sequence of figures.

16. A robed judge in a full-bottomed wig (pp. 36–37; drawing, Oppé, fig. 26, cat. no. 81d) balances the naked Venus on the right side as Hercules does on the left – a figure of judgment emblematized by a gallows. He is seated on a sarcophagus with a pyramid rising behind, inscribed: "[o]BIT. DECEM 1752 AETATIS" (the "2" is reversed). The design does not resemble contemporary monuments in Westminster Abbey, unless perhaps Cheere's monument to Admiral Sir Thomas Hardy (c. 1732). It most resembles the monuments of the popes in St. Peter's, Rome. All of the other sculptures (with the notable exception of the Venus) were in the pope's collection, implying clericalism, the "elevation" of Roman Catholic art, and Jacobitism.

The full-bottomed wig and heavy robes in the *Analysis* designate dignity, artificial and often unearned, and relate to Hogarth's incongruity theory of comedy (p. 37). The judge has a pentecostal flame on his head like that of the apostles (Acts 2.3; i.e., he is filled "with the holy ghost"). A weeping cherub is at his feet with a carpenter's square, used on such funerary sculpture to denote the judge's rectitude, here in the shape of a gallows. The relief on the sarcophagus is of buildings in ruins. He illustrates the theme of judgment, and "Obit 1752" implies the death of false judgment; with the publication of the *Analysis* Hogarth has put an end to bad judgment, aesthetic if not judicial.

The hanging judge, his face concealed by his wig, reappears among the judges in *The Bench* of 1758, another exploration of caricature. The defunct judge is now asleep and, with the other judges, labeled "semper eadem" – always the same. But in a final reworking of the plate, dated a few days before Hogarth's death, the "semper eadem" has been replaced by a band of further variations on caricature–character, contrasting versions of the hanging judge with faces from Leonardo's *Last Supper* and Raphael's *Sacrifice at Lystra* (*HGW* No. 205, ill. 21).

17–18. The judge with his wig and robes also introduces examples of the incongruous mixing of forms. (17) is "a fat grown face of a man, with an infant's cap on, and the rest of the child's dress stuff'd, and so well placed under his chin, as to seem to belong to that face": This derives from the "NO OLD BABY" in *The Stage-Coach* (1747, *HGW* No. 167). (18) is "a child with a man's wig and cap on": ". . . you see the ideas of youth and age jumbled together, in forms without beauty" but with a comic effect (pp. 37, 72).

19. A Roman general "dress'd by a modern tailor and peruke-maker for tragedy": the mixed dress turns it to comedy (p.37). This is the costume of a Shakespearean actor performing Brutus. In the context of the surrounding figures, he is stabbing Caesar, who is attached by a rope around his neck to a tripod and a scaffold. Caesar appears to fall under the roll of paper Brutus holds aloft, which appears to be a dagger. The rope is hoisting his statue into a standing position – or, in the context of the adjacent judge, onto a gallows.

The triangle of the title page reappears in the tripod that frames the statue of Julius Caesar as the other tripod frames the *Laocoön*. (The judge sits at the foot of a pyramid of the sort frequently used in funerary monuments.) The sexual triangle of Apollo–Venus–Hercules is played against the political one involving Brutus, Caesar, and Caesar's avenger. The *Apollo Belvedere* is placed in a double gestalt, one involving him romantically with Venus, the other placing him in a political context in which he seemingly knocks Brutus on the head as retaliation for his murder of Caesar. (This evokes the theory, which Hogarth notes, that the *Apollo Belvedere* showed Apollo at rest after having killed Python [p. 73].)

20. A dancing master dressed as Jupiter is identified in the text as another absurdity–and this also sets up Jupiter–Ganymede associations with the Antinous and dancing master in the sculpture yard (p. 37). The figure derives from *Charmers of the Age* (*HGW* No. 153; for drawings for figs. 17, 18, and 20, see Oppé, pl. 77, cat. no. 81c; for fig. 19, see Oppé, fig. 27, cat. no. 81f.).

21. A sphinx, another comic incongruity (pp. 38, 40, 129). She is set parallel to the figure of Venus above her, looking toward the Belvedere Torso, and parallel with another recumbent figure, the drunken Silenus.

22. Another comic incongruity: the head of an angel "with duck wings placed under its chin," like the one on the base of the judge's monument (p. 38); (Oppé, fig. 25, cat. no. 81; cf. Hogarth's *Kent's Altarpiece* of 1724, *HGW* No. 63).

Between (22) and (105). "Miserable scratches with the pen [which] sell at a considerable rate for only having in them a side face or two" (p. 4).

23–25. Various kinds of lines, straight and curved, ending in the serpentine (p. 41).

26. The ideal: Parallel to the horizontal serpentine line of (25), another spirals around a cone, which Hogarth tells us was an ancient symbol for Venus (pp. 41–42, 47, 79). Immediately beneath, at the center of the plate is the Venus de Medici. Compared to the fleshed-out vertical Venus, (26) symbolizes a recumbent Venus.

This is the horizontal version of the figure Hogarth used beneath his last print, *Tailpiece*, in order to suggest its origin in ancient icons of Venus (April 1764, *HGW* No. 216, ill. 14). In the inscription he compares the cone twined about with the Line of Beauty with another conic figure, a "pyramidal shell" – a resemblance that "did not occur to the Author, till two or three Years after his publication of the Analysis, in 1754." This, he writes, is *The Conic Form in wch the Goddess of beauty was worshipd by the Ancients at Paphos in ye Island of* Cyprus. *See the Medals struck when a Roman Emperor visited the Temple.* His source was presumably Dr. John Kennedy's coin collection (see text, n.17). He quotes two Latin passages, the first from Tacitus's *History*: "The image of the goddess does not bear the human shape; it is a rounded mass rising like a cone from a broad base to a small circumference. The meaning of this is doubtful" (Bk. 2, Chap. 3; Church and Brodribb trans.). The second is from Maximus Tyrius's *Dissertationes*: "By the Paphians Venus is honoured; but you cannot compare her statue to anything else than a white pyramid, the matter of which is unknown" (*Diss.* 38, Thomas Taylor trans.). Hogarth used the "pyramidal shell" as part of the crest he painted on his carriage (*Gen. Works*, 3:164).

29. A bell (p. 43). Note, in line with Hogarth's reduction of Venus to a pyramid or cone, that the bell served in *Harlot* 1 as a female symbol (recurring in the teacup in 2 and the spiggot-faucet of the Harlot's escutcheon in 6).

30–36. Studies of contemporary candlesticks; e.g., (p. 30) shows two halves of the socket of a candlestick, (A) solid before being turned, and (B) after (pp. 43–44): the first of a series of commonplace domestic objects. The Cupid and Venus who appear with the candlestick in (34, under fig. 49) are from a painting usually attributed to Pontormo (then in Kensington Palace, now in Hampton Court).

37. A parsley leaf (p. 44).

38–39. Branches from the sides of "common old-fashion'd stove-grates by way of ornament" (p. 45).

40–41. Two more candlesticks (p. 45).

42. An Indian-fig or torch-thistle (p. 45).

43. A lily (cf. Isis' headdress, Fig. 85) (pp. 12n., 45).

44. A Chalcedonian iris (p. 45).

45. An "imitation" of the lily-iris (p. 45).

46. A fleur-de-lis, a conventionalized lily or iris in heraldry; the French royal symbol (p. 45).

47. Autumn cyclamen (twisting in one way, vs. Fig. 43, where the leaves twist severally) (p. 12n.).

Under Fig. 47. A ship whose movement is seen in, and improved by, perspective (pp. 28, 78n.).

48. A capital of hats and periwigs: "Even a capital composed of the aukward and confin'd forms of hats and periwigs, as fig. [48, plate 1] in a skilful hand might be made to have some beauty" (p. 46; drawing, Oppé, pl. 84, cat. no. 81g). Hogarth anticipates this idea in the altar in *Masquerade Ticket* (1727) and elaborates it in *The Five Orders of Periwigs* (1761; *HGW* Nos. 108, 209).

49. A scale of curved lines, 1–7, centered in the "perfect" Line of Beauty, no. 4 (pp. 48, 97, 107).

50. A series of chair legs, 1–7 (p. 48).

53. A row of women's stays, 1–7 (pp. 48–49).

54. The Belvedere torso, from which Michelangelo "discover'd a certain principle,"

i.e., of the serpentine line, which the Greek inscription tells us was "made by Apollonius, son of Nestor," an Athenian (pp. 2, 7, 30, 58).

55. Opposite the torso is a book on proportions by Albrecht Dürer and Lomazzo (pp. 30, 65): Dürer, "who drew mathematically, never so much as deviated into grace" (p. 7). Lomazzo adapted some of Dürer's odd-looking figures in his *Tracte*; Hogarth copies his diagram of man and woman from Lomazzo, opp. p. 37 (reversed). Dürer's figures are all single-gender, and Hogarth needed another example of man *and* woman.

65–68. Types of legs. (65) is the ideal, representing serpentine lines (pp. 53–55). It is copied from William Cowper's *Myotomia Reformata; or, an Anatomaical Treatise on the Muscles of the Human Body* (1724), tab. lv (cf. *Analysis*, pp. 71 and 126; Hogarth's drawing, BL Eg. 3031, f. 94b). (67) represents rigidity of form; (66) is an *écorché* leg with a superimposed triangle, "taken from nature, and drawn in the same position [as 65], but treated in a more dry, stiff, and what the painters call, *sticky manner*."

The object of satire is Giles Hussey, who had used the leg to illustrate his theory of triangles and "harmonic" proportions for improving on the figures of both human and antique models (engraved by John Vardy after Hussey's design, BM; on his "scheem of Triangles," see Vertue, 1:126; Sheila O'Connell, "An Explanation of Hogarth's 'Analysis of Beauty,' Pl. 1, Fig. 66," *Burlington Magazine*, 126 [1984]: 33–34, fig. 61). Vertue's remark (above, p. xviii; 3: 126) juxtaposes Hogarth's talk of his Line of Beauty with Giles Hussey's about triangles. We can only speculate on the back-and-forth of Hogarth and Hussey, an equally obsessive theorist of proportions. Hogarth makes one derisive reference to him (p. 56), but all that survives is printed by W.T. Whitley in *Artists and their Friends in England 1700–1799* (London, 1928), 1: 125–29. Cf. Dobai, p. 341.

(68), by contrast, is a shapeless wooden leg, presumably prosthetic (pp. 54, 65).

To the left of (67) is a leaf "taken from an ash-tree ... growing only like an escrescence" (p. 60).

75 and 85. Two busts of Isis, one crowned with ball and horns, the other with a lily (illustration of the serpentine line among the ancients, p. 12). These numbers are repeated on the second plate. For the significance of Isis to Freemasons and to Hogarth, see *Hog.2*; 99–102, *Hog.3*: 127.

87–88. Shaded pieces of drapery, one apparently on a shoulder, the other on a walking figure (p. 86).

97–106. A series of heads (pp. 94–95): an antique head (97, drawing, Oppé, pl. 80, cat. no. 81i), and old man's head from a statue of St. Andrew in St. Peter's by François Duquesnoy called Francesco Fiammingo (98, drawing, Oppé, pl. 81, cat. no 81j), and other versions of the antique head (99–103); the figure is gradually mechanized until it becomes a barber's block (104) and a childish drawing of a head, seen straight on (105).

(105) recuperates a figure in *Characters and Caricaturas* (1743, *HGW* No. 156, ill. 15), Hogarth's response to the fad in caricature. One head, a stick face, was neither one of the "3 Characters" nor "4 Caricaturas." Hogarth used this childish drawing as an indication of the worth of the caricatures of Ghezzi and Carracci, an ultimate reduction, the final contrast with the "characters" above. But the face reappears, with the same hat, now turned to face us, in the *Analysis*. It is now no longer part of a contrast but related to a scale of schematization, perhaps to the Dürer diagrams within the design, and is explained in the text: "105 is composed merely of such plain lines as children make, when of themselves they begin to imitate in drawing a human face." It serves as the end of a reductive scale: the primitive linear face suggests the work of a child just beginning

to learn both the logic of the line and the rules of mimesis. At the other end (97) is the antique statue which, we are told, inspired Raphael and other artists to this ideal imitation. Turned one way it represents the degeneration of representation (character into caricature); turned the other way it represents a primitive point of origin for representation. (See introduction, pp. xxxvi–xxxvii.)

(106) is a Head with a Hudibras beard like a tile, juxtaposed with the serpentine lines of the Fiammingo head (p. 95; drawing, Oppé, fig. 28, cat. no. 81k).

107. A Silenus, oldest of the satyrs and always drunk, reclining on a wine skin (pp. 70, 97; copied from Montfaucon, *Antiquity Explained*, 1:167–68, pl. 80).

115. Three different sizes of the pupil of the eye (p. 100).

There are no figs. 5, 8, 27 and 28.

4. Plate 2 (p. 141)

"*Designed, Engraved, and Publish'd by Wm Hogarth, March 5th 1753, according to act of Parliament.*"
Engraved title: "ANALYSIS OF BEAUTY. plate II."
Etching and engraving; $14^9/_{16} \times 19^5/_8$ in. ($16^7/_8 \times 21$ in.); BM Sat. 3226; *HGW* No. 196

Painting (Ill. 7; Beckett, pl. 168, pp. 67–68): Some of the dancing figures, and the general composition of the central panel, derive from the painting (c. 1745–46) sometimes called *The Country (or Wedding) Dance* (probably painted as part of a series, "The Happy Marriage," projected after the publication of *Marriage A-la-mode*, i.e., the *un*happy marriage) (Tate Gallery, London). In the painting, however, there is a large bow window, open to the night and a full moon; a woman and table are where the cuckolded husband and his wife are in the engraving. The pure forms and colors of this unfinished sketch correspond in oil to the linear diagram of the movements of the dancers in the margin of plate 2 (71). They demonstrate Hogarth's method of building figures, actions, and scenes directly with paint on canvas. At this point form appears for its own sake, before it is finished into a representation, packed with coded messages (as in the central panel of plate 2).

Drawings (sketches for the figures): See Oppé, cat. nos. 81, 82.

States: 1 Ill. 5, BM 1868-8-22-1603 (detail) (also, Royal Library, Lewis-Walpole Library, Morgan Library). This state was evidently delivered to subscribers and appears in some copies: e.g., the Morgan Library, which has both plates inserted at the end of the book (and does not include *Columbus Breaking the Egg* as frontispiece); the marks on the BM and Lewis-Walpole impressions suggest that they were originally folded into a copy of the book.

2 Ill. 4, Yale University, Lewis-Walpole Library, from the George Steevens Collection (also Fitzwilliam Museum, Cambridge). The figure of the male dancer at the left has been changed, his face made less schematic, his sash, coat, and waistcoat darkened. The chair and the floor behind him have also been darkened. His partner's face has been slightly changed, the lower folds of her gown darkened, her ribbon lengthened. Horace Walpole's subscription copy has this state (Lewis-Walpole Library). Steevens's copy (reproduced) was unfolded, evidently bought as "furniture."

3 Ill. 6, BM C.c.1–156 (detail). The male dancer's face has been changed again, this time into a portrait of George III. His hand has also been turned so that his palm is now visible, and the ribbon on the back of his dancing partner is further lengthened. A

sleeping man has been introduced into the chair between these two dancers (BM, Lewis-Walpole, Royal Library, et al.; Jane Hogarth, Boydell, etc. folios).

A copy of the book presented to George III is in the BL. *Columbus* is bound in as frontispiece, the plates follow the text, and plate 2 is in the third state. The binding is stamped with the crest of feathers of the Prince of Wales (George III, stamped on the spine, is a later addition). In 1753 George, Prince of Wales, would have been fifteen years old. Compared with George Knapton's portrait of 1751, Hogarth's could conceivably be the Prince (*The Family of Frederick, Prince of Wales*, dated 1751; Royal Collection; Oliver Millar, *The Tudor-Stuart and Early Georgian Pictures in the Collection of Her Majesty the Queen* [London, 1963], pl. 212; cf. the Liotard portrait of about the same age, pl. 215). This copy appears to have been made up for the Prince of Wales by Hogarth. The Prince's household had not subscribed. In March 1754 Hogarth dedicated his subscription ticket for his *Election* prints to the Prince (and another state to his uncle, the duke of Cumberland). This time the Prince, the Princess Dowager, and Prince Edward all subscribed (BL. Add. MS. 22394.k.1).

One possible date for the third state is 4 June 1756, the date upon which he was declared of age. On that day Elizabeth Chudleigh gave a birthday ball for him, and a group of artists that included Hogarth celebrated the event at the Turk's Head Tavern in Gerrard Street (Whitley, *Artists and their Friends*, 1: 158 [misdated 1759]).

Opinions differ as to the identity of the people in the early states of the print. One view has it that this is the Wanstead Assembly, with the first Earl Tylney, his countess, their children, tenants, and friends (J. Ireland, 1: lxxvi). The other is that the prominent male dancer is the last Duke of Kingston (*Biogr. Anecd.*, p. 258).

The Scolar Press facsimile of the *Analysis* (1969) was based on the Beinecke copy (Chauncey Tinker's), which included not Hogarth's original plates but nineteenth-century copies. The error was corrected in a second edition (1975), which used the final state of plate 2 and quite mistakenly attempted to reorder the states to make this the first state. See *The Scolar Newsletter*, 8 May 1975; and Paulson, *Burlington Magazine*, 68 (1976): 653–54.

The purpose of plate 2, contrasted with plate 1, is to illustrate Hogarth's theories about the movement and shape of the human body in action and how these affect our responses. The couple at the left represents the ideal of grace, both in movement and shape. As the diagram above (fig. 71) shows, they are visualized as serpentine lines while the rest of the dancers are straight, angular, or semicircular. The diagrams of the dance may, Burke believed (pp. xl–xli), express Hogarth's system of visual mnemonics and the ultimate source of his theory of the serpentine line in this system. Other physical shapes and stances are illustrated by the figures in the portraits on the wall: Charles I, the Duchess of Wharton, a general (perhaps William III or Marlborough) in paintings; and Henry VIII, Edward VI (with a medallion of Mars above him), Queen Elizabeth, and a medieval king in effigies recessed in the wall.

The group in the right foreground, balancing the nobles at left, includes an elderly man pointing to his watch, indicating to his young wife the lateness of the hour; his servant, who has a prosthetic leg, and is buttoning his master's gaiter; and the wife, who is secretly accepting a letter from the young man who helps her with her cloak. A romantic triangle like that in plate 1 (Hercules–Venus–Apollo) is projected in terms of an old, comic figure, a beautiful young woman, and a young lover (the *commedia dell' arte* plot alluded to at the end of the *Analysis*, pp. 110–11).

Figures

51. Portrait of Charles I by Van Dyck (Royal Collection) (p. 103).

52. Portrait of Lady Jane (not the Duchess of) Wharton by Van Dyck (Chatsworth), engraved by Pieter van Gunst: "Thoroughly divested of every elegance" (p. 8). To the right of (52) are Queen Elizabeth and "two other wooden figures" (pp. 40, 103).

56–59. Different kinds of horns: straight (or a cone), bent, and twisted, ending in a cornucopia (pp. 50–52, 81).

60–64. (60–61) are a human pelvis with femur attached, and this structure transformed into "shell-like forms" of a decorative rococo kind (p. 52), (63) is (61) divested of "serpentine turnings," representing "the poor Gothic taste" of a century before (p. 53). (62, 64) show two femurs, one with the muscle for rotating a thigh (pp. 52–53).

69–70. A Greek cross and two Latin crosses (pp. 66, 102, 106). In order to "produce a figure of tolerable variety," he shows one Latin cross made of straight lines, the other of wavy Lines of Beauty. The Latin cross is the Christian crucifix, which is thereby rendered beautiful, that is, aestheticized as well as humanized. The three crosses are drawn on BL. Eg. MS. 3013, f. 98b.

71. Lines diagramming the stances of the characters in the picture of the dance (pp. 102–03). Cf. below, fig. 123.

72. Sculpture of Henry VIII (pp. 29, 103; drawing, Oppé, pl. 82, cat. no. 81a), no doubt based on the statue over the gate of St. Bartholomew's Hospital, a place of personal and professional importance to Hogarth.

73. Statue of Edward VI, based on the statue in the Great Hall of Bridewell Hospital (p. 103).

74. In the margin next to the nobleman is the Woman of Samaria, "taken from one of the best pictures Annibal Carrache ever painted" (*Christ and the Woman of Samaria*, Brera, Milan; engraved by Carracci himself, by Carlo Marratti, and others [ill. 20]). The Samaritan woman stands next to the young nobleman, formally parallel (except for the turn of her legs, which mirror his).

75. In the opposite margin, next to the young wife receiving a note from her lover, is Sancho Panza, showing astonishment at this deception by a beautiful women under his very nose. In the text he illustrates "one plain curve" that expresses "the comical posture of astonishment" as he watches "Don Quixote demolish[ing] the puppet show" (p. 103; drawing, Oppé, pl. 78, cat. no. 81h). Hogarth's Sancho is taken from Charles-Antoine Coypel's illustration, in his *Don Quixote* plates of 1724 (ill. 18), which Hogarth had used earlier, for figures of Quixote and others as well as this Sancho, in *The Mystery of Masonry* (*HGW* No. 55, ill. 19). The plain curve of Sancho's "comical posture of astonishment," Hogarth continues, is contrasted to "the serpentine lines [of Beauty] in the fine turn of the Samaritan woman ..."

In the context of the marginal figures, Sancho is astonished not by Don Quixote attacking the puppets, confusing art with reality, but by the Samaritan woman (in a position exactly parallel, in the opposite margin, to Sancho and to the young cuckolding woman), whose equivocation about her morals did not deceive Christ (John 4.18: "thou hast had five husbands; and he whom thou now hast is not truly thy husband"). The discrepancy between beauty and virtue (Shaftesbury's familiar equation) is Hogarth's point.

Adding to the context of the noble couple, the statue in the niche above them (his feet virtually bridging them) is of Henry VIII (72) without *his* lady. In the text, Henry

represents simple uniformity and is said to resemble a perfect X (as opposed to beautiful serpentine lines like those of the young couple below him). A man standing beneath Henry is embarrassing his lady by pointing out Henry's codpiece, his prominent sexuality, unconcealed by beauty or manners. Though contrasted in shape, iconographically Henry is linked to the Samaritan Wife of Bath with her five husbands-plus-one by his own six wives; and his strident pose contrasts him formally with the collapsed X of the cuckolded husband on the other side of the plate: the king who chopped off his errant wives' heads and the husband who meekly points to his watch as his wife arranges an assignation. (That Henry VIII represents brute power is confirmed by Hogarth's reuse of him in *The Times, Plate 1* as code for William Pitt [*HGW* No. 211].)

The nobleman and his lady are dancing a minuet on the edge of the crowd of rustics, who are in "attitudes" "of the ridiculous kind" (p. 136), performing a country dance. They demonstrate respectively the beautiful and the comic. Once again, the graphic image complicates the text. The couple, beautiful and minueting, are implicated in the Samaritan Woman's adulteries, presided over by Henry VIII; the crowd is presided over by Queen Elizabeth.

It seems likely that when Hogarth introduced the Prince of Wales into this scene (state 3) he satisfied any feeling of having flattered power with the small joke of placing his Royal Highness in the compromised context in which he had previously situated the nobleman (whose order, to judge by the text [p. 49], is of the Garter).

76–78. The serrati muscles on the left side, marked 1–4 (pp. 57–58).

79–81. The ribs from the foregoing (p. 57).

82–83. Two fingers (p. 58).

84–86, 89–96. Studies of tone and shade (Chaps. xii, xiii, xiv *passim.*).

108–14, 116–18. Studies of heads. (108–09) are laughing faces (p. 98); the rest are heads from youth to age (pp. 100–01). (For drawings for figs. 112, 113, 114, 117, and 118, see Oppé, pl. 81, cat. no. 81j; for 108, 109, see fig. 30, cat. no 81m).

119–20. An ogee molding (pp. 106–07).

121. Profile of a young girl (pp. 107, 111; drawing, Oppé, pl. 79, cat. no. 81n.).

122 and 123, below 71: Diagrams of the dances below: (71) shows the attitudes of the dancers, from graceful curve to crude semicircle; (122–23) show the graceful movements through the whole set of, respectively, a minuet and a country dance (p. 109). Cf. Hogarth's remarks on the "*joint-sensations* of bulk and motion" and "our usual feeling, or joint-sensation, of figure and motion" (pp. 61, 67). It is probably significant, in the context of the references to Warburton's *Divine Legation* and Isis, that the figures in (71) and beneath (123) resemble hieroglyphics.

Both dances follow serpentine floor patterns. The minuet is based on the single couple, the country dance on six or more couples merging in patterns of 8s. (122) diagrams a couple dancing the minuet pattern of two S and reversed-S curves; and (123) shows the "hey" path of S and reversed-S of the country dance (p. 111). A precedent for Hogarth's use of pictures and words to diagram dances can be found in Kellom Tomlinson's *Art of Dancing Explained by Reading and Figures* (1735, 1744). See Mary Klinger Lindberg, " 'A Delightful Play upon the Eye': William Hogarth and Theatrical Dance," *Dance Chronicle*, 4 (1981), 19–43; Tilden A. Russell, "Iconographic Paths to the Minuet," *Musikalische Ikonographie*, ed. Harold Heckmann, Monika Holl, and Hans Joachim Marx (Laaber, 1994), 221–234; and my special thanks to Carol Marsh and Heather McPherson.

There are no figs. 53–55, 65–68, 87–88, 97–107, and 115.

Index

acting, *see* theatre
Addison, Joseph, xii, xix, xxvi–xxxiii, xxxvi–xxxvii, xlvii, xlix, lvn., lvin., 6, 21n., 27n., 32n., 91n., 92n., 117, 124n.
"aerial perspective", 86
African beauty, xlvi, xlviii, 115
aging of pictures, 91n., 92n., 135–36
Akenside, Mark, xxviii, xxix, xxxii, lixn.
Alberti, Leon Battista, xix
Amalthea, xl
anatomy, xxxvii, xxxix, lvn., 52–54, 57, 155
Anderson, James, 7n.
Andrea, Thornhill assistant, 92n.
Antinous (pl. 1, fig. 6), xxiv, xl, lii, 3, 4, 29, 68, 69, 71, 97, 147, 149
Apelles, 9, 11
Apollo Belvedere (pl. 1, fig. 12), xxiv, xxv, xxvi, xxxii, lxn., 59, 71–74, 97, 99, 113, 146, 148, 149
Apollo killing python, 73
Apollo, Sacchi painting, 71
Apollonius, 151
architecture, li, lviin., 26, 36, 43, 46–48, 130, 131
Aristippus, xxiii, 8
Aristotle, xxxiv, 3, 7, 13
Artificial Changeling, The, 127
Asclepius, 12n.
ash leaf (pl. 1, left of fig. 67), 60, 151
Atlas, xl, 69, 70
Author Run Mad, The, see Sandby, Paul
automata, 62, 108

Baldwin and Cradock, 143
Barbier, Carl P., lxin.
Barrell, John, lvin.
Bartholomew Fair, 37
Baumgarten, Alexander, livn.
bell, 43, 150

Bellori, G.B., xix
Benzoni, Girolamo, 143
Bernini, Gianlorenzo, xxxvi
Birch, Thomas, xviii
birds, 63
Bloomsbury Church, *see* St George's
Bohn, Henry G., 143
Bouhours, Dominique, 4n.
boxing, 67, 129
Boydell, John, 143
Bridewell Hospital, 154
Brown, Lancelot "Capability", li, liii
Brunelleschi, Filippo, 143
Brutus (pl. 1, fig. 19), 149n.
Bulwer, John, 127
Burgess, Thomas, lxn.
Burke, Edmund, xi, xxviii, xlvii, liii
Burke, Joseph, xii, lviiin., 26n.
Burlingtonians, 46n., 47n.
Butler, Samuel, xlviii, 75, 95; *Hudibras*, 75, 95, 126, 152

Caesar, Julius, (pl. 1 behind fig. 19), 149n.
camel, xliv
candlesticks (pl. 1, figs. 31–34), xxv, xxxix, 43, 44, 45, 93n., 150
capitals, 46, 150
Carracci ["Carrache"], The, xxxvi, 103 (Annibale), 151, 154; *Christ and the Woman of Samaria*, xxxii–iii, xli, 103, 154
Castel, Louis-Bertrand, 131
cats, 32
centaurs, 38
Cervantes, Miguel de, *Don Quixote*, xxx, xxxvi, 103, 126, 154
chairmen, 70
Charles I, portrait of (pl. 2, fig. 51), 103, 117, 154; children of, 100n.
Charles II, portrait of, 100
Charon, 100

Cheere, Henry, xix, xxiv, 27, 146, 148
cherubs, 38, 148
children, 89, 96–100, 107–08, 149
Chinese art, 12, 46
Claude Lorrain ["Claud. de Lorain"], 77, 134
Clito, 146
Collins, William, xxviii
Colman, George, lxn.
Colonna, Francesco, 146
color, xxv, 87–93, 118, 131–35
Columbus, Christopher, xliii
Combe, William, liii
commedia dell'arte, xli, 110n., 137, 154
complexion, *see* skin
connoisseurs, xix, xxiii, xxiv, xliii, xlvi, lxn., 4, 10, 18, 19, 73, 116, 144, 147
copying of works of art, xxiv-v, 6, 18–20, 74, 121
cornucopia, xl, lviin., lixn., 12, 51, 154
Correggio [also "Coreggio"], Antonio, xiii, xxxvi, 5, 29, 93
Cortona, Pietro da ["Peter de Cortone"], 5
country dance, *see* dance
Covent-Garden Journal, xvii
Coverley, Sir Roger de, xxx
Cowper, William, 53, 151
Coypel, Antoine ["Anthony Coypel"], 5
Coypel, Charles-Antoine, 60n., 103n., 154
crosses, xxi, xxii, lixn., 102, 154
Crown, Patricia, lxin.
cyclamen (pl. 1, fig. 47), 12n., 150

Dabydeen, David, 115n.
dance, xli, xlii, 34, 102–03, 109–10, 137, 148, 152–53, 155
dancing masters, xxiv, 29, 37, 99n., 104, 110, 147, 149
De Bolla, Peter, xxxviii, lxin.
de Piles, Roger, xix, xxxix, xl, 2n., 3, 4n., 11n., 20n., 86n., 87n., 88n., 131, 148
de Vaucanson, Jacques, 62n.
Defoe, Daniel, xxi, xxii
Diana Multimammia (Diana of the Ephesians), xxxv, xliii, lviin.
Dobai, Johannes, lxin.
dogs, xxxvii, 32, 37, 63, 125
Don Quixote, *see* Cervantes
dress, 36, 38, 39–40, 127–29, 151
Drevet, Pierre *or* Pierre Imbert, 60
Dryden, John, 3n., 82, 91n., 92n.
Dufresnoy, Charles Alphonse, xix, xlv, 3
Dughet, Gaspard, 77n.

Duquesnoy, Francois (Fiammingo), 94, 151–52
Dürer, Albrecht ["Albert Durer"], 5, 29, 65, 124n., 151

Eastlake, Charles, lxin.
Edelincke ["Edlinck"], Gerard *or* Nicolas Etienne, 60
Edward VI, statue of (pl. 2, fig. 73), 103, 153, 154
Egyptian art, 6, 7, 9, 12, 36
Elizabeth I, Queen (pl. 2, right of fig. 52), xli, xlii, 40, 103, 153, 154
equestrian statues, *under* horses
Essex, John, dancing master (pl. 1, fig. 7), 147
Exclusion Crisis, xx
expression, 96, 98
eye, size of, 100, 152

Falstaff, Sir John, xxx, 118, 125
fashion, *see* dress
Faun, The Dancing, 97
Faustus, Doctor (harlequinade), 38
Félibien, André, xix, xl, 133n.
fencing masters, 104
Ferguson, Frances, lxin.
Fiammingo ["Fiamingo"], *see* Duquesnoy
Fielding, Henry, xvii, xxix, xxxii, xlix, livn., lvin., lviiin., 147; *Joseph Andrews*, xxix, livn.; *Tom Thumb*, 126, 127n.
fish, 63
Foundling Hospital, xli
Francesca, Piero della, 144
Freemasonry, xxii, xxxv, 7n., 85n., 151
French School of art, 4
furniture, xxv, 34, 45, 118, 50

Gainsborough, Thomas, xlix
Garrick, David, xviii
General Advertiser, xvii
Gentleman's Magazine, xliv
George III, portrait of, 153
Gerard, Alexander, xlvii, xlviii
Gerrard, Christine, lixn.
Ghezzi, Pier Leone (pl. 1, fig. 1), 18, 145, 147, 151
Gibbons, Grinling, 60
Gilpin, William, li, lii, liii
Giotto, 11n.
Gladiator, The Dying, 97
glair, 136n.

Glycon ["Glicon"], 26, 146
Gobelin tapestry, 7
Gowing, Lawrence, lix*n*.
Grand Tour, 116
grapes, xxxxix, xl
Graves, Richard, lx*n*.
Greek art, 9, 12
Greenwich Hospital, 192*n*.
griffins, 38
Guido, *see* Reni
Gulliver, Lemuel, 20

hair, xxv, xxxix, xlii, lii, lix*n*., lxii*n*.,
 34–35, 39, 129, 148
Halfpenny, William, 46*n*.
Handel, Georg Friederich, 8*n*., 132*n*.
Hardy, Admiral Sir Thomas, 148
hares, 32
harlequinades, 38*n*., 110
Harpocrates, 12
Harris, James, 109*n*.
Harrison, John, 62*n*.; marine
 chronometer, 61–62
hatching, 76
Hawkesworth, John, lx*n*.
Haydock, Richard, 3*n*.
Henry VIII (pl. 2, fig. 72), xli, xlii, 29,
 103, 153, 154, 155
Hercules, Farnese (pl. 1, figs. 3, 4),
 xxxii, 12, 26, 53, 146, 147, 148
Herostratus, xliii
history painting, xviii, xx, xxii, xli, liv*n*.,
 121
Hoadly, Dr. Benjamin, xliii, 14*n*., 84*n*.,
 119*n*., 120*n*.
Hobbes, Thomas, xli
Hogarth, Jane, 143
Hogarth, William, WORKS: *Analysis of
 Beauty, The*, authorship, 13, 118–21;
 editions, xii, xiii, xlv; Fielding's copy,
 lviii*n*.; manuscripts, xiii, 13*n*., 115–
 37; plates, xiii, xvii; reception, xlv;
 spelling and punctuation, xiii; title
 page, xxi; translations, xlv; *Beer Street*,
 40*n*; *Bench, The*, 149; *Boys Peeping at
 Nature*, xxxv, xxxvii, xliii, 3*n*., 148;
 Burlesque on Kent's Altarpiece, 38*n*.,
 149; *Characters and Caricaturas*, 127*n*.,
 151; *Cockpit, The*, xlvii; *Columbus
 Breaking the Egg*, xvii, xxxiii, xxxiv,
 6*n*., 118*n*., 143, 152, 153; *Cunicularii*,
 lv*n*., lviii*n*.; *Distrest Poet, The*, xxxii;
 Election series, xli, 7*n*.; *Enraged
 Musician*, xxxii; *Enthusiasm Delineated*
 xxii, xlvii, xlviii; *Finis: or the Tailpiece*,

xlvii; *Five Orders of Periwigs, The*, 150;
 Four Times of the Day, xix; *Gulielmus
 Hogarth*, xviii, xxi, xxxvii, xl, 6*n*;
 Harlot's Progress, xxii, xxiii, xxxi,
 xxxii, xxxiv, xxxv, xxxvi, xxxvii, lv*n*.,
 150; *Hogarth's Servants*, lix*n*; *Hudibras*
 illustrations, 75, 95, 126, 152; *March
 to Finchley*, xli, xlii, xlvi, xlvii;
 Marriage A-la-mode, 5*n*., 152;
 Marriage Contract, The, liv*n*;
 Masquerades and Operas, 38*n*., 108*n*.;
 Masquerade Ticket, 150; *Moses brought
 to Pharoah's Daughter*, xxxv, xliii;
 Mystery of Masonry, 154; *Rake's
 Progress*, xxxi, xlvii, liv*n*., 62*n*. 147;
 Reward of Cruelty, xxxvi, xxxvii; *Satan,
 Sin and Death*, 144; *Shrimp Girl*, xxxi;
 Southwark Fair, 108*n*.; *Strolling
 Actresses*, 126*n*.; *Tailpiece; or The
 Bathos*, xxiv, 150; *Times, The*, xlii,
 155
Holtz, William, lxi*n*
Horace, xx, 3*n*.
horn (pl. 2, figs. 56–58), xxxix, 12, 50,
 51, 52, 154
horses, xliv, 26, 30, 63, 69*n*., 105, 129
Hudibras, see Butler, Samuel; Hogarth
Hume, David, xxxviii, lx*n*.
humor and the ridiculous, xxviii–xxx,
 xxxii, 37–38, 125–27
Hussey, Giles, 54*n*., 151
Hutcheson, Francis, xxviii, xlviii, liii,
 1*n*., 19*n*., 27, 115*n*.
Hyde Park Corner, 27, 146

Idler, The, xlviii
Iris (pl. 1, fig. 44), 45, 150
Isis (pl. 1, above fig. 4), xxxiv, xxxv, 12,
 150, 151, 155
Italian art, xii, xxxvii, 5, 118

Jacobitism, xlii, 19*n*., 148
James II, portrait of, 100
Jansen, Hendrik, xlv
je ne sais quoi ["*Je ne sçais quois*"], 4, 8*n*.,
 10
Johnson, Samuel, xlviii, xlix, 108*n*.
Jones, Inigo, 93*n*.
Jupiter (pl. 1, fig. 20), 37, 99

Kennedy, Dr. John, 7, 150
Kirby, Joshua, 85*n*.
Kneller, Sir Godfrey, 82, 91*n*., 133*n*.

Lamb, Jonathan lxi*n.*
Lambert, George, xlvi, 77, 134
Laocoön (pl. 1, fig. 9), xxv, lii, 31, 147,
 148, 149
Laokoon, xlv, *see* Lessing, Gotthold
 Ephraim
La Tour, Quentin, xlvi
le Blon, James Christopher, xxxviii, 8,
 117*n.*
Lebrun ["Le Brun"], Charles, xl, 7, 97
Lely, Sir Peter ["Lilly"], 100
Leonardo da Vinci, lviii*n.*, 2, 118, 149
Leoni, Giacomo, 46*n.*
Lessing, Gotthold Ephraim, xlv
Lichtenberg, Georg Christoph, lxi*n.*
Lilburne, John, lv*n.*
lily (pl. 1, fig. 43), 12, 45, 150
Lindberg, Mary Klinger, 155
Lindsay, Jack, lxi*n.*
Lippincott, Louise, lxn., 18*n.*
Locke, John, xii, xx, l, 32
Lomazzo, Giampolo ["Lamozzo"], xii,
 xiii, xix, xliii, lviii*n.*, 2, 3, 11, 12, 13,
 65, 117, 144, 151
London Magazine, liv*n.*
Louis XIV, 5
Louvre, 36
Luxborough, Henrietta Knight, Lady, xliv

McPherson, Heather, 155
Mandeville, Bernard, xxiv, xxv, xxxi,
 lviii*n.*
Marco da Siena *or* da Pino ["Marcus de
 Sciena"], 2
Marlborough, duke of (pl. 2, right of fig.
 52), xxx
Marsh, Carol, 155
mathematics, xxviii, 5, 17, 41, 65, 84,
 85, 131*n.*
Maty, Matthew, lx*n.*
Maximus Tyrius, 150
Meier, Georg Friedrich, liv*n.*
Mercury, xl, 12*n.*, 69
mezzotints, 76
Michelangelo ["Michael Angelo"], xii,
 xxxvi, lviii*n.*, 2, 4, 5, 7, 11, 30, 147,
 150
Milton, John, *Paradise Lost,* xxi, xxv,
 xxvi, xxvii, xxxi, xl–lii, lixn., lxn.,
 35*n.*, 111, 144–45
minuet, *see* dance
mnemonics, visual, xiii, xxxvi, xxxvii,
 22*n.*, 121–22, 153
monkeys, 37, 106, 125
Montagu House, 85

Montfaucon, Bernard de, xxxv, lvii*n.*,
 lix*n.*, 12, 30*n.*, 73*n.*, 152
Monthly Review, xliv
"moral subjects", xi, xxxv, xlv, xlviii, l,
 liv*n.*, lxi*n.*
Morell, Rev. Thomas, xxiii, xliii, 8*n.*,
 13*n.*, 14*n.*, 26 120*n.*, 132*n.*, 145
Morris, Corbyn, xxx, 126*n.*
muscles, *see* anatomy
music, 44, 71, 77–78, 82*n.*, 131, 135,
 136
Mylius, Christlob, xlv

Niobe (pl. 1, fig. 97), 94
nosegay, xxxix, xl, lviii*n.*, 44
novelty, xlvii, xlix, lii, 32*n.*

ogee moulding, 48, 81, 107, 108, 155
optics, xlvi
Osiris, xxxv

pagodas, *see* Chinese art
palette, Hogarth's, xviii, xxi
Palladianism, li, 46
Pamphilus, 8
Panza, Sancho, *see* Cervantes
Parmigianino ["Parmigiano"], Francesco,
 72
Parrhasius, 8
parsley leaf (pl. 1, fig. 37), 44, 150
Pasqualini, Marcantonio, 71
Paul, Horatio, xliv
Pausias, 9
Payne Knight, Richard, li, lii, liii
perspective, 28, 85
Picturesque, xii, li, lii, liii, 35*n.*
Pierrot ["Pierrott"], xli, 110
Pinchbeck, Christopher, 108*n.*
pineapple, xl, lix*n.*, 31, 32, 148
Pitt, William, liii, 155
Plato, 1*n.*, 115*n.*
Pliny the Elder, 11
poco piu, il, 4*n.*, 56, 59
Podro, Michael, lvii*n.* 38
Pond, Arthur, xliv, 18, 147
Pontormo, Jacopo, (pl. 1 under fig. 49),
 19, 150
Pope, Alexander, *Rape of the Lock,* xxi,
 xxv, xxvi, lvi*n.*, lviii*n.*, 35*n.*, 39*n.*,
 127
Poussin, Nicolas, xviii, 20, 93
Price, Uvedale, li, lii, liii

Prior, Matthew, 11*n.*
Prometheus, lviii*n.*
Protogenes, 11
Puggs Graces, see Sandby, Paul
Punchinello, xli, 110
Puttfarken, Thomas, lviii*n.*, lix*n.*
Pythagoras, xxxiv, xxxv, 7

Quakers, 39
Quixote, Don, *see* Cervantes

rainbow, 70
Ralph, James, 14*n.*, 120*n.*, 146
Ramsay, Allan, xxxiv, xlvi
Rape of the Lock, see Pope, Alexander
Raphael, xviii, xxxvi, xlviii, 5, 94, 118, 149, 152; *Cartoons*, 5*n.*, 8*n.*
Reeves, John, 145
Rembrandt van Ryn, 133*n.*
Reni, Guido ["Guido"], 29, 93
Reynolds, Sir Joshua, xi, xl, xlviii,xlix, lii
Rich, John, 38*n.*
Richardson, Jonathan, lv*n.*, lvi*n.*, lviii*n.*, lviii*n.*, 2*n.*, 7*n.*, 8*n.*, 18*n.*, 20*n.*, 27*n.*, 94, 116*n.*, 133*n.*
Rigaud, Hyacinthe, 5
Ripa, Cesare, 146
Robinson, Sidney K., lxii*n.*
rococo, xi, xii
Rogers, Charles, xliv
Romaine, William, lx*n.*
Roman art, 9, 12
Rose, William, xliv
Roubiliac, Louis-François, 71*n.*
Rouquet, Jean-André, xlv
Rowlandson, Thomas, *Exhibition Stare-Case*, liii; *Statuary's Yard*, xlix
Royal Academy, xlix, liii
Royal Society, xviii, 62*n.*
Rubens, P.P., xxxviii, xxxix, 5, 20, 93
Russell, Tilden A., 155

Sacchi, Andrea, 71, 94
Sancho Panza, xxxii, xxxiii, xxxvi, 103, 154
Sandby, Paul, xliii, 14*n.*; *Author Run Mad*, xliii; *Puggs Graces*, xliii; *Vile Ephesian*, xliii
Saunderson, Professor Nicholas, 84
Sawday, Jonathan, lix*n.*
Scaramouch, xli, 110
Serapis, 12*n.*

Shaftesbury, Anthony Ashley Cooper, 1st earl of, xx
Shaftesbury, Anthony Ashley Cooper, 3rd earl of, xix, xx, xxii, xxiii, xxiv, xxv, xxvi, xxxii, xxxiii, xxxvi, xliii, xlviii, liii, lviii*n.*, 1*n.*, 19*n.*, 46*n.*, 59*n.*, 115*n.*, 144, 146, 155
Shakespeare ["Shakespear"], William, xxv, xl, lix*n.*, 10, 109, 112, 118*n.*, 126*n.*, 133, 149
Shenstone, William, xliv, lx*n.*
ships (pl. 1, between figs. 47 and 88), 26, 28, 78*n.*, 150
sign-painting, 93
Silenus (pl. 1, fig. 107), 70, 97, 149, 152
Simonides, 122*n.*
skin, lv*n.*, 88, 132–33
Smith, J. T., xlix
smokejack, xxv, xxxix, 1, 33, 148
Smollett, Tobias, xlix
Socrates, xxiii, xxxiv, lviii*n.*, 7, 8, 26, 109, 145
Somerset House, lxii*n.*
sounds, *see* music
South Sea Bubble, 75*n.*
Spectator, xii, xix, xxvii, xxviii, xxx, xxxi, xxxiii, xxxvii, lii, lvi*n.*, 6, 21*n.*
Spence, Joseph, 99*n.* 146, 148
sphinx (pl. 1, fig. 21), 38, 40, 129, 149
spires, 47, 84, 85
St Andrew's head, *see* Duquesnoy
St Bartholomew's Hospital, 154
St Bride's Church, 47
St George's, Bloomsbury, 85
St Martin's Lane Academy, xi, xix, xliii, liv*n.*, 118*n.*, 146
St Mary-le-Bow Church, 47
St Paul's Cathedral, 32, 38, 47, 48
St Peter's, Rome, 47, 148
Statuary's Yard, The, see Rowlandson, Thomas
stays (pl. 1, fig. 53), xxv, xxxix, 49, 150
Steele, Richard, xxx, xxxi
Steevens, George, 152
Sterne, Laurence, *Tristram Shandy*, xlix–li, lxii*n.*
Strasbourg Cathedral, 48
Stubbs, George, xlix
Sublime, xlvii, xlviii, lii, liii
Swift, Jonathan, xxii, xxviii, xl, xlviii, liv*n.*, 20, 65*n.*, 117

Tacitus, 150
Talbot, Catherine, xliv
Tave, Stuart, lvii*n.*

Taylor, Dr. Brook, 85*n*.
ten Kate, Lambert Hermansz ["Lambert Hermanson Ten Kate"], xxxviii, 4*n*., 8, 10*n*., 117*n*., 120*n*.
theatre, xlii, 110, 112–13, 125, 149
Thornhill, Sir James, xviii, 47*n*., 92*n*., 146
Thornton, Bonnell, lxn., 93*n*.
Titian, 93
toad, xlvi, 49
Toland, John, xx, xxiii, xxiv, xxvi, xxvii, xxxv, lviin.
Tonson, Jacob, 144
Torso del Belvedere, Vatican (pl. 1, fig. 54), 2, 58, 147, 149, 150
Townley, Rev. James, 7*n*., 14*n*., 120*n*.
Turner, J.M.W., xlix

Van Dyck, Sir Anthony ["Vandyke"], xliii, 6, 100, 117, 154
Van Gunst, Pieter, 6, 154
Vanderbank, John, 121*n*., 133*n*.
Vasari, Giorgio, 143
Venus and Cupid, *see* Pontormo
Venus de Medici (pl. 1, fig. 13), xix, xxiv, xxv, xxxii, xxxiv, xxxv, xxxvii, xl, 59, 68, 112, 146, 148, 149
Vertue, George, xviii, 151
Vile Ephesian, The, *see* Sandby, Paul
Virgil, lii
Voss, Christian Friedrich, xlv

Walpole, Horace, 46*n*., 152
Walpole, Lady, 8*n*.
Walpole, Sir Robert, xxii, xxx, xlii
Warburton, William, xxxv, xxxvi, 7*n*., 155
Warton, Joseph, xxviii
watchmaking, 61; *see also* Harrison
watermen, 70
Westminster Abbey, 48, 148
Wharton, Lady Jane, portrait of (pl. 2, fig. 52), 6, 154
Whitefield, George, liii
Whitehall Banqueting House ["Whitehall-chapel"], 93
Whitehead, William, 4*n*.
wigs, xxix, 37, 125, 131, 148, 150
Wills, James, xlv, lxn.
Windsor Castle, 36, 86
Woman of Samaria, Christ and the, *see* Carracci, Annibale
Woolston, Thomas, xxii
World, The, lxn.
Wren, Sir Christopher, 31, 47
Wright of Derby, Joseph, xlix

Xenophon, xxiii, 26, 145, 146

Zeus, xl
Zoffany, Johan, xlix

5. Plate 2, 1st state (detail). Courtesy of the Trustees of the British Museum, London.

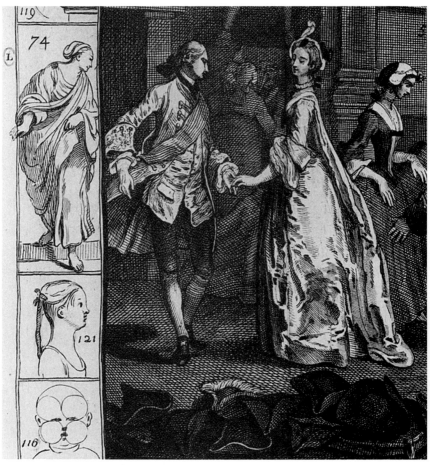

6. Plate 2, 3rd state (detail). Courtesy of the Trustees of the British Museum, London.

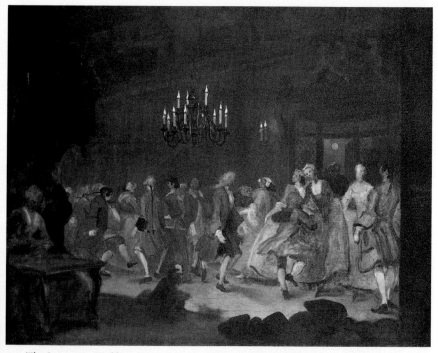

7. *The Country (or Wedding) Dance*; painting (c. 1745–46); Tate Gallery, London.

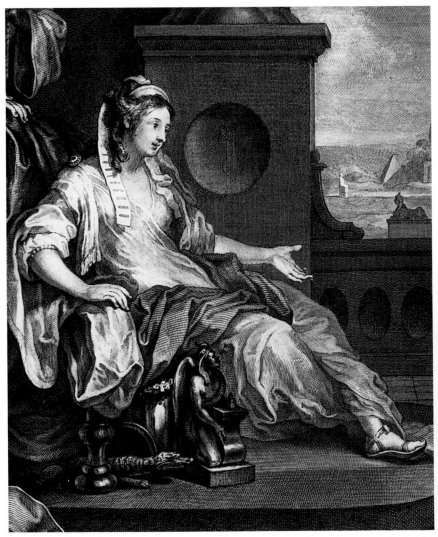

8. *Moses Brought to Paraoh's Daughter* (1752, detail). Courtesy of the Trustees of the British Museum, London.

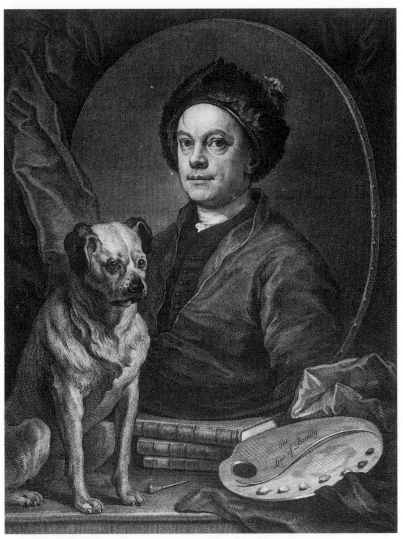

9. *Gulielmus Hogarth* (1749). Courtesy of the Trustees of the British Museum, London. (The names Shakespeare, Milton, and Swift appear on the books in the painting [National Gallery, London].)

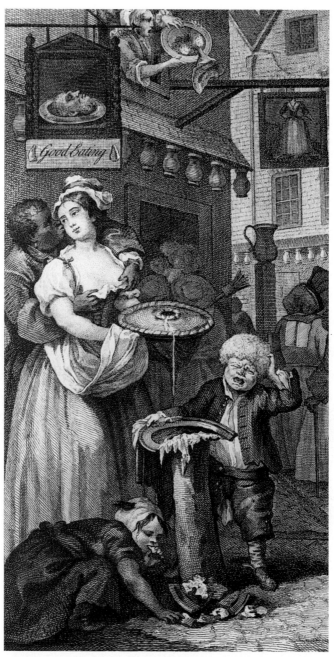

10. *Noon* (1738, detail). Courtesy of the Trustees of the British Museum, London.

11a. Logo, *Analysis* title page.

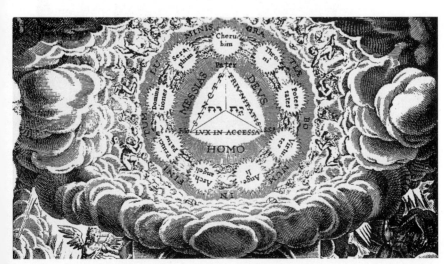

11b. Trinity with Tetragrammaton: L. Cecil, detail of title page, Thomas Heywood, *The Hierarchie of the Blessed Angells* (1635).

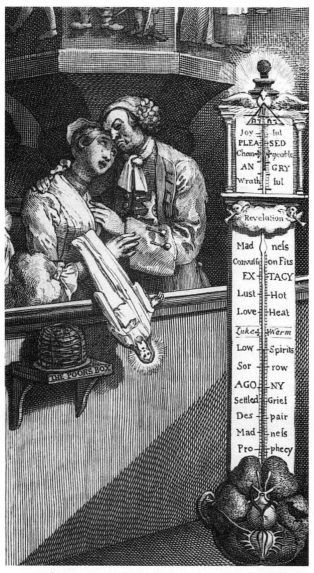

11c. *Enthusiasm Delineated* (c. 1759, detail). Courtesy of the Trustees of the British Museum, London.

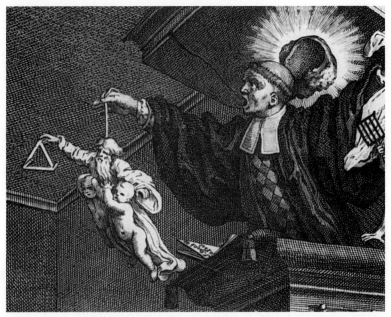

11d. *Enthusiasm Delineated*, detail. Courtesy of the Trustees of the British Museum, London.

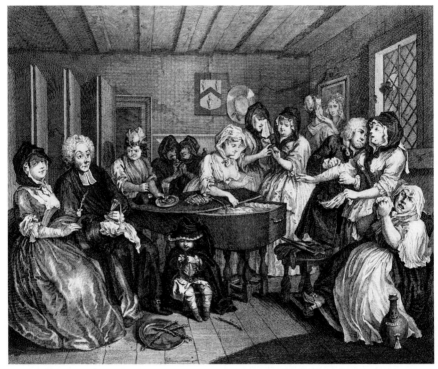

12. *Harlot's Progress*, Plate 6 (1732). Courtesy of the Trustees of the British Museum.

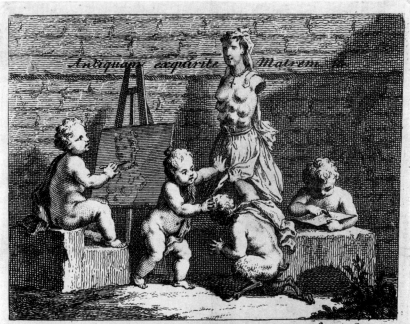

13. *Boys Peeping at Nature* (subscription ticket for *A Harlot's Progress*, 1731, detail). Royal Library, Windsor Castle C 1990, H.M. Queen Elizabeth II.

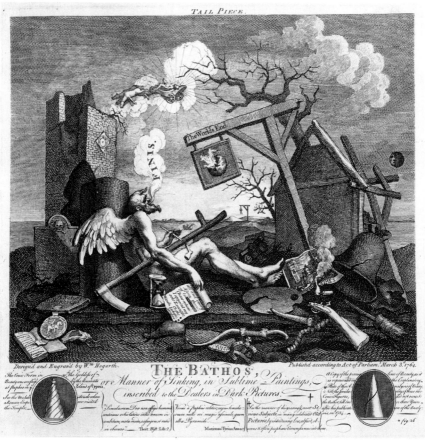

14. *Tailpiece; or the Bathos* (1764). Courtesy of the Trustees of the British Museum, London.

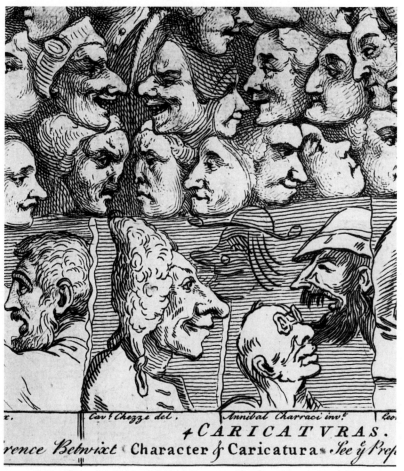

Cav.ᵉ Chezze del. · Annibal Charraci invᵗ· Leo.

✦CARICATVRAS.

rence Betwixt Character & Caricatura See y̆ Pre

15. *Characters and Caricaturas* (subscription ticket for Marriage A-la-Mode, 1743). Courtesy of the Trustees of the British Museum, London.

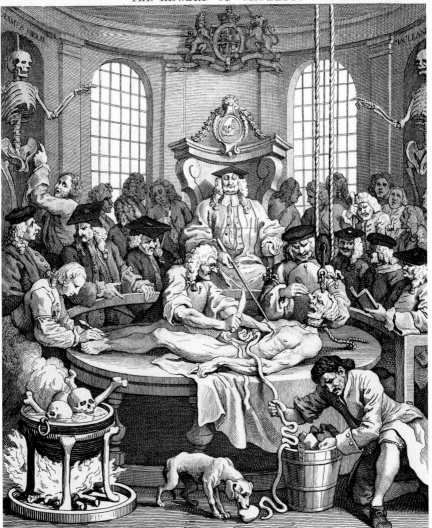

16. *The Reward of Cruelty* (1751/2). Courtesy of the Trustees of the British Museum, London.

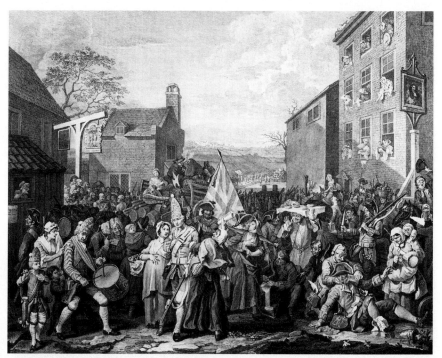

17. *The March to Finchley* (1750). Courtesy of the Trustees of the British Museum, London.

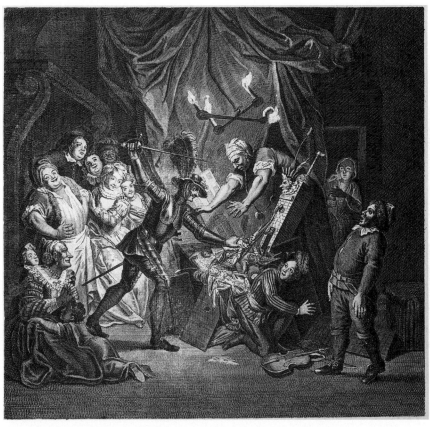

18. Charles-Antoine Coypel, *Don Quixote Attacks the Puppets*; etching and engraving by Francois Poilly (1724; 1756 ed.). Courtesy of the Trustees of the British Museum, London.

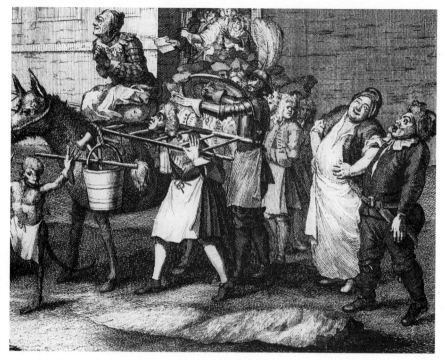

19. *The Mystery of Masonry Brought to Light by the Gormogons* (1724, detail). Courtesy of the Trustees of the British Museum, London.

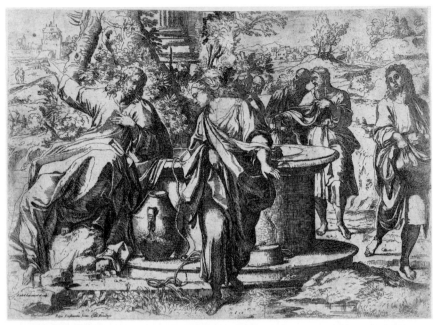

20. Annibale Carracci, *The Woman of Samaria*, etched, Carracci. Courtesy of the British Museum, London.

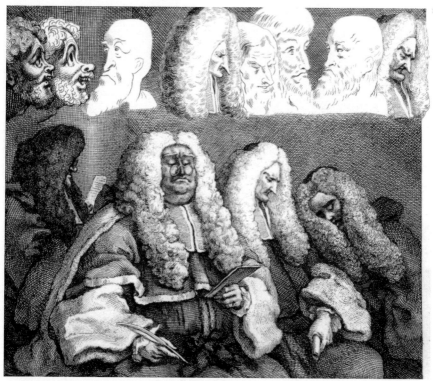

21. *The Bench* (1758; fourth state, 1764). Courtesy of the Trustees of the British Museum, London.

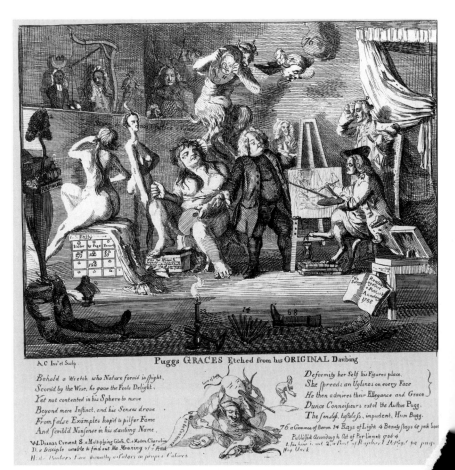

22. Paul Sandby, *Puggs Graces Etched from his Original Daubling* (1753/4). Courtesy of Trustees of the British Museum, London.

The Author run Mad

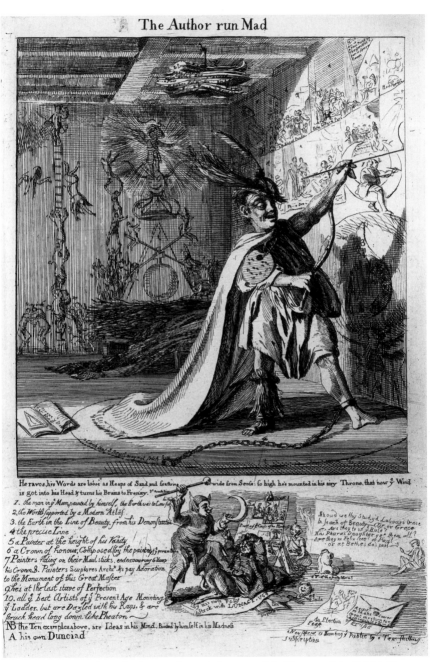

23. Paul Sandby, *The Author Run Mad* (1754). Courtesy of the Trustees of the British Museum, London.

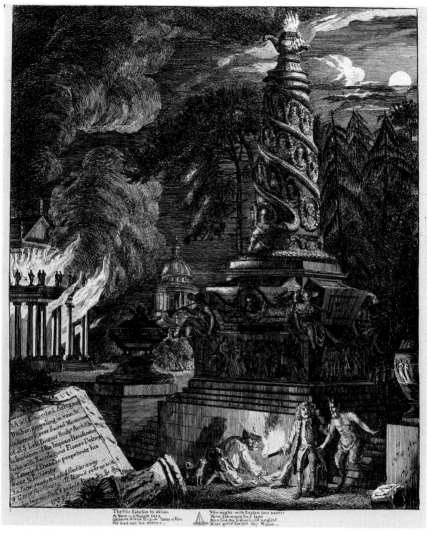

The Vile Ephesian to obtain
A Name —A Temple fired
Observe O land K-g-m Twas in Vain
He had not his desires —

You might with Reason sure expect
Your Law would b-g lame
Men fire the Labours will neglect
Next quite forgot they Name —

24. Paul Sandby, *The Vile Ephesian* (1753). Courtesy of the Trustees of the British Museum, London.